Nikon® D5000

FOR

DUMMIES®

Nikon® D5000

FOR

DUMMIES®

by Julie Adair King
with Doug Sahlin

WILEY

Wiley Publishing, Inc.

Nikon® D5000 For Dummies®

Published by
Wiley Publishing, Inc.
111 River Street
Hoboken, NJ 07030-5774

www.wiley.com

Copyright © 2009 by Wiley Publishing, Inc., Indianapolis, Indiana

Published by Wiley Publishing, Inc., Indianapolis, Indiana

Published simultaneously in Canada

For general information on our other products and services, please contact our Customer Care Department within the U.S. at 877-762-2974, outside the U.S. at 317-572-3993, or fax 317-572-4002.

For technical support, please visit www.wiley.com/techsupport.

Wiley also publishes its books in a variety of electronic formats. Some content that appears in print may not be available in electronic books.

Library of Congress Control Number: 2009929461

ISBN: 978-0-470-53969-9

Manufactured in the United States of America

10 9 8 7 6 5 4 3 2

WILEY

About the Authors

Julie Adair King is the author of many books about digital photography and imaging, including the best-selling *Digital Photography For Dummies*. Her most recent titles include a series of *For Dummies* guides to popular digital SLR cameras, including the Nikon D90, D60, and D40/D40x. Other works include *Digital Photography Before & After Makeovers*, *Digital Photo Projects For Dummies*, *Julie King's Everyday Photoshop For Photographers*, *Julie King's Everyday Photoshop Elements*, and *Shoot Like a Pro!: Digital Photography Techniques*. When not writing, King teaches digital photography at such locations as the Palm Beach Photographic Center. A graduate of Purdue University, she resides in Indianapolis, Indiana.

Doug Sahlin is an author and photographer living in Venice, Florida. He has written 21 books on computer applications such as Adobe Flash and Adobe Acrobat. He has written books on digital photography, and co-authored 13 books on applications such as Adobe Photoshop and Photoshop Elements. Recent titles include: *Flash CS4 All-in-One For Dummies*, *Digital Photography Quicksteps,* 2nd Edition, and *Digital Photography Workbook For Dummies*. Many of his books have been best sellers at Amazon.com.

He is president of Superb Images, Inc., a wedding and event photography company. Doug teaches Adobe Acrobat to local businesses and government institutions. He uses Flash and Acrobat to create Web content and multimedia presentations for his clients. He also hosts Pixelicious (www. pixelicious.info), a weekly podcast on digital photography, Photoshop, and Lightroom.

Author's Acknowledgments

Julie Adair King: I am grateful beyond measure to the team of talented professionals at John Wiley & Sons for all their efforts in putting together this book. Special thanks go to editors Kim Darosett and Heidi Unger, for whom the adjective *awesome* is an understatement; I am so, *so* fortunate to have you on my team. I also owe much to many other folks in both the editorial and art departments, including Rashell Smith, Shelley Lea, Steve Hayes, Andy Cummings, and Mary Bednarek. Last but not least, I am also indebted to technical editor Dave Hall, without whose insights and expertise this book would not have been the same.

Publisher's Acknowledgments

We're proud of this book; please send us your comments through our online registration form located at http://dummies.custhelp.com. For other comments, please contact our Customer Care Department within the U.S. at 877-762-2974, outside the U.S. at 317-572-3993, or fax 317-572-4002.

Some of the people who helped bring this book to market include the following:

Acquisitions and Editorial

Project Editor: Kim Darosett

Executive Editor: Steven Hayes

Copy Editor: Heidi Unger

Technical Editor: Dave Hall

Editorial Manager: Leah Cameron

Sr. Editorial Assistant: Cherie Case

Cartoons: Rich Tennant
(www.the5thwave.com)

Composition Services

Project Coordinator: Patrick Redmond

Layout and Graphics: Claudia Bell, Carl Byers, Reuben W. Davis, Christin Swinford

Proofreaders: Melissa Cossell, Toni Settle

Indexer: Broccoli Information Management

Publishing and Editorial for Technology Dummies

 Richard Swadley, Vice President and Executive Group Publisher

 Andy Cummings, Vice President and Publisher

 Mary Bednarek, Executive Acquisitions Director

 Mary C. Corder, Editorial Director

Publishing for Consumer Dummies

 Diane Graves Steele, Vice President and Publisher

Composition Services

 Debbie Stailey, Director of Composition Services

Contents at a Glance

Table of Contents

Introduction

*N*ikon. The name has been associated with top-flight photography equipment for generations. And the introduction of the D5000 has only enriched Nikon's well-deserved reputation, offering all the control a die-hard photography enthusiast could want while at the same time providing easy-to-use, point-and-shoot features for the beginner.

In fact, the D5000 offers so *many* features that sorting them all out can be more than a little confusing, especially if you're new to digital photography, SLR photography, or both. For starters, you may not even be sure what SLR means or how it affects your picture taking, let alone have a clue as to all the other techie terms you encounter in your camera manual — *resolution, aperture, white balance,* and so on. And if you're like many people, you may be so overwhelmed by all the controls on your camera that you haven't yet ventured beyond fully automatic picture-taking mode. Which is a shame because it's sort of like buying a Porsche 911 and never driving it on a winding road.

Therein lies the point of *Nikon D5000 For Dummies:* Through this book, you can discover not just what each bell and whistle on your camera does, but also when, where, why, and how to put it to best use. Unlike many photography books, this one doesn't require any previous knowledge of photography or digital imaging to make sense of things, either. In classic *For Dummies* style, everything is explained in easy-to-understand language, with lots of illustrations to help clear up any confusion.

In short, what you have in your hands is the paperback version of an in-depth photography workshop tailored specifically to your Nikon picture-taking powerhouse.

A Quick Look at What's Ahead

This book is organized into four parts, each devoted to a different aspect of using your camera. Although chapters flow in a sequence that's designed to take you from absolute beginner to experienced user, I've also tried to make each chapter as self-standing as possible so that you can explore the topics that interest you in any order you please.

The following sections offer brief previews of each part. If you're eager to find details on a specific topic, the index shows you exactly where to look.

Part I: Fast Track to Super Snaps

Part I contains four chapters that help you get up and running with your D5000:

- ✔ Chapter 1, "Getting the Lay of the Land," offers a tour of the external controls on your camera, shows you how to navigate camera menus to access internal options, and walks you through initial camera setup and customization steps.

- ✔ Chapter 2, "Taking Great Pictures, Automatically," shows you how to get the best results when using the camera's fully automatic exposure modes, including the Digital Vari-Program scene modes such as Sports mode, Portrait mode, and Landscape mode.

- ✔ Chapter 3, "Controlling Picture Quality and Size," introduces you to two camera settings that are critical whether you shoot in automatic or manual mode: the Image Size and Image Quality settings, which control resolution (pixel count), file format, file size, and picture quality.

- ✔ Chapter 4, "Monitor Matters: Picture Playback and Live View Shooting" offers just what its title implies. Look here to find out how to use the D5000's cool, swiveling monitor to review your photos, compose photos in Live View mode, and record short movies. This chapter also discusses how to delete unwanted images and protect your favorites from accidental erasure.

Part II: Taking Creative Control

Chapters in this part help you unleash the full creative power of your D5000 by moving into semiautomatic or manual photography modes.

- ✔ Chapter 5, "Getting Creative with Exposure and Lighting," covers the all-important topic of exposure, starting with an explanation of three critical exposure controls: aperture, shutter speed, and ISO. This chapter also discusses your camera's advanced exposure modes (P, S, A, and M); explains exposure options such as Active D-Lighting, automatic exposure bracketing, metering modes, and exposure compensation; and offers tips for using the built-in flash.

- ✔ Chapter 6, "Manipulating Focus and Color," provides help with controlling those aspects of your pictures. Head here for information about your camera's many autofocusing options, for tips on how to manipulate depth of field (the zone of sharp focus in a picture), and for details about color controls such as white balance.

- ✔ Chapter 7, "Putting It All Together," summarizes all the techniques explained in earlier chapters, providing a quick-reference guide to the camera settings and shooting strategies that produce the best results for specific types of pictures: portraits, action shots, landscape scenes, close-ups, and more.

Part III: Working with Picture Files

This part of the book, as its title implies, discusses the often-confusing aspect of moving your pictures from camera to computer and beyond.

- Chapter 8, "Downloading, Organizing, and Archiving Your Picture Files," guides you through the process of transferring pictures from your camera memory card to your computer's hard drive or other storage device. Look here, too, for details about using the D5000's built-in tool for processing files that you shoot in the Nikon RAW format (NEF). Just as important, this chapter explains how to organize and safeguard your photo files.

- Chapter 9, "Printing and Sharing Your Pictures," helps you turn your digital files into "hard copies" that look as good as those you see on the camera monitor. This chapter also explains how to prepare your pictures for online sharing, create digital slide shows and stop-motion movies, and, for times when you have the neighbors over, display your pictures and movies on a television screen.

Part IV: The Part of Tens

In famous *For Dummies* tradition, the book concludes with two "top ten" lists containing additional bits of information and advice.

- Chapter 10, "Ten (Or So) Fun and Practical Retouch Menu Features," shows you how to fix less-than-perfect images using features found on your camera's Retouch menu, such as automated red-eye removal. You also find out how to apply color effects and perform a few other photo-enhancement tricks.

- Chapter 11, "Ten Special-Purpose Features to Explore on a Rainy Day," presents information about some camera features that, while not found on most "Top Ten Reasons I Bought My D5000" lists, are nonetheless interesting, useful on occasion, or a bit of both.

Icons and Other Stuff to Note

If this isn't your first *For Dummies* book, you may be familiar with the large, round icons that decorate its margins. If not, here's your very own icon-decoder ring:

A Tip icon flags information that will save you time, effort, money, or some other valuable resource, including your sanity.

When you see this icon, look alive. It indicates a potential danger zone that can result in much wailing and teeth-gnashing if ignored. I've already found this, so you won't have to.

Lots of information in this book is of a technical nature — digital photography is a technical animal, after all. But if I present a detail that is useful mainly for impressing your technology-geek friends, I mark it with this icon.

I apply this icon either to introduce information that is especially worth storing in your brain's long-term memory or to remind you of a fact that may have been displaced from that memory by some other pressing fact.

Additionally, I need to point out three additional details that will help you use this book:

- **Other margin art:** Replicas of some of your camera's buttons also appear in the margins of some paragraphs. I include these to provide a quick reminder of the appearance of the button being discussed.

- **Software menu commands:** In sections that cover software, a series of words connected by an arrow indicates commands that you choose from the program menus. For example, if a step tells you to "Choose File⇨Convert Files," click the File menu to unfurl it and then click the Convert Files command on the menu.

- **Camera firmware:** *Firmware* is the internal software that controls many of your camera's operations. The D5000 firmware consists of three parts, called A, B, and L. At the time this book was written, A and B were version 1.00, and L was version 1.001.

 Occasionally, Nikon releases firmware updates, and it's a good idea to check out the Nikon Web site (www.nikon.com) periodically to find out whether any updates are available. (Chapter 1 tells you how to determine which firmware version your camera is running.) Firmware updates typically don't carry major feature changes — they're mostly used to solve technical glitches in existing features — but if you do download an update, be sure to read the accompanying description of what it accomplishes so that you can adapt my instructions as necessary.

About the Software Shown in This Book

Providing specific instructions for performing photo organizing and editing tasks requires that I feature specific software. In sections that cover file downloading, archiving, printing, and e-mail sharing, I selected Nikon ViewNX and Nikon Transfer, both of which ship free with your camera and work on both the Windows and Mac operating systems.

Rest assured, though, that the tools used in ViewNX and Nikon Transfer work very similarly in other programs, so you should be able to easily adapt the steps to whatever software you use. (I recommend that you read your software manual for details. And of course, there are *For Dummies* books on all the major image editing applications, and you can use them if you find the manual a tad — ahem — boring.)

Practice, Be Patient, and Have Fun!

To wrap up this preamble, I want to stress that if you initially think that digital photography is too confusing or too technical for you, you're in very good company. *Everyone* finds this stuff a little mind-boggling at first. So take it slowly, experimenting with just one or two new camera settings or techniques at first. Then, each time you go on a photo outing, make it a point to add one or two more shooting skills to your repertoire.

I know that it's hard to believe when you're just starting out, but it really won't be long before everything starts to come together. With some time, patience, and practice, you'll soon wield your camera like a pro, dialing in the necessary settings to capture your creative vision almost instinctively.

So without further ado, I invite you to grab your camera, a cup of whatever it is you prefer to sip while you read, and start exploring the rest of this book. Your D5000 is the perfect partner for your photographic journey, and I thank you for allowing me, through this book, to serve as your tour guide.

Part I

Fast Track to Super Snaps

The 5th Wave By Rich Tennant

"Remember, when the subject comes into focus, the camera makes a beep. But that's annoying, so I set it on vibrate."

Making sense of all the controls on your D5000 isn't something you can do in an afternoon — heck, in a week, or maybe even a month. But that doesn't mean that you can't take great pictures today. By using your camera's automatic point-and-shoot modes, you can capture terrific images with very little effort. All you do is compose the scene, and the camera takes care of almost everything else.

This part shows you how to take best advantage of your camera's automatic features and also addresses some basic setup steps, such as adjusting the viewfinder to your eyesight and getting familiar with the camera menus, buttons, and dials. In addition, chapters in this part explain how to obtain the very best picture quality, whether you shoot in an automatic or manual mode, and how to use your camera's picture-playback, Live View, and movie recording features.

Getting the Lay of the Land

In This Chapter

▶ Attaching and using an SLR lens

▶ Adjusting the viewfinder to your eyesight

▶ Working with memory cards

▶ Getting acquainted with your camera

▶ Selecting from menus

▶ Displaying onscreen help

▶ Customizing basic operations

I still remember the day that I bought my first SLR film camera. I was excited to finally move up from my one-button point-and-shoot camera, but I was a little anxious, too. My new pride and joy sported several unfamiliar buttons and dials, and the explanations in the camera manual clearly were written for someone with an engineering degree. And then there was the whole business of attaching the lens to the camera, an entirely new task for me. I saved up my pennies a long time for that camera — what if my inexperience caused me to damage the thing before I even shot my first pictures?

You may be feeling similarly insecure if your Nikon D5000 is your first SLR, although some of the buttons on the camera back may look familiar if you've previously used a digital point-and-shoot camera. If your D5000 is both your first SLR and first digital camera, you may be doubly intimidated.

Trust me, though, that your camera isn't nearly as complicated as its exterior makes it appear. With a little practice and the help of this chapter, which introduces you to each external control, you'll quickly become as comfortable with your camera's buttons and dials as you are with the ones

on your car's dashboard. This chapter also guides you through the process of mounting and using an SLR lens, working with digital memory cards, navigating your camera's menus, and customizing basic camera operations.

Getting Comfortable with Your Lens

One of the biggest differences between a point-and-shoot camera and an SLR *(single-lens reflex)* camera is the lens. With an SLR, you can swap out lenses to suit different photographic needs, going from an extreme close-up lens (also known as a *macro lens)* to a *wide-angle lens,* which encompasses a wide field of view, to a *super-long telephoto,* which lets you photograph a distant subject without getting too close. In addition, an SLR lens has a movable focusing ring that gives you the option of focusing manually instead of relying on the camera's autofocus mechanism.

Of course, those added capabilities mean that you need a little background information to take full advantage of your lens. To that end, the next four sections explain the process of attaching, removing, and using this critical part of your camera.

Attaching a lens

Your camera can autofocus only with a type of lens that carries the specification *AF-S.* (Well, technically speaking, the camera can also autofocus with *AF-I* lenses. But since those are high-end, very expensive lenses that are no longer made, this is the only mention you'll find of AF-I lenses in this book.) You can use other types of lenses, as long as they're compatible with the camera's lens mount, but you'll have to focus manually.

Whatever lens you choose, follow these steps to attach it to the camera body:

1. **Turn the camera off and remove the cap that covers the lens mount on the front of the camera.**

2. **Remove the cap that covers the back of the lens.**

3. **Hold the lens in front of the camera so that the little white dot on the lens aligns with the matching dot on the camera body.**

 Official photography lingo uses the term *mounting index* instead of *little white dot.* Either way, you can see the markings in question in Figure 1-1.

 Note that the figure (and others in this chapter) shows you the D5000 with its so-called "kit lens" — the 18–55mm Vibration Reduction (VR) zoom lens that Nikon sells as a unit with the body. If you buy a lens from a manufacturer other than Nikon, your dot may be red or some other color, so check the lens instruction manual.

4. **Keeping the dots aligned, position the lens on the camera's lens mount as shown in Figure 1-1.**

 When you do so, grip the lens by its back collar, not the movable, forward end of the lens barrel.

5. **Turn the lens in a counter-clockwise direction until the lens clicks into place.**

 To put it another way, turn the lens toward the side of the camera that sports the shutter button, as indicated by the red arrow in the figure.

6. **On a lens that has an aperture ring, set and lock the ring so the aperture is set at the highest f-stop number.**

 Check your lens manual to find out whether your lens sports an aperture ring and how to adjust it. (The D5000 kit lens doesn't.) To find out more about apertures and f-stops, see Chapter 5.

Mounting index dots

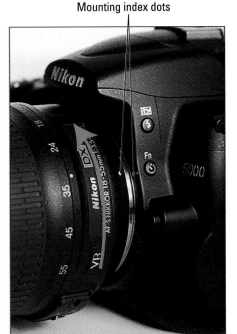

Figure 1-1: When attaching the lens, align the index markers as shown here.

Even though the D5000 is equipped with a dust reduction system, you should always attach (or switch) lenses in a clean environment to reduce the risk of getting dust, dirt, and other contaminants inside the camera or lens. Changing lenses on a sandy beach, for example, isn't a good idea. For added safety, point the camera body slightly down when performing this maneuver; doing so helps prevent any flotsam in the air from being drawn into the camera by gravity.

Removing a lens

To detach a lens from the camera body, take these steps:

1. **Turn off the camera and locate the lens-release button, labeled in Figure 1-2.**

2. **Grip the rear collar of the lens.**

 In other words, hold on to the stationary part of the lens that's closest to the camera body and not the movable focusing ring or zoom ring, if your lens has one.

3. **Press the lens-release button while turning the lens clockwise until the mounting index on the lens is aligned with the index on the camera body.**

The mounting indexes are the little guide dots labeled in Figure 1-1. When the dots line up, the lens should detach from the mount.

4. **Place the rear protective cap onto the back of the lens.**

If you aren't putting another lens on the camera, cover the lens mount with the protective cap that came with your camera, too.

Using a VR (vibration reduction) lens

If you purchased the D5000 camera kit — that is, the body-and-lens combination put together by Nikon — your lens offers a feature called *vibration reduction*. On Nikon lenses, this feature is indicated by the initials *VR* in the lens name.

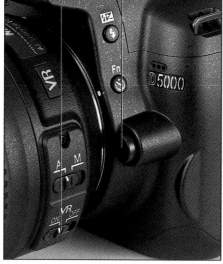

Vibration Reduction switch

Lens-release button

Figure 1-2: Press the lens-release button to disengage the lens from the mount.

Vibration reduction attempts to compensate for small amounts of camera shake that are common when photographers handhold their cameras and use a slow shutter speed, a lens with a long focal length, or both. That camera movement during the exposure can produce blurry images. Although vibration reduction can't work miracles, it does enable most people to capture sharper handheld shots in many situations than they otherwise could.

However, when you use a tripod, vibration reduction can have detrimental effects because the system may try to adjust for movement that isn't actually occurring. That's why your kit lens — and all Nikon VR lenses — have an On/ Off switch, which is located on the side of the lens, as shown in Figure 1-2. Whether you should turn off the VR feature, though, depends on the specific lens, so check the manual. For the 18–55mm kit lens, Nikon does recommend setting the switch to the Off position for tripod shooting, assuming that the tripod is "locked down" so the camera is immovable.

If you use a non-Nikon lens, the vibration reduction feature may go by another name: *image stabilization, optical stabilization, anti-shake, vibration compensation,* and so on. In some cases, the manufacturers may recommend that you leave the system turned on or select a special setting when you use a tripod, so be sure to check the lens manual for information.

Chapter 6 offers more tips on achieving blur-free photos, and it also explains focal length and its impact on your pictures. See Chapter 5 for an explanation of shutter speed.

Setting the focus mode (auto or manual)

Again, the option to switch between autofocusing and manual focusing depends on matching the D5000 with a fully compatible lens, as I explain in the earlier section, "Attaching a Lens." With the kit lens, as well as with other AF-S lenses, you can enjoy autofocusing as well as manual focusing.

The AF stands for *autofocus,* as you may have guessed. The S stands for *silent wave,* a Nikon autofocus technology.

For times when you attach a lens that doesn't support autofocusing or the autofocus system has trouble locking on your subject, you can focus manually by simply twisting a focusing ring on the lens barrel. The placement and appearance of the focusing ring depend on the lens; Figure 1-3 shows you the one on the kit lens.

To focus manually with the kit lens, take these steps:

1. **Set the lens to manual focus mode.**

 Look for the switch labeled in Figure 1-3, and move it from the A to the M position, as shown in the figure.

2. **While looking through the viewfinder, twist the focusing ring to adjust focus.**

 If you have trouble focusing, you may be too close to your subject; every lens has a minimum focusing distance. You may also need to adjust the viewfinder to accommodate your eyesight; you can get help with the process a few paragraphs from here.

If you use a lens other than the kit lens, check the lens instruction guide for details about focusing manually; your lens may or may not have a switch similar to the one on the kit lens. Also see the Chapter 6 section related to the Focus mode option, which should be set to MF for manual focusing. (The camera may automatically choose the setting for you, depending on the lens.)

Zooming in and out

If you bought a zoom lens, it has a movable zoom barrel. The location of the zoom barrel on the D5000 kit lens is shown in Figure 1-3. To zoom in or out, just rotate that zoom barrel clockwise or counterclockwise.

Focusing ring Auto/Manual focus switch

Zoom barrel

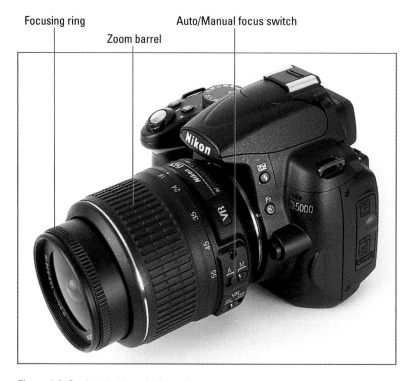

Figure 1-3: On the 18–55mm kit lens, the manual-focusing ring is set near the front of the lens, as shown here.

The numbers on the zoom ring, by the way, represent *focal lengths.* I explain focal lengths in Chapter 6. In the meantime, just note that when the lens is mounted on the camera, the number that's aligned with the lens mounting index (the white dot) represents the current focal length. In Figure 1-3, for example, the focal length is 18mm.

Adjusting the Viewfinder Focus

Tucked behind the right side of the rubber eyepiece that surrounds the view-finder is a tiny slider called a *diopter adjustment control.* With this control, labeled in Figure 1-4, you can adjust the focus of your viewfinder to accommodate your eyesight.

If you don't take this step, scenes that appear out of focus through the view-finder may actually be sharply focused through the lens, and vice versa. Here's how to make the necessary adjustment:

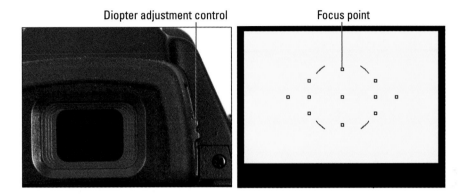

Figure 1-4: Use the diopter adjustment control to set the viewfinder focus for your eyesight.

1. **Remove the lens cap from the front of the lens.**

2. **Look through the viewfinder and concentrate on the little black markings shown on the right in Figure 1-4.**

 The little rectangles represent the camera's autofocusing points, which you can read more about in Chapters 2 and 6. The four curved lines represent the center-weighted metering area, which relates to an exposure option you can explore in Chapter 5.

3. **Push the diopter adjustment slider up or down until the viewfinder markings appear to be in focus.**

 The Nikon manual warns you not to poke yourself in the eye as you perform this maneuver. This warning seems so obvious that I laugh every time I read it — which makes me feel doubly stupid the next time I poke myself in the eye as I perform this maneuver.

Working with Memory Cards

Instead of recording images on film, digital cameras store pictures on *memory cards.* Your D5000 uses a specific type of memory card called an *SD card* (for *Secure Digital*), shown in Figures 1-5 and 1-6. You can also use the new, high-capacity Secure Digital cards, which are labeled SDHC, as well as Eye-Fi SD cards, which enable you to send pictures to your computer over a wireless network. (Because of space limitations, I don't cover Eye-Fi connectivity in this book; if you want more information about these cards, you can find it online at www.eye.fi.)

Safeguarding your memory cards — and the images you store on them — requires just a few precautions:

✓ **Inserting a card:** First, be sure that the camera is turned off. Then put the card in the card slot with the label facing the back of the camera, as shown in Figure 1-5. Push the card into the slot until it clicks into place; the memory card access light (circled in Figure 1-5) blinks for a second to let you know the card is inserted properly.

✓ **Formatting a card:** The first time you use a new memory card or insert a card that has been used in other devices (such as an MP3 player), you should *format* it. Formatting ensures that the card is properly prepared to record your pictures.

Formatting erases *everything* on your memory card. So before formatting, be sure that you have copied any pictures or other data to your computer.

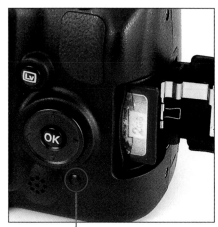

Memory card access light

Figure 1-5: Insert the card with the label facing the camera back.

To format a memory card, choose the Format Memory Card command from the Setup menu. The upcoming section "Ordering from Camera Menus" explains how to work with menus. When you select the command, you're informed that all images will be deleted, and you're asked to confirm your decision to format the card. Highlight Yes and press the OK button to go forward.

If you insert a memory card and see the letters *For* in the viewfinder, you must format the card before you can do anything else. You also see a message requesting formatting in the Shooting Information display.

✓ **Removing a card:** After making sure that the memory card access light is off, indicating that the camera has finished recording your most recent photo, turn the camera off. Open the memory card door, as shown in Figure 1-5. Depress the memory card slightly until you hear a little click and then let go. The card should pop halfway out of the slot, enabling you to grab it by the tail and remove it.

If you turn on the camera when no card is installed, the symbol [-E-] appears in the Shots Remaining area of the viewfinder (lower-right corner), and you also see a little symbol that looks like an SD card on the left side of the viewfinder screen. (That card symbol appears whether or not the camera is turned on.) If the Shooting Information screen is displayed on the monitor, that screen also nudges you to insert a memory card. If you do have a card in the camera and you get these messages, try taking it out and reinserting it.

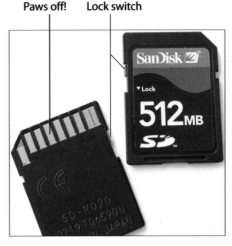

Paws off! Lock switch

Figure 1-6: Avoid touching the gold contacts on the card.

Some computer programs enable you to format cards as well, but it's not a good idea to go that route. Your camera is better equipped to optimally format cards.

- **Handling cards:** Don't touch the gold contacts on the back of the card. (See the left card in Figure 1-6.) When cards aren't in use, store them in the protective cases they came in or in a memory card wallet. Keep cards away from extreme heat and cold as well.

- **Locking cards:** The tiny switch on the left side of the card, labeled *lock switch* in Figure 1-6, enables you to lock your card, which prevents any data from being erased or recorded to the card. Press the switch toward the bottom of the card to lock the card contents; press it toward the top of the card to unlock the data.

You can protect individual images from accidental erasure by using the camera's Protect feature, which is covered in Chapter 4.

One side note on the issue of memory cards and file storage: Given that memory cards are getting cheaper and larger in capacity, you may be tempted to pick up an 8GB (gigabyte) or 16GB card thinking you can store a gazillion images on one card and not worry about running out of room. But memory cards are mechanical devices that are subject to failure, and if a large card fails, you lose lots of images. So I carry several 4GB SD cards in my camera bag. Although I hate to lose any images, I'd rather lose 4GB worth of images than 8 or 16GB.

Do you need high-speed memory cards?

Memory cards are categorized not just by their storage capacity, but also by their data-transfer speed. SD cards (the type used by your D5000) fall into one of three *speed classes,* Class 2, Class 4, and Class 6, with the number indicating the minimum number of *megabytes* (units of computer data) that can be transferred per second. A Class 2 card, for example, has a minimum transfer speed of 2 megabytes, or MB, per second. Of course, with the speed increase comes a price increase.

Photographers who shoot action benefit most from high-speed cards — the faster data-transfer rate helps the camera record shots at its maximum speed. Users who shoot at the highest resolution or prefer the NEF (Raw) file format also gain from high-speed cards; both

options increase file size and, thus, the time needed to store the picture on the card. (See Chapter 3 for details.) Finally, you sometimes enjoy better movie-recording performance when using higher speed cards. As for picture downloading, how long it takes for files to shuffle from card to computer depends not just on card speed, but also on the capabilities of your computer and, if you use a memory card reader to download files, on the speed of that device. (Chapter 8 covers the file-downloading process.)

Long story short, if you want to push your camera to its performance limits, a high-speed card is worth considering, assuming budget is no issue. Otherwise, even a Class 2 card should be more than adequate for most photographers.

Exploring External Camera Controls

Scattered across your camera's exterior are buttons, dials, and switches that you use to change picture-taking settings, review and edit your photos, and perform various other operations. In later chapters, I discuss all your camera's functions in detail and provide the exact steps to follow to access them. This section provides just a basic road map to the external controls plus a quick introduction to each.

One note before you move on: Many of the buttons perform multiple functions and so have multiple "official" names. The AE-L/AF-L button, for example, is also known as the Protect button. In the camera manual, Nikon's instructions refer to these multi-tasking buttons by the name that's relevant for the current function. I think that's a little confusing, so I always refer to each button by the first moniker you see in the lists here.

Topside controls

Your virtual tour begins with the bird's-eye view shown in Figure 1-7. There are a number of controls of note here:

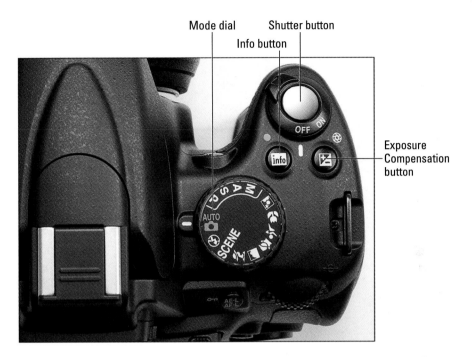

Figure 1-7: The tiny pictures on the Mode dial represent special automatic shooting modes.

✔ **On/Off switch and shutter button:** Okay, I'm pretty sure you already figured this combo button out. But check out Chapter 2 to discover the proper shutter-button-pressing technique — you'd be surprised how many people mess up their pictures because they press that button incorrectly.

✔ **Exposure Compensation button:** This button activates a feature that enables you to tweak exposure when working in three of your camera's autoexposure modes: programmed autoexposure, aperture-priority autoexposure, and shutter-priority autoexposure, represented by the letters P, S, and A on the camera Mode dial. Chapter 5 explains. In manual exposure (M) mode, you press this button while rotating the Command dial to adjust the aperture setting.

✔ **Info button:** You press this button to display the Shooting Information screen on the camera monitor. The screen not only enables you to easily view the current picture-taking settings but also is the pathway to the Quick Settings screen, through which you can adjust some settings more quickly than by using the camera menus. See the upcoming section "Monitoring Shooting Settings" for details. To turn the screen off, press the Info button again.

See the little green dots above this button and the Information Edit button (bottom-left button on the camera back)? The dots are reminders that pressing these two buttons simultaneously for more than two seconds restores the most critical picture-taking options to their default settings. See "Restoring default settings," at the end of this chapter, for more on this topic.

✔ **Mode dial:** With this dial, labeled in Figure 1-7, you set the camera to fully automatic, semi-automatic, or manual photography mode. The little pictographs, or icons, represent the Nikon Digital Vari-Program modes, which are automatic settings geared to specific types of photos: action shots, portraits, landscapes, and so on. Chapter 2 details the Digital Vari-Program and Auto modes; Chapter 5 explains the four others (P, S, A, and M).

Back-of-the-body controls

Traveling over the top of the camera to its back side, shown in Figure 1-8, you encounter the following controls:

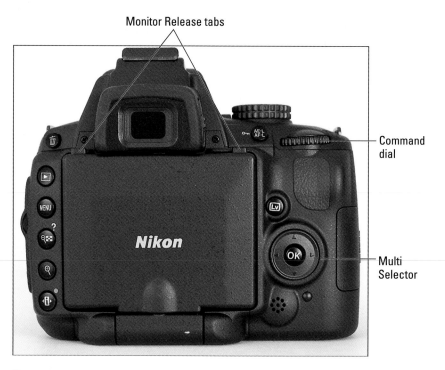

Figure 1-8: You use the Multi Selector to navigate menus and access certain other camera options.

⮕ **Command dial:** After you activate certain camera features, you rotate this dial, labeled in Figure 1-8, to select a specific setting. For example, to choose an f-stop when shooting in aperture-priority (A) mode, you rotate the Command dial. And in manual exposure (M) mode, you change the f-stop by rotating the dial while pressing the Exposure Compensation button, as explained in the preceding section. (Chapter 5 explains apertures and f-stops.)

 ⮕ **AE-L/AF-L/Protect button:** Pressing this button initiates autoexposure lock (AE-L) and autofocus lock (AF-L). Chapter 5 explains autoexposure lock; Chapter 6 talks about autofocus lock.

In playback mode, pressing the button locks the picture file — hence the little key symbol that appears to the left of the button — so that it isn't erased if you use the picture-delete functions. See Chapter 4 for details. (The picture *is* erased if you format the memory card, however.)

You can adjust the performance of the button as it relates to locking focus and exposure, too. Instructions in this book assume that you stick with the default setting, but if you want to explore your options, see Chapter 11.

⮕ **Monitor Release tabs:** You use these tabs to release the monitor from its locked position. More about the monitor in Chapter 4.

 ⮕ **Lv (Live View) button:** You press this button as the first step in recording a movie or taking advantage of Live View shooting, in which you can use the monitor to compose your shots. Chapter 4 introduces you to both Live View features.

⮕ **Multi Selector/OK button:** This dual-natured control, labeled in Figure 1-8, plays a role in many camera functions. You press the outer edges of the Multi Selector left, right, up, or down to navigate camera menus and access certain other options. At the center of the control is the OK button, which you press to finalize a menu selection or other camera adjustment. See the next section for help with using the camera menus.

 ⮕ **Delete button:** Sporting a trash can icon, the universal symbol for delete, this button enables you to erase pictures from your memory card. Chapter 4 has specifics.

 ⮕ **Playback button:** Press this button to switch the camera into picture review mode. Chapter 4 details the features available to you in this mode.

 ⮕ **Menu button:** Press this button to access menus of camera options. See the next section for details on navigating menus.

✔ **Zoom Out/Thumbnail/Help button:** This button has a number of functions, but the ones you'll use most often are

- *Display help screens.* You can press this button to display helpful information about certain menu options. See "Asking Your Camera for Help," later in this chapter, for details.

- *Adjust the image display during playback.* In playback mode, pressing the button enables you display multiple image thumbnails on the screen and reduce the magnification of the currently displayed photo. See Chapter 4 for a complete rundown of picture playback options.

✔ **Zoom In button:** In playback mode, pressing this button magnifies the currently displayed image and also reduces the number of thumbnails displayed at a time. Note the plus sign in the middle of the magnifying glass — plus for zoom in. Like the Zoom Out button, this one also serves a few minor roles that I explain in later chapters.

✔ **Information Edit button:** In picture-taking mode, use this button to shift from the Shooting Information display to the Quick Settings display, where you can change critical picture taking options.

This chapter is the only time you'll see the monitor in its locked position. When you aren't using the camera, it's a good idea to return it to this position to prevent damage to the monitor. Chapter 4 offers a quick refresher on how to adjust the monitor position.

Front-left buttons

On the front-left side of the camera body, shown in Figure 1-9, you find the following controls:

✔ **Flash/Flash compensation:** Pressing this button pops up the camera's built-in flash (except in automatic shooting modes, in which the camera decides whether the flash is needed). By holding the button down and rotating the Command dial, you can adjust the flash mode (normal, red-eye reduction, and so on). In advanced exposure modes (P, S, A, and M), you also can adjust the flash power by pressing the button, while simultaneously pressing the Exposure Compensation button and rotating the Command dial. See Chapter 5 for all things flash related.

✔ **Function (Fn) button:** By default, this button changes the current Release mode to the Self Timer setting. But if you don't use that feature often, you can use the button to perform one of seven other operations. Chapter 11 provides the details on changing the button's purpose. (*Note:* All instructions in this book assume that you haven't changed the function, however.)

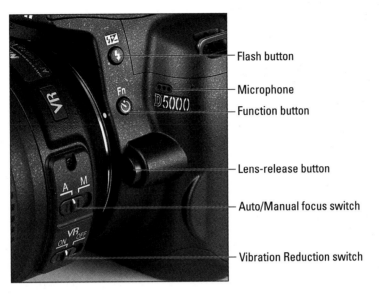

Figure 1-9: Press the Flash button to pop up the built-in flash.

✔ **Lens-release button:** You press this button before removing the lens from your camera. See the first part of this chapter for help with mounting and removing lenses.

✔ **Lens switches:** As detailed in the first part of this chapter, you use the A/M switch to set the kit lens to automatic or manual focusing. The VR Switch turns the Vibration Reduction feature on and off.

Make note, too, of the tiny microphone perched just above the D5000 label. Be careful not to obscure the microphone with your finger when you're recording a movie, a subject you can explore in Chapter 4.

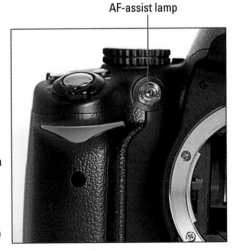

Figure 1-10: The AF-assist lamp is a lonely animal.

Front-right controls

Wrapping up the list of external controls, the front-right side of the camera is really quite sparse. There's only one item there, as shown in Figure 1-10.

In dim lighting, a beam of light shoots out from the AF-assist lamp to help the camera's autofocus system find its target. In general, leaving the AF-sssist option enabled is a good idea, but if you're doing a lot of shooting at a party, wedding, or some event where the light from the lamp may be distracting, you can disable it through an option on the Custom Setting menu. Chapter 6 explains this and other autofocus features.

Ordering from Camera Menus

 You access many of your camera's features via internal menus, which, conveniently enough, appear when you press the Menu button. Features are grouped into six main menus, described briefly in Table 1-1.

Table 1-1		D5000 Menus
Symbol	**Open This Menu . . .**	**to Access These Functions**
▶	Playback	Viewing, deleting, and protecting pictures
📷	Shooting	Basic photography settings
✏	Custom Setting	Advanced photography options and some basic camera operations
🔧	Setup	Additional basic camera operations
🖌	Retouch	Built-in photo retouching options
📋 📋	Recent Settings/ My Menu	Your 20 most-recently-used menu options or your custom-designed menu

After you press the Menu button, you see on the camera monitor a screen similar to the one shown in Figure 1-11. Along the left side of the screen, you see the icons shown in Table 1-1, each representing one of the available menus. The icon that is highlighted or appears in color is the active menu; options on that menu automatically appear to the right of the column of icons. In the figure, the Shooting menu is active, for example.

I explain all the important menu options elsewhere in the book; for now, just familiarize yourself with the process of navigating menus and selecting options therein. The Multi Selector, shown in Figure 1-8, is the key to the

game. You press the edges of the
Multi Selector to navigate up,
down, left, and right through the
menus.

In this book, the instruction
"Press the Multi Selector left"
simply means to press the left
edge of the control. "Press the
Multi Selector right" means to
press the right edge, and so on.

Here's a bit more detail about
the process of navigating menus:

Menu icons

Figure 1-11: Highlight a menu in the left
column to display its contents.

- ✓ **To select a different menu:**
 Press the Multi Selector left to
 jump to the column containing the menu icons. Then press up or down
 to highlight the menu you want to display. Finally, press right to jump
 over to the options on the menu.

- ✓ **To select and adjust a function on the current menu:** Again, use the
 Multi Selector to scroll up or down the list of options to highlight the
 feature you want to adjust and then press OK. Settings available for the
 selected item then appear. For example, if you select the Image Quality
 item from the Shooting menu, as shown on the left in Figure 1-12, and
 press OK, the available Image Quality options appear, as shown on the
 right in the figure. Repeat the old up-and-down scroll routine until the
 choice you prefer is highlighted. Then press OK to return to the previous
 screen.

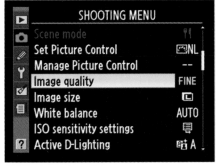

Figure 1-12: Select the option you prefer and press OK again to return to the active menu.

In some cases, you may see a right-pointing arrowhead instead of the OK symbol next to an option. That's your cue to press the Multi Selector right to display a submenu or other list of options (although, most of the time, you also can just press the OK button if you prefer).

Figure 1-13: The Recent Settings menu offers quick access to the last 20 menu options you selected.

✏ **To quickly access your 20 most recent menu items or create a custom menu:** The sixth menu is actually two menus bundled into one. The Recent Settings menu, shown in Figure 1-13, provides a list of the 20 menu items you ordered most recently. So if you want to adjust those settings, you don't have to wade through all the other menus looking for them — just head to this menu instead.

Through the Choose Tab option at the bottom of the menu (not shown in the figure), you can switch to the My Menu screen. From there, you can create your own custom menu that contains your favorite options. Chapter 11 details the steps involved in making and using your menu. The My Menu screen also contains a Choose Tab option so that you can switch back to the Recent Settings menu at any time.

The menu icon changes depending on which of these two functions is active; Table 1-1 shows both icons.

Monitoring Shooting Settings

Your D5000 gives you the following ways to monitor the most critical picture-taking settings.

✏ **Shooting Information display:** If your eyesight is like mine, reading the tiny type in the viewfinder is a tad difficult. Fortunately, you also can press the Info button to display the Shooting Information screen on the monitor. Press the Info button to display the screen; press again to turn it off.

As shown in Figure 1-14, the Shooting Information screen displays the current shooting settings at a size that's a little easier on the eyes and also provides more detailed data than the viewfinder. If you rotate the camera to compose a portrait shot (the image is taller than it is wide), the Shooting Information display rotates as well. The default display shows white text on black, as shown here. See the section "Customizing

shooting and display options" for information on how to switch to a different display style.

After you display the Shooting Information screen, press the Information Edit button on the back of the camera to switch the display to Quick Settings mode. Or, if you find it easier, just press the Information Edit button twice; your first press brings up the Shooting Information screen, and the second takes you to Quick Settings mode. Either way, you then can quickly access a variety of camera settings, represented by the icons at the right side and bottom of the screen. Press the Multi Selector left or right to high-light the icon for the setting you want to adjust — a little label appears at the top of the screen to tell you what each icon means, as shown in Figure 1-15. Press OK to jump directly to the menu where you can change the setting.

✔ **Viewfinder:** You can view some camera settings in the viewfinder as well. For example, the data in Figure 1-16 shows the current shutter speed, f-stop, ISO setting, and number of shots remaining. The exact viewfinder informa-tion that appears depends on what action you're currently undertaking.

If what you see in Figures 1-14 through 1-16 looks like a big confusing mess, don't worry. Many of the settings relate to options that won't mean any-thing to you until you make your way through later chapters and explore the advanced exposure modes. But do make note of the following two key points of data that are helpful even when you shoot in the fully automatic modes:

Battery status indicator

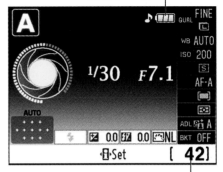

Shots remaining

Figure 1-14: Press the Info button to view picture-taking settings on the monitor.

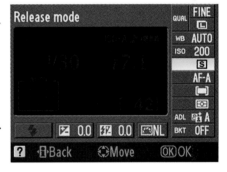

Figure 1-15: Press the Information Edit button to shift from the Shooting Information screen to the Quick Settings display.

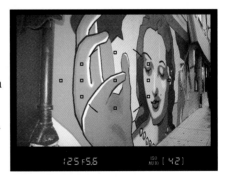

Figure 1-16: You also can view some camera information at the bottom of the viewfinder.

✏ **Battery status indicator:** A full battery icon like the one in Figure 1-14 shows that the battery is fully charged; if the icon appears empty, go look for your battery charger.

Your viewfinder also displays a tiny low-battery icon when things get to the dangerous point. It appears in the lower-left corner of the framing screen (that is, not on the row of camera-settings data, but actually in the image area).

✏ **Pictures remaining:** Labeled in Figure 1-14 and also visible in the viewfinder in Figure 1-16, this value (42, in the figures) indicates how many additional pictures you can store on the current memory card. If the number exceeds 999, the value is presented a little differently. The initial K appears above the value to indicate that the first value represents the picture count in thousands. For example, 1.0K means that you can store 1,000 more pictures (*K* being a universally accepted symbol indicating 1,000 units). The number is then rounded down to the nearest hundred. So if the card has room for, say, 1,230 more pictures, the value reads as 1.2K.

Asking Your Camera for Help

 If you see a small question mark in the lower-left corner of a menu, press and hold the Zoom Out button — note the question-mark label above the button — to display information about the current shooting mode or selected menu option. For example, Figure 1-17 shows the Help screen associated with the ISO setting. If you need to scroll the screen to view all the Help text, keep the button depressed and scroll by using the Multi Selector. Release the button to close the information screen.

> **?** ISO sensitivity
>
> **ISO sensitivity:** Choose ISO sensitivity. Choosing higher values allows faster shutter speeds to be used to achieve optimal exposure with a given subject at a given aperture, making higher values suited to taking pictures of moving subjects or shooting under low light.

Figure 1-17: Press and hold the Zoom Out button to display onscreen help.

A blinking question mark in the viewfinder or Shooting Information screen indicates that the camera wants to alert you to a problem. Again, press the Zoom Out button to see what solution the camera suggests.

Reviewing Basic Setup Options

Your camera offers scads of options for customizing its performance. Later chapters explain settings related to actual picture taking, such as those that affect flash behavior and autofocusing. The rest of this chapter details options related to initial camera setup, such as setting the date and time, adjusting monitor brightness, and the like.

Cruising the Setup menu

Start your camera customization by opening the Setup menu. It's the menu marked with the little wrench icon, as shown on the left in Figure 1-18. Scroll down the menu using the Multi Selector to display the second screen of the menu, shown on the right.

Figure 1-18: Visit the Setup menu to start customizing your camera.

Here's a quick rundown of each menu item:

- ✔ **Format Memory Card:** You can use this command to format your memory card, which wipes all data off the card and ensures that it's properly set up to record pictures. See the earlier section "Working with Memory Cards" for more details about formatting.

- ✔ **LCD Brightness:** This option enables you to make the camera monitor brighter or darker. If you take this step, keep in mind that what you see on the display may not be an accurate rendition of the actual exposure of your image. Crank up the monitor brightness, for example, and an underexposed photo may look just fine. So I recommend that you keep the brightness at the default setting (0). A second option on this menu, Auto Dim, causes the screen to dim gradually (to save battery power) when the Shooting Information screen is displayed. The feature is turned on by default.

- ✔ **Info Display Format:** You can use this command to choose the type of graphic and color used to display basic camera settings. You can save different choices for Auto/Scene modes and P, S, A, and M modes. Your choices are Classic and Graphic (the default, shown in this book). You can display Classic with a Blue, Black, or Orange background, or you can display Graphic with a Green, Black, or Brown background.

- ✔ **Auto Information Display:** As with the Info Display Format, you can set this option separately for the Auto/Scene modes and the advanced modes (P, S, M, and A). When you enable this option, the shooting information is displayed when you press the shutter button halfway, and, if

you disable Image Review (an option covered in Chapter 4), after you take a picture. When this option is set to Off, you can press the Info button to display the Shooting Information screen.

✔ **Info Wrap-Around:** When you enable this option, the cursor wraps around from one side of the screen to the other when you are changing settings using the Quick Settings screen. That is, if you press the Multi Selector to move the cursor to the setting at the top-right corner of the screen, an additional press right takes the cursor around the horn to the setting at the lower-left corner. With the default option (Off), you're instead stopped dead in your tracks when you reach the boundary of the screen.

✔ **Clean Image Sensor:** Your D5000 is set up at the factory to perform an internal cleaning routine each time you turn the camera on or off. This cleaning system is designed to keep the image sensor — that's the part of the camera that actually captures the image — free of dust and dirt.

By choosing the Clean Image Sensor command, you can perform a cleaning at any time, however. Just choose the command, press OK, select Clean Now, and press OK again. The other option with this command specifies whether the camera performs automatic cleaning only at startup, only at shutdown, or never. To change the way the camera sensor is cleaned, select Clean At Startup/Shutdown instead of Clean Now. Then press the Multi Selector right, highlight the cleaning option you prefer, and press OK.

✔ **Lock Mirror Up for Cleaning:** This feature is necessary when cleaning the camera interior — an operation that I don't recommend that you tackle yourself because you can easily damage the camera if you don't know what you're doing. And if you've used mirror lock-up on a film camera to avoid camera shake when shooting long-exposure images, note that in this case, the lock-up feature is provided for cleaning purposes only. You can't take pictures on the D5000 while the mirror lock-up option is enabled.

✔ **Video Mode:** This option is related to viewing your images on a television, a topic I cover in Chapter 9. Select NTSC if you live in North America or other countries that adhere to the NTSC video standard; select PAL for playback in areas that follow that code of video conduct.

✔ **HDMI:** See Chapter 9 for information about this setting, which relates to options involved with connecting your camera to an HDMI device.

✔ **Time Zone and Date:** When you turn on your camera for the very first time, it automatically displays this option and asks you to set the current date and time. Keeping the date/time accurate is important because that information is recorded as part of the image file. In your photo browser, you can then see when you shot an image and, equally handy, search for images by the date they were taken.

✔ **Language:** You're asked to specify a language along with the date and time when you fire up your camera for the first time. Your choice determines the language of text on the camera monitor. Screens in this book display the English language, but I find it entertaining on occasion to hand my camera to a friend after changing the language to, say, Swedish. I'm a real yokester, yah?

✔ **Image Comment:** See Chapter 11 to find out how to use this feature, which enables you to add text comments into a picture file. You then can read that information in Nikon ViewNX, the software that shipped with your camera. (The text doesn't actually appear on the image itself.)

✔ **Auto Image Rotation:** Keep this option set at the default setting (On) so that the image is automatically rotated to the correct orientation (horizontal or vertical) in playback mode. The orientation is recorded as part of the image file, too, so the auto-rotating also occurs when you browse your image thumbnails in ViewNX. *Note:* The rotation data may not be accurate for pictures that you take with the camera pointing directly up or down. See Chapter 4 for more about picture playback. Also, when you shoot pictures in burst mode, the first image of the sequence is used as the basis for rotation, even if you rotate the camera while shooting the sequence.

✔ **Image Dust Off Ref Photo:** This specialty feature enables you to record an image that serves as a point of reference for the automatic dust-removal filter available in Nikon Capture NX 2. I don't cover this accessory software, which must be purchased separately, in this book.

✔ **GPS:** If you purchase the optional Nikon GPS tracking unit for your camera, this menu item holds settings related to its operation. This book doesn't cover this accessory, but the manual that comes with the unit explains everything you need to know about using it.

✔ **Eye-Fi Upload:** This menu item (not shown in Figure 1-18) appears only if you install an Eye-Fi memory card, a special type of card that enables you to send your pictures over a wireless network to your computer. Unfortunately, Eye-Fi cards are significantly more expensive than regular cards — about $50 for a 2MB card. But if you do use the cards and you find yourself in a situation where wireless devices are not allowed, choose Disable from the Eye-Fi Upload menu to shut off the signal. For the whole story on Eye-Fi, including help with setting up your wireless transfers, visit the company's Web site at www.eye.fi.

✔ **Firmware Version:** Select this option and press OK to view what version of the camera *firmware,* or internal software, your camera is running. You see three separate firmware items, A, B, and L. At the time this book was written, A and B were version 1.00 and L was version 1.001.

Keeping your camera firmware up-to-date is important, so visit the Nikon Web site (www.nikon.com) regularly to find out whether your camera sports the latest version. You can find detailed instructions on how to download and install any firmware updates on the site.

Browsing the Custom Setting menu

Displaying the Custom Setting menu, whose icon is a little pencil, takes you to the screen shown in Figure 1-19. Here you can access six submenus that carry the labels A through F. Each of the submenus holds clusters of options related to a specific aspect of the camera's operation. Highlight a submenu and press OK to get to those actions, as shown in Figure 1-20.

In the Nikon manual, instructions sometimes reference these settings by a menu letter and number. For example, "Custom Setting a1" refers

Figure 1-19: The Custom Setting menu contains six submenus (A through F).

to the first option on the Autofocus submenu. I try to be more specific in this book, however, so I use the actual setting names. (Really, we've all got enough numbers to remember, don't you think?)

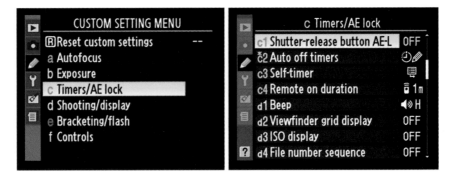

Figure 1-20: Highlight a submenu and press OK again to access the available settings.

With that clarification out of the way, the following sections describe only the customization options related to basic camera operations. Turn to the index for help locating information about other Custom Setting options.

Adjusting auto off timers

To help save battery power, your camera automatically shuts off the monitor, viewfinder, and the exposure metering system if you don't perform any camera operations for a period of time. Through the Auto Off Timers menu option, you can specify how long you want the camera to wait before taking that step. Open the Custom Setting menu, choose Timers/AE Lock, and press

OK. Then highlight Auto Off Timers, as shown on the left in Figure 1-21. Press OK to display the second screen in the figure. Here, you can select from three prefab timing settings, Short, Normal, and Long. If none of those settings works well for you, choose Custom, which enables you to customize the shut-off timing for playback and menu display, image review, and metering independently. If you go this route, be sure to highlight Done and press OK after changing the settings, or your changes don't "stick."

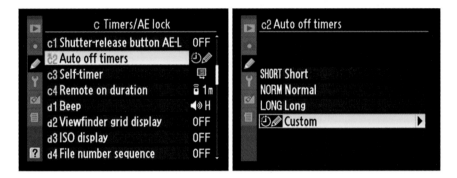

Figure 1-21: Visit the Timers/AE Lock submenu to adjust the timing of automatic monitor, viewfinder, and metering shut-off.

Customizing shooting and display options

Visit the Shooting/Display submenu (see Figure 1-22) of the Custom Setting menu to tweak various aspects of how the camera communicates with you, as well as to control a couple of basic shooting functions. Check out the following options:

✔ **Beep:** By default, your camera beeps at you after certain operations, such as after it sets focus when you shoot in autofocus mode. If you're doing top-secret surveillance work and need the camera to hush up, set this option to Off. On the Shooting Information Display, a little musical note icon appears when the beep is enabled. Turn the beep off, and the icon appears in a circle with a slash through it. You can also control the volume of the beep. Your choices are High (the default) and Low. *Tres* cool.

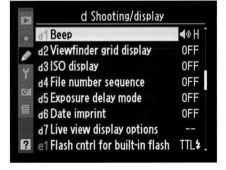

Figure 1-22: Customize your shooting and display options from this menu.

✔ **Viewfinder Grid Display:** You can display tiny gridlines in the viewfinder by setting this option to On. The gridlines are a great help when you need to ensure the alignment of objects in your photo — for example, to make sure that the horizon is level in a landscape.

✔ **ISO Display:** Normally, the Shooting Information display and viewfinder indicate how many shots will fit in the remaining space on your memory card. But if you prefer, you can use this display space to instead show the current ISO setting. See Chapter 5 for the complete story on this option.

✔ **File Number Sequence:** This option controls how the camera names your picture files. When the option is set to Off, as it is by default, the camera restarts file numbering at 0001 every time you format your memory card or insert a new memory card. Numbering is also restarted if you create custom folders (an advanced option covered in Chapter 11).

Needless to say, this setup can cause problems over time, creating a scenario where you wind up with multiple images that have the same filename — not on the current memory card, but when you download images to your computer. So I strongly encourage you to set the option to On. Note that when you get to picture number 9999, file numbering is still reset to 0001, however. The camera automatically creates a new folder to hold for your next 9999 images.

As for the Reset option, it enables you to assign the first file number (which ends in 0001) to the next picture you shoot. Then the camera behaves as if you selected the On setting.

Should you be a really, really prolific shooter and snap enough pictures to reach image 9999 in folder 999, the camera will refuse to take another photo until you choose that Reset option and either format the memory card or insert a brand new one.

✔ **Exposure Delay Mode:** If you turn this option on, the camera waits to record your picture until about one second after you press and release the shutter button. What's the point? Well, a tiny mirror inside the camera moves every time you press the shutter button to take a picture. For shots that require a long exposure time, there is a slight chance that the vibration caused by that mirror movement will blur the picture. So by delaying the actual image capture a little, the odds of that mirror-related blur are lessened. For normal shooting, leave this one at its default setting, Off. And check out Chapter 2 for information on using the camera's self-timer function as an alternative option when you want to delay the shutter release.

✔ **Date Imprint:** Through this option, you can choose to imprint the shooting date, date and time, or the number of days that have passed since you took the photo.

The default setting, which disables the imprint, is the best way to go, however; you don't need to permanently mar your photos to find out when you took them. Every picture file includes a hidden vat of text data, called *metadata,* that records the shooting date and time, as well as all the camera settings you used — f-stop, shutter speed, and lots more. You can view this data in the free software provided with your camera as well as in many photo programs. Chapter 8 shows you how.

✔ **Live View Display Options:** Use these settings to control the screen appearance when you use Live View. Chapter 4 tells all.

Preventing shooting without a memory card

If you explore the Controls submenu of the Custom Setting menu, you find an option called No Memory Card. Keep this one set at the default (Release Locked), which disables the shutter button when no memory card is in the camera. If you set it to Enable Release, you can take a temporary picture, which appears in the monitor with the word "Demo" but isn't recorded anywhere. (The feature is provided mainly for use in camera stores, enabling salespeople to demonstrate the camera without having to keep a memory card installed.)

Customizing external controls

The Controls submenu also enables you to change the function of the AE-L/AF-L button and the Function button. Chapter 11 provides details, but while you're working with this book, leave both options at their default settings so that things operate as I describe. For the record, the AE-L/AF-L default setting is AE/AF Lock; the Function button default is the Self Timer option.

This same submenu also offers two "Reverse" options: Reverse Dial Rotation and Reverse Indicators. The first one reverses the direction in which you rotate the Command dial to change camera settings; the second reverses the orientation of the exposure meter, a feature covered in Chapter 5. Again, leave both settings at their defaults unless you want to be terribly confused when you read instructions here and in the camera manual. (Set Reverse Dial Rotation to Off; select the Reverse Indicators option that puts the plus sign on the left side of the meter.)

Restoring default settings

You can quickly reset all the Custom Setting menu options to their original, factory default settings by choosing the Reset command at the top of the menu. (Refer to Figure 1-19.) Press OK to display a confirmation screen that asks whether you really want to go forward with the reset; highlight Yes and press OK again.

To restore critical picture-taking settings *without* affecting options on the Custom Setting menu, you can instead use the so-called *two-button reset* method: Press and hold the Info button and the Information Edit button simultaneously for longer than two seconds. (The little green dots near the buttons are a reminder of this function.)

One fly in the ointment to remember — and it's a pretty big, ugly, hairy fly: After you restore the camera defaults, be sure that you also revisit the File Number Sequence option on the Shooting/Display submenu of the Custom Setting menu. The default setting, Off, is Not a Good Thing; turn the option On to avoid file-number confusion. See the earlier section "Customizing shooting and display options" for details. (You don't have to take this step if you use the two-button reset method of restoring defaults.)

Taking Great Pictures, Automatically

Are you old enough to remember the Certs television commercials from the 1960s and '70s? "It's a candy mint!" declared one actor. "It's a breath mint!" argued another. Then a narrator declared the debate a tie and spoke the famous catchphrase: "It's two, two, two mints in one!"

Well, that's sort of how I see the Nikon D5000. On one hand, it provides a full range of powerful controls, offering just about every feature a serious photographer could want. On the other, it offers automated photography modes that enable people with absolutely no experience to capture beautiful images. "It's a sophisticated photographic tool!" "It's as easy as 'point and shoot!'" "It's two, two, two cameras in one!"

Now, my guess is that you bought this book for help with your camera's advanced side, so that's what other chapters cover. This chapter, however, is devoted to your camera's simpler side. Because even when you shoot in automatic exposure and focus modes, following a few basic guidelines can help you get better results. For example,

your camera offers a variety of automatic exposure modes, some of which may be new to you. The mode affects the look of your pictures, so this chapter explains those options. In addition, this chapter reviews flash options available to you in automatic modes and covers techniques that enable you to get the best performance from your camera's autofocus and autoexposure systems.

Note that this chapter covers normal, through-the-viewfinder still photography. For help with shooting in Live View mode, where you compose pictures using the monitor instead of the viewfinder, or shooting movies, visit the end of Chapter 4.

Getting Good Point-and-Shoot Results

Your D5000 offers several automatic photography modes, all of which I explain later in this chapter. But in any of those modes, the key to good photos is to follow a specific picture-taking technique.

 To try it out, set the Mode dial on top of the camera to Auto, as shown in the left image in Figure 2-1. Then set the focusing switch on the lens to the A (autofocus) position, as shown in the right image in Figure 2-1. The figure and these instructions assume that you're using the *kit lens* — the Nikkor 18–55mm AF-S lens bundled with the D5000. If you use some other lens, see Chapter 1 for information about autofocusing and manual focusing.

Auto/Manual focus switch

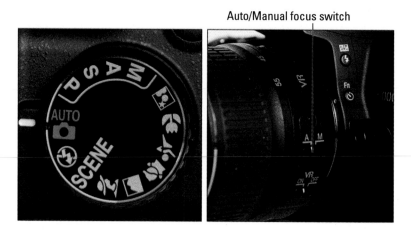

Figure 2-1: Choose these settings for fully automatic exposure and focus.

Unless you are using a tripod, also set the VR (vibration reduction) switch to the On setting, as shown in Figure 2-1. This feature is designed to produce sharper images by compensating for camera movement that can occur when you handhold the camera. Again, Figure 2-1 features a Nikon VR lens; for other lenses, check your lens manual for details about using its vibration reduction feature, if provided.

Your camera is now set up to work in the most automatic of automatic modes. Follow these steps to take the picture:

1. **Looking through the viewfinder, frame the image so that your subject appears under one of the 11 focusing points, as shown in Figure 2-2.**

 The focusing points are those tiny rectangles you see clustered near the center of viewfinder. I labeled one of the little guys in the figure.

2. **Press and hold the shutter button halfway down.**

 The camera's autofocus system begins to do its thing. In dim light, a little lamp located on the front of the camera, just to the left of the shutter button, may shoot out a beam of light. That lamp, called the *autofocus-assist illuminator,* or *AF-Assist lamp* for short, helps the camera measure the distance between your subject and the lens so that it can better establish focus.

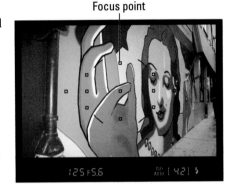

Figure 2-2: The small rectangles in the viewfinder indicate autofocus points.

At the same time, the autoexposure meter analyzes the light and selects initial aperture (f-stop) and shutter speed settings, which are two critical exposure controls. These two settings appear in the viewfinder; in Figure 2-2, the shutter speed is 1/125 second, and the f-stop is f/5.6. (Chapter 5 explains these two options in detail.) The built-in flash may pop up if the camera thinks additional light is needed.

When the camera has established focus, one or more of the points appears surrounded by black brackets, as shown in Figure 2-3. The focusing points that are hugged by those rectangles represent the areas of the frame that are now in focus. In the display at the bottom of the viewfinder, the green focus lamp, labeled in the figure, lights to give you further notice that focus has been achieved.

The autoexposure meter continues monitoring the light up to the time you take the picture, so the f-stop and shutter speed values in the viewfinder may change if the lighting conditions change.

3. Press the shutter button the rest of the way down to record the image.

While the camera sends the image data to the camera memory card, the memory card access lamp lights, as shown in Figure 2-4. Don't turn off the camera or remove the memory card while the lamp is lit, or you may damage both camera and card.

When the recording process is finished, the picture appears briefly on the camera monitor. I'm assuming you have the monitor open. If you haven't opened the monitor yet, see Chapter 4. If the picture doesn't appear or you want to take a longer look at the image, Chapter 4 covers that issue as well.

Selected focus points

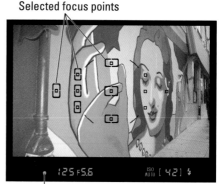

Focus lamp

Figure 2-3: The green light indicates that the camera has locked focus on the objects under the bracketed focusing points.

I need to add a few important points about working in the Auto mode and the other point-and-shoot modes covered in this chapter:

- ✓ **Release mode options:** The steps here assume that you are using the default Release mode, in which the camera records a single image with each press of the shutter button. For a look at other options — continuous (burst mode) shooting, self-timer shooting, and remote-control shooting — see the section, "Changing the (Shutter Button) Release Mode," later in this chapter.

- ✓ **Flash options:** Whether you can use flash and which flash modes are available depend on the automatic exposure mode you use. See the next section for details.

- ✓ **Autofocus options:** Assuming that your lens can autofocus with the D5000, you can choose to focus manually or take advantage of autofocusing in any exposure mode. If you go the autofocus route, you can customize the behavior of the autofocus system through options discussed in Chapter 6. Instructions in this chapter assume that you stick with the default autofocus options.

But understand that in some cases, no amount of fiddling with the autofocus settings will help your camera lock focus where you intend. Some subjects just give autofocusing systems fits: Highly reflective objects, subjects behind fence bars, and scenes in which little contrast exists between the subject and the background are just a few potential problem areas.

My advice? If the autofocus mechanism can't lock onto your subject after a few seconds, just switch to manual focusing and be done with it. See Chapter 1 for a primer in manual focusing.

✓ **Exposure problems:** If an exposure meter blinks in the viewfinder or Shooting Information display, the camera can't select settings that will properly expose the picture. A blinking flash symbol tells you that the camera suggests using flash. See Chapter 5 for details about reading the exposure meter and coping with exposure problems; see the next section for an introduction to using flash.

Using Flash in Automatic Exposure Modes

The built-in flash on your D5000 offers a variety of different modes. Table 2-1 offers a quick-reference guide to the six basic modes. In addition to these basic modes, the camera also offers some combo modes, such as Auto with Red-Eye Reduction, Slow Sync with Red-Eye Reduction, and the like.

More focus factors to consider

When you focus the lens, either in autofocus or manual focus mode, you determine only the point of sharpest focus. The distance to which that sharp-focus zone extends from that point — what photographers call the *depth of field* — depends in part on the *aperture setting,* or *f-stop,* which is an exposure control. Some of the D5000's Digital Vari-Program autoexposure modes are designed to choose aperture settings that deliver a certain depth of field.

The Portrait setting, for example, uses an aperture setting that shortens the depth of field so that background objects are softly focused — an artistic choice that most people prefer for portraits. On the flip side of the coin, the Landscape setting selects an aperture that produces a large depth of field so that both foreground and background objects appear tack sharp.

Another exposure-related control, *shutter speed,* plays a focus role when you photograph moving objects. Moving objects appear blurry at slow shutter speeds; at fast shutter speeds, they appear sharply focused. On your D5000, the camera chooses a fast shutter speed in Sports shooting mode.

A fast shutter speed can also help safeguard against allover blurring that results when the camera is moved during the exposure. The faster the shutter speed, the shorter the exposure time, which reduces the time that you need to keep the camera absolutely still. If you're using the Nikon D5000 kit lens, you can also improve your odds of shake-free shots by enabling the vibration reduction (VR) feature. (Set the switch on the lens to the On position.) For a very slow shutter speed, using a tripod is the best way to avoid camera shake; be sure to turn the VR *off* when you do so.

Keep in mind, too, that the range of f-stops and shutter speeds the camera can select in any of the automatic exposure modes depends on the lighting conditions. When you're shooting at night, for example, the camera may not be able to select a shutter speed fast enough to stop action even in Sports mode.

If you want to manipulate focus and depth of field to a greater extent than the automated exposure modes allow, visit Chapter 6. For an explanation of the role of shutter speed and aperture in exposure, check out Chapter 5.

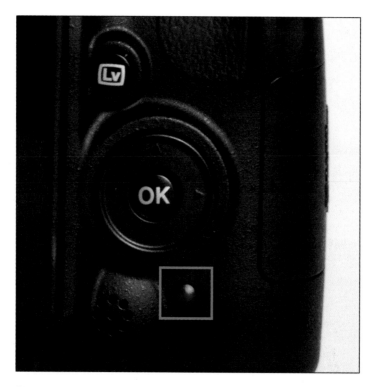

Figure 2-4: The memory card access lamp lights while the camera sends the picture data to the card.

Table 2-1		Flash Mode Quick-Reference Guide
Symbol	*Flash Mode*	*What It Does*
⚡AUTO	Auto	Fires the flash automatically if the camera thinks the ambient light is insufficient or the subject is backlit
⚡	Fill	Fires the flash regardless of the ambient light
🚫	Off	Disables the flash
⚡👁	Red-Eye Reduction	AF-assist lamp lights briefly before the flash goes off to help reduce red-eye reflections

Symbol	Flash Mode	What It Does
⚡ SLOW	Slow Sync	Results in a longer-than-normal exposure time so that the background is illuminated by ambient light and the foreground is lit by the flash
⚡ REAR	Rear-Curtain Sync	Causes illuminated, moving objects (such as car head lamps) to appear as long, trailing fingers of light

You can check the current flash mode in the Shooting Information display, as shown on the left in Figure 2-5. The viewfinder display doesn't advise you of the specific flash mode but instead just displays the universal lightning bolt icon when the flash is enabled, as shown in Figure 2-3, and hides the icon when the flash is disabled. If you disable the flash and the camera thinks you're making a mistake, the flash symbol blinks in both displays.

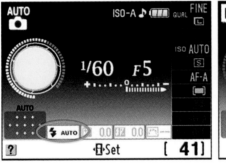 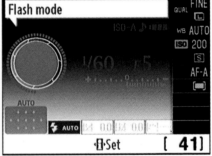

Figure 2-5: Look here to check flash status.

 To change the flash mode, press and hold the Flash button to display the screen you see on the right in Figure 2-5. Keep holding the button as you rotate the Command dial to cycle through the flash modes available for your selected exposure mode.

You can also change the flash mode by using the Quick Settings screen. After highlighting the Flash Mode icon, as shown on the left in Figure 2-6, press OK to display the right screen in the figure. Highlight your choice and press OK.

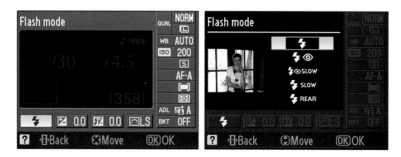

Figure 2-6: You also can change the flash mode by using the Quick Settings screen.

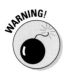

Now for the bad news: When you do try to change the flash mode, you'll quickly discover that you have access to only a couple of flash modes when you shoot in the automatic exposure modes covered in this chapter. Additionally, you don't have access to flash compensation, which enables you to diminish or strengthen the burst of light the flash produces, as well as a few other flash features your camera offers. Bummer, as the youngsters say.

The upcoming sections tell you which flash modes are available in each of the fully automatic exposure modes. For more details about flash photography, see Chapter 5.

Exploring Your Automatic Exposure Options

You can choose from eight fully automatic exposure modes, plus a Scene mode that expands your shooting options from the camera menus. You can access all of the automatic modes, plus the Scene mode, via the Mode dial on the top of the camera, shown in Figure 2-7.

The next sections provide details on each of these options. For information about the four other settings on the Mode dial — P (programmed autoexposure), S (shutter-priority autoexposure), A (aperture-priority autoexposure), and M (manual exposure) — see Chapter 5.

Remember that in any of these exposure modes, you have the option to focus manually or take advantage of autofocusing, assuming that your lens is capable of autofocusing with the D5000. (See Chapter 1 for details on that issue.)

Auto mode

 In Auto mode, represented on the Mode dial by the icon you see in the margin here, the camera selects all settings based on the scene that it detects in front of the lens. Your only job is to lock in focus, either by using the auto-focus technique that I outline at the beginning of the chapter or by using the manual-focusing method explained in Chapter 1.

Auto mode

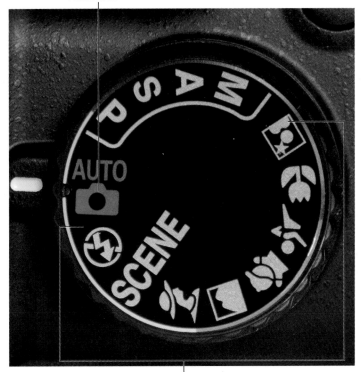

Digital Vari-Program modes

Figure 2-7: You can select from eight fully automatic, point-and-shoot photography modes, and a Scene mode.

Auto mode is great for casual, quick snapshooting. But keep these details in mind:

✓ **Autofocusing:** At the default settings, autofocusing works like so:

- **AF-area mode:** The Auto Area option is selected by default. That means that the camera analyzes the scene and then selects which of the 11 autofocus points to use when establishing focus. Chapter 6 explains how to modify this autofocusing behavior.

- **Focus mode:** The default setting is AF-A. If the subject isn't moving, focus remains locked as long as you hold the shutter button halfway down. But if the camera detects motion, it continually adjusts focus up to the time you press the button fully to record the picture. To ensure that focus is correct, you must keep your subject within the area of the viewfinder covered by the focusing points. You can't alter this aspect of the focusing system in Auto mode as you can in the advanced exposure modes. Your only other option is to switch to manual focusing. See the Chapter 6 section related to the Focus mode option for details.

What does [r 12] in the viewfinder mean?

When you look in your viewfinder to frame a shot, the initial value shown in brackets at the right end of the viewfinder display indicates the number of additional pictures that can fit on your memory card at the currently selected Image Size and Image Quality settings. (Chapter 3 explains those settings.) For example, in the left viewfinder image below, the value shows that the card can hold 612 more images.

As soon as you press the shutter button halfway, which kicks the autofocus and exposure mechanisms into action, that value changes to instead show you how many pictures can fit in the camera's *memory buffer.* In the right image here, for example, the r 12 value tells you that 12 pictures can fit in the buffer. This number also varies depending on the size and quality settings you use. (The dot at the left end of the display is the focus lamp, which lights when focus is achieved.)

So what's the *buffer?* It's a temporary storage tank where the camera stores picture data until it has time to fully record that data onto the camera memory card. This system exists so that you can take a continuous series of pictures without having to wait between shots until each image is fully written to the memory card.

When the buffer is full, the camera automatically disables the shutter button until it catches up on its recording work. Chances are, though, that you'll very rarely, if ever, encounter this situation; the camera is usually more than capable of keeping up with your shooting rate.

For more information about rapid-fire photography, see the section on action photography in Chapter 7. And for help translating all the other viewfinder information, check out Chapters 5 and 6.

```
125  F5.6        ISO     [612]
                 AUTO
```

```
●  125  F5.6     ISO     [r 12]
                 AUTO
```

✔ **Flash:** You have only three flash mode choices: Auto, Auto with Red-Eye Reduction, and Off. (See Table 2-1 for a reminder of what these modes do.) You can't enable the flash if the camera's autoexposure meter doesn't sense that additional light is needed.

✔ **Color:** You can't adjust color. If the image displays a *color cast* (white objects in the scene are not pure white in the image), you must switch to a mode that enables you to adjust the White Balance setting, covered in Chapter 6.

✔ **Exposure:** You have access to only one exposure-adjustment option, ISO Sensitivity. This setting determines the light sensitivity of the camera — or, to put it another way, how much light is needed to properly expose the image. By default, this option is set to Auto, and the camera adjusts the ISO Sensitivity as needed. For more information about how ISO affects your pictures — and why you may want to select a specific ISO setting — visit Chapter 5.

I purposely didn't include an example of a photo taken in Auto mode because, frankly, the results that this setting creates vary widely depending on how well the camera detects whether you're trying to shoot a portrait, landscape, action shot, or whatever, as well as on lighting conditions. But the bottom line is that full auto is a one-size-fits-all approach that may or may not take best advantage of your camera's capabilities. So if you want to more consistently take great pictures instead of merely good ones, I encourage you to explore the exposure, focus, and color information found in Part II so that you can abandon this mode in favor of modes that put more photographic decisions in your hands.

Digital Vari-Program modes

In Auto mode, the camera tries to figure out what type of picture you want to take by assessing what it sees through the lens. If you don't want to rely on the camera to make that judgment, your D5000 offers seven *Digital Vari-Program modes,* which are designed to automatically capture specific scenes in ways that are traditionally considered best from a creative standpoint. For example, most people prefer portraits that have softly focused backgrounds. So in Portrait mode, the camera selects settings that can produce that type of background.

All the Digital Vari-Program modes share a few limitations:

✔ **Exposure:** As with Auto mode, the camera takes complete control of exposure, with the exception of the ISO Sensitivity setting, introduced in the preceding section and detailed in Chapter 5.

- ✔ **Autofocusing:** You get the same choices as in Auto mode — that is, you can adjust the AF-Area mode option but not the Focus mode setting (except to choose MF for manual focusing). Chapter 6 details both features.

- ✔ **Color:** You can't tweak color, either. Some modes manipulate colors in ways that you may or may not appreciate, and you're stuck if you have a color cast problem.

- ✔ **Flash:** Available flash options vary depending on the Digital Vari-Program mode you select, but none of the modes offers complete flash flexibility.

In the next sections, you can read about the unique features of each of the Digital Vari-Program modes. To see whether you approve of how your camera approaches the different scenes, take some test shots. If you aren't happy with the results, you can switch to one of the advanced exposure modes (P, S, A, or M) and then check out Chapters 5–7 to find out how to manipulate whatever aspect of the picture isn't to your liking.

For details about the additional automatic modes that you can access by setting the Mode dial to the Scene setting, check out the section "Scene mode," later in this chapter.

Auto Flash Off mode

 The Auto Flash Off mode delivers the same results as Auto mode but ensures that the flash doesn't fire. In other words, think of this mode as a faster alternative to selecting Auto mode and then changing the flash setting to Off. From a practical standpoint, this mode provides an easy way to ensure that you don't break the rules when shooting in locations that don't permit flash: museums, churches, and so on.

Portrait and Child modes

The Portrait and Child modes are so closely related that it makes sense to consider them together.

 First, Portrait mode. This mode selects an aperture setting designed to produce a short depth of field, which results in a slightly blurry background and thus puts the visual emphasis on your subject. Figure 2-8 offers an example. However, this effect occurs only if your subject is at least a few feet from the background. The extent to which the background blurs also depends on the other depth-of-field factors that I discuss in Chapter 6. Portrait mode also selects settings designed to produce natural skin tones.

 Child mode, represented by the toddler icon you see in the margin here, offers a slight variation on the theme. It differs from Portrait mode in a couple of ways:

✔ In Child mode, the camera renders hues that are traditionally found in clothing and backgrounds more boldly than in Portrait mode. In Figure 2-9, for example, notice that the football and the little boy's shorts are noticeably more vivid than in the portrait example in Figure 2-8. Skin tones are left natural, although they, too, can appear a little more saturated, depending on the subject and the lighting.

✔ Child mode chooses an aperture setting that's designed to produce a slightly larger depth of field than Portrait mode. That extra depth of field can come in handy if the children in question are moving a little because they're more likely to remain within the zone of sharp focus. However, in order to balance out the change in aperture, Child mode must use a slightly slower shutter speed than Portrait. So for subjects that are really on the move, you typically have better results with Sports mode, which favors a faster shutter, to freeze action, over depth-of-field considerations.

Understand that the aperture and shutter speed the camera selects in either mode depend greatly on the available light, the subject, and the range of aperture settings on your lens. Your mileage may vary, as they say. Sometimes you may see very little difference between the two modes except for the more-vivid background colors of Child mode.

Both modes have these traits in common:

✔ **Autofocusing:** Autofocusing works as it does for Auto mode, described earlier in this chapter.

Portrait mode

Figure 2-8: Portrait mode produces a softly focused background and natural skin tones.

Child mode

Figure 2-9: Child mode renders non-skin tones more vividly than Portrait mode.

 ✔ **Flash:** You can choose from Auto, Auto with Red-Eye Reduction flash, or Off. You can't enable the flash, though, if the camera doesn't think extra lighting is needed. This restriction can be problematic when shooting outdoor portraits, which often benefit from a small pop of flash light even in bright sunlight. See Chapter 7 for an example as well as some other tips on shooting portraits by flash light.

In my experience, the biggest decision about whether to use Portrait or Child mode depends on your color preferences. I prefer Portrait mode because the strengthened background colors in Child mode can easily distract the eye from the subject's face, which should be the point of emphasis in any portrait.

Landscape mode

 Whereas Portrait mode aims for a very shallow depth of field (small zone of sharp focus), Landscape mode, which is designed for capturing scenic vistas, city skylines, and other large-scale subjects, goes the other route, selecting an aperture setting (f-stop) that produces a large depth of field. As a result, objects both close to the camera and at a distance appear sharply focused. Figure 2-10 offers an example. In this picture, focus was set on the palm tree in the foreground. Notice that the palm trees on the right side of the image are in sharp focus as well.

Landscape mode

Doug Sahlin

Figure 2-10: Landscape mode produces a large zone of sharp focus and also boosts color intensity slightly.

Note these other factoids about Landscape mode:

✔ **Depth of field:** As with Portrait mode, the camera manipulates depth of field by adjusting the aperture setting (f-stop). To produce the larger depth of field, the camera tries to use a high f-stop value, which means a very small aperture. But in dim lighting, the camera may be forced to open the aperture to allow enough light into the camera to properly expose the photo, so the depth of field may not be enough to keep the entire landscape in sharp focus. (Again, Chapter 5 offers a primer on aperture; Chapter 6 fully explains depth of field.)

✔ **Color and contrast:** This mode boosts color saturation and contrast slightly to produce the kind of bold, rich hues that most people prefer in landscape pictures. In addition, greens and blues are emphasized. If you want more control, switch to an advanced exposure mode (P, S, A, or M) and see Chapter 6 for details.

✔ **Autofocusing:** By default, the camera uses the Single Point AF-Area mode setting. That means that it looks at only one autofocus point to establish focus rather than considering all 11. The center autofocus point is selected automatically, but you can use the Multi Selector to select a different focus point. The Focus mode is set to AF-A by default. The camera locks focus when you depress the shutter button halfway — unless it senses a moving subject, in which case focus is continually adjusted up to the time you take the shot. Your other Focus mode option is MF for manual focus. See Chapter 6 for help with all this autofocus stuff.

✔ **Flash:** The built-in flash is disabled, which is typically no big deal: Because of its limited range, a built-in flash is of little use when shooting most landscapes anyway. However, if you attach an external flash unit, you can use it in this mode. (Chapter 5 discusses external flash units.)

Sports mode

 Sports mode activates a number of settings that can help you photograph a moving object, whether it's an athlete, a race car, or a romping dog like the one in Figure 2-11. Here's what you need to know:

✔ **Shutter speed:** In order to catch a moving subject without blur, you need a fast shutter speed. So in Sports mode, the camera automatically chooses that fast shutter speed for you.

Understand, though, that in dim lighting, the camera may not be able to select a very fast shutter speed and still deliver a good exposure. And because getting a good exposure trumps all, the shutter speed the camera uses may not be fast enough to "freeze" action, especially if your subject is moving very quickly.

In Figure 2-11, the camera selected a shutter speed that did, in fact, catch my furkid in mid-romp, although if you look very closely, you can see some slight blurring of his beard. Because of the very bright light,

the camera also selected a small aperture setting, which produces a large depth of field — so the grass in the background is as sharply focused as that in the foreground. To fully understand these issues, explore Chapters 5 and 6.

✔ **Autofocusing:** The camera sets the AF-Area mode option to the Dynamic Area mode. Chapter 6 provides full details, but here's the short story: You use the Multi Selector to indicate which focusing point you want the camera to use when calculating the focusing distance. But if the object moves out of that point, the camera tries to draw focus information from the other points. With luck, your subject will move within one of the focus points before you record the image.

Additionally, Sports mode selects the AF-A

Sports mode

Figure 2-11: To capture moving subjects without blur, try Sports mode.

Focus mode, which means that if the camera detects motion, it continually adjusts focus up to the time you fully depress the shutter button and take the shot. Your other option is MF mode, for manual focusing. (Chapter 6 details the Focus mode options as well.)

If your subject moves after you press the shutter button halfway, be sure that you adjust the framing so that the subject remains under one of the focus points. Otherwise, the camera may not lock focus on the subject correctly.

✔ **Flash:** The built-in flash is disabled. That can be a problem in low-light situations, but it also enables you to shoot successive images more quickly because the flash needs a brief period to recycle between shots. If you own an external flash unit, however, you can use it in Sports mode if you like; just be aware that you may sacrifice in the speed-shooting department because of the necessary flash-recycle time. Additionally, you are limited to a maximum shutter speed of 1/200 second, which may not be fast enough to freeze a fast-moving subject. Chapter 5 has tips on this subject.

Sometimes, allowing a moving object to blur can actually create a heightened sense of motion — an artistic choice that you can't make in Sports mode. For more control over shutter speed, try out S mode (shutter-priority autoexposure), explained in Chapter 5.

Close Up mode

Switching to Close Up mode doesn't enable you to focus at a closer distance to your subject than normal as it does on some non-SLR cameras. The close-focusing capabilities of your camera depend entirely on the lens you bought, so check your lens manual for details.

Close Up mode does affect your pictures in a couple of ways, however:

- **Depth of field:** Close Up mode, like Portrait mode, selects an aperture setting designed to produce short depth of field, which helps keep background objects from competing for attention with your main subject. As with Portrait mode, though, how much the background blurs varies depending on the available light (which determines the aperture setting the camera can use), the distance between your subject and the background, as well as the lens focal length, all outlined in Chapter 6.

- **Autofocusing:** At the default settings, the camera uses the Single Point AF-Area mode, meaning that it looks to only a single focus point to establish focus. Initially, the center point is selected, but you can press the Multi Selector to choose a different point. Or you can follow the instructions in Chapter 6 to choose an entirely different AF-Area mode option.

 As for the Focus mode, also covered in Chapter 6, the camera uses the AF-A setting. Again, that means that focus is locked when you press the shutter button halfway. But if the camera detects motion, it adjusts focus as needed, up to the time you take the picture. Your only other alternative is to use manual focusing.

- **Flash:** You can set the Flash mode to Auto, Auto with Red-Eye Reduction, and Off. (I urge you, though, to be very careful about using the built-in flash when you're shooting a person or animal at close range — that strong burst of light isn't healthy for the eyes.)

Chapter 7 offers additional tips on close-up photography.

Night Portrait mode

This mode is designed to deliver a better-looking flash portrait at night (or in any dimly lit environment). It does so by constraining you to using Auto Slow Sync, Auto Slow Sync with Red-Eye Reduction, or Off flash modes. In all three flash modes, the camera selects a shutter speed that results in a long exposure time. That slow shutter speed enables the camera to rely more on ambient light and less on the flash to expose the picture, which produces softer, more even lighting.

I cover the issue of long-exposure and slow-sync flash photography in detail in Chapter 5. For now, the critical thing to know is that the slower shutter speed means that you probably need a tripod. If you try to handhold the camera, you run the risk of moving the camera during the long exposure, resulting in a blurry image. Enabling the vibration reduction (VR) feature of your lens, if available, can help, but for nighttime shooting, even that may not permit successful handheld shooting. Your subjects also must stay perfectly still during the exposure, which can add to the challenge.

Autofocusing in this mode works the same way as in Auto mode, described earlier in this chapter.

Scene mode

This option enables you to choose an additional array of scene-specific modes, all described briefly in the following list. Like the other scene modes, these work best when you've got the optimum conditions for which the modes were designed.

If you want to give them a try, set the Mode dial to Scene. In the Shooting Information display, a little icon representing the currently selected mode appears in the top-left corner of the screen, as shown on the left in Figure 2-12. By rotating the Command dial, you bring to life a screen similar to the one on the right in the figure. As you rotate the dial, you cycle through the various Scene mode settings, with a sample image appearing for each one. If you pause for a second, the camera locks in the currently selected scene type, and the normal Shooting Information screen reappears.

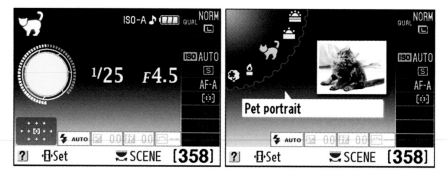

Figure 2-12: After setting the Mode dial to Scene, rotate the Command dial to select the type of picture you want to capture.

If you prefer, you can also choose Scene Mode from the Shooting menu. Press OK to display a scrolling list of all the available modes, highlight your choice, and press OK.

However you choose to go about selecting a Scene mode, you can choose from these options:

- **Night Landscape:** Use this mode when shooting city landscapes at night. The camera chooses a low ISO setting to reduce noise and a white balance setting that renders lights in their natural colors. Flash is disabled when this mode is selected. You'll have to attach your camera to a tripod to avoid blurry shots because this mode uses a slow shutter speed.

- **Party Indoors:** Use this mode when photographing indoor parties. The camera chooses a white balance setting to faithfully reproduce the ambient light. You can set the Flash mode to Auto, Auto with Red-Eye Reduction, or Off, depending on the ambient light.

- **Beach/Snow:** Use this mode when you're photographing a scene with lots of bright areas, like sand or snow. In this mode, flash and Autofocus Assist are disabled.

- **Dusk/Dawn:** Use this mode when you're taking pictures of landscapes just before the sun rises, or just after the sun sets. Flash and the AF-Assist beam are disabled. I recommend using a tripod when using this mode as well, as the shutter speed the camera selects may be very slow.

- **Candlelight:** Use this mode when shooting portraits lighted by candle-light. Flash is disabled when using this mode, and, since the ambient light will be dim, the shutter speed will likely be slow. Again, you'll need to mount your camera on a tripod to avoid a blurry photo.

- **Autumn Colors:** Use this mode when shooting landscapes in the Fall. This mode yields pictures with saturated reds and yellows of autumn leaves. The built-in flash is disabled. Mount your camera on a tripod in lowlight situations.

- **Sunset:** Use this mode when you're photographing sunsets and the sun is in the picture. This mode attempts to preserve the brilliant colors you see at sunset. And, yep, you guessed it: A tripod produces a better chance of a sharp shot, since the light will be low and the camera will need to use a slow shutter speed.

When photographing sunsets, don't stare at the sun directly through your viewfinder, as this can permanently damage your vision, especially when you're using a telephoto lens. In fact, you may want to use Live View when shooting sunsets. (See Chapter 4 for help with Live View.)

- **Pet Portrait:** Use this mode when you're taking portraits of a pet that's a moving target. When using this mode, the AF-Assist beam is disabled. You can set the flash to Auto, Auto with Red-Eye Reduction, and Off.

- **Blossom:** Use this mode when you're photographing a field of blooming flowers. Flash is disabled when using this mode. Use a tripod when photographing in lowlight situations.

✔ **Food:** Use this mode when you're photographing food. When shooting in this mode, the camera saturates the colors for vivid photographs. You can use the flash when shooting in this mode. If you want to use flash in this mode, press the Flash button on the side of the camera to pop up the flash. To go flash-free, simply close the flash unit.

✔ **Silhouette:** Use this mode when the sun is behind your subject(s), and you want the subjects to render as silhouettes. Flash is disabled in this mode. Use a tripod in lowlight situations.

✔ **Low Key:** Use this mode when you're shooting dark scenes and you want a somber look. Highlights are rendered properly, but shadows and dark areas of the image are black. Flash is disabled when shooting in this mode. Use a tripod for sharp, blur-free shots.

✔ **High Key:** Experiment with using this mode for an interesting effect when photographing bright objects in bright light — crystal on a lace doily, for example. Flash is disabled in High Key mode.

In all these modes, the camera sets the Focus mode to the AF-A setting by default. Chapter 6 explains the Focus mode completely, but for now, just understand that in the AF-A mode, focus is set when you press the shutter button halfway, unless the camera senses movement in front of the lens. In that case, it continues to adjust focus as needed until the moment you snap the picture. Your only other choice is to select the MF (manual focus) setting and take the focusing reins.

The default setting for the other critical autofocus option, AF-Area mode, depends on the scene mode you select. Chapter 6 details all the options and shows you how to select a different setting if you're not happy with the camera's initial choice.

Changing the (Shutter Button) Release Mode

In addition to all its other mode settings — exposure modes, focus modes, flash modes, and the like — your D5000 offers a generically named but critical setting called Release mode. This setting determines how you trigger the actual image capture and what happens after you take that step. You have the following options:

✔ **Single Frame:** This setting, which is the default, records a single image each time you press the shutter button completely. In other words, this is normal-photography mode.

✔ **Continuous:** Sometimes known as *burst mode,* this mode records a continuous series of images as long as you hold down the shutter button. In this mode, you can capture up to four frames per second. When using this mode, you must disable the built-in flash.

The Continuous mode is designed to make it easier for you to capture action. But keep in mind that the actual number of frames you can record per second depends in part on your shutter speed. At a slow shutter speed, the camera may not be able to reach the maximum frame rate. (See Chapter 5 for an explanation of shutter speed.)

 ✔ **Self-Timer:** Want to put yourself in the picture? Select this mode, press the shutter button, and run into the frame. As soon as you press the shutter button, the AF-assist illuminator on the front of the camera starts to blink, and the camera emits a series of beeps (assuming that you didn't disable its voice, a setting I cover in Chapter 1). A few seconds later, the camera captures the image

At the default settings, the capture-delay time is 10 seconds, and the camera records one shot for each press of the shutter button. But you can adjust both the delay time and the number of images recorded by visiting the Custom Setting menu. After you pull up the menu, highlight Timers/AE Lock, press OK, highlight Self-Timer, and press OK to display the left screen in Figure 2-13. Highlight the self-timer setting you want to change and press OK to access the available settings. For example, on the right in Figure 2-13, you see the timer delay settings. Again, highlight your choice and press OK to wrap things up.

You can select a capture-delay time of 2, 5, 10, or 20 seconds and set the number of images recorded between 1 and 9.

Whatever the settings you choose, remember this little quirk about the Self-Timer mode: After you capture the self-timer image (or images, if you set the Number of Shots option to capture more than one picture), the camera reverts to whatever Release mode you previously used.

 ✔ **Delayed Remote and Quick Response Remote:** The final two Release mode settings relate to the optional Nikon wireless remote-control unit. If you select Delayed Remote, the camera snaps the picture two seconds after you press the shutter-release button on the remote unit. If you select Quick Response Remote, the image is captured immediately.

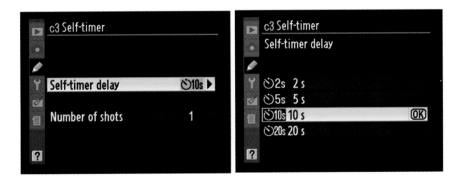

Figure 2-13: You can adjust the self-timer capture delay via the Custom Setting menu.

When you use Self-Timer or the remote control modes, you should remove the little rubber cup that surrounds the viewfinder and then insert the viewfinder cover that shipped with your camera. (Dig around in the accessories box — the cover is a tiny black piece of plastic, about the size of the viewfinder.) Otherwise, light may seep into the camera through the viewfinder and affect exposure. You can also simply use the camera strap or something else to cover the viewfinder in a pinch.

✔ **Quiet:** This Release mode setting is designed for situations when you want the camera to be as silent as possible. It disables the autofocus beep, and the camera is silent except for the shutter-release sound you hear when you take a picture.

To change the Release mode, bring up the Quick Settings display and navigate to the Release mode icon, highlighted in Figure 2-14. Then press OK, highlight the desired mode from the menu shown on the right side of Figure 2-14, and press OK.

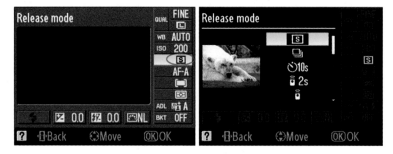

Figure 2-14: You can check the current Release mode in the Shooting Information display.

If you want to use Self-Timer mode, you have an even easier option: Just press the Fn button on the left side of the camera. The Shooting Information screen displays a text label telling you that you're in Self-Timer mode, and you're ready to take your picture. Again, though, the camera reverts to the previously selected Release mode after you capture your self-timer shot. (If you don't use the Self-Timer Release mode frequently, you can customize the function of the Fn button as outlined in Chapter 11.)

With the exception of the Self-Timer setting, your selected Release mode stays in force until you change it. However, the camera cancels out of the remote control modes if it doesn't receive a signal from the remote after about one minute. You can adjust this timing through an option on the Timers/AE Lock submenu of the Custom Setting menu. Select the Remote On Duration option and press OK to reveal the available options. The maximum delay time is 15 minutes; keep in mind that a shorter delay time saves battery life. After the delay time expires, the camera resets itself to either Single or Continuous mode, depending on which mode you last used.

Taking Advantage of Interval Timer Shooting

In addition to the various Release modes covered in the preceding section, you can use the Interval Timer Shooting feature to automatically capture a series of pictures over a given period of time. The common photo lingo for this type of capture is *time-lapse photography*. Here's how to do it:

1. **Display the Shooting menu, highlight Interval Timer Shooting as shown on the left in Figure 2-15, and press OK.**

 The screen on the right in Figure 2-15 appears.

2. **To begin setting up your capture session, highlight Now or Start Time.**

 • If you want to start the captures right away, highlight Now, as shown on the right in Figure 2-15.

 • To set a later start time for the captures, highlight Start Time.

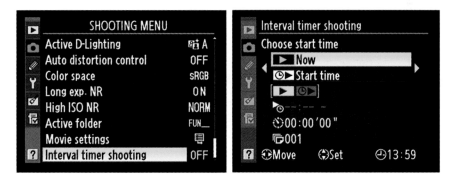

Figure 2-15: The Interval Timing feature enables you to do time-lapse photography.

3. Press the Multi Selector right to display the capture-setup screen.

If you selected Start Time in Step 2, the screen looks like the one in Figure 2-16. If you selected Now, the Start Time option is dimmed and the Interval option is highlighted instead.

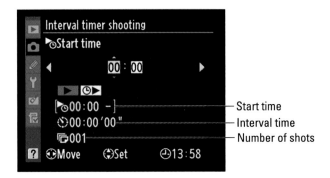

Figure 2-16: Press the Multi Selector right or left to cycle through the setup options; press up or down to change the highlighted value.

4. Set up your recording session.

You get three options: Start Time, Interval (time between shots) and Number of Intervals (number of shots recorded). The current settings for each option appear in the bottom half of the screen, as labeled in Figure 2-16.

At the top of the screen, little value boxes appear. The highlighted box is the active option and relates to the setting that's highlighted at the bottom of the screen. For example, in the figure, the hour box for the Start Time setting is active. Press the Multi Selector right or left to cycle through the value boxes; to change the value in a box, press the Multi Selector up or down.

A few notes about your options:

- The Interval and Start Time options are based on a 24-hour clock. (The current time appears in the bottom-right corner of the screen and is based upon the date/time information you entered when setting up the camera.)

- For the Interval option, the left column box is for the hour setting; the middle, minutes; and the right, seconds. Make sure that the value you enter is longer than the shutter speed you plan to use.

- For the Start Time option, you can set the hour and minute values only. Again, the Start Time option is available only if you selected Start Later in Step 2.

- The Number of Intervals option determines how many pictures will be recorded. You can set the value as high as 999.

5. **When you're done setting up the capture options, press the Multi Selector right until you see the On and Off options on the screen, as shown in Figure 2-17.**

6. **Highlight On and press OK.**

 If you selected Now as your interval-capture starting option, the first shot is recorded about three seconds later. If you set a delayed start time, the camera displays a "Timer Active" message for a few seconds and before returning to the Shooting menu.

Figure 2-17: Highlight On and press OK to finalize the Internal Timing setup.

A few final factoids:

✐ **Interrupting interval shooting:** Just turn the camera off or change the Mode dial to a different setting if you want to stop the interval-shooting session.

✐ **Bracketing:** You can apply automatic bracketing during interval shooting. See Chapter 5 to find out what bracketing is all about.

✐ **Release mode:** You can set the Release mode to any setting you want, but the camera always records just a single shot at each interval stage. You can' use the remote control or self-timer, either.

3

Controlling Picture Quality and Size

*A*lmost every review of the D5000 contains glowing reports about the camera's top-notch picture quality. As you've no doubt discovered for yourself, those claims are true, too: This baby can create large, beautiful images.

What you may *not* have discovered is that Nikon's default Image Quality setting isn't the highest that the D5000 offers. Why, you ask, would Nikon do such a thing? Why not set up the camera to produce the best images right out of the box? The answer is that using the top setting has some downsides. Nikon's default choice represents a compromise between avoiding those disadvantages while still producing images that will please most photographers.

Whether that compromise is right for you, however, depends on your photographic needs. To help you decide, this chapter explains the Image Quality setting, along with the Image Size setting, which is also critical to the quality of images that you print. Just in case you're having quality problems related to other issues, though, the first section of the chapter provides a handy quality-defect diagnosis guide.

A word of warning before you dive in: This stuff may be a little confusing at first. In fact, unless you've worked with image-editing applications, or delved into the wild world of document size versus resolution, I pretty much guarantee it. Some math is even involved, which is usually against my principles. On top of that, discussions of picture quality and size involve lots of technical terms, such as pixels, resolution, JPEG compression, and the like.

So take it slowly, and if your eyes start to glaze over, put the book down, and come back later for another go-round. It may require a few reads of this chapter, but before long, you'll feel confident about controlling these important aspects of your pictures.

Diagnosing Quality Problems

When I use the term *picture quality,* I'm not talking about the composition, exposure, or other traditional characteristics of a photograph. Instead, I'm referring to how finely the image is rendered in the digital sense.

Figure 3-1 illustrates the concept: The first example is a high-quality image, with clear details and smooth color transitions. The other examples show five common digital-image defects.

Figure 3-1: Refer to this symptom guide to determine the cause of poor image quality.

Each of these defects is related to a different issue, and only one is affected by the Image Quality setting on your D5000. So if you aren't happy with your image quality, first compare your photos to those in the figure to properly diagnose the problem. Then try these remedies:

- ✓ **Pixelation:** When an image doesn't have enough *pixels* (the colored tiles used to create digital images), details aren't clear, and curved and diagonal lines appear jagged. The fix is to increase image resolution, which you do via the Image Size control. See the next section, "Considering Resolution (Image Size)," for details.

- ✓ **JPEG artifacts:** The "parquet tile" texture and random color defects that mar the third image in Figure 3-1 can occur in photos captured in the JPEG *(jay-peg)* file format, which is why these flaws are referred to as *JPEG artifacts.* This is the defect related to the Image Quality setting; see "Understanding the Image Quality Options" to find out more.

- ✓ **Noise:** This defect gives your image a speckled look, as shown in the lower-left example in Figure 3-1. Noise can occur with very long exposure times or when you choose a high ISO Sensitivity setting on your camera. You can explore both issues in Chapter 5.

- ✓ **Color cast:** If your colors are seriously out of whack, as shown in the lower-middle example in the figure, try adjusting the camera's White Balance setting. Chapter 6 covers this control and other color issues. Note, though, that you can control white balance only when you shoot in the advanced exposure modes (P, S, A, and M).

- ✓ **Lens/sensor dirt:** A dirty lens is the first possible cause of the kind of defects you see in the last example in the figure. If cleaning your lens doesn't solve the problem, dust or dirt may have made its way onto the camera's image sensor. See the sidebar "Maintaining a pristine view," elsewhere in this chapter, for information on safe lens and sensor cleaning.

When diagnosing image problems, you may want to open the photos in ViewNX or some other photo software and zoom in for a close-up inspection. Some defects, especially pixelation and JPEG artifacts, have a similar appearance until you see them at a magnified view. (See Part III for information about using ViewNX.)

I should also tell you that I used a little digital enhancement to exaggerate the flaws in my example images to make the symptoms easier to see. With the exception of an unwanted color cast or a big blob of lens or sensor dirt, these defects may not even be noticeable unless you print or view your image at a very large size. And the subject matter of your image may camouflage some flaws; most people probably wouldn't detect a little JPEG artifacting in a photograph of a densely wooded forest, for example.

In other words, don't consider Figure 3-1 as an indication that your D5000 is suspect in the image quality department. First, *any* digital camera can

produce these defects under the right circumstances. Second, by following the guidelines in this chapter and the others mentioned in the preceding list, you can resolve any quality issues that you may encounter.

Considering Resolution (Image Size)

Like other digital devices, your D5000 creates pictures out of *pixels,* which is short for *picture elements.* You can see some pixels close up in the right example of Figure 3-2, which shows a greatly magnified view of the eye area in the left image.

Figure 3-2: Pixels are the building blocks of digital photos.

You specify the pixel count of your images, also known as the *resolution,* via the Image Size control. The D5000 offers three Image Size settings: Large, Medium, and Small; Table 3-1 lists the resulting resolution values for each setting.

Table 3-1	Image Size (Resolution) Options
Setting	*Resolution*
Large	4288 x 2848 pixels (12.3 MP)
Medium	3216 x 2136 pixels (6.9 MP)
Small	2144 x 1424 pixels (3.1 MP)

In the table, the first pair of numbers shown for each setting represents the image *pixel dimensions* — that is, the number of horizontal pixels and the number of vertical pixels. The values in parentheses indicate the

approximate total resolution. This number is usually stated in *megapixels,* abbreviated MP for short. One megapixel equals 1 million pixels.

Note, however, that if you select RAW (NEF) as your file format, all images are captured at the Large setting. You can vary the resolution only if you select JPEG as the file format. The upcoming section "Understanding the Image Quality Options" explains file formats.

So how many pixels are enough? To make the call, you need to understand how resolution affects print quality, display size, and file size. The next sections explain these issues, as well as a few other resolution factoids.

If you're already schooled on the subject and just want to know how to select a resolution setting on your D5000, skip to "Setting Image Size and Quality," near the end of this chapter, for specifics.

Pixels and print quality

When mulling over resolution options, your first consideration is how large you want to print your photos, because pixel count determines the size at which you can produce a high-quality print. If you don't have enough pixels, your prints may exhibit the defects you see in the pixelation example in Figure 3-1, or worse, you may be able to see the individual pixels, as in the right example in Figure 3-2.

Depending on your photo printer, you typically need anywhere from 200 to 300 pixels per linear inch, or *ppi,* of the print. To produce an 8-x-10-inch print at 200 ppi, for example, you need 1600 horizontal pixels and 2000 vertical pixels (or vice versa, depending on the orientation of your print).

Table 3-2 lists the pixel counts needed to produce traditional print sizes at 200 ppi and 300 ppi. But again, the optimum ppi varies depending on the printer — some printers prefer even more than 300 ppi — so check your manual or ask the photo technician at the lab that makes your prints. (And note that ppi is *not* the same thing as *dpi,* which is a measurement of printer resolution. *Dpi* refers to how many dots of color the printer can lay down per inch; most printers use multiple dots to reproduce 1 pixel.)

Table 3-2	Pixel Requirements for Traditional Print Sizes	
Print Size	*Pixels for 200 ppi*	*Pixels for 300 ppi*
4 x 6 inches	800 x 1200	1200 x 1800
5 x 7 inches	1000 x 1400	1500 x 2100
8 x 10 inches	1600 x 2000	2400 x 3000
11 x 14 inches	2200 x 2800	3300 x 4200

Even though many photo editing programs enable you to add pixels to an existing image, doing so isn't a good idea. For reasons I won't bore you with, adding pixels — known as *resampling* — doesn't enable you to successfully enlarge your photo. In fact, resampling typically makes matters worse. The printing discussion at the start of Chapter 9 includes some example images that illustrate this issue.

Pixels and screen display size

Resolution doesn't affect the quality of images viewed on a monitor, television, or other screen device as it does printed photos. What resolution *does* determine is the *size* at which the image appears.

This issue is one of the most misunderstood aspects of digital photography, so I explain it thoroughly in Chapter 9. For now, just know that you need *way* fewer pixels for onscreen photos than you do for printed photos. For example, Figure 3-3 shows a 450-x-300-pixel image that I attached to an e-mail message.

For e-mail images, I recommend a maximum of 640 pixels for the picture's longest dimension. If your image is much larger, the recipient may not be able to view the entire picture without scrolling the display.

In short, even if you use the smallest Image Size setting on your D5000, you'll have more than enough pixels for onscreen use, whether you display the picture on a computer monitor, a digital projector, or television set — even one of the new, supersized high-definition TVs. Again, Chapter 9 details this issue and also shows you how to prepare your pictures for online sharing.

Pixels and file size

Every additional pixel increases the amount of data required to create a digital picture file. So a higher-resolution image has a larger file size than a low-resolution image.

Large files present several problems:

- ✔ You can store fewer images on your memory card, on your computer's hard drive, and on removable storage media such as a CD-ROM.
- ✔ The camera needs more time to process and store the image data on the memory card after you press the shutter button. This extra time can hamper fast-action shooting.
- ✔ When you share photos online, larger files take longer to upload and download.
- ✔ When you edit your photos in your photo software, your computer needs more resources and time to process large files.

Figure 3-3: The low resolution of this image (450 x 300 pixels) ensures that it can be viewed without scrolling when shared via e-mail.

To sum up, the tradeoff for a high-resolution image is a large file size. But note that the Image Quality setting also affects file size. See the upcoming section "Understanding the Image Quality Options" for more on that topic. The upcoming sidebar "How many pictures fit on my memory card?" provides additional thoughts about the whole file-storage issue.

Resolution recommendations

As you can see, resolution is a bit of a sticky wicket. What if you aren't sure how large you want to print your images? What if you want to print your photos *and* share them online?

Personally, I take the "better safe than sorry" route, which leads to the following recommendations about the Image Size setting:

✔ **Always shoot at a resolution suitable for print.** You then can create a low-resolution copy of the image in your photo editor for use online. Chapter 9 shows you how.

Again, you *can't* go in the opposite direction, adding pixels to a low-resolution original in your photo editor to create a good, large print. Even with the very best software, adding pixels doesn't improve the print quality of a low-resolution image.

✔ **For everyday images, Medium is a good choice.** I find the Large setting to be overkill for most casual shooting, which means that you're creating huge files for no good reason. Keep in mind that even at the Medium setting, your pixel count (3216 x 2136) exceeds what you need to produce an 8-x-10-inch print at 200 ppi.

✔ **Choose Large for an image that you plan to crop, print very large, or both.** The benefit of maxing out resolution is that you have the flexibility to crop your photo and still generate a decent-sized print of the remaining image. Perhaps you're taking pictures at the zoo, for example, and you want a close-up of your favorite animal. Even with a telephoto lens, you may not be able to get the close-up view you want. So take the approach shown in Figure 3-4. Frame the scene as tightly as your lens permits and then capture the shot at the highest resolution. You then can crop the photo and still have enough pixels left to produce a great print, as you see in the right image.

Doug Sahlin

Figure 3-4: Capture images that you plan to crop and enlarge at the highest possible Image Size setting.

How many pictures fit on my memory card?

That question is one of the first asked by new camera owners — and it's an important one because you don't want to run out of space on your memory card just as the perfect photographic subject presents itself.

As explained in the Image Size and Image Quality discussions in this chapter, image resolution (pixel count) and file format (JPEG or RAW) together help determine the size of the picture file which, in turn, determines how many photos fit in a given amount of camera memory. (The actual file size of any image also depends on a few other factors, including the level of detail and color in the subject.)

On the D5000, file sizes range anywhere from 16.9MB (megabytes) to 0.4MB, depending on the combination of Image Size and Image Quality settings you select. That means the capacity of a 2GB (gigabyte) memory card ranges from 89 pictures to a whopping 3800 pictures, again, depending on your Size/Quality settings.

The table here shows the approximate file sizes for just some Size/Quality combinations; you can find a table that lists all the possibilities in your camera manual if you're curious.

Image Quality + Image Size = File Size

Image Quality	Large	Medium	Small
JPEG Fine	5.9MB	3.3MB	1.5MB
JPEG Normal	3.0MB	1.7MB	0.8MB
JPEG Basic	1.5MB	0.9MB	0.4MB
NEF (RAW)	10.6MB	NA*	NA*
NEF + JPEG Fine	16.7MB	14.0MB	12.1MB

*NEF (RAW) images are always captured at the Large size; for NEF+JPEG, user can set size for the JPEG image.

✏ **Reduce resolution if shooting speed is paramount.** If you're shooting action and the shot-to-shot capture time is slower than you'd like — that is, the camera takes too long after you take one shot before it lets you take another — dialing down the resolution may help. Also see Chapter 7 for other tips on action photography.

After you decide which resolution setting is right for your picture, visit the section "Setting Image Size and Quality," later in this chapter.

Understanding the Image Quality Options

If I had my druthers, the Image Quality option on the D5000 would instead be called File Type, because that's what the setting controls.

Here's the deal: The file type, more commonly known as a file *format,* determines how your picture data is recorded and stored. Your choice does impact picture quality, but so do other factors, as outlined at the beginning of this chapter. In addition, your choice of file type has ramifications beyond picture quality.

At any rate, your D5000 offers the two file types common on most of today's digital cameras: JPEG and Camera RAW, or just RAW for short, which goes by the specific moniker NEF on Nikon cameras. The next sections explain the pros and cons of each format. If your mind is already made up, skip ahead to "Setting Image Size and Quality," near the end of this chapter, to find out how to make your selection.

Don't confuse *file format* with the Format Memory Card option on the Setup menu. That option erases all data on your memory card; see Chapter 1 for details.

JPEG: The imaging (and Web) standard

Pronounced *jay-peg,* this format is the default setting on your D5000, as it is for most digital cameras. JPEG is popular for two main reasons:

- ✔ **Immediate usability:** All Web browsers and e-mail programs can display JPEG files, so you can share them online immediately after you shoot them. The same can't be said for NEF (RAW) files, which must be processed and converted to JPEG files before you can share them online. And although you can view and print RAW files in Nikon ViewNX without converting them, many third-party photo programs don't enable you to do that. You can read more about the conversion process in the upcoming section "NEF (RAW): The purist's choice."

- ✔ **Small files:** JPEG files are smaller than NEF (RAW) files. And smaller files consume less room on your camera memory card and in your computer's storage tank.

The downside — you knew there had to be one — is that JPEG creates smaller files by applying *lossy compression.* This process actually throws away some image data. Too much compression leads to the defects you see in the JPEG Artifacts example in Figure 3-1.

Fortunately, your camera enables you to specify how much compression you're willing to accept. The Image Quality menu offers three JPEG settings, which produce the following results:

- ✔ **JPEG Fine:** At this setting, the compression ratio is 1:4 — that is, the file is four times smaller than it would otherwise be. In plain English, that means that very little compression is applied, so you shouldn't see many compression artifacts, if any.

- ✔ **JPEG Normal:** Switch to Normal, and the compression ratio rises to 1:8. The chance of seeing some artifacting increases as well.

✔ **JPEG Basic:** Shift to this setting, and the compression ratio jumps to 1:16. That's a substantial amount of compression and brings with it a lot more risk of artifacting.

Note, though, that even the JPEG Basic setting on your D5000 doesn't result in anywhere near the level of artifacting that you see in my example in Figure 3-1. Again, that example is exaggerated to help you be able to recognize artifacting defects and understand how they differ from other image-quality issues.

In fact, if you keep your image print or display size small, you aren't likely to notice a great deal of quality difference between the Fine, Normal, and Basic compression levels, although details in the Fine version may appear slightly crisper than the Normal and Basic options. It's only when you greatly enlarge a photo that the differences become apparent.

Figure 3-5: This subject offered a good test for comparing the Image Quality settings.

Take a look at Figures 3-5 and 3-6, for example. I captured the scene in Figure 3-5 four times, keeping the resolution the same for each shot but varying the Image Quality setting. For the photo you see in Figure 3-5, I used the JPEG Fine setting. I thought about printing the three other shots along with the JPEG Fine example, but frankly, you wouldn't be able to detect a nickel's worth of difference between the examples at the size that I could print them on this page. So Figure 3-6 shows just a portion of each shot at a greatly enlarged size. The first three images show the JPEG Fine, Normal, and Basic shots; for the fourth image, I used the NEF (RAW) setting, which applies no compression. (Note that during the process of converting the RAW image to a print-ready file, I tried to use settings that kept the RAW image as close as possible to its JPEG cousins in all aspects but quality. But any variations in exposure, color, and contrast are a result of the conversion process, not of the format per se.)

Even at the greatly magnified size, it takes a sharp eye to detect the quality differences between the Raw and Fine images. When you carefully inspect the Normal version, you can see some artifacting start to appear; jump to the Basic example, and compression artifacting becomes more obvious.

Nikon chose to use the Normal setting as the default on the D5000. I suppose that's okay for everyday images that you don't plan to print or display very large. And because file size shrinks as you apply more compression, Normal enables you to fit more photos on your memory card than Fine or NEF (RAW).

JPEG Fine JPEG Normal

JPEG Basic RAW (NEF)

Figure 3-6: Here you see a portion of the tower at greatly enlarged views.

For my money, though, the file-size benefit you gain when going from Fine to Normal isn't worth even a little quality loss, especially with the price of camera memory cards getting lower every day. You never know when a casual snapshot is going to turn out to be so great that you want to print or display it large enough that even minor quality loss becomes a concern. And of all the defects that you can correct in a photo editor, artifacting is one of the hardest to remove. So if I shoot in the JPEG format, I stick with Fine.

I suggest that you do your own test shots, however, carefully inspect the results in your photo editor, and make your own judgment about what level of artifacting you can accept. Artifacting is often much easier to spot when you view images onscreen. It's difficult to reproduce artifacting here in print because the print process obscures some of the tiny defects caused by compression.

If you don't want *any* risk of artifacting, bypass JPEG altogether and change the file type to NEF (RAW). Or consider your other option, which is to record two versions of each file, one RAW and one JPEG. The next section offers details.

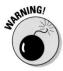

Whichever format you select, be aware of one more important rule for preserving the original image quality: If you retouch pictures in your photo software, don't save the altered images in the JPEG format. Every time you alter and save an image in the JPEG format, you apply another round of lossy compression. And with enough editing, saving, and compressing, you *can* eventually get to the level of image degradation shown in the JPEG example in Figure 3-1, at the start of this chapter. (Simply opening and closing the file does no harm.)

Always save your edited photos in a nondestructive format. TIFF, pronounced *tiff,* is a good choice and is a file-saving option available in most photo editing programs. Should you want to share the edited image online, create a JPEG copy of the TIFF file when you're finished making all your changes. That way, you always retain one copy of the photo at the original quality captured by the camera. You can read more about TIFF in Chapter 8, in the section related to processing RAW images. Chapter 9 explains how to create a JPEG copy of a photo for online sharing.

NEF (RAW): The purist's choice

The other picture file type you can create on your D5000 is called *NEF RAW,* or just *RAW* (as in uncooked) for short.

Each manufacturer has its own flavor of RAW. Nikon's is called NEF, so you see the three-letter extension NEF at the end of RAW filenames.

RAW is popular with advanced, very demanding photographers, for these reasons:

- ✔ **Greater creative control:** With JPEG, internal camera software tweaks your images, making adjustments to color, exposure, and sharpness as needed to produce the results that Nikon believes its customers prefer. With RAW, the camera simply records the original, unprocessed image data. The photographer then copies the image file to the computer and uses special software known as a *RAW converter* to produce the actual image, making decisions about color, exposure, and so on at that point. The upshot is that "shooting RAW" enables you, and not the camera, to have the final say on the visual characteristics of your image.

- ✔ **Higher bit depth:** *Bit depth* is a measure of how many distinct color values an image file can contain. JPEG files restrict you to 8 bits each for the red, blue, and green color components, or *channels,* that make up a digital image, for a total of 24 bits. That translates to roughly 16.7 million possible colors. On the D5000, a RAW file delivers a higher bit count, collecting 12 bits per channel.

Although jumping from 8 to 12 bits sounds like a huge difference, you may not really ever notice any difference in your photos — that 8-bit palette of 16.7 million values is more than enough for superb images. Where having the extra bits can come in handy is if you really need to

adjust exposure, contrast, or color after the shot in your photo editing program. In cases where you apply extreme adjustments, having the extra original bits sometimes helps avoid a problem known as *banding* or *posterization,* which creates abrupt color breaks where you should see smooth, seamless transitions. (A higher bit depth doesn't always prevent the problem, however, so don't expect miracles.)

✔ **Best picture quality:** Because RAW doesn't apply the destructive compression associated with JPEG, you don't run the risk of the artifacting that can occur with JPEG.

But of course, as with most things in life, RAW isn't without its disadvantages. To wit:

✔ **You can't do much with your pictures until you process them in a RAW converter.** You can't share them online, for example, or put them into a text document or multimedia presentation. You can print them immediately if you use Nikon ViewNX, but most other photo programs require you to convert the RAW files to a standard format first. So when you shoot RAW, you add to the time you must spend in front of the computer instead of behind the camera lens.

✔ **To get the full benefit of RAW, you need software other than Nikon ViewNX.** The ViewNX software that ships free with your camera does have a command that enables you to convert RAW files to JPEG or to TIFF, introduced in the preceding section. However, this free tool gives you limited control over how your original data is translated in terms of color, exposure, and other characteristics — which defeats one of the primary purposes of shooting RAW.

Nikon Capture NX 2 offers a sophisticated RAW converter, but it costs about $180. (Sadly, if you already own Capture NX, you need to upgrade to version 2 to open the RAW files from your D5000.) If you own Adobe Photoshop or Photoshop Elements, however, you're set; both include the converter that most people consider one of the best in the industry. Watch the sale ads, and you can pick up Elements for well under $100. You may need to download an update from the Adobe Web site (www. adobe.com) to get the converter to work with your D5000 files.

Of course, the D5000 also offers an in-camera RAW converter, found on the Retouch menu. But although it's convenient, this tool isn't the easiest to use because you must rely on the small camera monitor when making judgments about color, exposure, sharpness, and so on. The in-camera tool also doesn't offer the complete cadre of features available in Capture NX 2 and other converter software utilities.

Chapter 8 offers more information on the in-camera conversion process and also offers a look at the converter found in ViewNX.

✒ **RAW files are larger than JPEGs.** The type of file compression that RAW applies doesn't degrade image quality, but the tradeoff is a larger file. In addition, Nikon RAW files are always captured at the maximum resolution available on the camera, even if you don't really need all those pixels. For both reasons, RAW files are significantly larger than JPEGs, so they take up more room on your memory card and on your computer's hard drive or other picture-storage device.

Are the disadvantages worth the gain? Only you can decide. But before you make up your mind, refer to Figure 3-6 and compare the JPEG Fine example with its NEF (RAW) counterpart. You may be able to detect some subtle quality differences when you really study the two, but a casual viewer likely would not, especially if shown the entire example images at normal print sizes rather than the greatly magnified views shown in the figure. I took Figure 3-5, for example, using JPEG Fine.

That said, I *do* shoot in the RAW format when I'm dealing with tricky lighting because doing so gives me more control over the final image exposure. For example, if you use a capable RAW converter, you can specify how bright you want the brightest areas of your photo to appear and how dark you prefer your deepest shadows. With JPEG, the camera makes those decisions, which can potentially limit your flexibility if you try to adjust exposure in your photo editor later. And the extra bits in a RAW file offer an additional safety net because I usually can push the exposure adjustments a little further in my photo editor if necessary without introducing banding.

I also go RAW if I know that I'm going to want huge prints of a subject. But keep in mind: I'm a photography geek, I have all the requisite software, and I don't really have much else to do with my time than process scads of RAW images. Oh, and I'm a bit of a perfectionist, too. (Although I'm more bothered by imperfections than I am motivated to remove them. A lazy perfectionist, if you will.)

If you do decide to try RAW shooting, you can select from four options on your D5000's Image Quality menu:

✒ **NEF (RAW):** This setting produces a single RAW file. Again, you don't have a choice of Image Size settings; the camera always captures the file at the maximum resolution.

✒ **NEF (RAW)+JPEG Fine, Normal, or Basic:** You also can choose to capture the image as both a NEF file and a JPEG file, and you can specify whether you want the JPEG version recorded at the Fine, Normal, or Basic setting. (You can also set the resolution of the JPEG file at Large, Medium, or Small.) Of course, with two files, you consume more space on your camera memory card.

I often choose the RAW+JPEG Fine option when I'm shooting pictures I want to share right away with people who don't have software for viewing RAW files. I upload the JPEGs to a photo-sharing site where everyone can view them, and then I process the RAW versions of my favorite images for my own use when I have time. Having the JPEG version also enables you to display your photos on a DVD player or TV that has a slot for an SD memory card — most can't display RAW files but can handle JPEGs. Ditto for portable media players and digital photo frames.

If you choose to create both files, note a couple of things:

- ✔ When you view your pictures on the camera, you see only one photo, and the Image Quality data reflects your capture setting (Raw+Basic, for example.) See Chapter 4 to find out how to view picture data.

- ✔ If you delete the displayed image, you delete both the JPEG and RAW files. (After you transfer the two files to your computer, deleting one doesn't affect the other.)

Chapter 4 explains more about viewing and deleting photos; see the upcoming section "Setting Image Size and Quality" to find out how to specify the size for your JPEG files.

My take: Choose JPEG Fine or NEF (RAW)

At this point, you may be finding all this technical goop a bit much — I recognize that panicked look in your eyes — so allow me to simplify things for you. Until you have time or energy to completely digest all the ramifications of JPEG versus RAW, here's a quick summary of my thoughts on the matter:

- ✔ If you require the absolute best image quality and have the time and interest to do the RAW conversion, shoot RAW. See Chapter 8 for more information on the conversion process.

- ✔ If great photo quality is good enough for you, you don't have wads of spare time, or you aren't that comfortable with the computer, stick with JPEG Fine.

- ✔ If you don't mind the added file-storage space requirement and want the flexibility of both formats, choose RAW+JPEG. If you need your JPEGs to exhibit the best quality, go with RAW+JPEG Fine.

- ✔ If you go with JPEG only, stay away from JPEG Normal and Basic. The tradeoff for smaller files isn't, in my opinion, worth the risk of compression artifacts. As with my recommendations on image size, this fits the "better safe than sorry" formula: You never know when you may capture a spectacular, enlargement-worthy subject, and it would be a shame to have the photo spoiled by compression defects. If you select RAW+JPEG, of course, this isn't as much of an issue because you always have the RAW version as backup if you aren't happy with the JPEG quality.

Setting Image Size and Quality

To sum up this chapter: The Image Size and Image Quality options together determine the quality of your pictures and also play a large role in image file size. Choose a high Image Quality setting (NEF or JPEG Fine) and the maximum Image Size setting (Large), and you get top-quality pictures and large file sizes. Combining the lowest Quality setting (JPEG Basic) with the lowest Size setting (Small) greatly shrinks files, enabling you to fit lots more pictures on your memory card, but it also increases the chances that you'll be disappointed with the quality of those pictures, especially if you make large prints.

As for actually selecting the options you want to use, the fastest route is to use the Quick Settings screen. Bring up the Shooting Information display and then press the Information Edit button to get to the Quick Settings screen. Then use the Multi Selector to highlight the Image Quality icon in the top-right corner, as shown on the left in Figure 3-7. Press OK to view the second screen in the figure, where you can select the option you want to use. When you select one of the settings, the screen shows you the resulting file size (in megabytes) and the number of pictures that will fit on your memory card at that size. Highlight your choice and then press OK. Repeat the process to set the Image Size option which is right below the Image Quality setting on the Quick Settings screen.

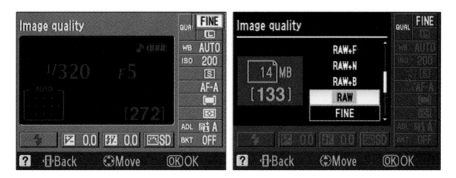

Figure 3-7: You can use the Quick Settings screen to change the Image Size and Quality settings.

As an alternative, you can adjust the settings via the Shooting menu, as shown in Figure 3-8. Either way, remember that when you choose the RAW (NEF) format, you don't need to worry about the Image Size setting — the camera captures all RAW images at the Large resolution. If you go with one of the RAW+JPEG options, the Image Size setting affects the JPEG version only.

Maintaining a pristine view

Often lost in discussions of digital photo defects — compression artifacts, pixelation, and the like — is the impact of plain-old dust and dirt on picture quality. But no matter what camera settings you use, you aren't going to achieve great picture quality with a dirty lens. So make it a practice to clean your lens on a regular basis, using one of the specialized cloths and cleaning solutions made expressly for that purpose.

If you continue to notice random blobs or hair-like defects in your images (refer to the last example in Figure 3-1), you probably have a dirty *image sensor*. That's the part of your camera that does the actual image capture — the digital equivalent of a film negative, if you will.

Your D5000 offers an automated, internal sensor-cleaning mechanism. By default, this automatic cleaning happens every time you turn the camera on or off. You also can request a cleaning session at any time via the Clean Image Sensor command on the Setup menu. (Chapter 1 has details on this menu option.)

But if you frequently change lenses in a dirty environment, the internal cleaning mechanism may not be adequate, in which case a manual sensor cleaning is necessary. You can do this job yourself, but . . . I don't recommend it. Image sensors are pretty delicate beings, and you can easily damage them or other parts of your camera if you aren't careful. Instead, find a local camera store that offers this service. In my area (central Indiana), sensor cleaning costs from $30–$50.

One more cleaning tip: Never — and I mean *never* — try to clean any part of your camera using a can of compressed air. Doing so can not only damage the interior of your camera, blowing dust or dirt into areas where it can't be removed, but also crack the external monitor.

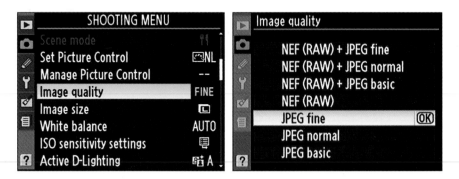

Figure 3-8: You also can set Image Size and Image Quality via the Shooting menu.

Again, adjusting the Image Size or Image Quality setting changes the picture file size, which changes the number of new shots you can fit on the current memory card. You can monitor the remaining card capacity in the Shots Remaining area of the Shooting Information display. (It reads 133 in Figure 3-7.)

Monitor Matters: Picture Playback and Live View Shooting

- -

In This Chapter

▶ Positioning the monitor

▶ Exploring picture playback functions

▶ Deciphering the picture information displays

▶ Understanding the exposure histogram

▶ Deleting bad pictures and protecting great ones

▶ Using the monitor as viewfinder in Live View mode

▶ Recording digital movies

- -

*W*ithout question, my favorite thing about digital photography is being able to view my pictures on the camera monitor the instant after I shoot them. No more guessing whether I captured the image I wanted or I need to try again, as in the film era. And no more wasting money on developing and printing pictures that stink.

Of course, with the D5000, you can use the monitor not only to review your photos, but also to *preview* them. That is, if you turn on Live View shooting, you can use the monitor instead of the viewfinder to compose your shots. And the monitor on the D5000 can tilt this way and that, which opens new possibilities for your photography. You can position the monitor parallel to the ground for snail's view shots without having to crawl on your belly, for example. In Live View mode, you also can record short digital movies.

Because all these functions involve some of the same buttons, bells, and whistles, I cover them together in this chapter. In addition, this chapter explains how to delete pictures that you don't like and protect the ones you love from accidental erasure. (Be sure to also visit Chapter 9, which covers some additional ways to view your images, including how to create slide shows and display your photos and movies on a television screen.)

Using the LCD Monitor

The default position of your D5000 monitor is rotated away from you. To review images and access the menus, the monitor needs to be rotated.

Before rotating the monitor for the first time, please (please) read the instructions and warnings in your camera manual thoroughly to avoid any potential damage to this critical part of your equipment. Then consider the following steps as a general reminder of the process only:

1. **Push the tabs down on each side of the viewfinder and gently pull the monitor away from the camera body.**

2. **Gently pull the monitor down and rotate it in the direction shown on the left in Figure 4-1.**

 Don't force the monitor at any time. The ribbon that connects the monitor to the camera is somewhat fragile and may get damaged if you get rough with the monitor or try to force it to move in a direction it was not designed to go.

3. **Rotate the monitor a full 180 degrees until the display screen is facing the front of the camera.**

 At this stage, the Nikon logo on the back of the monitor is upside down and backwards.

4. **Raise the monitor toward the viewfinder until it locks into position.**

 You're ready to start reviewing and previewing your pictures, as shown on the right in Figure 4-1.

Enabling Automatic Picture Rotation

When you take a picture, the camera can record the image *orientation* — whether you held the camera normally, creating a horizontally oriented image, or turned the camera on its side to shoot a vertically oriented photo. This bit of data is simply added into the picture file.

Release tab

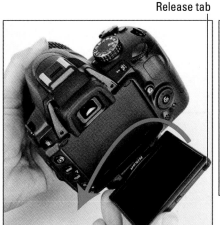

Figure 4-1: The monitor is locked and loaded, ready for picture playback.

During playback, the camera reads the data and automatically rotates the image so that it appears in the upright position, as shown on the left in Figure 4-2. The image is also automatically rotated when you view it in Nikon ViewNX, Capture NX 2, and some other photo programs that can interpret the data.

Figure 4-2: You can display vertically oriented pictures in their upright position (left) or sideways (right).

Official photo lingo uses the term *portrait orientation* to refer to vertically oriented pictures and *landscape orientation* to refer to horizontally oriented pictures.

Automatic rotation is turned on by default with the D5000. But if you prefer to turn the feature off, you can. Your vertically oriented pictures then appear sideways, as shown on the right in Figure 4-2.

To check or adjust the status of automatic rotation, you need to visit two menus:

1. **On the Setup menu, select Auto Image Rotation, as shown in the left image in Figure 4-3.**

 You need to scroll to the second screen of the menu to get to the Auto Image Rotation option. If you select On, the rotation data is added to the picture file. Select Off to leave the data out.

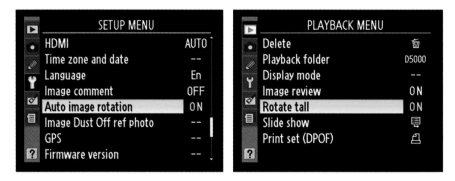

Figure 4-3: Visit the Setup and Playback menus to enable image rotation.

2. **Display the Playback menu and select the Rotate Tall option, as shown on the right in Figure 4-3.**

 Select On if you want the camera to read the orientation data and rotate vertical pictures. Select Off if you prefer not to rotate the photos during playback. The images are still rotated automatically in photo programs that can read the orientation data in the file.

 Shooting with the lens pointing directly up or down sometimes confuses the camera, causing it to record the wrong data in the file. If that issue bothers you, turn off Auto Image Rotation on the Setup menu before you shoot the pictures. The camera then won't record the orientation information as part of the picture file. Note that even if you select On, images aren't rotated for the instant review display, explained next.

Disabling and Adjusting Instant Review

After you take a picture, it automatically appears briefly on the camera monitor. By default, this instant-review period lasts four seconds. But you can customize this behavior in two ways:

✔ **Adjust the length of the instant-review period:** Display the Custom Setting menu, highlight the Timers/AE Lock submenu, and then press OK to display the screen shown on the left in Figure 4-4. Highlight Auto Off Timers and press OK. Highlight Custom and press OK again to display the screen on the right in Figure 4-4. Highlight Image Review and then press the Multi Selector right to access the timing options (not shown in the figure). You have five choices, ranging from four seconds to 10 minutes. Highlight the timing option you want to use and then press OK to return to the Custom screen. Highlight Done, as shown on the right in the figure, and press OK to lock in your choice.

Note that through this same Custom screen, you also can vary the length of time that a picture is displayed during regular playback before the monitor turns off. Just select the Playback/menus option on the screen you see on the right in Figure 4-4 to make the change.

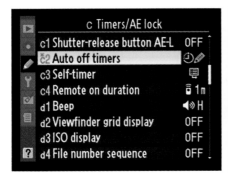 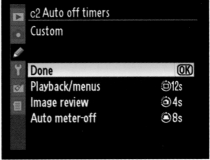

Figure 4-4: To adjust the length of the instant-review period, visit the Custom Setting menu.

✔ **Disable instant review:** Because any monitor use is a strain on battery power, consider turning off instant review altogether if your battery is running low. To turn off the feature, first display the Playback menu. Then highlight Image Review, as shown in Figure 4-5. Press OK, highlight Off, and press OK once more. You can still view your pictures by pressing the Playback button at any time.

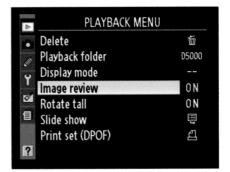

Figure 4-5: Head for the Playback menu to disable instant review altogether.

Viewing Images in Playback Mode

To take a look at the pictures on your camera memory card, take these steps:

1. **If you created custom image folders, specify which ones you want to view. Otherwise, skip to Step 2.**

 Your D5000 normally organizes pictures automatically into folders that are assigned generic names: 100D5000, 101D5000, and so on. You can see the name of the current folder by looking at the Active Folder option on the Shooting menu. (The default folder name appears as just D5000 on the menu.)

 You also can create custom folders through that same menu option. (See Chapter 11 for specifics.) If you do, you need to tell the camera whether you want to view only pictures in the current folder or in all folders. To do so, display the Playback menu and highlight Playback Folder, as shown on the left in Figure 4-6. Press OK to display the screen shown on the right in the figure. Select All to view all folders; select Current to view only the active folder. Press OK to exit the screen.

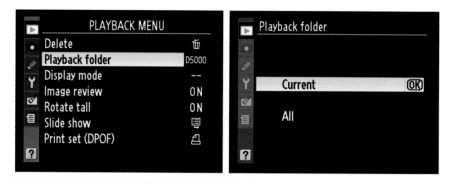

Figure 4-6: If you create custom folders, specify which folder you want to view.

 Again, this step applies only if you create custom folders. If you let the camera handle all folder-creation duties, you can view all pictures on the card regardless of the Playback Folder setting.

2. **Press the Playback button, labeled in Figure 4-7.**

 The monitor displays the last picture you took, along with some picture data, such as the frame number of the photo. To find out how to interpret the picture information and specify what data you want to see, see the upcoming section "Viewing Picture Data."

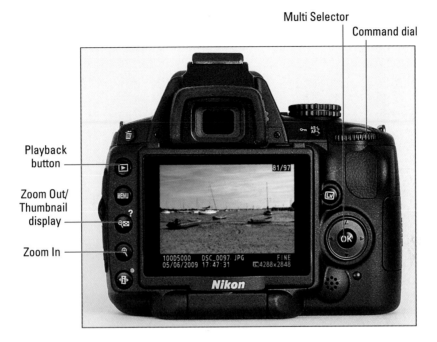

Figure 4-7: Navigate and inspect your photos using these controls.

3. **To scroll through your pictures, rotate the Command dial or press the Multi Selector right or left.**

 I highlighted the dial and Multi Selector in Figure 4-7.

4. **To return to picture-taking mode, press the shutter button halfway and then release it.**

These steps assume that the camera is currently set to display a single photo at a time, as shown in Figure 4-7. You can also display multiple images at a time, as explained next.

Viewing multiple images at a time

Along with viewing images one at a time, you can choose to display 4, 9, or 72 thumbnails, as shown in Figure 4-8. Just press the button shown in the margin here and labeled Zoom Out/Thumbnail display in Figure 4-7. Press once to cycle from single-picture view to 4-thumbnail view, press again to shift to 9-picture view, and press once more to bring up those itty-bitty thumbnails featured in 72-image view. Press yet again, and you shift to Calendar view, a nifty feature explained in the next section.

Selected image

Figure 4-8: You can view 4, 9, or 72 thumbnails at once.

To reduce the number of thumbnails, press the Zoom In button, shown cling-ing to the margin here and in Figure 4-7. Or to jump immediately to single-frame view without having to cycle back through all the display modes, just press the OK button.

In any of the thumbnail display modes, use these techniques to navigate your photo collection:

- ✔ **Scroll through your pictures.** Rotate the Command dial or press the Multi Selector right or left.

- ✔ **Select an image.** As you scroll through your pictures, a yellow box sur-rounds the currently selected image. For example, in Figure 4-8, Image 19 is selected. To select a different image, use the Command dial or Multi Selector to scroll the display until the highlight box surrounds the image.

- ✔ **View the selected image at the full-frame size.** Press the OK button.

After you return to full-frame view, pressing OK displays the Retouch menu. Now you can select a retouch option and apply it to the image. See Chapter 10 for a look at some of the picture fixes you can apply to your photo from the Retouch menu.

Displaying photos in Calendar view

In Calendar display mode, you see a little calendar on the monitor, as shown in Figure 4-9. By selecting a date on the calendar, you can quickly navigate to all pictures you shot on that day. (An empty date indicates that your memory card doesn't contain any photos from that day.)

Figure 4-9: Calendar view makes it easy to view all photos shot on a particular day.

The key to navigating Calendar view is the Zoom Out button:

1. **Press the Zoom Out button as needed to cycle through the thumbnail display modes until you reach Calendar view.**

 If you're currently viewing images in full-frame view, for example, you need to press the button four times to get to Calendar view.

2. **Using the Multi Selector or Command dial, move the yellow highlight box over a date that contains an image.**

 In Figure 4-9, for example, the 27th day of April is selected. (The number of the month appears in the top-left corner of the screen.) After you select a date, the right side of the monitor displays a vertical strip of thumbnails of pictures taken on that date.

3. **To view all thumbnails from the selected date, press the Zoom Out button again.**

 Now the vertical thumbnail strip becomes active, and you can scroll through the thumbnails by pressing the Multi Selector up and down, or by scrolling with the Command dial. A second highlight box appears in the thumbnail strip to indicate the currently selected image.

4. **To temporarily display a larger view of the selected thumbnail, hold down the Zoom In button.**

 The image filename appears under the larger preview, as shown in Figure 4-10. When you release the button, the large preview disappears, and the calendar comes back into view.

Figure 4-10: Press and hold the Zoom In button to temporarily view the selected image at a larger size.

5. **To jump back to the calendar and select a different date, press the Zoom Out button again.**

 You can just keep pressing the button to jump between the calendar and the thumbnail strip as much as you want.

6. **To exit Calendar view and return to single-image view, press OK.**

 If you want to return to Calendar view, you have to press the Zoom Out button four times to cycle from full-frame view through the different thumbnail display modes.

Zooming in for a closer view

After displaying a photo in single-frame view, you can magnify it so that you can get a close-up look at important details, such as whether someone's eyes are closed in a portrait. Here's the scoop:

- **Zoom in.** Press the Zoom In button, shown in the margin here. You can magnify the image to a maximum of 13 to 27 times its original display size, depending on the resolution (pixel count) of the photo. Just keep pressing the button until you reach the magnification you want.

 Note the magnifying glass icon on the button face — the plus sign in the middle is your reminder that this button enlarges the image.

- **View another part of the magnified picture.** When an image is magnified, a little navigation thumbnail showing the entire image appears briefly in the lower-right corner of the monitor, as shown in Figure 4-11. The yellow outline in this picture-in-picture image indicates the area that's currently consuming the rest of the monitor space. Use the Multi Selector to scroll the yellow box and display a different portion of the image. After a few seconds, the navigation thumbnail disappears; just press the Multi Selector in any direction to redisplay it.

Figure 4-11: Use the Multi Selector to move the yellow outline over the area you want to inspect.

↙ **Inspect faces.** When you magnify a photo that contains what the camera perceives to be faces, the picture-in-picture thumbnail displays a white border around each detected face. Press the Information Edit button and rotate the Command dial to examine each face with a magnified view.

↙ **View more images at the same magnification.** Here's another neat trick: While the display is zoomed, you can rotate the Command dial to display the same area of the next photo at the same magnification. So if you shot the same subject several times, you can easily check how the same details appear in each one.

↙ **Zoom out.** To zoom out to a reduced magnification, press the Zoom Out button, shown in the margin here. This button also sports the magnifying glass symbol, but this time with a minus sign to indicate that it reduces the display size. That little grid-like thingy next to the magnifying glass reminds you that the button also comes into play when you want to go from full-frame view to one of the thumbnail views or Calendar view.

↙ **Return to full-frame view.** When you're ready to return to the normal magnification level, you don't need to keep pressing the Zoom Out button until you're all the way zoomed out. Instead, just press the OK button, which quickly returns you to the standard, full-frame view.

Viewing Picture Data

In single-image picture view, you can choose from five Photo Information modes, each of which presents a different set of shooting data along with the image. To cycle between the different modes, press the Multi Selector up or down.

Note, though, that three of the five modes don't appear unless they are enabled through a menu option. To enable them, display the Playback menu and highlight Display Mode, as shown on the left in Figure 4-12. Press OK to display the second screen you see in the figure. A check mark in the box next to a mode means that mode is enabled. To toggle a display mode on, highlight it and then press the Multi Selector right. After turning on the options you want to use, highlight Done and press OK again to return to the Playback menu.

The next sections explain exactly what details you can glean from each display mode. I present them here in the order they appear if you cycle through the modes by pressing the Multi Selector down. You can spin through the modes in the other direction by pressing the Multi Selector up.

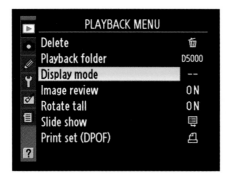 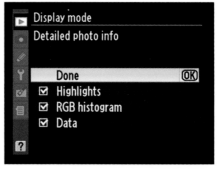

Figure 4-12: You must enable some of the information display modes via the Playback menu.

File Information mode

In this display mode, the monitor displays the data shown in Figure 4-13.

The following bits of info appear at the top of the monitor:

✔ **Protect Status:** A little key icon indicates that you used the camera's file-protection feature to prevent the image from being erased when you use the camera's Delete function. See "Protecting Photos," later in this chapter, to find out more. (*Note:* Formatting your memory card, a topic discussed in Chapter 1, *does* erase even protected pictures.) This area appears empty if you didn't apply protection.

✔ **Retouch Indicator:** This icon appears if you used any of the Retouch menu options to alter the image. (I cover most Retouch features in Chapter 10.) Again, no icon means that you didn't retouch the photo.

Figure 4-13: In File Information mode, you can view these bits of data.

✔ **Frame Number/Total Pictures:** The first value here indicates the frame number of the currently displayed photo; the second tells you the total number of pictures on the memory card. In Figure 4-13, for example, the image is number 41 out of 41.

Underneath the image, you can view these details:

✔ **Folder Name:** Folders are named automatically by the camera unless you create custom folders, an advanced trick you can explore in Chapter 11. The first camera-created folder is named 100D5000. Each folder can contain up to 9999 images; when you exceed that limit, the camera creates a new folder and assigns the next folder number: 101D5000, 102D5000, and so on.

✔ **Filename:** The camera also automatically names your files.

Filenames end with a three-letter code that represents the file format, which is either JPG (for JPEG) or NEF (for Camera RAW) for still photos. Chapter 3 discusses these two formats. If you record a movie (a project you can explore near the end of this chapter), the file extension is AVI, which represents a digital-movie file format. If you create a dust-off reference image file, an advanced feature designed for use with Nikon Capture NX 2, the camera instead uses the extension NDF. (Because this software must be purchased separately, I don't cover it or the dust-off function in this book.)

The first three letters of filenames also vary. Here's what the possible three-letter codes indicate:

- *DSC:* This code means normal, plain-old picture file.

- *SSC:* This trio appears at the beginning of files that you create with the Small Picture option on the Retouch menu. Chapter 9 discusses this feature.

- *CSC:* This code is used for images that you alter using other Retouch menu features. For example, I applied the D-Lighting correction feature to the image in Figure 4-13, so the filename begins with CSC, and the Retouch Indicator appears in the top-left corner of the monitor.

- *_ (underscore):* If you change the Color Space setting on the Shooting menu to the Adobe RGB color profile, a topic you can investigate in Chapter 6, an underscore character precedes the filename. (The exception is for dust-off reference photos, which don't use the underscore.) For photos taken in the default color profiles (sRGB), the underscore appears after the three-letter code, as in DSC_.

Each image is also assigned a four-digit file number, starting with 0001. When you reach image 9999, the file numbering restarts at 0001, and the new images go into a new folder to prevent any possibility of overwriting the existing image files. For more information about file numbering, see the Chapter 1 section that discusses the File Number Sequence option.

🖛 **Date and Time:** Just below the folder and filename info, you see the date and time that you took the picture. Of course, the accuracy of this data depends on whether you set the camera's date and time values correctly, which you do via the Setup menu. Chapter 1 has details.

🖛 **Image Quality:** Here you can see which Image Quality setting you used when taking the picture. Again, Chapter 3 has details, but the short story is this: Fine, Normal, and Basic are the three JPEG recording options, with Fine representing the highest JPEG quality. The word *RAW* indicates that the picture was recorded in the Nikon Camera RAW format, NEF.

🖛 **Image Size:** This value tells you the image resolution, or pixel count. See Chapter 3 to find out about resolution.

RGB Histogram mode

Press the Multi Selector down to shift from File Information mode to this mode, which displays your image in the manner shown in Figure 4-14. (Remember: You can view your picture in this mode only if you enable it via the Display Mode option on the Playback menu. See "Viewing Picture Data," earlier in this chapter, for help.)

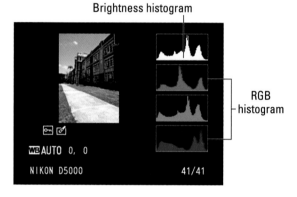

Figure 4-14: Histogram mode presents exposure and color information in chart-like fashion.

Underneath the image thumbnail, you see just a few pieces of data. As with File Information mode, you see the Protect Status and Retouch Indicator icons if you used those features. Beneath that, you see the White Balance settings used for the shot. (White balance is a color feature you can explore in Chapter 6.) Along the bottom row of the display, you see the camera name along with the Frame Number/Total Pictures data, also part of the standard File Information display data.

The core of this display mode, though, are those chart-like thingies, officially called *histograms*. You actually get two types of histograms: The top one is a Brightness histogram; the three others are collectively called an RGB (red, green, blue) histogram.

The next two sections explain what you can discern from the histograms. But first, here's a cool trick to remember: If you press the Zoom In button while in this display mode, you can zoom the thumbnail to a magnified view. The histograms then update to reflect only the magnified area of the photo. To return to the regular view and once again see the whole-image histogram, press OK.

Reading a Brightness histogram

You can get an idea of image exposure by viewing your photo on the camera monitor. But if you adjust the brightness of the monitor or the ambient light affects the display brightness, you may not get the real story. The Brightness histogram provides a way to gauge exposure that's a little more reliable.

A Brightness histogram indicates the distribution of shadows, highlights, and midtones (areas of medium brightness) in your image. Figure 4-15 shows you a sample histogram.

The horizontal axis of the histogram represents the possible picture brightness values — the maximum *tonal range,* in photography-speak — from the darkest shadows on the left to the brightest highlights on the right. And the vertical axis shows you how many pixels fall at a particular brightness value. A spike indicates a heavy concentration of pixels. For example, in Figure 4-15, the histogram shows a large supply of pixels clustered in the range just above medium brightness, but very few in the deepest shadows.

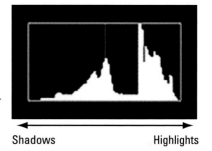

Shadows Highlights

Figure 4-15: The Brightness histogram indicates tonal range, from shadows on the left to highlights on the right.

Keep in mind that there is no one "perfect" histogram that you should try to achieve. Instead, interpret the histogram with respect to the distribution of shadows, highlights, and midtones that comprise your subject. You wouldn't expect to see lots of shadows, for example, in a photo of a polar bear walking on a snowy landscape. Pay attention, however, if you see a very high concentration of pixels at the far right or left end of the histogram, which can indicate a seriously overexposed or underexposed image, respectively. To find out how to resolve exposure problems, visit Chapter 5.

Understanding RGB histograms

When you view your images in RGB Histogram display mode, you see two histograms: the Brightness histogram, covered in the preceding section, and an RGB histogram. Figure 4-16 offers a sample RGB histogram for your consideration.

To make sense of the RGB histogram, you first need to know that digital images are called *RGB images* because they are created out of three primary colors of light: red, green, and blue. The RGB histogram shows you the brightness values for each of those primary colors.

By checking the brightness levels of the individual color components, sometimes referred to as color *channels,* you can assess the picture's color saturation levels. If most of the pixels for one or more channels are clustered toward the right end of the histogram, colors may be oversaturated, which destroys detail. On the flip side, a heavy concentration of pixels at the left end of the histogram indicates an image that may be under-saturated.

A savvy RGB histogram reader also can spot color-balance issues by looking at the pixel values. But frankly, color-balance problems are fairly easy to notice just by looking at the image itself on the camera monitor. And understanding how to translate the histogram data for this purpose requires more knowledge about RGB color theory than I have room to present in this book.

For information about manipulating color, see Chapter 6.

Less saturated More saturated

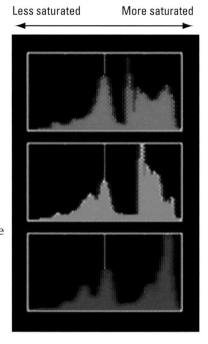

Figure 4-16: The RGB histogram can indicate problems with color saturation.

Highlight display mode

One of the most difficult photo problems to correct in a photo editing program is known as *blown highlights* in some circles and *clipped highlights* in others. In plain English, both terms mean that *highlights* — the brightest areas of the image — are so overexposed that areas that should include a variety of light shades are instead totally white. For example, in a cloud image, pixels that should be light to very light gray become white due to overexposure, resulting in a loss of detail in those clouds.

In Highlight display mode, areas that are totally white blink in the camera monitor. Notice the black spot over the right part of the sky in Figure 4-17. This area (shown here at the moment the highlights blinked off) indicates that all detail is lost in that area of the image. Like RGB Histogram mode, the Highlight mode is provided because simply viewing the image isn't always a reliable way to gauge exposure. To use it, however, you must follow the instructions laid out in the earlier section "Viewing Picture Data" to enable the mode.

Along with the blinking highlight warning, Highlight display mode presents the standard bits of information in this mode: the Protect Status, Retouch Indicator, and File Number/Total Pictures values, all explained in the earlier section "File Information mode." The label *Highlights* also appears to let you know the current display mode, as shown in Figure 4-17.

Figure 4-17: In Highlight mode, blinking areas indicate blown highlights.

I suggest that you check both the Brightness histogram offered in RGB Histogram display mode and the Highlight display, though, when you're concerned about overexposure. If an image contains only a small area of blown highlights, the histogram may indicate a very small pixel population at the brightest end of the spectrum, leading you to assume that you're okay in the exposure department. But if those blown highlights happen to fall in an important part of your image — someone's face, for example — they can wreck your picture.

Shooting Data display mode

Before you can access this mode, you must enable it via the Display Mode option on the Playback menu. See the earlier section, "Viewing Picture Data," for details. After turning on the option, press the Multi Selector down to shift from Highlights mode to Shooting Data mode.

In this mode, you can view three screens of information, which you toggle between by pressing the Multi Selector up and down. Figure 4-18 shows you the three screens, referred to in the Nikon manual as Shooting Data Page 1, 2, and 3.

Most of the data here won't make any sense to you until you explore Chapters 5 and 6, which explain the exposure, color, and other advanced settings available on your camera. But I do want to call your attention to a couple of factoids now:

- ✔ The top-left corner of the monitor shows the Protect Status and Retouch Indicator icons, if you used the protect or retouch features. Otherwise, the area is empty. (See the earlier section "File Information Mode" for details about these particular features.)

- ✔ The current frame number, followed by the total number of images on the memory card, appears in the lower-right corner of the display.

✔ The Comment item, which is the final item on the third screen, contains a value if you use the Image Comment feature on the Setup menu. I cover this option in Chapter 11.

✔ If the ISO value on Shooting Data Page 1 (the first screen in Figure 4-18) appears in red, the camera is letting you know that it overrode the ISO Sensitivity setting that you selected in order to produce a good exposure. This shift occurs only if you enable automatic ISO adjustment for the P, S, A, and M exposure modes. See Chapter 5 for details.

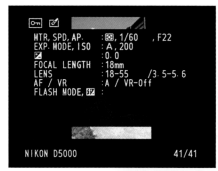

Figure 4-18: You can view the camera settings used to capture the image in Shooting Data display mode.

GPS Data mode

This display mode is available only if the image you're viewing was shot with the optional Nikon GPS (Global Positioning System) attached.

If you use the GPS unit, this display mode shows you the latitude, longitude, and altitude information recorded with the image file. You also see the date and time of the shot along with the standard Frame Number/Total Pictures numbers, the Protect Status icon, and the Retouch Indicator icon, all explained in the earlier section "File Information mode." The data screen appears in the same fashion as in Shooting Data mode, superimposed over your image.

Overview Data mode

This mode is the second of the two default photo-information modes. (Meaning, you don't have to enable it via the Display Mode option on the Playback menu to use it.) In this mode, the playback screen contains a small image thumbnail along with scads of shooting data — although not quite as much as Shooting Data mode — plus a Brightness histogram. Figure 4-19 offers a look.

The earlier section "Reading a Brightness histogram" tells you what to make of that part of the screen. Just above the histogram, you see the Protect Status and Retouch Indicator, while the Frame Number/Total Pictures data appears at the upper-right corner of the image thumbnail. For details on that data, see the earlier section "File Information mode." (As always, the Protect status and Retouch Indicator icons appear only if you used those two features; otherwise, the area is empty.)

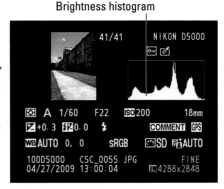

Brightness histogram

Figure 4-19: In Overview Data mode, you can view your picture along with the major camera settings you used to take the picture.

To sort out the maze of other information, the following list breaks things down into the five rows that appear under the image thumbnail and histogram. In the accompanying figures as well as in Figure 4-19, I include all possible data simply for the purposes of illustration; if any of the items don't appear on your screen, it simply means that the relevant feature wasn't enabled when you captured the shot.

- **Row 1:** This row shows the exposure-related settings labeled in Figure 4-20, along with the focal length of the lens you used to take the shot. Chapter 5 details the exposure settings; Chapter 6 introduces you to focal length.

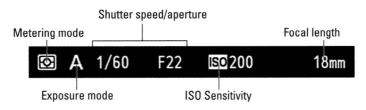

Figure 4-20: Here you can inspect major exposure settings along with the lens focal length.

✔ **Row 2:** This row contains a few additional exposure settings, labeled in Figure 4-21. On the right end of the row, the Comment and GPS labels appear if you took advantage of those options when recording the shot. (You must switch to the Shooting Data mode or GPS mode, respectively, to view the actual comment and GPS data.)

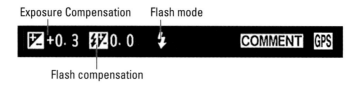

Exposure Compensation Flash mode

Flash compensation

Figure 4-21: This row contains additional exposure information.

✔ **Row 3:** The first three items on this row, labeled in Figure 4-22, relate to color options explored in Chapter 6. The last item indicates the Active D-Lighting setting, another exposure option discussed in Chapter 5.

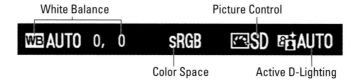

White Balance Picture Control

Color Space Active D-Lighting

Figure 4-22: Look at this row for details about advanced color settings.

✔ **Rows 4 and 5:** The final two rows of data (refer to Figure 4-19) show the same information you get in File Information mode, explained earlier in this chapter.

Deleting Photos

You can erase pictures from a memory card when it's in your camera in three ways. The next sections give you the lowdown. (Or is it the down low? I can't seem to keep up.)

Deleting images one at a time

The Delete button is key to erasing single images. But the process varies a little depending on which Playback display mode you're using, as follows:

✔ In single-image view, you can erase the current image by pressing the Delete button.

✔ In thumbnail view (displaying 4, 9, or 72 thumbnails), use the Multi Selector to highlight the picture you want to erase and then press the Delete button.

✔ In Calendar view, first highlight the date that contains the image. Then press the Zoom Out button to jump to the scrolling list of thumbnails, highlight a specific image, and press the Delete button.

After you press Delete, you see a message asking whether you really want to erase the picture. If you do, press the Delete button again. Or, to cancel out of the process, press the Playback button.

See the earlier section, "Viewing Images in Playback Mode," for more details about the display modes.

If you accidentally erase a picture, don't panic — you *may* be able to restore it by using data-restoration software such as MediaRecover ($30, www.mediarecover.com) or Lexar Image Rescue (also about $30, www.lexar.com). SanDisk also currently offers a recovery program with some of its high-performance memory cards. But in order to have a chance, you must not take any more pictures or perform any other operations on your camera while the current memory card is in it. If you do, you may overwrite the erased picture data for good and eliminate the possibility of recovering the image.

Deleting all photos

To erase all pictures, display the Playback menu and highlight Delete, as shown in the first image in Figure 4-23. Press OK to display the options shown in the second image. Highlight All and press the Multi Selector right. You then see a screen that asks you to verify that you want to delete all of your images. Select Yes and press OK.

Figure 4-23: To delete all photos, use the Delete option on the Playback menu.

If you create custom image folders, a feature I cover in Chapter 11, be aware that this step deletes only pictures in the folder that is currently selected via the Playback Folder option on the Playback menu. See the section "Viewing Images in Playback Mode," earlier in this chapter, for information.

Deleting a batch of selected photos

To erase multiple photos — but not all of them — display the Playback menu, highlight Delete, and press OK. You see the Delete screen shown in the second image in Figure 4-23.

You then have two options for specifying which photos to erase:

✔ **Select photos one-by-one.** To go this route, highlight Selected and press the Multi Selector right to display a screen of thumbnails, as shown in Figure 4-24. Use the Multi Selector to place the yellow highlight box over the first photo you want to delete and then press the Zoom Out button, shown in the margin here. A little trash can icon, the universal symbol for delete, appears in the upper-right corner of the thumbnail, as shown in the figure. If you change your mind, press the Zoom Out button again to remove the Delete tag from the image. To undo deletion for all selected photos, press the Playback button.

Delete icon

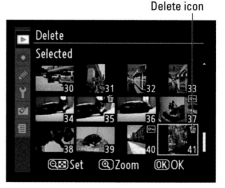

Figure 4-24: Use the Zoom Out button to tag pictures you want to delete.

For a closer look at the selected image, press and hold the Zoom In button. When you release the button, the display returns to normal thumbnail view.

✔ **Erase all photos taken on a specific date.** This time, choose Select Date from the main Delete screen. (Refer to the right image in Figure 4-23.) Press the Multi Selector right to display a list of dates on which you took the pictures on the memory card. Highlight a date and press the Multi Selector right. A little check mark appears in the box next to the date, tagging all images taken on that day for deletion. To remove the check mark and save the photos from the digital dumpster, press the Multi Selector right again.

Can't remember what photos are associated with the selected date? Press the Zoom Out button to display thumbnails of all the images. You can then press the Zoom In button to temporarily view a selected thumbnail at full-size view. To return to the date list, press the Zoom Out button again.

Deleting versus formatting: What's the diff?

In Chapter 1, I introduce you to the Format Memory Card command, which lives on the Setup menu and erases everything on your memory card. What's the difference between erasing photos by formatting and by choosing Delete from the Playback menu and then selecting the All option?

Well, if you happen to have stored other data on the card, such as, say, a music file or a picture taken on another type of camera, you need to format the card to erase everything on it. You can't view those files on the monitor, so you can't use Delete to get rid of them.

Also keep in mind that the Delete function affects only the currently selected folder of camera images. As long as you use the default folder system that the camera creates for you, however, "currently selected folder" is the same as "all images." The section "Viewing Images in Playback Mode," earlier in this chapter, talks more about this issue; Chapter 11 explains how to create custom folders.

One final — and important — note: Although using the Protect feature (explained elsewhere in this chapter) prevents the Delete function from erasing a picture, formatting erases all pictures, protected or not. Formatting also wipes out any photos you hid by using the Hide Image feature.

After selecting the photos or a shooting date, press OK to start the Delete process. You see a confirmation screen asking permission to destroy the images; select Yes and press OK. The camera trashes the photos and returns you to the Playback menu.

You have one alternative way to quickly erase all images taken on a specific date: In the Calendar display mode, you can highlight the date in question and then press the Delete button instead of going through the Playback menu. You get the standard confirmation screen asking you whether you want to go forward. Press the Delete button again to dump the files.

Protecting Photos

You can safeguard pictures from accidental erasure by giving them *protected status.* After you take this step, the camera doesn't allow you to erase a picture by using either the Delete button or the Delete option on the Playback menu.

Formatting your memory card, however, *does* erase even protected pictures. See the nearby sidebar for more about formatting.

The picture protection feature comes in especially handy if you share a camera with other people. You can protect pictures so that those other people know that they shouldn't delete your super-great images to make room on the memory card for their stupid, badly photographed ones. (This step isn't foolproof, though, because anyone can remove the protected status from an image.)

Perhaps more importantly, when you protect a picture, it shows up as a read-only file when you transfer it to your computer. Files that have that read-only status can't be altered. Again, anyone with some computer savvy can remove the status, but this feature can keep casual users from messing around with your images after you've downloaded them to your system. Of course, *you* have to know how to remove the read-only status yourself if you plan on editing your photo in your photo software. (**Hint:** In Nikon ViewNX, you can do this by clicking the image thumbnail and then choosing File⇨Protect Files⇨Unprotect.)

Anyway, protecting a picture is easy:

1. **Display or select the picture you want to protect.**

 - In single-image view, just display the photo.

 - In 4/9/72 thumbnail mode, use the Multi Selector as needed to place the yellow highlight box over the photo.

 - In Calendar view, highlight the date that contains the image and then press the Zoom Out button to jump to the scrolling list of thumbnails. Then move the highlight box over the image.

2. **Press the AE-L/AF-L button.**

 See the tiny key symbol that appears next to the button? That's your reminder that you use the button to lock a picture. After you press the button, the same symbol appears on the image display, as shown in Figure 4-25.

3. **To remove protection, display or select the image and press the AE-L/AF-L button again.**

Figure 4-25: Press the AE-L/AF-L button to prevent accidental deletion of the selected image.

Exploring Live View Shooting

If you've used a compact, point-and-shoot digital camera, you may be used to composing your pictures on the camera monitor rather than by looking through the viewfinder. In fact, many compact cameras no longer even offer a viewfinder, which is a real shame, in my opinion. Why? Because when you use the monitor to frame the image, you must hold the camera away from your body, a posture that increases the likelihood of blurry images caused by camera shake. When you use the viewfinder, you can brace the camera against your face, creating a steadier shooting stance.

Due to some design complexities that I won't bore you with, most digital SLR cameras do not enable you to preview shots on the monitor. Your D5000, however, does offer that feature, known as *Live View* in dSLR nomenclature. The D5000 also uses Live View when you record movies.

You need to know a few points about Live View as it's provided on your camera:

- **Manual focusing is recommended.** You can autofocus, assuming that you're using an AF-S type lens like the kit lens. (See Chapter 1 for more about that issue.) But even if your lens does offer autofocusing, manual focusing usually offers faster, more precise results.

- **Continuous autofocusing isn't possible.** In normal shooting, you can set the camera to continually adjust focus automatically up to the moment you fully depress the shutter button to record your picture. (See Chapter 6 for details.) This autofocus feature helps ensure that moving subjects remain sharply focused even after you initially establish focus by pressing the shutter button halfway.

 When you use autofocus in Live View mode, focus is always locked when you press the shutter button halfway. For still photography, you can always release the button and reset focus if needed, assuming that your subject isn't moving so quickly that you don't have time to do so. But when you use autofocusing in movie mode, you can't adjust the focus point after recording begins.

- **You must be extra careful to keep the camera steady.** Just as with a point-and-shoot camera, holding the camera out in front of you to capture the image can cause camera shake that can blur your image. But with an SLR, the risk is greater because of the added weight of the camera and lens. And if you use a so-called *long lens* — a telephoto or zoom lens that extends to a long focal length — the potential for camera shake is compounded. So for best results, mount the camera on a tripod when you use Live View. If you can't use a tripod, enable vibration reduction (VR on Nikon lenses), if your lens is equipped with this feature.

✔ **Using Live View for an extended period can harm your pictures and the camera.** When you work in Live View mode, the camera's innards heat up more than usual, and that extra heat can create the right electronic conditions for *noise,* a defect that gives your pictures a speckled look. (Chapter 5 offers more information.)

Perhaps more critically, the increased temperatures can damage the camera itself. For that reason, Live View is automatically disabled after one hour of shooting — or earlier, if a critical heat level is detected. When the camera is 30 seconds or less from shutting down your Live View session, you see a little LV symbol, with a numerical value (such as 18s) to let you know how many seconds you have to wrap things up. In extremely warm environments, you may not be able to use Live View mode for very long before the system shuts down.

✔ **Aiming the lens at the sun or other bright lights also can damage the camera.** Of course, you can cause problems doing this even during normal shooting, but the possibilities increase when you use Live View. You not only can harm the camera's internal components but also the monitor.

Live View also presents the two additional disadvantages which, in this case, are the same as for a point-and-shoot camera. First, any time you use the monitor, you put extra strain on the battery. So keep an eye on the battery status icon to avoid running out of juice at a critical moment. Second, the monitor can wash out in bright sunlight, making it difficult to compose outdoor shots.

This list of caveats doesn't mean that I'm telling you not to use Live View. But for normal photography — that is, still shooting rather than movie recording — you shouldn't envision Live View as a full-time alternative to using the viewfinder. Rather, think of it as a special-purpose tool that can help in situations where framing with the viewfinder is cumbersome. With the D5000, you do have the added advantage of being able to tilt the monitor, which enables you to compose scenes that would otherwise require the skills of a contortionist to compose through the viewfinder.

I find Live View most helpful for still-life, tabletop photography, especially in cases that require a lot of careful arrangement of the scene. For example, I have a shooting table that's about waist high. Normally, I put my camera on a tripod, come up with an initial layout of the objects I want to photograph, set up my lights, and then check the scene through the viewfinder. Then there's a period of refining the object placement, the lighting, and so on. If I'm shooting from a high angle, requiring the camera to be positioned above the table and pointing downward, I have to stand on my tiptoes or get a stepladder to check things out through the viewfinder between each compositional or lighting change. At lower angles, where the camera is tabletop height or below, I have to either bend over or kneel to look through the viewfinder, causing no end of later aches and pains to back and knees.

With Live View, I can alleviate much of that bothersome routine (and pain) because I can usually see how things look in the monitor no matter what the camera position. When composing a shot when the camera is overhead, remember that you can tilt the monitor to a position where it's easier to see.

With that lengthy preamble out of the way, the following section provides a primer in standard Live View shooting. Following that, you can find details about movie recording and discover a few ways to customize the Live View display.

Taking pictures in Live View mode

The following steps walk you through the process of Live View photography. For reasons explained in the preceding introduction to Live View shooting, manual focusing is recommended, so the steps assume that you stick with that focusing choice.

1. **Open the Custom Setting menu, select the Autofocus submenu, and set the Live View Autofocus option to Normal Area or Wide Area.**

 Okay, I know I just said that these steps assume that you're going to focus manually. But for reasons I won't get into, setting the Live View Autofocus option to the other available choices, Face Priority or Subject Tracking, limits your control when you check your focus later, in Step 7. So select either of the other two options.

 You also can adjust the autofocus mode by using the Quick Settings technique. Just press the Info Edit button to display the normal Quick Settings screen. In Live View mode, the autofocus option takes the place of the normal Focus mode option on the screen; look for it near the middle of the column of settings on the right side of the screen. After highlighting the option, press OK to display the four focus settings, select your choice, and press OK. Finally, press the Info Edit button again to return to the Live View display.

2. **Set the lens to manual focusing mode.**

 On the kit lens, set the A/M switch on the lens to M.

3. **If you're not using a tripod, turn on Vibration Reduction.**

 For the kit lens, set the VR switch on the lens to On.

4. **Press the Lv button on the camera back.**

 When the camera shifts to Live View, the scene in front of the lens appears on the monitor, as shown in Figure 4-26, and you no longer can see anything through the viewfinder.

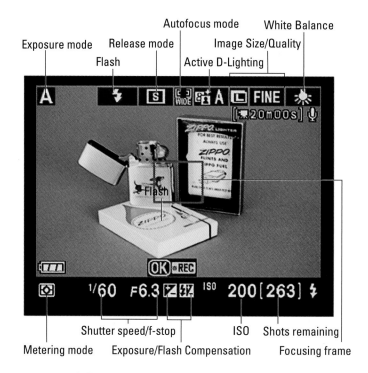

Figure 4-26: In Live View mode, you can compose your image on the monitor.

In the default Live View display mode, shown in Figure 4-26, you see a bunch of shooting data along with your image, as labeled in Figure 4-26. If your monitor doesn't show the same data as in Figure 4-26, don't worry: You can control what data is displayed by adjusting the settings explained in the last section of this chapter. A few notes about this display:

- Some symbols, such as those representing Exposure Compensation and Flash Compensation values, appear only if you enable those features. (Chapter 5 details these settings.)

- The OK symbol near the bottom center of the screen is a reminder that you press OK to start recording video.

- The symbols just under the Image Size/Quality symbols in Figure 4-26 also relate to movie recording, explained later in this chapter.

- The red rectangle, labeled Focusing frame in the figure, appears as a result of choosing the Wide Area auto focusing option in Step 1. If you instead select Normal Area, you see a smaller rectangle. More on what you actually do with that rectangle in Step 7.

Again, you can easily adjust any of these settings without exiting Live View mode by pressing the Info Edit button to shift to the Quick Settings display. (Refer to Step 1 for more details.)

5. **Frame the shot.**

6. **Turn the lens focusing ring to set initial focus.**

7. **Press the Zoom In button to magnify the view and refine focus, if needed.**

Pressing the button zooms the display, with each press giving you a closer look at the shot. As when you magnify an image when you're viewing photos in Playback mode, a small thumbnail in the corner of the monitor appears, with the yellow highlight box indicating the area that's currently being magnified. To scroll the display and check another part of the image, press the Multi Selector to move the red focusing frame over the area you want to inspect. (Here's where that Live View Autofocus setting selected in Step 1 becomes important: If it's set to Face Priority or Subject Tracking mode, you can't scroll the display to view specific parts of the picture.)

To reduce the magnification, press the Zoom Out button. When you're happy with the focus, zoom out until you return to full-frame view.

8. **Check the exposure settings.**

They appear at the bottom of the screen, as shown in Figure 4-26. If needed, you can adjust exposure in the P, S, and A exposure modes by using Exposure Compensation, explained in Chapter 5. In Manual (M) mode, you can adjust f-stop and shutter speed as outlined in Chapter 5. In the fully automatic exposure modes, you can't adjust exposure.

9. **Depress the shutter button fully to take the shot.**

You see your just-captured picture on the monitor for a few seconds, as usual. Then the Live View preview returns, and you're ready to take the next shot.

10. **To exit the Live View preview, press the Lv button.**

You can then return to framing your images through the viewfinder.

Recording movies

Your D5000 offers the ability to record digital movies. Although recording live action with a D5000 involves a few limitations and difficulties that you don't experience with a real video camera, it's a fun option to have onboard nonetheless.

Before I give you the specifics, here's the broad overview of D5000 movie making:

✔ **Movie quality:** Select this option from the Movie Settings option on the Shooting menu, as shown in Figure 4-27. The settings determine the frame size and aspect ratio of the movie: 320 x 216 pixels, for a 3:2 aspect ratio (the same aspect ratio as your D5000 still images); 640 x 424, also a 3:2 aspect ratio; and 1280 x 720, which gives you a 16:9 aspect ratio, which is found on many new TV sets and computer monitors.

The higher the pixel count, the larger you can display the movie on a TV or monitor before you see the quality of the playback deteriorate. But a higher Quality setting also produces a larger file, eating up more of your memory card, and reduces the maximum length of the movie you can record, as outlined next.

✔ **Maximum movie length/file size:** If you select the highest movie resolution (1280 x 720 pixels), your movie can have a maximum length of five minutes and a maximum file size of 2GB. At the two lower-resolution settings, you're still restricted to 2GB file sizes, but the movies can run as long as 20 minutes. Of course, you must have 2GB of empty memory card space to store the movie.

✔ **Frame rate:** The *frame rate* determines the smoothness of the playback. At all three Quality settings, the frame rate is 24 frames per second, or fps. By contrast, the standard frame rate for television-quality video is 30 frames per second, so expect your movies to play a little less smoothly than your favorite sitcoms.

✔ **Sound recording:** You can record sound or shoot a silent movie; make the call via the Movie Settings option on the Shooting menu (shown in Figure 4-27).

If you enable sound, note the position of the microphone: It's the little three-holed area above the D5000 logo, on the front of the camera. Make sure that you don't inadvertently cover up the microphone with your finger. And keep in mind that anything *you* say will be picked up by the mike along with any other audio present in the scene.

Figure 4-27: Specify movie quality and sound recording options via the Shooting menu.

✔ **Video format:** Movies are created in the AVI format, which means you can play them on your computer using most movie-playback programs. If you want to view your movies on a TV, you can connect the camera to the TV, as explained in Chapter 9. Or if you have the necessary computer software, you can convert the AVI file to a format that a standard DVD player can recognize and then burn the converted file to a DVD disk. You also can edit your movie in a program that can work with AVI files.

So far, so good. None of the aforementioned details is terribly unusual or complicated. Where things get a little tricky for the would-be filmmaker are in the areas of focus and exposure:

✔ **Focusing:** As with regular Live View photography, you can use auto-focusing to establish initial focus on your subject before you begin recording. But after recording begins, the autofocus system lays down and plays dead. So unless you're recording a static subject — say, a guitar player sitting on a stool or a speaker at a lectern — opt for manual focusing. You can then adjust focus manually any time during the recording.

If you plan to also zoom in and out, give yourself some time to practice before the big event. It's a bit of a challenge to zoom and focus at the same time, especially while holding the camera in front of you so that you can see the monitor. (A tripod makes the maneuver slightly easier.)

✔ **Exposure:** The camera automatically sets exposure based on the light throughout the entire scene. In the P, S, and A modes, you can apply Exposure Compensation, a feature covered in Chapter 5, to produce a darker or lighter exposure. And, in the M and A modes, you can request a specific f-stop, but you must do so before you begin recording. In the other modes, you get no exposure control.

To try out movie recording, first set your camera to manual focusing and, if you're not using a tripod, turn on Vibration Reduction (or whatever form of image stabilization your lens offers). Then take these steps:

1. **Set your movie preferences through the Movie Settings option on the Shooting menu.**

 The first part of this section explains your options.

2. **Press the Lv button to switch to Live View mode.**

3. **Compose your shot.**

4. Set focus.

You can use the techniques outlined in the preceding section to magnify the display to check focus if needed.

5. Press OK to begin recording.

A red Rec symbol begins flashing at the top of the monitor. If your monitor is set to the default Live View display mode, you also see the recording symbols shown at the top of Figure 4-28. As recording progresses, the area labeled Time Remaining value shows you how many more seconds of video you will be able to record. (The length is dependent on the movie-quality settings you choose and the amount of space on your memory card.) Again, see the last section of this chapter for more details about customizing the screen display.

6. To stop recording, press OK.

7. Press the Lv button to exit Live View mode and return to normal shooting.

To play your movie, press the Playback button. In single-image playback mode, you can spot a movie file by looking for the little movie-camera icon in the top-left corner of the screen, as shown on the left in Figure 4-29. Press OK to start playback.

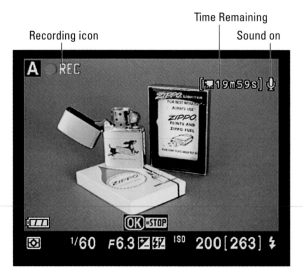

Figure 4-28: The red Rec symbol flashes while recording is in progress.

Movie icon Movie length

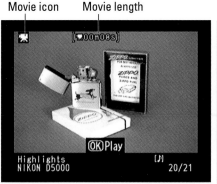

Movie file thumbnail

Figure 4-29: The little movie camera symbol tells you you're looking at a movie file.

In the thumbnail and Calendar playback modes, you see little filmstrip dots along the edges of movie files, as shown on the right in Figure 4-29. This time, press OK twice: once to shift to single-image view and again to start movie playback.

After playback begins, a little playback control icon appears in the lower-left corner of the screen, as shown in Figure 4-30. It represents the Multi Selector and reminds you that you can use these techniques to control the playback:

Playback control

Figure 4-30: This little icon reminds you to use the Multi Selector to control movie playback.

- ✔ Press OK to pause or resume playback.

- ✔ Press the Multi Selector right or left to fast-forward or rewind the movie or, if playback is paused, to advance or rewind one frame.

- ✔ Press the Multi Selector up to stop playback.

- ✔ To increase playback volume, press the Zoom In button; for a quieter playback, press the Zoom Out button.

Chapter 9 explains how to connect your camera to a television so you can play your movies "on the big screen."

Customizing the Live View display

Whether you are shooting movies or still photos, you can choose from several Live View display styles, which include:

- ✔ **Show Indicators:** In this mode, your screen appears as shown earlier in this chapter, in Figure 4-26.

- ✔ **Hide Indicators:** Select this mode to hide all the indicators that are displayed over your image in the Show Indicators mode except the icon that represents your chosen exposure mode and the battery status icon.

- ✔ **Framing Grid:** This mode displays a grid over the image, as shown on the left in Figure 4-31. The grid is helpful when you need to precisely align objects in your photo. But note that if you zoom the display to check focusing, the grid disappears until you return to normal magnification.

- ✔ **Show Shooting Information:** In this mode, the screen appears as shown on the right in Figure 4-31. It's like having the Quick Settings screen data available to you without actually having to shift to Quick Settings mode. (Remember that if you do want to enter Quick Settings mode, a quick press of the Information Edit button gets the job done.

To cycle through the various displays, you just press the Info button. But which ones appear depend on some menu options you select through the Custom Settings menu. After traveling to that menu, highlight the Shooting/Display option and press OK. Then highlight Live View Display Options, as shown on the left in Figure 4-32, and press OK. You then see the screen shown on the right in the figure. A check mark in the box next to the display option enables that display choice. To toggle the check mark on and off, highlight the box and press the Multi Selector up or down. When you're finished choosing options, highlight Done and press OK.

Figure 4-31: While in Live View mode, press the Info button to change the display mode.

Figure 4-32: Use this menu to change Live View options.

If you connect your camera to an HDMI (High-Definition Multimedia Interface) device, you no longer see the live scene on your camera monitor. Instead, the view is displayed on your video device. In that scenario, the arrangement of the shooting information on the screen may appear slightly different than in the examples in this chapter.

Part II
Taking Creative Control

The 5th Wave By Rich Tennant

"I've got some new image editing software, so I took the liberty of erasing some of the smudges that kept showing up around the clouds. No need to thank me."

In this part . . .

*A*s nice as it is to be able to set your D5000 to automatic mode and let the camera handle most of the photographic decisions, I encourage you to take creative control and explore the advanced exposure modes (P, S, A, and M). In these modes, you can make your own decisions about the exposure, focus, and color characteristics of your photo, which are key to capturing a compelling image as you see it in your mind's eye. And don't think that you have to be a genius or spend years to be successful — adding just a few simple techniques to your photographic repertoire can make a huge difference in the quality of the pictures you take.

The first two chapters in this part explain everything you need to know to do just that, providing both some necessary photography fundamentals as well as details about using the advanced exposure modes. Following that, Chapter 7 helps you draw together all the information presented earlier in the book, summarizing the best camera settings and other tactics to use when capturing portraits, action shots, landscapes, and close-up shots. In short, this part helps you get the most out of your camera, which results in you becoming a better photographer.

5

Getting Creative with Exposure and Lighting

*U*nderstanding exposure is one of the most intimidating challenges for the new photographer. Discussions of the topic are loaded with unfamiliar, techy-sounding terms — *aperture, metering, shutter speed, ISO,* and the like. Add the fact that your D5000 offers oodles of exposure controls, all sporting equally foreign names, and it's no wonder that most people throw up their hands and decide that their best option is to simply stick with the Auto exposure mode and let the camera take care of all exposure decisions.

You can, of course, turn out super shots in Auto mode. And I fully relate to the exposure confusion you may be feeling — I've been there. But from years of working with beginning photographers, I can promise that when you take things nice and slow, digesting just a piece of the exposure pie at a time, the topic is not nearly as complicated as it seems on the surface. And I guarantee that the payoff will be well worth your time and brain energy.

You'll not only gain the power to resolve just about any exposure problem, but also discover ways to use exposure to put your own creative stamp on a scene.

To that end, this chapter provides everything you need to know to really exploit your D5000's exposure options, from a primer in exposure science (it's not as bad as it sounds) to explanations of all the camera's exposure controls. In addition, because some controls aren't accessible in the fully automatic exposure modes, this chapter also introduces you to the four advanced modes, P, S, A, and M.

Introducing the Exposure Trio: Aperture, Shutter Speed, and ISO

Any photograph, whether taken with a film or digital camera, is created by focusing light through a lens onto a light-sensitive recording medium. In a film camera, the film negative serves as that medium; in a digital camera, it's the image sensor, which is an array of light-responsive computer chips.

Between the lens and the sensor are two barriers, known as the *aperture* and *shutter,* which together control how much light makes its way to the sensor. The actual design and arrangement of the aperture, shutter, and sensor vary depending on the camera, but Figure 5-1 offers an illustration of the basic concept.

The aperture and shutter, along with a third feature known as *ISO,* determine *exposure* — what most of us would describe as the picture's overall brightness and contrast. This three-part exposure formula works as follows:

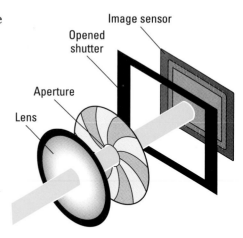

Figure 5-1: The aperture size and shutter speed determine how much light strikes the image sensor.

- ✏ **Aperture (controls amount of light):** The *aperture* is an adjustable hole in a diaphragm set just behind the lens. By changing the size of the aperture, you control the size of the light beam that can enter the camera. Aperture settings are stated as *f-stop numbers,* or simply *f-stops,* and are expressed with the letter *f* followed by a number: f/2, f/5.6, f/16, and so on. The lower the f-stop number, the larger the aperture, and the more light is permitted into the camera, as illustrated by Figure 5-2.

The range of possible f-stops depends on your lens and, if you use a zoom lens, on the zoom position (focal length) of the lens. When you use the 18–55mm lens that Nikon bundles in the D5000 kit, you can select apertures from f/3.5–f/22 when zoomed all the way out to the shortest focal length, 18mm. When you zoom in to the maximum focal length, 55mm, the aperture range is f/5.6–f/36. (See Chapter 6 for a discussion of focal lengths.)

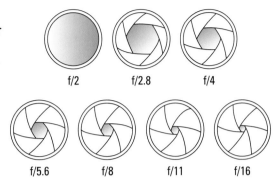

Figure 5-2: A lower f-stop number means a larger aperture, allowing more light into the camera.

✐ **Shutter speed (controls duration of light):** Set behind the aperture, the shutter works something like, er, the shutters on a window. When you aren't taking pictures, the camera's shutter stays closed, preventing light from striking the image sensor, just as closed window shutters prevent sunlight from entering a room. When you press the shutter button, the shutter opens briefly to allow light that passes through the aperture to hit the image sensor.

The length of time that the shutter is open is called the *shutter speed* and is measured in seconds: 1/60 second, 1/250 second, 2 seconds, and so on. Shutter speeds on the D5000 range from 30 seconds to 1/4000 second when you shoot without the built-in flash. If you do use the built-in flash, the range is more limited; see the sidebar "In sync: Flash timing and shutter speed," later in this chapter, for information.

Should you want a shutter speed longer than 30 seconds, manual (M) exposure mode also provides a feature called *bulb* exposure. At this setting, the shutter stays open indefinitely as long as you press the shutter button down.

✐ **ISO (controls light sensitivity):** ISO, which is a digital function rather than a mechanical structure on the camera, enables you to adjust how responsive the image sensor is to light. The term ISO is a holdover from film days, when an international standards organization rated each film stock according to light sensitivity: ISO 200, ISO 400, ISO 800, and so on. Film or digital, a higher ISO rating means greater light sensitivity, which means that less light is needed to produce the image, enabling you to use a smaller aperture, faster shutter speed, or both.

On the D5000, you can select ISO settings ranging from 100 to a whopping 6400. (The high and low ends of the scale are named Lo 1 and Hi 1, respectively.)

Distilled down to its essence, the image-exposure formula is just this simple:

✔ Aperture and shutter speed together determine the quantity of light that strikes the image sensor.

✔ ISO determines how much the sensor reacts to that light.

The tricky part of the equation is that aperture, shutter speed, and ISO settings affect your pictures in ways that go *beyond* exposure. You need to be aware of these side effects, explained in the next section, to determine which combination of the three exposure settings will work best for your picture.

Understanding exposure-setting side effects

You can create the same exposure with many combinations of aperture, shutter speed, and ISO. You're limited only by the aperture range allowed by the lens and the shutter speeds and ISO range offered by the camera.

But as I hinted in the preceding section, the settings you select impact your image beyond mere exposure, as follows:

✔ **Aperture affects depth of field.** The aperture setting, or f-stop, affects *depth of field,* which is the range of sharp focus in your image. I introduce this concept in Chapter 2, but here's a quick recap: With a shallow depth of field, your subject appears more sharply focused than faraway objects; with a large depth of field, the sharp-focus zone spreads over a greater distance.

As you reduce the aperture size — or *stop down the aperture,* in photo lingo — by choosing a higher f-stop number, you increase depth of field. As an example, take a look at the two images in Figure 5-3. For both shots, I established focus on the foreground grass. Notice that the background in the first image, taken at an aperture setting of f/5.6, appears noticeably softer than in the right example, taken at f/13. Aperture is just one contributor to depth of field, however; see Chapter 6 for the complete story.

✔ **Shutter speed affects motion blur.** At a slow shutter speed, moving objects appear blurry, whereas a fast shutter speed captures motion cleanly. Compare the tall foreground grass in the images in Figure 5-3, for example. A brisk wind was blowing when I took these pictures, and as a result, the foreground grass is captured without blur only at the 1/160 second shutter speed used for the left image. How fast a shutter speed you need to freeze action depends on the speed of the subject, of course.

f/5.6, 1/160 second, ISO 200 f/13, 1/60 second, ISO 400

Figure 5-3: Stopping down the aperture (by choosing a higher f-stop number) increases depth of field, or the zone of sharp focus.

If your picture suffers from overall image blur like you see in Figure 5-4, where even stationary objects appear out of focus, the camera itself moved during the exposure, which is always a danger when you hand-hold the camera. The slower the shutter speed, the longer the exposure time and the longer you have to hold the camera still to avoid the blur that is caused by camera shake.

How slow is too slow? It depends on your physical capabilities and your lens — a longer, heavier lens adds to the challenge, obviously. For reasons that are too technical to get into, camera shake also affects your picture more when you shoot with a lens that has a long focal length. For example, you may be able to use a much slower shutter speed when you shoot with a lens that has a maximum focal length of 55mm, like the kit lens, than if you switch to a 200mm telephoto lens. (Chapter 6 explains focal length, if the term is new to you.)

The best idea is to do your own tests to see where your hand-holding limit lies. Start with a slow shutter speed — say, in the 1/40 second neighborhood, and then click off multiple shots, increasing the shutter speed for each picture. If you have a zoom lens, run the test first at the minimum focal length (widest angle) and then zoom to the maximum focal length for another series of shots. Then it's simply a matter of comparing the images in your photo editing program. (You may not be able to accurately judge the amount of blur on the camera monitor.) See Chapter 8 to find out how to see the shutter speed you used for each picture when you view your images.

Some Nikon lenses, including the 18–55mm kit lens, offer *vibration reduction,* which is designed to help compensate for small amounts of camera shake. If you're using a lens from another manufacturer, the feature may go by the name *image stabilization* or something similar. Whatever you call it, this option can enable you to capture sharp images at slightly slower shutter speeds than normal when handholding the camera. (Again, your mileage may vary, but most people can expect to go at least two or three notches down the shutter-speed ramp.) On the D5000 kit lens, just set the VR switch on the side of the lens to the On position to enable vibration reduction.

See Chapter 6 for tips on solving other focus problems and Chapter 7 for more help with action photography.

f/13, 1/20 second, ISO 200

Figure 5-4: Slow shutter speeds increase the risk of all-over blur caused by camera shake.

✔ **ISO affects image noise.** As ISO increases, making the image sensor more reactive to light, you increase the risk of producing a defect called *noise.* This defect looks like sprinkles of sand and is similar in appearance to film *grain,* a defect that often mars pictures taken with high ISO film. Noise can also be caused by very long exposure times.

Ideally, then, you should always use the lowest ISO setting on your camera to ensure top image quality. But sometimes, the lighting conditions simply don't permit you to do so and still use the aperture and shutter speeds you need. Take the rose images in Figure 5-5, for example. Here again, a mild breeze was blowing, so I knew I needed a

fast shutter to capture the flower without blur. I opened the aperture to f/6.3, which was the maximum on the lens I was using, to allow as much light as possible into the camera. Even so, I needed a shutter speed of 1/40 second to expose the picture at ISO 200 — and that shutter speed wasn't fast enough to catch the swaying flower without blur, as shown on the left in the figure. Using the lowest ISO (ISO 100, or Lo 1) would have made the situation that much worse. By raising the ISO to 400, I was able to use a shutter speed of 1/80 second, which captured a sharp image of the flower.

Fortunately, you don't encounter serious noise on the D5000 until you really crank up the ISO. In fact, you may even be able to get away with ISO 3200 if you keep your print or display size small. But as with other image defects, noise becomes more apparent as you enlarge the photo. Noise is also easier to spot in shadow areas of your picture and in large areas of solid color, like the sky in the marina scene you see in Figure 5-6. To give you an idea of how ISO affects noise, Figure 5-7 shows you magnified views of a bit of the marina scene captured at several ISO settings, from ISO 200 to 3200.

Long story short, understanding how aperture, shutter speed, and ISO affect your image enables you to have much more creative input over the look of your photographs — and, in the case of ISO, to also control the quality of your images. (Chapter 3 discusses other factors that affect image quality.)

ISO 200, f/6.3, 1/40 second ISO 400, f/6.3, 1/80 second

Figure 5-5: A higher ISO enabled me to select a shutter speed fast enough to capture a blur-free flower shot on a windy day.

Doug Sahlin

Figure 5-6: When you print or view a photo at a small size, as here, you may not be able to spot noise even at high ISO settings.

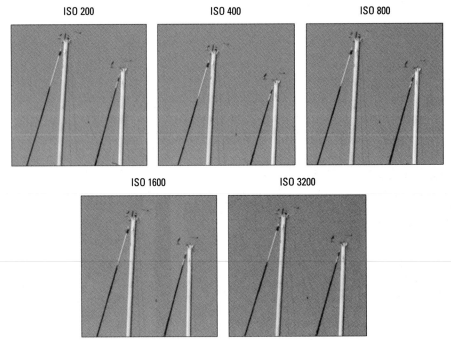

Doug Sahlin

Figure 5-7: High ISO noise is revealed in these enlarged views of the sky area from Figure 5-6.

Putting the f (stop) in focus

One way to remember the relationship between f-stop and depth of field, or the range of distance over which objects remain in sharp focus, is simply to think of the *f* as standing for *focus*. A higher f-stop number produces a larger depth of field, so if you want to extend the zone of sharp focus to cover a greater distance from your subject, you set the aperture to a higher f-stop. Higher f-stop number, greater zone of sharp focus.

Please *don't* share this tip with photography elites, who will roll their eyes and inform you that the *f* in *f-stop* most certainly does *not* stand

for focus but for the ratio between the aperture size and lens focal length — as if *that's* helpful to know if you're not an optical engineer. (Chapter 6 explains focal length, which *is* helpful to know.)

As for the fact that you *increase* the f-stop number when you want a *smaller* aperture, well, I'm still working on the ideal mnemonic tip for that one. But try this in the meantime: **L**ower f-stop, **l**arger aperture. Or maybe the opposite: **R**aise the f-stop to **r**educe the aperture size and **r**estrict the light. (As I said, I'm working on it.)

Doing the exposure balancing act

As you change any of the three exposure settings — aperture, shutter speed, and ISO — one or both of the others must also shift in order to maintain the same image brightness. Say that you're shooting a soccer game, for example, and you notice that although the overall exposure looks great, the players are appearing slightly blurry at your current shutter speed. If you raise the shutter speed, you have to compensate with either a larger aperture, to allow in more light during the shorter exposure, or a higher ISO setting, to make the camera more sensitive to the light — or both.

As the preceding section explains, changing these settings impacts your image in ways beyond exposure. As a quick reminder:

- ✔ Aperture affects depth of field, with a higher f-stop number producing a greater zone of sharp focus.

- ✔ Shutter speed affects whether motion of the subject or camera results in a blurry photo. A faster shutter "freezes" action and also helps safeguard against allover blur that can result from camera shake when you're handholding the camera.

- ✔ ISO affects the camera's sensitivity to light. A higher ISO makes the camera more responsive to light but also increases the chance of image noise.

So when you boost that shutter speed to capture your soccer subjects, you have to decide whether you prefer the shorter depth of field that comes with a larger aperture or the increased risk of noise that accompanies a higher ISO.

Everyone has their own approach to finding the right combination of aperture, shutter speed, and ISO, and you'll no doubt develop your own system as you become more practiced at using the advanced exposure modes. In the meantime, here's how I handle things:

- ✐ I always use the lowest possible ISO setting unless the lighting conditions are so poor that I can't use the aperture and shutter speed I want without raising the ISO.

- ✐ If my subject is moving (or might move, as with a squiggly toddler or antsy pet), I give shutter speed the next highest priority in my exposure decision. I might choose a fast shutter speed to ensure a blur-free photo or, on the flip side, select a slow shutter to intentionally blur that moving object, an effect that can create a heightened sense of motion. (The waterfall photo in Chapter 7 offers an example of the latter technique.)

- ✐ For images of non-moving subjects, I make aperture a priority over shutter speed, setting the aperture according to the depth of field I have in mind. For portraits, for example, I use the largest aperture (the lowest f-stop number, known as shooting *wide open,* in photographer speak) so that I get a short depth of field, creating a nice, soft background for my subject. For landscapes, I go the opposite direction, stopping down the aperture as much as possible to capture the subject at the greatest depth of field.

I know that keeping all this straight is a little overwhelming at first, but the more you work with your camera, the more the whole exposure equation will make sense to you. You can find tips for choosing exposure settings for specific types of pictures in Chapter 7; keep moving through this chapter for details on how to actually monitor and adjust aperture, shutter speed, and ISO settings on the D5000.

Exploring the Advanced Exposure Modes

You can control one critical aspect of exposure, ISO, in the fully automatic exposure modes. But if you want access to all options, you need to set the Mode dial to one of the advanced modes highlighted in Figure 5-8: P, S, A, or M. You also need to shoot in these modes to use certain other features, such as manual white balancing, a color control that you can explore in Chapter 6.

Each of the four modes offers a different way to control aperture and shutter speed:

Advanced exposure modes

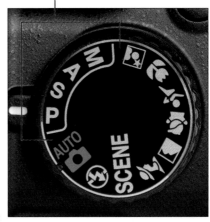

- **P (programmed autoexposure):** In this mode, the camera selects both aperture and shutter speed. But you can choose from different combinations of the two, which gives you creative flexibility not possible in the fully automatic exposure modes discussed in Chapter 2.

- **S (shutter-priority autoexposure):** In this mode, you select a shutter speed, and the camera chooses the aperture setting that produces a good exposure at your selected ISO setting.

Figure 5-8: You can control exposure and certain other picture properties fully only in P, S, A, or M mode.

- **A (aperture-priority autoexposure):** The opposite of shutter-priority autoexposure, this mode asks you to select the aperture setting. The camera then selects the appropriate shutter speed to properly expose the picture.

- **M (manual exposure):** In this mode, you specify both shutter speed and aperture.

To sum up, the first three modes are semi-automatic exposure modes that are designed to help you get a good exposure while still providing you with some photographic flexibility. Note one important point about the semi-auto modes, however: In extreme lighting conditions, the camera may not be able to select settings that will produce a good exposure. (The camera will warn you about the potential problem but doesn't prevent you from capturing the shot.) Manual mode puts all exposure control in your hands. But even in Manual mode, you're never really flying without a net — the camera assists you by displaying the exposure meter, explained next.

Reading the Meter

To help you determine whether your exposure settings are on cue in M (manual) exposure mode, the camera displays an *exposure meter* in the viewfinder and Shooting Information display. The meter is a little linear

graphic that indicates whether your current settings will properly expose the image. Figure 5-9 shows the exposure meter as viewed in the Shooting Information display. In the viewfinder, the meter appears to the right of the f-stop and looks similar to the examples shown in Figure 5-10.

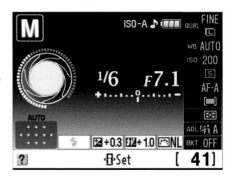

Figure 5-9: You can view the exposure meter in the Shooting Information display.

The minus-sign end of the meter represents underexposure; the plus sign, overexposure. So if the little notches on the meter fall to the right of 0, as shown in the first example in Figure 5-10, the image will be underexposed. If the indicator moves to the left of 0, as shown in the second example, the image will be overexposed. The farther the indicator moves toward the plus or minus sign, the greater the potential problem. When the meter shows a balanced exposure, as in the third example, you're good to go.

Underexposure Overexposure Good exposure

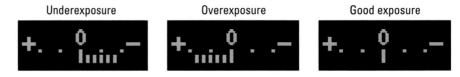

Figure 5-10: The exposure meter indicates whether your exposure settings are on target.

In the other exposure modes, the meter appears in the viewfinder and Shooting Information screen if the camera anticipates an exposure problem. The word Lo at the end of the meter tells you that the photo may be seriously underexposed; the Word Hi indicates severe overexposure. In dim lighting, you may also see a blinking flash symbol. It's a not-so-subtle suggestion to add some light to the scene. A blinking question mark tells you that you can press the Zoom Out button to display a Help screen with more information.

If you're so inclined, you can customize the meter in the following ways:

 ✔ **Adjust the meter shutoff timing.** The meter turns off automatically if you don't press the shutter button for a period of time — 8 seconds, by default. You can adjust the shut-off timing if you like, however. First, display the Custom Setting menu, highlight Timers/AE Lock, and press OK. Highlight Auto Off Timers, as shown on the left in Figure 5-11, and

press OK. Highlight Custom, as shown on the right in Figure 5-11, and press OK. On the next screen, shown on the left in Figure 5-12, highlight Auto Meter-Off and press OK. Now you can adjust the timing of the meter without also affecting the timing of the image-review and play-back/menu displays. Highlight your choice from the options shown on the right in Figure 5-12 and press OK again. Finally — and this is a critical last step — highlight Done and press OK. Keep in mind that shorter delay times conserve battery power.

✔ **Reverse the meter orientation.** You can flip the meter so that the positive (overexposure) side appears on the right and the negative (underexposure) side falls on the left. This option also lies on the Custom Setting menu, but this time you need to visit the Controls submenu. Highlight the Reverse Indicators submenu of the Controls submenu, as shown in Figure 5-13, and press OK. Choose the desired option and press OK.

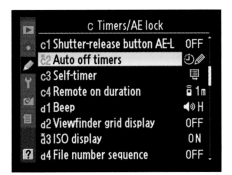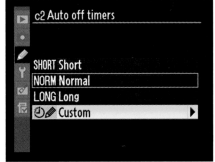

Figure 5-11: You can customize the behavior of the exposure meter.

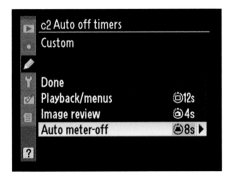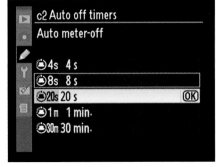

Figure 5-12: Choose the desired time from the available options and then choose Done to make your changes official.

Keep in mind that the meter's suggestion on exposure may not always be the one you want to follow. For example, you may want to shoot a backlit subject in silhouette, in which case you *want* that subject to be underexposed. In other words, the meter is a guide, not a dictator. In addition, remember that the exposure information the meter reports is based on the *exposure metering mode,* which determines which part of the frame the camera considers when calculating exposure. At the default setting, exposure is based on the

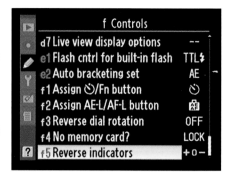

Figure 5-13: You can reverse the meter orientation from this menu option.

entire frame, but you can select two other metering modes. See the upcoming section "Choosing an Exposure Metering Mode" for details.

Setting ISO, Aperture, and Shutter Speed

The next sections detail how to view and adjust these three critical exposure settings. Remember, you can adjust ISO in any exposure mode, but to control aperture (f-stop) or shutter speed, you must switch to one of the four advanced exposure modes (P, S, A, or M).

Adjusting aperture and shutter speed

You can view the current aperture (f-stop) and shutter speed in the view-finder and Shooting Information display, as shown in Figure 5-14. (Press the Info button to display the Shooting Information screen.)

In the viewfinder, shutter speeds are presented as whole numbers, even if the shutter speed is set to a fraction of a second. For example, the number 125 indicates a shutter speed of 1/125 second. When the shutter speed slows to 1 second or more, quote marks appear after the number — 1" indicates a shutter speed of 1 second, 4" means 4 seconds, and so on.

To select aperture and shutter speed, start by pressing the shutter button halfway to kick the exposure system into gear. You can then release the button if you want. The next step depends on the exposure mode, as follows:

Shutter speed Aperture

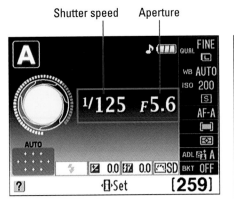

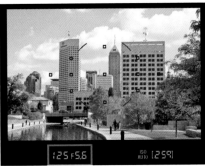

Figure 5-14: Look for the current f-stop, shutter speed, and ISO settings here.

✔ **P (programmed auto):** In this mode, the camera shows you its recommended f-stop and shutter speed when you press the shutter button halfway. But you can rotate the Command dial to select a different combination of settings. The number of possible combinations depends upon the aperture settings the camera can select, which in turn depend on the lighting conditions and your lens.

An asterisk (*) appears next to the P exposure mode symbol in the upper-left corner of the Shooting Information display after you rotate the Command dial to indicate that you adjusted the aperture/shutter speed settings from those the camera initially suggested. You see a P* symbol at the end of the viewfinder display as well. To get back to the initial combo of shutter speed and aperture, rotate the Command dial until the asterisk disappears from the Shooting Information display and the P* turns off in the viewfinder.

✔ **S (shutter-priority autoexposure):** In this mode, you select the shutter speed. Just rotate the Command dial to get the job done.

As you change the shutter speed, the camera automatically adjusts the aperture as needed to maintain what it considers the proper exposure. Remember that as the aperture shifts, so does depth of field — so even though you're working in shutter-priority mode, keep an eye on the f-stop, too, if depth of field is important to your photo. Also note that in extreme lighting conditions, the camera may not be able to adjust the aperture enough to produce a good exposure at your current shutter speed — again, possible aperture settings depend on your lens. So you may need to compromise on shutter speed (or in dim lighting, raise the ISO).

✏ **A (aperture-priority autoexposure):** In this mode, you control aperture, and the camera adjusts shutter speed automatically. To set the aperture (f-stop), rotate the Command dial.

When you stop down the aperture (raise the f-stop value), be careful that the shutter speed doesn't drop so low that you run the risk of camera shake if you handhold the camera — unless you have a tripod handy, of course. And if your scene contains moving objects, make sure that when you dial in your preferred f-stop, the shutter speed that the camera selects is fast enough to stop action (or slow enough to blur it, if that's your creative goal). These same warnings apply when you use P mode, by the way.

✏ **M (manual exposure):** In this mode, you select both aperture and shutter speed, like so:

- *To adjust shutter speed:* Rotate the Command dial.

- *To adjust aperture:* Press the Exposure Compensation button while simultaneously rotating the Command dial. Notice the little aperture-like symbol that lies next to the button, on the top of the camera? That's your reminder of the button's role in setting the f-stop in Manual mode.

Keep in mind that when you use P, S, or A modes, the settings that the camera selects are based on what it thinks is the proper exposure. If you don't agree with the camera, you have two options: You can switch to manual exposure mode and simply dial in the aperture and shutter speed that deliver the exposure you want; or if you want to stay in P, S, or A mode, you can tweak exposure using the Exposure Compensation feature, explained later in this chapter.

Controlling ISO

The ISO setting, introduced at the start of this chapter, adjusts the camera's sensitivity to light. At a higher ISO, you can use a faster shutter speed or a smaller aperture (higher f-stop number) because less light is needed to expose the image.

You can adjust ISO in any exposure mode. Moreover, you can specify whether you want to display the ISO value in the viewfinder. To make that call, open the Custom Setting menu, navigate to the Shooting/Display submenu, highlight ISO Display (as shown on the left in Figure 5-15), and press OK to display the options shown on the right in Figure 5-15.

Here are your choices:

✓ **Off:** This mode is the default setting. With this setup, you see an ISO readout in the viewfinder only when the ISO setting is set to Auto, an option you can read about a little later in this chapter. If you shift to a manual ISO control, you must refer to the Shooting Information display to see the setting.

✓ **On:** If you choose this option, the ISO value replaces the frames-remaining value in the viewfinder. After enabling this option, you must visit the Shooting Information screen to see the frames-remaining value.

Whichever display option you choose, you can quickly adjust the ISO setting through the Quick Settings screen. Highlight the current ISO setting as shown on the left in Figure 5-16 and press OK to display the options shown on the right. Choose the desired ISO setting and press OK. If you find that you're changing ISO settings frequently, you may want to consider changing the Function (Fn) button option to ISO Sensitivity as outlined in Chapter 11.

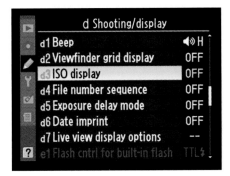 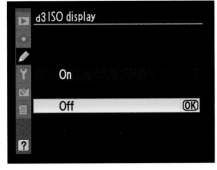

Figure 5-15: You can choose from two options for displaying ISO.

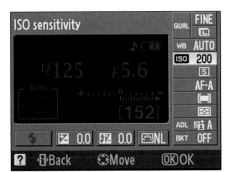 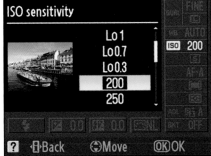

Figure 5-16: You can adjust ISO easily through the Quick Settings Screen.

Dampening noise

Noise, the digital defect that gives your pictures a speckled look (refer to Figure 5-7), can occur for two reasons: a high ISO speed and a long exposure time.

The D5000 offers two noise-removal filters: High ISO Noise Reduction, designed to help eradicate ISO-related noise, and Long Exposure Noise Reduction, designed to dampen the type of noise that occurs during long exposures. You can enable both filters through the Shooting menu. Look for the options named Long Exp. NR and High ISO NR.

If you turn on Long Exposure Noise Reduction, the camera applies the filter to any pictures taken at shutter speeds of longer than 8 seconds. For High ISO Noise Reduction, choosing High, Normal, or Low applies the filter at ISO settings of 800 or higher; the setting you choose determines the strength of the filter. If you choose Off, the camera actually still applies a tiny amount of noise removal, but only when you shift into the Hi ISO settings (Hi 0.3 or greater).

Before you enable noise reduction, be aware that doing so has a few disadvantages. First, the filters are applied after you take the picture, as the camera processes the image data. (While the Long Exposure Noise Reduction filter is being applied, the message "Job nr" appears in the viewfinder, in the area normally reserved for the shutter speed and aperture.) The time needed to apply the filter can slow down your shooting speed.

Second, noise-reduction filters work primarily by applying a slight blur to the image. Don't expect this process to totally eliminate noise, and do expect some resulting image softness. You may be able to get better results by using the blur tools or noise-removal filters found in many photo editors, because you can blur just the parts of the image where noise is most noticeable — usually in areas of flat color or little detail, such as skies.

You also can select the ISO setting through the Shooting menu. Highlight ISO Sensitivity Settings, as shown on the left in Figure 5-17, and press OK to display the right screen in the figure. Highlight ISO Sensitivity and press OK. Highlight the setting you want to use and press OK again. Note that the second screen in the figure shows options available only in the P, S, A, and M modes.

Keep the following factoids in mind about the ISO settings themselves:

✔ **Auto ISO in Auto and Digital Vari-Program modes:** In these exposure modes, the list of ISO settings includes Auto ISO. Select this option if you want the camera to take the ISO reins entirely.

✔ **Auto ISO in advanced exposure modes:** In the advanced exposure modes (P, S, A, and M), Auto ISO doesn't appear on the ISO settings list. However, you still can enable Auto ISO as sort of a safety net. Here's how it works: You dial in a specific ISO setting — say, ISO 200. If the camera decides that it can't properly expose the image at that ISO given your current aperture and shutter speed, it automatically adjusts ISO as necessary.

Figure 5-17: You can also set ISO and access additional ISO options through the Shooting menu.

To get to this option, first select ISO Sensitivity Settings on the Shooting menu, as shown on the left in Figure 5-17. Then press OK to display the screen shown on the right. This screen displays the current ISO setting, which can be changed by highlighting it, pressing OK, and then choosing the desired setting from the next menu. To enable Auto ISO, highlight ISO Sensitivity Auto Control, as shown in the figure, and press OK. Highlight On from the next screen and press OK. The camera will now override your ISO choice when it thinks a proper exposure is not possible with the settings you've specified.

Next, use the Maximum Sensitivity and Minimum Shutter Speed options, also shown in Figure 5-17, to tell the camera exactly when it should step in and offer ISO assistance. With the first option, you specify the highest ISO setting the camera may select when it does override your ISO decision. The second option sets the minimum shutter speed at which the ISO override engages. For example, you can specify that you want the camera to amp up ISO if the shutter speed drops to 1/40 second or below. This second option only affects shots you take in the P and A exposure modes, however.

If the camera is about to override your ISO setting, it alerts you by blinking the ISO Auto label in the viewfinder. The message "ISO-A" blinks in the top-right corner of the Shooting Information screen as well. And in Playback mode, the ISO value appears in red if you view your photos in the Shooting Information display mode. (Chapter 4 has details.)

To disable Auto ISO override, just reset the ISO Sensitivity Auto Control to Off.

↙ **Hi/Lo settings:** The specific ISO values presented to you range from 200 to 3200. But if you scroll past those settings, you discover three more settings in each direction: Hi 0.3, Hi 0.7, and Hi 1.0; and Lo 0.3, Lo 0.7, and Lo 1.0. These settings, in order, translate to ISO values of about 160, 125, and 100 at the low end and 4000, 5000, and 6400 at the high end.

Choosing ISO 3200 pretty much ensures a noisy image (refer to Figure 5-7), and shifting into the Hi settings just makes things worse. If cranking up ISO is the only way to capture the image, and you'd rather have a noisy picture than no picture, go for it. Otherwise, adjust shutter speed and aperture to get the exposure you want instead. You can always mount the camera on a tripod if the shutter speed is too slow for using the camera handheld, although you should keep in mind that a long exposure time also can produce added noise.

Also check out the earlier sidebar "Dampening noise" for features that may help calm noise somewhat.

Choosing an Exposure Metering Mode

To fully interpret what your exposure meter tells you, you need to know which *metering mode* is active. The metering mode determines which part of the frame the camera analyzes to calculate the proper exposure. The metering mode affects the exposure-meter reading as well as the exposure settings that the camera chooses in the fully automatic shooting modes (Auto, Portrait, and so on) as well as in the semi-auto modes (P, S, and A).

Your D5000 offers three metering modes, described in the following list and represented on the Shooting Information display by the icons you see in the margins:

✔ **Matrix:** The camera analyzes the entire frame and then selects an exposure that's designed to produce a balanced exposure.

Your camera manual refers to this mode as 3D Color Matrix II, which is simply the label that Nikon created to describe the specific technology used in this mode.

✔ **Center-weighted:** The camera bases exposure on the entire frame but puts extra emphasis — or *weight* — on the center of the frame. When you choose this metering option, the area that's given priority in this mode is about 8mm in diameter, which is represented by the circle in the viewfinder, labeled in Figure 5-18.

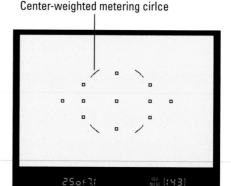

Figure 5-18: In center-weighted metering, the camera gives priority to objects that fall under the circle.

✔ **Spot:** In this mode, the camera bases exposure entirely on a circular area that's about 3.5mm in diameter. The exact location used for this pin-point metering depends on an autofocusing option called the AF-area mode. Detailed in Chapter 6, this option determines which of the camera's 11 focus points the autofocusing system uses to establish focus. Here's how the setting affects exposure:

- • If you choose the Auto-area mode, in which the camera chooses the focus point for you, exposure is based on the center focus point.

- • If you use any of the other AF-area modes, which enable you to select a specific focus point, the camera bases exposure on that point.

Because of this autofocus/autoexposure relationship, it's best to switch to one of the AF-area modes that allow focus-point selection when you want to use spot metering. In the Auto-area mode, exposure may be incorrect if you compose your shot so that the subject isn't at the center of the frame.

As an example of how metering mode affects exposure, Figure 5-19 shows the same image captured at each mode. In the Matrix example, the bright background caused the camera to select an exposure that left the statue quite dark. Switching to center-weighted metering helped somewhat, but didn't quite bring the statue out of the shadows. Spot metering produced the best result as far as the statue goes, although the resulting increase in exposure left the sky a little washed out.

Matrix metering Center-weighted metering Spot metering

Figure 5-19: The metering mode determines which area of the frame the camera considers when calculating exposure.

 You don't have a choice of metering modes in Auto mode or any of the Digital Vari-Program scene modes; the camera automatically uses matrix mode for all shots. But in P, A, S, or M modes, you can specify which metering mode you prefer. When the Shooting Information screen is displayed, press the Information Edit button and use the Multi Selector to navigate to the Metering mode icon, as shown on the left in Figure 5-20. Click OK to display the second screen in the figure, select the desired mode, and press OK to make the change.

 The metering mode you choose stays in effect when shooting in P, S, A, and M modes, even when you turn the camera off. Remember to change the metering mode when taking a picture under different lighting conditions.

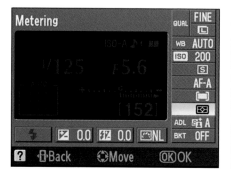
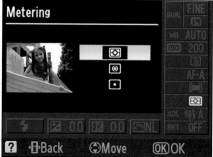

Figure 5-20: You can change the metering mode for difficult lighting conditions.

 In theory, the best practice is to check the metering mode before you shoot and choose the one that best matches your exposure goals. But in practice, that's a bit of a pain, not just in terms of having to adjust yet one more capture setting but in terms of having to *remember* to adjust one more capture setting. So here's my advice: Until you're really comfortable with all the other controls on your camera, just stick with the default setting, which is matrix metering. That mode produces good results in most situations, and, after all, you can see in the monitor whether you disagree with how the camera metered or exposed the image and simply reshoot after adjusting the exposure settings to your liking. This option, in my mind, makes the whole metering mode issue a lot less critical than it is when you shoot with film.

The one exception to this advice might be when you're shooting a series of images in which a significant contrast in lighting exists between subject and background, as in my examples here. Then, switching to center-weighted metering or spot metering may save you the time of having to adjust the exposure for each image. You may also want to investigate the section

"Expanding Tonal Range with Active D-Lighting," which tells you about a camera feature that can help you record brighter shadows without losing highlights.

Applying Exposure Compensation

When you set your camera to the P, S, or A modes, you can enjoy autoexposure support but still retain some control over the final exposure. If you think that the image the camera produced is too dark or too light, you can use a feature known as *Exposure Compensation*.

This feature enables you to tell the camera to produce a darker or lighter exposure than what its autoexposure mechanism thinks is appropriate. Best of all, this feature is probably one of the easiest on the whole camera to understand. Here's all there is to it:

 ✔ Exposure compensation settings are stated in terms of EV values, as in +2.0 EV. Possible values range from +5.0 EV to –5.0 EV. (The *EV* stands for *exposure value*.)

Each full number on the EV scale represents an exposure shift of one *stop*. In plain English, that means that if you change the exposure compensation setting from EV 0.0 to EV –1.0, the resulting exposure is equivalent to adjusting the aperture or shutter speed to allow half as much light into the camera as at the current setting. If you instead raise the value to EV +1.0, the exposure is equivalent to adjusting the settings to allow twice the light.

 ✔ A setting of EV 0.0 results in no exposure adjustment.

 ✔ For a brighter image, raise the EV value. The higher you go, the brighter the image becomes.

 ✔ For a darker image, lower the EV value.

As an example, take a look at the first image in Figure 5-21. The initial exposure selected by the camera left the balloon a tad too dark for my taste. So I just amped the Exposure Compensation setting to EV +1.0, which produced the brighter exposure on the right.

You can view the current Exposure Compensation setting in the Shooting Information screen (look for it in the area highlighted at the bottom of the screen in Figure 5-22). To change the setting, hold down the Exposure Compensation button, found near the shutter button. The Shooting Information display then appears as shown in Figure 5-22. If you're looking through the viewfinder, the frames-remaining value is temporarily replaced by the Exposure Compensation value when you press the Exposure Compensation button.

EV 0.0

EV +1.0

Figure 5-21: For a brighter exposure, raise the EV value.

While holding the Exposure Compensation button, rotate the Command dial to adjust the EV value. Notice that as you change the setting, the exposure meter in the viewfinder and Shooting Information display will update to show you the degree of adjustment you're making, as shown in Figure 5-22.

After you release the button, the Shooting Information screen goes back to normal, and the frames-remaining value returns to the viewfinder.

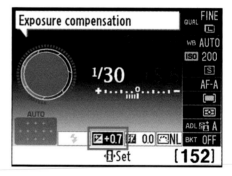

Figure 5-22: Press the Exposure Compensation button to display this screen; then rotate the Command dial to change the setting.

Your Exposure Compensation setting remains in force until you change it, even if you power off the camera. So you may want to make a habit of checking the setting before each shoot or always setting the value back to EV 0.0 after taking the last shot for which you want to apply compensation.

Here are a few other tips about Exposure Compensation:

✔ How the camera arrives at the brighter or darker image you request through your Exposure Compensation setting depends on the exposure mode:

- In A (aperture-priority autoexposure) mode, the camera adjusts the shutter speed but leaves your selected f-stop in force. Be sure to check the resulting shutter speed to make sure that it isn't so slow that camera shake or blur from moving objects is problematic.

- In S (shutter-priority autoexposure) mode, the opposite occurs: The camera opens or stops down the aperture, leaving your selected shutter speed alone.

- In P (programmed autoexposure) mode, the camera decides whether to adjust aperture, shutter speed, or both.

- In all three modes, the camera may also adjust ISO if you have Auto ISO enabled.

Keep in mind that the camera can adjust f-stop only so much, according to the aperture range of your lens. And the range of shutter speeds, too, is limited by the camera itself. So if you reach the ends of those ranges, you either have to compromise on shutter speed or aperture or adjust ISO.

✔ By default, Exposure Compensation settings are provided in increments of one-third of a stop. For example, you can shift from EV 0.0 to 0.3, 0.7. 1.0, and so on. If you want a more pronounced result from each step up or down the EV ladder, you can set the mechanism to increments of one-half stop instead. Then the settings become EV 0.0, 0.5, 1.0, and so on. Make the adjustment via the EV Steps for Exposure Control option on the Exposure submenu of the Custom Setting menu, shown in Figure 5-23.

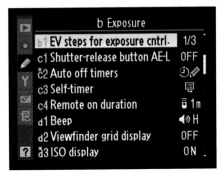

Figure 5-23: You can set the Exposure Compensation option to adjust exposure in one-half stops rather than one-third stops if you prefer.

✔ Finally, if you don't want to fiddle with Exposure Compensation, just switch to Manual exposure mode — M, on the Mode dial — and select whatever aperture and shutter speed settings produce the exposure you're after. Exposure Compensation has no effect on manual exposures; again, that adjustment is made only in the P, S, and A modes.

Using Autoexposure Lock

To help ensure a proper exposure, your camera continually meters the light in a scene until the moment you depress the shutter button fully and capture the image. In autoexposure modes — that is, any mode but M — it also keeps adjusting exposure settings as needed to maintain a good exposure.

For example, say that you set your camera to shutter-priority autoexposure (S) mode and set the shutter speed to 1/125 second. The camera immediately reports the f-stop that it considers appropriate to expose the scene at that shutter speed. But if the light in the scene changes or you reframe your shot before snapping the picture, the camera may shift the f-stop automatically to make sure that the exposure remains correct.

For most situations, this approach works great, resulting in the right settings for the light that's striking your subject at the moment you capture the image. But on occasion, you may want to lock in a certain combination of exposure settings. For example, perhaps you want to appear at the far edge of the frame. If you were to use the normal shooting technique, you would place the subject under a focus point, press the shutter button halfway to lock focus and set the initial exposure, and then reframe to your desired composition to take the shot. The problem is that the exposure is then recalculated based on the new framing, which can leave your subject under- or overexposed.

The easiest way to lock in exposure settings is to switch to M (manual) exposure mode and use the f-stop, shutter speed, and ISO settings that work best for your subject. But if you prefer to stay in P, S, or A mode, you can press the AE-L/AF-L button to lock exposure and focus simultaneously. Here's the technique I recommend:

1. **Set the metering mode to spot metering.**

 See the section "Choosing an Exposure Metering Mode," earlier in this chapter, if you need help changing the metering mode.

2. **Set the AF-area mode option to the Single Point setting and then use the Multi Selector to select your desired focus point.**

 This step tells the camera which part of the frame you want to use for establishing focus and, if you use spot metering, also determines which part of the frame the camera uses to calculate exposure. (You sometimes need to press the shutter button halfway and release it before you can do so.)

The fastest way to select the AF-area mode is through the Quick Settings display; see Chapter 6 for details. After you select the Single Point option, you can use the Multi Selector to choose a focusing point.

3. **Frame your shot so that the subject appears under the selected focus point and then press the shutter button halfway to set focus.**

 You can then release the shutter button if you want.

4. **Press and hold the AE-L/AF-L button.**

 The button's just to the right of the viewfinder.

 While the button is pressed, the letters AE-L appear at the left end of the viewfinder to remind you that exposure lock is applied.

5. **Reframe the shot if desired and take the photo.**

 Be sure to keep holding the AE-L/AF-L button until you release the shutter button!

By default, this step locks both exposure and focus for as long as you press the button, even if you release the shutter button. (AE-L stands for autoexposure lock; AF-L, for autofocus lock.) But if you dig into the Custom Setting menu, you can change the button's function. You can set the button to lock only exposure, for example, or only focus, instead of locking both as it does by default. Chapter 11 offers details.

One more tidbit: You can also use Autoexposure Lock in the Digital Vari-Program and Autoexposure modes. However, because those modes use matrix metering, this technique usually doesn't work well in those modes.

Expanding Tonal Range with Active D-Lighting

A scene like the one in Figure 5-24 presents the classic photographer's challenge: Choosing exposure settings that capture the darkest parts of the subject appropriately causes the brightest areas to be overexposed. And if you instead "expose for the highlights" — that is, set the exposure settings to capture the brightest regions properly — the darker areas are underexposed.

In the past, you had to choose between favoring the highlights or the shadows. But thanks to a feature that Nikon calls Active D-Lighting, you have a better chance of keeping your highlights intact while better exposing the darkest areas. In my seal scene, turning on Active D-Lighting produced a brighter rendition of the darkest parts of the rocks and the seals, for example, and yet the color in the sky didn't get blown out as it did when I captured the image with Active D-Lighting turned off. The highlights in the seal and in the rocks on the lower-right corner of the image also are toned down a tad in the Active D-Lighting version.

Active D-Lighting Off

Automatic Active D-Lighting On

Figure 5-24: Active D-Lighting enabled me to capture the shadows without blowing out the highlights.

Active D-Lighting actually does its thing in two stages. First, it selects exposure settings that result in a slightly darker exposure than normal. This half of the equation guarantees that you retain details in your highlights. Without that adjustment, the brightest areas of the image might be overexposed, leaving you with a batch of all-white pixels that really should contain a range of tones from light to lighter to white. So a cloud, for example, would appear as a big white blob, with no subtle tonal details to give it form. After you snap the photo, the second part of the process occurs. During this phase, the camera applies an internal software filter to brighten only the darkest areas of the image. This adjustment rescues shadow detail, so that you wind up with a range of dark tones instead of a big black blob.

You can turn Active D-Lighting on and off in two ways:

✔ Select Active D-Lighting from the Shooting menu, as shown on the left in Figure 5-25. Press OK to display the second screen in the figure, where you can specify the amount of Active D-Lighting adjustment. At the Auto setting, the camera determines how much adjustment is needed. If you prefer to take control, you can select from one of the other four settings

(Extra High, High, Normal, and Low). Press OK to enable the adjustment for your next shot.

✔ After displaying the Shooting Information screen, press the Information Edit button to shift to Quick Settings mode. Then use the Multi Selector to highlight the Active D-Lighting option, as shown on the left in Figure 5-26. Press OK to get to the screen shown on the right in the figure, where you can select the amount of Active-D-Lighting you want to apply. Highlight your choice and press OK.

TIP

If you're not sure how much adjustment to apply, try out the Active D-Lighting *bracketing* feature. With this option, you take one shot without Active D-Lighting and another shot with the current Active D-Lighting setting. You then can decide which image you prefer. See the last section in this chapter for details about bracketing with the D5000.

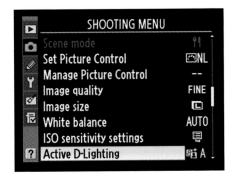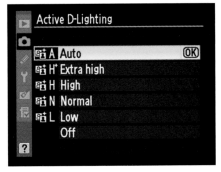

Figure 5-25: At the Auto setting, the camera automatically applies the amount of Active D-Lighting adjustment as it sees fit.

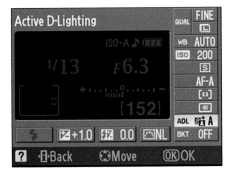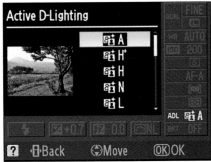

Figure 5-26: You can change the Active D-Lighting setting easily via the Quick Settings screen.

If you decide you're better off not using the feature, just set the option to Off via the Shooting menu or Quick Settings display.

Remember, too, that the camera's Retouch menu offers a D-Lighting filter that applies a similar adjustment to existing pictures. (See Chapter 10 for help.) Some photo editing programs, such as Adobe Photoshop Elements and Photoshop, also have good shadow and highlight recovery filters. In either case, when you shoot with Active D-Lighting disabled, you're better off setting the initial exposure settings to record the highlights as you want them. It's very difficult to bring back lost highlight detail after the fact, but you typically can unearth at least a little bit of detail from the darkest areas of the image.

Using Flash in P, S, A, and M modes

Sometimes, no amount of fiddling with aperture, shutter speed, and ISO produces a bright enough exposure — in which case, you simply have to add more light. The built-in flash on your D5000 offers the most convenient solution.

When you shoot in the advanced exposure modes, you have much more control over your flash than when you use the fully automatic modes covered in Chapter 2. First, you gain access to flash modes not available in the full-auto modes. Even better, you can adjust the strength of the flash by using a feature called *Flash Compensation*.

The rest of this chapter explains how to use these flash functions and also offers some tips on getting better results in your flash pictures. Be sure to also visit Chapter 7, where you can find additional flash and lighting tips related to specific types of photographs.

Setting the flash mode

To raise the built-in flash in P, S, A, and M exposure modes, press the Flash button on the front-left side of the camera. You then can view the current flash mode in the Shooting Information display, as labeled in Figure 5-27. In the viewfinder, you see a simple lightning-bolt icon when flash is enabled.

To change the flash mode, hold the Flash button down as you rotate the Command dial. Alternatively, you can set the flash mode through the Quick Settings screen. After highlighting the Flash mode icon, press OK to access the available settings, as shown on the right in Figure 5-27. Highlight the desired mode and press OK.

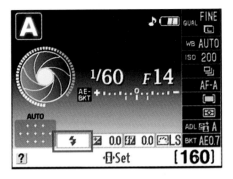
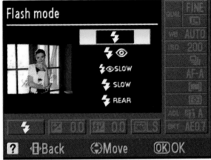

Figure 5-27: You can verify the flash mode in the Shooting Information display.

Your flash mode choices break down into three basic categories, described in the next sections: fill flash; red-eye reduction flash; and the sync modes, slow-sync and rear-sync, which are special-purpose flash options. Note that the list of available flash modes doesn't include three options available in the fully automatic exposure modes: Auto, in which the camera makes the decisions about when to fire the flash; its companion, Auto Plus Red-Eye Reduction; and Off. Instead, if you don't want the flash to fire, simply keep the flash unit closed.

The camera does give you a little auto-flash input though: You see a blinking question mark, flash symbol, or both in the viewfinder in the P, S, and A modes if the camera thinks you need to use flash, and the Shooting Information display also tells you that the scene is too dark. Press the Zoom Out button (the one with the question mark above it), and a message appears recommending that you use flash.

Before moving on to explore the flash modes, here's one tip that applies to all of them: Pay careful attention to your results when you use the built-in flash with a telephoto lens that is very long. You may find that the flash casts an unwanted shadow when it strikes the lens. For best results, try switching to an external flash head, as discussed near the end of this chapter.

Fill flash

 The fill flash setting is represented by the plain-old lightning-bolt symbol you see in the margin here. (Figure 5-27 shows you the symbol as it appears in the Shooting Information display.) You can think of this setting as "normal flash" — at least in the way that most of us think of using a flash.

You may also hear this mode called *force* flash because the flash fires no matter what the available light, unlike in the Auto flash mode provided for the fully automatic exposure modes, in which the camera decides when flash is needed. In Fill flash mode, the flash fires even in the brightest daylight — which, by the way, is often an excellent idea.

Yep, you read me correctly: Adding a flash can really improve outdoor photos, even when the sun is at its sunniest. Just as an example, Figure 5-28 shows a floral image taken both with and without a flash. The small pop of light provided by the built-in flash is also extremely beneficial when shooting subjects that happen to be slightly shaded, such as the carousel horses featured in the next section. For outdoor portraits, a flash is even more important; Chapter 7 discusses that subject.

Using a flash in bright sunlight also produces a slight warming effect, as illustrated in Figure 5-28. This color shift occurs because when you enable the flash, the camera's white balancing mechanism warms color slightly to compensate for the bluish light of a flash. But because your scene is actually lit primarily by sunlight, which is *not* as cool as flash light, the white balance adjustment takes the image colors a step warmer than neutral. If you don't want this warming effect, see Chapter 6 to find out how to make a manual white balance adjustment.

Do note, however, that when you use the built-in flash, you're restricted to a top shutter speed of 1/200 second. That means that in very bright sun, you may need to stop down the aperture significantly or lower ISO, if possible, to avoid overexposing the image. See the sidebar "In Sync: Flash timing and shutter speed," later in this chapter, for details on shutter-speed ranges available for flash photography.

Figure 5-28: Adding flash resulted in better illumination and a slight warming effect.

Red-eye reduction flash

Red-eye is caused when flash light bounces off a subject's retinas and is reflected back to the camera lens. Red-eye is a human phenomena, though; with animals, the reflected light usually glows yellow, white, or green, producing an image that looks like your pet is possessed by some demon.

Man or beast, this issue isn't nearly the problem with the type of pop-up flash found on your D5000 as it is on non-SLR cameras. The D5000's flash is positioned in such a way that the flash light usually doesn't hit a subject's eyes straight on, which lessens the chances of red-eye. However, red-eye may still be an issue when you use a lens with a long focal length (a telephoto lens) or you shoot subjects from a distance.

 If you do notice red-eye, you can try the red-eye reduction mode, represented by the icon shown in the margin here. In this mode, the AF-assist lamp on the front of the camera lights up briefly before the flash fires. The subject's pupils constrict in response to the light, allowing less flash light to enter the eye and cause that glowing red reflection. Be sure to warn your subjects to wait for the flash, or they may step out of the frame or stop posing after they see the light from the AF-assist lamp.

For an even better solution, try the flash-free portrait tips covered in Chapter 7. If you do a lot of portrait work that requires flash, you may also want to consider an external flash unit, which enables you to aim the flash light in ways that virtually eliminate red-eye.

If all else fails, check out Chapter 10, which shows you how to use the built-in red-eye removal tool on your camera's Retouch menu. Sadly, though, this feature removes only red-eye, not the yellow/green/white eye that you get with animal portraits.

Slow-sync and rear-sync flash

In fill flash and red-eye reduction flash modes, the flash and shutter are synchronized so that the flash fires at the exact moment the shutter opens.

Technical types refer to this flash arrangement as *front-curtain sync.*

Your D5000 also offers four special-sync modes, which work as follows:

- ✓ **Slow-sync flash:** This mode, available only in the P and A exposure modes, also uses front-curtain sync but allows a shutter speed slower than the 1/60 second minimum that is in force when you use fill flash and red-eye reduction flash.

The benefit of this longer exposure is that the camera has time to absorb more ambient light, which in turn has two effects: Background areas that are beyond the reach of the flash appear brighter; and less flash power is needed, resulting in softer lighting.

The downside of the slow shutter speed is, well, the slow shutter speed. As discussed earlier in this chapter, the longer the exposure time, the more you have to worry about blur caused by movement of your subject or your camera. A tripod is essential to a good outcome, as are subjects that can hold very, very still. I find that the best practical use for this mode is shooting nighttime still-life subjects such as the one you see in Figure 5-29.

Some photographers, though, turn the downside of slow-sync flash to an upside, using it to purposely blur their subjects, thereby emphasizing motion.

Normal flash Slow-sync flash

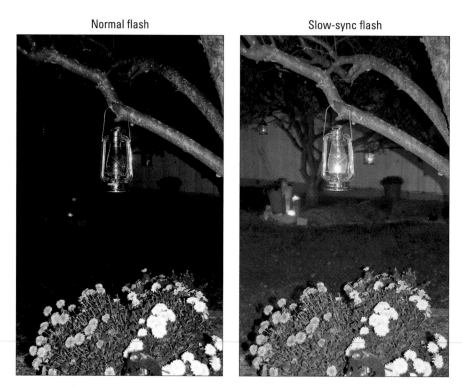

Figure 5-29: Slow-sync flash produces softer, more even lighting than normal flash in nighttime pictures.

✓ **Rear-curtain sync:** In this mode, available only in shutter-priority (S) and manual (M) exposure modes, the flash fires at the very end of the exposure, just before the shutter closes. The classic use of this mode is to combine the flash with a slow shutter speed to create trailing-light effects like the one you see in Figure 5-30. With rear-curtain sync, the light trails extend behind the moving object (my hand, and the match, in this case), which makes visual sense. If instead you use slow-sync flash, the light trails appear in front of the moving object.

✓ **Slow-sync with rear-curtain sync:** Hey, not confusing enough for you yet? This mode enables you to produce the same motion trail effects as with rear-curtain sync, but in the P and A exposure modes.

Figure 5-30: I used rear-curtain flash to create this candle-lighting image.

✓ **Slow-sync with red-eye reduction:** In P and A exposure modes, you can also combine a slow-sync flash with the red-eye reduction feature. Given the potential for blur that comes with a slow shutter, plus the potential for subjects to mistake the prelight from the AF-assist lamp for the real flash and walk out of the frame before the image is actually recorded, I vote this flash mode as the most difficult to pull off successfully.

Note that all of these modes are somewhat tricky to use successfully, however. So have fun playing around, but at the same time, don't feel too badly if you don't have time right now to master these modes plus all the other exposure options presented to you in this chapter. In the meantime, do a Web search for slow-sync and rear-sync image examples if you want to get a better idea of the effects that other photographers create with these flash modes.

Adjusting flash output

When you shoot with your built-in flash, the camera attempts to adjust the flash output as needed to produce a good exposure. But if you shoot in the P, S, A, or M exposure modes and you want a little more or less flash light than the camera thinks is appropriate, you can adjust the flash output by using a feature called *Flash Compensation.*

This feature works just like Exposure Compensation, discussed earlier in the chapter, except that it enables you to override the camera's flash-power decision instead of its autoexposure decision. As with Exposure Compensation, the Flash Compensation settings are stated in terms of EV *(exposure value)* numbers. A setting of 0.0 indicates no flash adjustment; you can increase the flash power to EV +1.0 or decrease it to EV –3.0.

As an example of the benefit of this feature, look at the carousel images in Figure 5-31. The first image shows you a flash-free shot. Clearly, I needed a flash to compensate for the fact that the horses were shadowed by the roof of the carousel. But at normal flash power, as shown in the middle image, the flash was too strong, creating glare in some spots and blowing out the highlights in the white mane. By dialing the flash power down to EV –0.7, I got a softer flash that straddled the line perfectly between no flash and too much flash.

No flash Flash EV 0.0

Flash EV –0.7

Figure 5-31: When normal flash output is too strong, dial in a lower Flash Compensation setting.

In sync: Flash timing and shutter speed

In order to properly expose flash pictures, the camera has to synchronize the timing of the flash output with the opening and closing of the shutter. For this reason, the range of shutter speeds available to you is more limited when you use flash than when you go flash-free.

When you use the built-in flash, the maximum shutter speed is 1/200 second. The minimum shutter speed varies depending on your exposure mode. The minimum speed for the main exposure modes are as follows:

- ✓ **P, A, Auto, Portrait, Child modes:** 1/60 second

- ✓ **Close Up mode:** 1/125 second

- ✓ **Nighttime Portrait mode:** 1 second

- ✓ **S mode:** 30 seconds

- ✓ **M mode:** 30 seconds (unless you use bulb mode, in which the shutter stays open as long as you hold the shutter button down)

These same shutter-speed requirements apply when you attach an external flash head as well as for the built-in flash.

As for boosting the flash output, well, you may find it necessary on some occasions, but don't expect the built-in flash to work miracles even at a Flash Compensation of +1.0. Any built-in flash has a limited range, and you simply can't expect the flash light to reach faraway objects. In other words, don't even try taking flash pictures of a darkened recital hall from your seat in the balcony — all you'll wind up doing is annoying everyone.

With that preface in mind, you can enable Flash Compensation in two ways:

✓ **Use the two-button plus Command dial maneuver.** First, press the Flash button to pop up the built-in flash. Then press and hold the Flash button and the Exposure Compensation button simultaneously. When you press the buttons, you see the screen shown in Figure 5-32. In the viewfinder, the current setting takes the place of the usual frames-remaining value. While keeping both the buttons pressed, rotate the Command dial to adjust the setting. I find that any technique that involves coordinating this many fingers a little complex, but you may find it easier than I do.

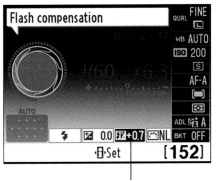

Flash compensation

Figure 5-32: Rotate the Command dial while pressing the Flash and Exposure Compensation buttons to adjust flash power.

✏ **Use the standard Quick-Settings screen approach.** Just bring up the Shooting Information display, press the Information Edit button to shift to Quick Settings mode, and highlight the Flash Compensation setting. (It's the setting that's highlighted at the bottom of the screen in Figure 5-32.) Press OK to display a screen where you can set the flash power. Press the Multi Selector up or down to change the setting and then press OK.

As with Exposure Compensation, any flash-power adjustment you make remains in force, even if you turn off the camera, until you reset the control. So be sure to check the setting before you next use your flash.

If you're an advanced flash user and want to control flash power manually, Chapter 11 shows you how.

Using an external flash head

In addition to its built-in flash, your camera has a *hot shoe,* which is photo-geek terminology for a connection that enables you to add an external flash head like the one shown in Figure 5-33. The figure features the Nikon Speedlight SB-600, which currently retails for about $225. (The hot shoe is covered by a little cap when you first get the camera; you have to remove it to add your flash.)

Although not the cheapest of accessories, an external flash may be a worthwhile invest-ment if you do a lot of flash photography. For one thing, an external flash offers greater power, enabling you to illuminate a larger area than you can with a built-in flash. And with flash units like the one in Figure 5-33, you can rotate the flash head so that the flash light bounces off a wall or ceiling instead of hitting your subject directly. This results in softer lighting and can eliminate the harsh shadows often caused by the strong, narrowly focused light of a built-in flash. (Chapter 7 offers an example of the difference this lighting technique can make in portraits.)

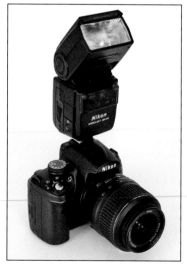

Figure 5-33: You can mount a flash head via the hot shoe on top of the camera.

If you do purchase an external flash, I highly recommend that you visit a good camera store, where the personnel can help you select the right unit for the kind of flash work you want to do. You may also want to dig

into some of the many books that concentrate on flash photography and the Nikon Creative Lighting System. There's a lot more to that game than you may imagine, and you'll no doubt discover some great ideas about lighting your pictures with flash. You can start with Chapter 7, which provides some specific examples of how to get better flash results when you shoot portraits, whether you go with the built-in flash, an external flash, or, my favorite, no flash.

Bracketing Exposures

Many professional photographers use a strategy called *bracketing* to ensure that at least one shot of a subject is properly exposed. They shoot the same subject multiple times, slightly varying the exposure settings for each image.

To make bracketing easy, your D5000 offers *automatic bracketing*. When you enable this feature, your only job is to press the shutter button to record the shots; the camera automatically adjusts the exposure settings between each image.

The D5000, however, takes things one step further than most cameras that offer automatic bracketing. In addition to bracketing exposure, you can bracket the amount of Active D-Lighting that's applied. And when you're concerned about color, you can instead choose to bracket white balancing, an adjustment that you can explore fully in Chapter 6. This third bracketing option doesn't work if you capture your photo in the RAW format, however; you must set the Image Quality setting to one of the JPEG options.

With the D5000, you record a three-shot series of bracketed images when you use the autoexposure and white balance bracketing options. For Active D-Lighting, you can take only two shots in the series, one with the feature turned on and one off. To try your hand at bracketing, follow these steps:

1. **Set your camera to the P, S, A, or M exposure mode.**

 You can't take advantage of the feature in the Auto or Digital Vari-Program modes.

2. **If you want to use white balance bracketing, set the Image Quality option to a setting other than RAW (NEF).**

 Again, you can't bracket white balance unless you use one of the JPEG file options. (You can, however, easily apply any desired color shift at the time you process your RAW images, a topic you can explore in Chapter 8.)

3. **Display the Custom Setting menu, highlight Bracketing/Flash, and press OK.**

4. **Highlight the Auto Bracketing Set option from the menu shown on the left in Figure 5-34 and press OK.**

Now you see the options shown on the right in Figure 5-34. This screen is where you tell the camera whether you want to bracket exposure (AE), white balance (WB), or Active D-Lighting (ADL). Note that even though the first option is called AE (for autoexposure), it enables you to bracket exposure in M (manual exposure) mode just the same.

5. **Select the desired bracking option and press OK.**

6. **Use the Quick Settings screen to specify the amount of shift you want between each bracketed shot.**

After shifting to Quick Settings mode, highlight the Bracketing Increment setting in the lower-right corner of the screen, as shown on the left in Figure 5-35. Press OK to display the second screen in the figure, where you can tell the camera how strong of an adjustment to make between shots. The available settings depend on the feature you're bracketing (exposure, color, or Active D-Lighting).

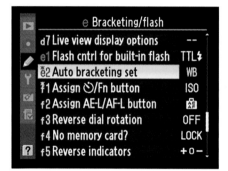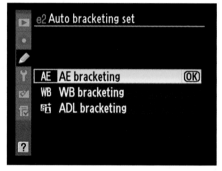

Figure 5-34: Before enabling auto bracketing, select the feature you want the camera to adjust between shots.

Figure 5-35: Set the bracketing amount through the Quick Settings screen.

A few notes on that point:

• For the exposure bracketing, the settings are based on Exposure Compensation values. For example, if you choose 0.7 for an auto-exposure bracketing set, the camera makes three exposures, one with exposure values as metered by the camera, one exposure with +0.7 EV, and one exposure with –0.7 EV. Your choices are from 0.3 EV to 2.0 EV. (When you view the picture settings during playback, a topic covered in Chapter 4, the amount of bracketing adjustment for a shot appears in the Exposure Compensation field.)

The adjustment increments are based on the current setting of the EV Steps for Exposure Control option, located on the Custom Setting menu. The earlier section, "Applying Exposure Compensation," introduces you to this menu. By default, the option is set to increments of one-third stop, but if you want a larger variation between each bracketed shot, you can change the menu setting to 1/2 stop (0.5). Just remember that the selected setting affects the amount of adjustment when you apply Exposure Compensation as well as Flash Compensation, also covered earlier in this chapter.

• For white balance (WB) bracketing, you can shift the white balance in increments of 1, 2, or 3, with each step making the picture either progressively more amber or more blue. See Chapter 6 for the details that will make that feature clear. In the meantime, just understand that the differences between each shot will be subtle, even if you choose the highest shift amount.

7. After selecting the bracketing increment, press OK to return to the Shooting Information display.

8. Shoot your first bracketed series.

Remember, for autoexposure bracketing, a series consists of three shots. For Active D-Lighting, you need to fire off two shots. For white-balance bracketing, however, you press the shutter button only once. The camera then records the image three times, using a different white balance adjustment for each photo.

When autoexposure bracketing is enabled, the exposure meter in the Shooting Information display offers a *bracketing progress indicator.* That's a pretty technical way of saying, "Little bars appear under the meter, each one representing one shot in your bracketed series." The indicator updates after each picture to show you how many more shots are left in the series. For example, the middle bar represents your first shot; after you take your first picture, it disappears. You then see two bars — and thus, two shots left to shoot. For White Balance bracketing, you see the three bars under the meter at all times (because a single press of the shutter button records the entire bracketed series). For ADL bracketing, look to the lower-right corner of the screen to find out which shot you're about to take. Just above the Flash mode setting, you

see the letters ADL-BKT and then two additional values: Off and a letter representing the ADL strength (H for High, for example). The underscore beneath the value indicates which shot you're about to capture.

9. To disable bracketing, repeat Step 6 and select Off from the second screen shown in Figure 5-35.

Don't be put off by the length of these steps, by the way. Although describing the feature takes quite a few words, using bracketing really isn't all that complicated. Bracketing is a wonderful way to hedge your bet, especially when you're taking pictures of a place you may never visit again, or experiencing a once-in-a-lifetime photo opportunity such as your son's first birthday party.

6

Manipulating Focus and Color

To many people, the word *focus* has just one interpretation when applied to a photograph: Either the subject is in focus or it's blurry. And it's true — this characteristic of your photographs is an important one. There's not much to appreciate about an image that's so blurry that you can't make out whether you're looking at Peru or Peoria.

But an artful photographer knows that there's more to focus than simply getting a sharp image of a subject. You also need to consider *depth of field,* or the distance over which objects remain sharply focused. This chapter explains all the ways to control depth of field, how to use your D5000's advanced autofocus options, and how to take advantage of autofocus in Live View mode.

In addition, this chapter dives into the topic of color, explaining your camera's white balance control, which compensates for the varying color casts created by different light sources. You also can get my take on the other advanced color options on your D5000, including the Color Space option and Picture Controls, in this chapter.

Reviewing Focus Basics

I touch on various focus issues in Chapters 1, 2, and 5. But just in case you're not reading this book from front to back, here's a recap of the basic process of focusing with your D5000.

These steps assume that Live View, introduced in Chapter 4, is not enabled. Focusing works a little differently in Live View mode; see the upcoming section "Autofocusing in Live View mode" for details.

1. **Set the focusing switch on the lens to manual or automatic focusing.**

 If you want to focus manually, set the switch to the M position; for auto-focusing, set it to the A position.

 These directions are specific to the kit lens sold with the D5000. Other lenses may have a different sort of switch or no switch at all, so check the product manual. And note that not all lenses provide autofocusing when paired with the D5000. For manual focusing, be sure to set the Focus mode to MF (manual focus), as explained in the upcoming section "Changing the Focus mode setting." (With the kit lens and some other lenses, the camera takes care of that step automatically for you.)

2. **Frame the picture so that your subject falls under one of the 11 auto-focus points.**

 The autofocus points are represented by the little black squares in the view-finder. For most exposure modes, all 11 focus points are active by default and can be used for autofocusing.

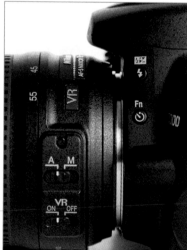

 Note, however, that when you set the lens to manual focusing or set the Mode dial to the Landscape, Close Up, or Sports mode, only a single point is active at the default settings. It appears surrounded by black brackets. Use the Multi Selector to move the brackets over the object on which you want to focus.

3. **To set focus in autofocus mode, press and hold the shutter button halfway down.**

 Figure 6-1: Set the lens switch to the A position for autofocusing.

 Depending on the lighting conditions, the camera's AF-assist illuminator on the front of the camera may emit a beam to help the autofocus system find its target. (If the light becomes a distraction, you can disable it through the Built-in AF-assist illuminator

option, found on the Autofocus submenu of the Custom Setting menu. But the camera may have trouble locking focus, so you may need to focus manually.)

When focus is established, the focus lamp in the viewfinder lights. If a single focus point was selected in the preceding step, it briefly flashes red and then appears black again. If all focus points were active, one or more of the focus points flashes and then appears surrounded by brackets, as shown in Figure 6-2. Any objects that fall under those points are in focus.

The part of the frame the camera uses to establish focus depends on the current *AF-area mode*. To find out more about this issue, including how to select the focus point you want to use, check out the section "Adjusting Autofocus Performance".

4. **To set focus manually, twist the focusing ring on the lens.**

Don't forget! First set the lens switch to the manual focusing position, or you may damage the lens.

If you press the shutter button halfway before moving the focusing ring, the focus lamp lights when you achieve focus. This feedback is based upon the focus point you selected in Step 2. See the next section for help with another manual-focusing tool, the Rangefinder.

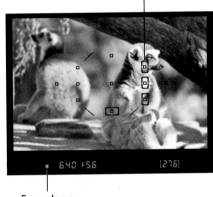

Active focus point

Focus lamp

Figure 6-2: The brackets indicate the active focus points.

By default, if you use autofocusing and your subject moves before you take the shot, the camera tries to adjust focus as needed. In the P, S, A, and M exposure modes, you can control this behavior through the Focus mode setting, also explained later in this chapter.

Taking Advantage of Manual-Focusing Aids

Today's autofocusing systems are pretty remarkable. As long as you follow the suggested techniques for autofocusing and use the right settings for the situation, you can expect a nice, sharply focused subject.

However, some subjects baffle even the most capable autofocus system: objects behind fences, highly reflective objects, dimly-lit subjects, and scenes in which very little contrast exists between the subject and background. And of course, if the lens you use on your D5000 doesn't offer an autofocus motor, you must focus manually.

Manual focus doesn't mean that you don't get some focusing assistance from the camera, however. First, even in manual focus mode, you get the benefit of the focus-indicator lamp, as I mention in the preceding section.

Additionally, through your camera's Rangefinder option, you can swap out the exposure meter in the viewfinder with a focus-distance meter. Here's how it works: You take the same manual focusing approach as described in the preceding section, using the Multi Selector to select a focus point and then dialing in focus by twisting the focusing ring on the lens. When you press the shutter button halfway, the rangefinder display indicates whether focus is set on the object in the selected focus point.

If bars appear to the left of the 0, as shown in the left example in Figure 6-3, focus is set in front of the subject; if the bars are to the right, as in the middle example, focus is slightly behind the subject. The more bars you see, the greater the focusing error. As you twist the focusing ring, the rangefinder updates to help you get focus on track. When you see a single bar on either side of the 0, you're good to go.

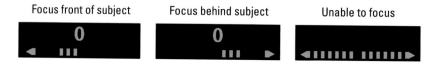

Figure 6-3: The rangefinder offers manual-focusing assistance.

Before I tell you how to activate this feature, I want to point out a couple of issues:

- ✔ You can use the Rangefinder in any exposure mode except M. In Manual mode, the viewfinder always displays the exposure meter.

- ✔ Your lens must offer a maximum aperture (f-stop number) of f/5.6 or lower. To understand f-stops, head back to Chapter 5. The kit lens sold with the D5000 meets this qualification.

- ✔ The Rangefinder is unavailable during Live View shooting.

- ✔ With subjects that confuse the camera's autofocus system, the rangefinder may not work well either; it's based on the same system. If the system can't find the focusing target, you see the Rangefinder display shown on the right in Figure 6-3.

Shutter speed and blurry photos

A poorly focused photo isn't always related to the issues discussed in this chapter. Any movement of the camera or subject can also cause blur. Both of these problems are related to shutter speed, an exposure control that I cover in Chapter 5. Be sure to also visit Chapter 7, which provides some additional tips for capturing moving objects without blur.

If none of those caveats concern you, you can enable the rangefinder display via the Custom Setting menu. Look on the Autofocus submenu for the Rangefinder option, press OK, select On, and press OK again.

After you turn the Rangefinder option to On, the rangefinder automatically replaces the exposure meter in the viewfinder when you switch to manual focusing, assuming that you set the Mode dial to any exposure setting but M. Again, you don't have the option to replace the exposure meter with the rangefinder in M exposure mode.

Do you need to worry about not having the exposure meter in the other modes? Well, the meter still appears in the Shooting Info display if the camera anticipates an exposure problem. So you can always check exposure in the Shooting Info display and then check focus through the rangefinder.

That said, I typically leave the Rangefinder off and just rely on the focus indicator lamp and my eyes to verify focus. I shoot in the S and A exposure modes frequently, and I just find it a pain to have to monitor exposure in the Shooting Info display rather than in the viewfinder. That's not a recommendation to you either way — it's just how I prefer to work.

Adjusting Autofocus Performance

You can adjust two aspects of your camera's focusing system: the AF-area mode and the Focus mode. The following sections fill in the details.

Understanding the AF-area mode setting

The AF-area mode option determines which of the 11 focusing points the camera uses to establish focus. (The *AF* in AF-area mode stands for *autofocus*). You can view the current setting on the Shooting Information display, as shown in Figure 6-4.

You can choose from four settings, which work as described in the following list and are represented in the displays by the accompanying icons. (Note that the icons look slightly different depending on where you view them. The ones in the margins here are shown as they appear in the Shooting Information display.)

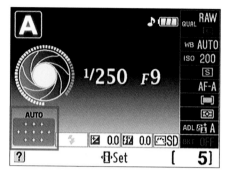

Figure 6-4: The symbol for the current AF-area mode appears here.

 ✔ **Single Point:** This mode is designed for shooting still subjects. You select one of the 11 focus points, and the camera sets focus on the object that falls within that point. (See the upcoming section "Selecting a single focus point" for specifics on how to designate your chosen point.) The camera uses this mode by default when you shoot in the Close Up and Landscape exposure modes.

On the Shooting Information display, the position of the brackets in the AF-area mode icon show you which point is selected. For example, an icon like the one you see in the margin here tells you that the center point is selected.

 ✔ **Dynamic Area:** In this mode, designed for shooting moving subjects, you select an initial focus point, just as in Single Point mode. But if the subject within that focus point moves after you press the shutter button halfway to set focus, the camera looks for focus information from the other focus points. The idea is that the subject is likely to wind up within one of the 11 focus areas. It's the default setting when you shoot in the Sports exposure mode.

 However — and this is a biggie — in order for the automatic focus adjustment to occur, you also must set the Focus mode option (explained next) to either AF-A or AF-C. (AF-A is the default.) If you instead set that option to AF-S, which is designed for shooting still subjects, the camera sticks with the initial focus point you select, even if the subject moves before you take the picture.

In the displays, the icon for this mode looks similar to the one in the margin here. Your selected focus point is surrounded by brackets, but you also see little plus signs marking the other points. Note that the brackets surrounding your selected focus point don't move if the camera shifts to a different point to focus, but the focus shift is happening just the same.

 ✔ **Auto Area:** The camera analyzes the objects under all 11 autofocus points and selects the one it deems most appropriate. This mode is the default setting for the Portrait, Child, Night Portrait, Flash Off, and Auto modes as well as for all the advanced exposure modes.

✔ **3D Tracking:** This one is a variation of Dynamic Area autofocusing —
well, sort of. As with Dynamic Area mode, you start by selecting a single
focus point (surrounded by brackets in the displays) and then press the
shutter button halfway to set focus. But the goal of this mode is to main-
tain focus on your subject if you recompose the shot after you press the
shutter button halfway to lock focus. Again, you have to set the Focus
mode to AF-A or AF-C for this focus adjustment to occur.

The only problem is that the way the camera detects your subject is by
analyzing the colors of the object under your selected focus point. So if
not much difference exists between the subject and other objects in the
frame, the camera can get fooled. And if your subject moves out of the
frame, you must release the shutter button and reset focus by pressing
it halfway again.

The 3D Tracking display icon appears in the Shooting Information dis-
play as shown in the margin here.

If you're feeling overwhelmed by all of your autofocus options (not to men-
tion all the other D5000 features), Auto-area produces good results for most
subjects. Personally, however, I rely on the first two modes because if the
Auto mode makes the wrong focus assumptions, there's no way to select a
different focus point. So for still subjects, I stick with Single Point focus; for
moving subjects, I go with Dynamic Area.

Whatever your conclusions on the subject, the next two sections show you
how to adjust the AF-area mode and select a specific focus point.

Changing the AF-area mode setting

You can control the AF-area mode setting in any of your camera's expo-
sure modes. The fastest way is to use the Quick Settings display. With the
Shooting Settings screen displayed, press the Information Edit button to shift
to Quick Settings mode and then highlight the AF-area mode icon, as shown
on the left in Figure 6-5. Press OK to access the second screen in the figure,
where you see four icons representing the different mode options. From
top to bottom, the settings are Single Point, Dynamic Area, Auto Area, and
3D-Tracking.

You also can change the mode through the menus if you find it easier. Just
head for the Custom Setting menu, highlight the Autofocus submenu, and
press OK to display the screen shown in Figure 6-6. From there, press OK to
display the options shown on the right in the figure. This time, the option
names are spelled out.

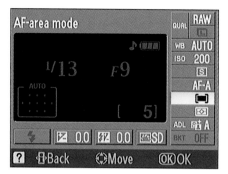
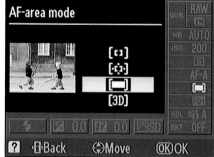

Figure 6-5: The fastest way to adjust the AF-area mode is through the Quick Settings screen.

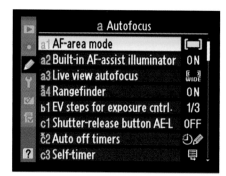
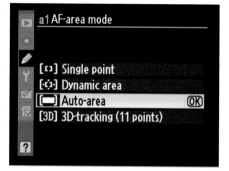

Figure 6-6: You also can adjust the setting through the Autofocus submenu of the Custom Setting menu.

Selecting a single focus point

In any AF-area mode except Auto-area, take these steps to select a focus point:

1. **Press the shutter button halfway and release it to engage the exposure meters.**

2. **Use the Multi Selector to select a focus point.**

 The currently selected point is surrounded by brackets, as shown in Figure 6-7.

To quickly select the center focus point, press OK. No need to cycle your way through all the other focus points to get to the center.

You use this same technique, by the way, to select a focus point when you are focusing manually. Taking that step isn't actually necessary to establish focus, but it affects the feedback you get from the focus lamp in the viewfinder. The lamp lights when the area inside the selected focus point comes into focus.

Selected focus point

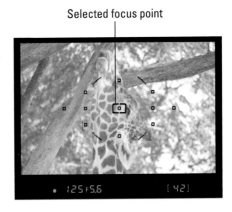

Changing the Focus mode setting

Throughout this book, I use the term *focusing mode* generically to refer to the lens switch that shifts your camera from autofocusing to

Figure 6-7: You can select a single auto-focus point that's over your subject.

manual focusing — at least, on the kit lens sold with the D5000. But there is also an official Focus mode setting, which controls another aspect of your camera's focusing behavior. There are four options, which work as follows:

- ✔ **AF-S (single-servo autofocus):** In this mode, which is geared to shooting stationary subjects, the camera locks focus when you depress the shutter button halfway.

 Use this mode if you want to frame your subject so that it doesn't fall under an autofocus point: Compose the scene initially to put the subject under a focus point, press the shutter button halfway to lock focus, and then reframe to the composition you have in mind. As long as you keep the button pressed halfway, focus remains set on your subject.

- ✔ **AF-C (continuous-servo autofocus):** In this mode, which is designed for moving subjects, the camera focuses continuously for the entire time you hold the shutter button halfway down. If the subject moves but still falls under one of the other focus points, the camera should adjust focus correctly. Otherwise, the camera looks for something else on which to establish focus. If you want to lock focus at a certain distance, you must press the AE-L/AF-L button, as described in the section, "Using autofocus lock," later in this chapter.

- ✔ **AF-A (auto-servo autofocus):** This mode is the default setting. The camera analyzes the scene and, if it detects motion, automatically selects continuous-servo mode (AF-C). If the camera instead believes you're shooting a stationary object, it selects single-servo mode (AF-S). This mode works pretty well, but it can get confused sometimes. For example, if your subject is motionless but other people are moving in the background, the camera may mistakenly switch to continuous autofocus. By the same token, if the subject is moving only slightly, the camera may not make the switch.

✓ **MF (Manual Focus):** If you use a lens that does not offer an external switch to shift from auto to manual focus, you need to select this setting to focus manually. You also need to choose this setting if your lens doesn't offer an autofocus motor at all. On the kit lens featured in this book, simply setting the switch on the lens to M automatically sets the Focus mode to MF. However, the opposite isn't true: Choosing the MF setting for the Focus mode does not free the focusing ring so that you can set focus manually; you must set the lens switch to the M position.

You can choose from all four settings only in the P, S, A, and M exposure modes. In the other modes, you can choose between AF-A and MF only.

Assuming that you are using a mode that allows full control, which Focus mode should you select? As for the autofocus options, single-servo mode (AF-S) works best for shooting still subjects, and continuous-servo (AF-C) is the right choice for moving subjects. But frankly, auto-servo (AF-A), which is the default setting, does a good job in most cases of making that shift for you. So, in my mind, there's no real reason to fiddle with the setting unless you're having trouble getting the camera to lock onto your subject.

At any rate, you can change the Focus mode only through the Quick Settings display. After bringing up the Shooting Settings screen, press the Information Edit button to shift to Quick Settings mode. (You can also simply press the Info Edit button twice.) Then use the Multi Selector to navigate to the Focus mode setting, as shown on the left in Figure 6-8. Press OK to display the Focus Mode options shown on the right. Choose the desired mode and press OK.

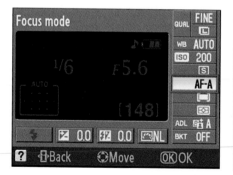 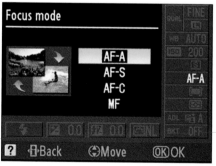

Figure 6-8: The Focus mode determines whether the autofocusing system locks focus when you press the shutter button halfway.

Choosing the right autofocus combo

You'll get the best autofocus results if you pair your chosen Focus mode with the most appropriate AF-area mode, because the two settings work in tandem. Here are the combinations that I suggest for the maximum autofocus control:

- ✔ **For still subjects, use Single Point as the AF-area mode and AF-S as the Focus mode.** You then select a specific focus point, and the camera locks focus on that point at the time you press the shutter button halfway. Focus remains locked on your subject even if you reframe the shot after you press the button halfway. (It helps to remember the *s* factor: For **s**till subjects, **S**ingle Point and AF-**S**.)

- ✔ **For moving subjects, set the AF-area mode to Dynamic Area and the Focus mode to AF-C.** You still begin by selecting a focus point, but the camera adjusts focus as needed if your subject moves within the frame after you press the shutter button halfway to establish focus. (Think *motion, dynamic, continuous.*)

Again, though, you get full control over the Focus mode only in the P. S, A, and M exposure modes. In the other modes, you have only two choices — either MF (manual focus) or AF-A.

Using autofocus lock

When you set your camera's Focus mode to AF-C (continuous-servo autofocus), pressing and holding the shutter button halfway initiates autofocus. But focusing is continually adjusted while you hold the shutter button halfway, so the focusing distance may change if the subject moves out of the active autofocus area before you press the shutter button the rest of the way to take the picture. The same is true if you use AF-A mode (auto-servo autofocus) and the camera senses movement in front of the lens, in which case it shifts to AF-C mode and operates as I just described. Either way, the upshot is that you can't control the exact focusing distance the camera ultimately uses.

Should you want to lock focus at a specific distance, you have a couple of options:

- ✔ Focus manually.

- ✔ Change the Focus mode to AF-S (single-servo autofocus). In this mode, focus is locked when you press and hold the shutter button halfway.

✔ Use *autofocus lock.* First set focus by pressing the shutter button half-way. When the focus is established at the distance you want, press and hold the AE-L/AF-L button, located near the viewfinder. Focus remains set as long as you hold the button down, even if you release the shutter button.

Keep in mind, though, that by default, pressing the AE-L/AF-L button also locks in autoexposure. (Chapter 5 explains.) You can change this behavior, however, setting the button to lock just one or the other. Chapter 11 explains this option as well as a couple other ways to customize the button's function.

For my money, manual focusing is by far the easiest solution. Yes, it may take you a little while to get comfortable with manual focusing, but in the long run, you really save yourself a lot of time fiddling with the various autofocus settings, remembering which button initiates the focus lock, and so on. Just be sure that you have adjusted the viewfinder diopter to your eyesight, as explained in Chapter 1, so that there's not a disconnect between what you see in the viewfinder and where the camera is actually focusing. After a little practice, focusing manually will become second nature to you.

Autofocusing in Live View mode

Chapter 4 covers the basics of shooting in Live View mode, which enables you to compose your shots by using the camera monitor instead of the view-finder. You can opt for Live View shooting for taking still pictures, and you're required to use it to record movies.

As I mention in the Chapter 4 discussion, the simplest and most reliable focusing choice is to focus manually. That said, you can use autofocus in Live View mode if you prefer.

If you do try Live View autofocusing, first set aside all the autofocusing information presented heretofore in this chapter. All the settings related to normal autofocusing — AF-area mode, Focus mode, and the like — are irrelevant. Instead, you can choose from the following autofocusing methods:

✔ **Face Priority:** Designed for portrait shooting, this mode attempts to hunt down and lock focus on faces when you press the shutter button halfway. This setting is chosen by default if you set the exposure Mode dial to the Auto, Portrait, Child, or Night Portrait setting.

✔ **Wide Area:** In this mode, you use the Multi Selector to move a little rectangular focusing frame around the screen to specify your desired focusing spot. When you press the shutter button halfway, the camera tries to lock focus on objects within the focusing frame. This mode is the default for the Sports, Landscape, and Flash Off modes as well as P, S, A, and M modes.

 ✔ **Normal Area:** This mode works the same way as Wide Area autofocusing but uses a smaller focusing frame. The idea is to enable you to base focus on a very specific area. It's the default mode for pictures you take in the Close Up exposure mode.

 With such a small focusing frame, however, you can easily miss your focus target when handholding the camera. If you move the camera slightly just as you're locking focus, and the focusing frame shifts off your subject as a result, focus will be incorrect. So for best results, use a tripod in this mode.

 ✔ **Subject Tracking:** This mode is designed to help you establish focus on a moving subject. You position a little focus target over the subject, and the camera then tries to follow the subject through the frame so that when you're ready to set focus, it can do so quickly. However, understand that this feature works differently from the AF-C (continuous autofocus) option you get with regular shooting. Subject Tracking "tracks" a moving subject through the frame only up to the point you press the shutter button halfway to initiate autofocusing. After that, focus is set, and no further adjustment is made, even if your subject moves.

To use Live View autofocusing, first set the switch on your lens to the autofocus position. (Remember, you can use autofocusing only with AF-S lenses; with other lens types, you must focus manually — in which case, this whole section doesn't apply.)

In the default Live View screen layout, an icon representing the current Autofocus mode appears at the top center spot of the screen, as shown in Figure 6-9. (Press the Info button to cycle through the available Live View display modes.)

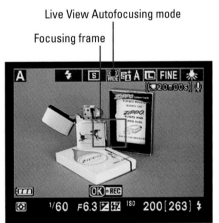

Figure 6-9: In the default Live View display mode, an icon representing the focusing mode appears here.

To change the setting, you have two choices:

 ✔ Press the Information Edit button to shift to Quick Settings mode. Then highlight the Autofocus mode icon, as shown on the right in Figure 6-9. Press OK to access a screen containing the four focusing options, highlight your choice, and press OK.

 ✔ Open the Custom Setting menu, highlight Autofocus, press OK, and then highlight Live View Autofocus, as shown on the right in Figure 6-10. Press OK to display the four focusing settings, highlight your choice, and press OK.

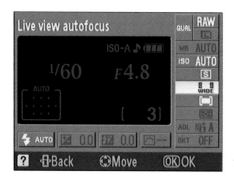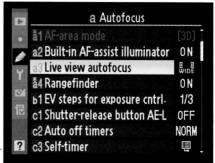

Figure 6-10: You can change the focusing mode through the Quick Settings screen (left) or Autofocus menu (on the Custom Settings menu, right).

What happens after you change the autofocus mode and how you go about focusing depend on the mode you choose:

- For Wide Area and Normal Area autofocus, you see the rectangular focusing frame, labeled in Figure 6-9. (The figure shows the frame at the size it appears in Wide Area mode.) Use the Multi Selector to position the frame over your subject and press the shutter button halfway to focus.

- In Face Priority mode, a double yellow focusing frame appears around the subject's face. Again, press the shutter button halfway to lock focus. (For scenes containing more than one person, focus is set on the closest one.) If you don't see the highlight, the camera can't detect your subject's face, and it will set focus on the center of the frame.

- In Subject Tracking mode, you see a little white box on the screen. Frame your subject so that it's under that box and then press the Multi Selector up. The camera sets the initial focusing distance, and the box turns yellow. If the subject moves, the box tags along for the ride. When you're ready to take the picture, press the shutter button halfway to lock focus as usual. The camera then sets the final focusing distance on your subject. Note that focus is not adjusted after that point if your subject moves.

Whichever mode you choose, the focusing frame turns green and the camera beeps when focus is established. If the camera can't establish focus, the focusing frame blinks red.

 After setting focus, you can press the Zoom In button to magnify the scene and check focus. In Normal Area, Wide Area, and Subject Tracking mode, you can press the Multi Selector to scroll the display if needed. In Face Priority mode, the camera automatically keeps the face in the highlight box centered on the monitor.

 To zoom out, press Zoom Out button until you see the entire scene.

Correcting lens distortion

If you take a lot pictures with wide-angle lenses, you may notice that verticals in the scene sometimes appear to bow out toward the edges of the frame. This is known as *barrel distortion*. On the flip side of the coin, shooting with a long telephoto lens sometimes causes those verticals to bow inward, creating an effect called *pincushion distortion*.

The Retouch menu on your camera has a post-capture filter you can apply to try to correct both problems. (See Chapter 10 for help.) But the D5000 also has a feature called Auto-Distortion Control that attempts to correct the image as you're shooting. It only works with certain types of lenses (specifically, those that Nikon classifies as type G and D), but if your lens fits the bill, it's worth trying.

To activate the option, highlight Auto Distortion Control on the Shooting Menu, as shown in the left figure here. Press OK to reveal the second screen, highlight On, and press OK.

When you use this feature, understand that some of the area you see in your viewfinder may not be visible in the final photo because the anti-distortion manipulation requires some cropping of the scene. So after activating the feature, take some test shots and examine the results carefully. If you're not happy with the results, return to the menu and change the setting back to Off.

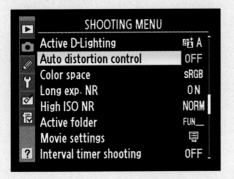

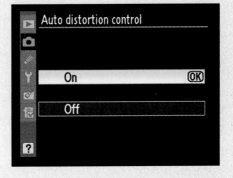

You can use these same steps to establish your initial focusing point when recording movies. Release the shutter button after focus is established and then press OK to start recording.

Remember that for both still and movie photography, though, there is no such thing as continuous autofocusing in Live View mode. After you press the shutter button halfway to set focus, focus is locked, even if you set the autofocus mode to Subject Tracking. In still photography Live View mode, you must release the shutter button and then press it halfway again to adjust the focus point. In movie mode, you must stop recording, reset focus, and start the recording anew. For moving subjects, then, manual focusing makes life a lot easier.

Manipulating Depth of Field

Getting familiar with the concept of *depth of field* is one of the biggest steps you can take to becoming a more artful photographer. I introduce you to depth of field in Chapters 2 and 5, but here's a quick recap just to hammer home the lesson:

- ✓ *Depth of field* refers to the distance over which objects in a photograph appear sharply focused.

- ✓ With a shallow, or small, depth of field, distant objects appear more softly focused than the main subject (assuming that you set focus on the main subject, of course).

- ✓ With a large depth of field, the zone of sharp focus extends to include objects at a distance from your subject.

Which arrangement works best depends entirely on your creative vision and your subject. In portraits, for example, a classic technique is to use a shallow depth of field, as shown in the photo in Figure 6-11. This approach increases emphasis on the subject while diminishing the impact of the background. In the photo shown in Figure 6-12, a large depth of field works better. It emphasizes the footprints in the sand and keeps the background buildings sharply focused to give them equal weight in the scene.

So exactly how do you adjust depth of field? You have three points of control: aperture, focal length, and camera-to-subject distance, as spelled out in the following list:

- ✓ **Aperture setting (f-stop):** The aperture is one of three exposure settings, all explained fully in Chapter 5. Depth of field increases as you stop down the aperture (by choosing a higher f-stop number). For shallow depth of field, open the aperture (by choosing a lower f-stop number). Figure 6-13 offers an example; in the f/22 version, focus is sharp all the way through the frame; in the f/13 version, focus softens as the distance from the center lure increases. I snapped both images

Doug Sahlin

Figure 6-11: A shallow depth of field blurs the background and draws added attention to the subject.

using the same focal length and camera-to-subject distance, setting focus on the center lure.

✓ **Lens focal length:** In lay terms, *focal length* determines what the lens "sees." As you increase focal length, measured in millimeters, the angle of view narrows, objects appear larger in the frame, and — the important point for this discussion — depth of field decreases. Additionally, the spatial relationship of objects changes as you adjust focal length. As an example, Figure 6-14 compares the same scene shot at a focal length of 127mm and 183mm. I used the same aperture, f/5.6, for both examples.

Whether you have any focal length flexibility depends on your lens: If you have a zoom lens, you can adjust the focal length — just zoom in or out. (The D5000 kit lens, for example, offers a focal-length range of 18–55mm.) If you don't have a zoom lens, the focal length is fixed, so scratch this means of manipulating depth of field.

For more technical details about focal length and your D5000, see the sidebar "Fun facts about focal length."

✓ **Camera-to-subject distance:** As you move the lens closer to your subject, depth of field decreases. This assumes that you don't zoom in or out to reframe the picture, thereby changing the focal length. If you do, depth of field is affected by both the camera position and focal length.

Doug Sahlin

Figure 6-12: A large depth of field keeps both foreground and background subjects in focus.

Aperture, f/22; Focal length, 92mm

Aperture, f/13; Focal length, 92mm

Figure 6-13: A lower f-stop number (wider aperture) decreases depth of field.

Together, these three factors determine the maximum and minimum depth of field that you can achieve, as illustrated by my clever artwork in Figure 6-15 and summed up in the following list:

🖉 **To produce the shallowest depth of field:** Open the aperture as wide as possible (the lowest f-stop number), zoom in to the maximum focal length of your lens, and get as close as possible to your subject.

✓ **To produce maximum depth of field:** Stop down the aperture to the highest possible f-stop number, zoom out to the shortest focal length your lens offers, and move farther from your subject.

Aperture, f/5.6; Focal length, 127mm

Aperture, f/5.6; Focal length, 183mm

Figure 6-14: Zooming to a longer focal length also reduces depth of field.

Just to avoid a possible point of confusion that has arisen in some of the classes I teach: When I say *zoom in,* some students think that I mean to twist the zoom barrel so that it moves *in* toward the camera body. But in fact, the phrase *zoom in* means to zoom to a longer focal length, which produces the visual effect of bringing your subject closer. This requires twisting the zoom barrel of the lens so that it extends further *out* from the camera. And the

phrase *zoom out* refers to the opposite maneuver: I'm talking about widening your view of the subject by zooming to a shorter focal length, which requires moving the lens barrel *in* toward the camera body.

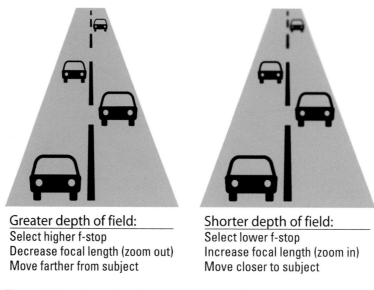

Greater depth of field: | Shorter depth of field:
Select higher f-stop | Select lower f-stop
Decrease focal length (zoom out) | Increase focal length (zoom in)
Move farther from subject | Move closer to subject

Figure 6-15: Your f-stop, focal length, and shooting distance determine depth of field.

Here are a few additional tips and tricks related to depth of field:

- **Aperture-priority autoexposure mode (A) enables you to easily control depth of field.** In this mode, detailed fully in Chapter 5, you set the f-stop, and the camera selects the appropriate shutter speed to produce a good exposure. The range of aperture settings you can access depends on your lens.

 Even in aperture-priority mode, keep an eye on shutter speed as well. To maintain the same exposure, shutter speed must change in tandem with aperture, and you may encounter a situation where the shutter speed is too slow to permit hand-holding of the camera. Lenses that offer optical image stabilization, or vibration reduction (VR lenses, in the Nikon world), do enable most people to use a slower shutter speed than normal, but double-check your results just to be sure. Or use a tripod for extra security. Of course, all this assumes that you have dialed in a specific ISO Sensitivity setting; if you instead are using Auto ISO adjustment, the camera may adjust the ISO setting instead of shutter speed. (Chapter 5 explores the whole aperture/shutter speed/ISO relationship.)

Fun facts about focal length

Every lens can be characterized by its *focal length,* or in the case of a zoom lens, the range of focal lengths it offers. Measured in millimeters, focal length determines the camera's angle of view, the apparent size and distance of objects in the scene, and depth of field. According to photography tradition, a focal length of 50mm is described as a "normal" lens. Most point-and-shoot cameras feature this focal length, which is a medium-range lens that works well for the type of snapshots that users of those kinds of cameras are likely to shoot.

A lens with a focal length under 35mm is characterized as a *wide-angle* lens because at that focal length, the camera has a wide angle of view and produces a large depth of field, making it good for landscape photography. A short focal length also has the effect of making objects seem smaller and farther away. At the other end of the spectrum, a lens with a focal length longer than 80mm is considered a *telephoto* lens and often referred to as a *long lens.* With a long lens, angle of view narrows, depth of field decreases, and faraway subjects appear closer and larger, which is ideal for wildlife and sports photographers.

Note, however, that the focal lengths stated here and elsewhere in the book are so-called *35mm equivalent* focal lengths. Here's the deal: For reasons that aren't really important, when you put a standard lens on most digital cameras, including your D5000, the available frame area is reduced, as if you took a picture on a camera that uses 35mm film negatives (the kind you've probably been using for years) and then cropped it.

This so-called *crop factor,* sometimes also called the *magnification factor,* varies depending on the digital camera, which is why the photo industry adopted the 35mm-equivalent measuring stick as a standard. With the D5000, the cropping factor is roughly 1.5. So the 18–55mm kit lens, for example, actually captures the approximate area you would get from a 27–83mm lens on a 35mm film camera. In the figure here, for example, the red outline indicates the image area that results from the 1.5 crop factor.

Note that although the area the lens can capture changes when you move a lens from a 35mm film camera to a digital body, depth of field isn't affected, nor are the spatial relationships between objects in the frame. So when lens shopping, you gauge those two characteristics of the lens by looking at the stated focal length — no digital-to-film conversion math is required.

Doug Sahlin

- ✔ **Portrait and Close Up modes are designed to produce shallow depth of field; Landscape mode is designed for large depth of field.** You can't adjust aperture in these modes, however, so you're limited to the setting the camera chooses. In addition, the extent to which the camera can select an appropriate f-stop depends on the lighting conditions. If you're shooting in Landscape mode at dusk, for example, the camera may have to open the aperture to a wide setting to produce a good exposure.

- ✔ **For greater background blurring, move the subject farther from the background.** The extent to which background focus shifts as you adjust depth of field also is affected by the distance between the subject and the background. For increased background blurring, move the subject farther in front of the background.

Controlling Color

Compared with understanding some aspects of digital photography — resolution, aperture and shutter speed, depth of field, and so on — making sense of your camera's color options is easy-breezy. First, color problems aren't all that common, and when they are, they're usually simple to fix with a quick shift of your D5000's white balance control. And getting a grip on color requires learning only a couple of new terms, an unusual state of affairs for an endeavor that often seems more like high-tech science than art.

The rest of this chapter explains the aforementioned white balance control, plus a couple of menu options that enable you to fine-tune the way your camera renders colors. For information on how to use the Retouch menu's color options to alter colors of existing pictures, see Chapter 10.

Correcting colors with white balance

Every light source emits a particular color cast. The old-fashioned fluorescent lights found in most public restrooms, for example, put out a bluish-greenish light, which is why our reflections in the mirrors in those restrooms always look so sickly. And if you think that your beloved looks especially attractive by candlelight, you aren't imagining things: Candlelight casts a warm, yellow-red glow that is flattering to the skin.

Science-y types measure the color of light, officially known as *color temperature,* on the Kelvin scale, which is named after its creator. You can see the Kelvin scale in Figure 6-16.

Kelvin	
8000	Snow, water, shade
	Overcast skies
	Flash
5000	Bright sunshine
	Fluorescent bulbs
3000	Tungsten lights
	Incandescent bulbs
2000	Candlelight

Figure 6-16: Each light source emits a specific color.

When photographers talk about "warm light" and "cool light," though, they aren't referring to the position on the Kelvin scale — or at least not in the way we usually think of temperatures, with a higher number meaning hotter. Instead, the terms describe the visual appearance of the light. Warm light, produced by candles and incandescent lights, falls in the red-yellow spectrum you see at the bottom of the Kelvin scale in Figure 6-16; cool light, in the blue-green spectrum, appears at the top of the Kelvin scale.

At any rate, most of us don't notice these fluctuating colors of light because our eyes automatically compensate for them. Except in very extreme lighting conditions, a white tablecloth appears white to us no matter whether we view it by candlelight, fluorescent light, or regular houselights.

Similarly, a digital camera compensates for different colors of light through a feature known as *white balancing*. Simply put, white balancing neutralizes light so that whites are always white, which in turn ensures that other colors are rendered accurately. If the camera senses warm light, it shifts colors slightly to the cool side of the color spectrum; in cool light, the camera shifts colors the opposite direction.

The good news is that, as with your eyes, your camera's Auto white balance setting tackles this process remarkably well in most situations, which means that you can usually ignore it and concentrate on other aspects of your picture. But if your scene is lit by two or more light sources that cast different colors, the white balance sensor can get confused, producing an unwanted color cast like the one you see in the left image in Figure 6-17.

I shot this product image in my home studio, which I light primarily with a couple of high-powered photo lights that use tungsten bulbs, which produce light with a color temperature similar to regular household incandescent bulbs. The problem is that the windows in that room also permit some pretty strong daylight to filter through. In Auto white balance mode, the camera reacted to that daylight — which has a cool color cast — and applied too much warming, giving my original image a yellow tint. No problem: I just switched the white balance mode from Auto to the Incandescent setting. The right image in Figure 6-17 shows the corrected colors.

There's one little problem with white balancing as it's implemented on your D5000, though. You can't make this kind of manual white balance selection if you shoot in the Auto mode or the Digital Vari-Program scene modes. So if you spy color problems in your camera monitor, you need to switch to either P, S, A, or M exposure mode. (Chapter 5 details all four modes.)

The next section explains precisely how to make a simple white balance correction; following that, you can explore some advanced white balance options.

Figure 6-17: Multiple light sources resulted in a yellow color cast in Auto white balance mode (left); switching to the Incandescent setting solved the problem (right).

Changing the white balance setting

The current white balance setting appears in the Shooting Information display, as shown in Figure 6-18. The manual settings are represented by the icons you see in Table 6-1.

Table 6-1	Manual White Balance Settings
Symbol	**Light Source**
☀	Incandescent
▥	Fluorescent
☀	Direct sunlight
⚡	Flash

Symbol	Light Source
	Cloudy
	Shade
PRE	Custom preset

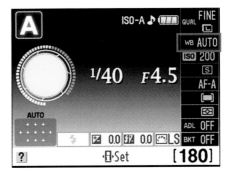

To change the white balance, one option is to use the Quick Settings screen. When the Shooting Settings screen is displayed, press the Information Edit button to shift to Quick Settings mode. Then use the Multi Selector to highlight the white balance option, as shown on the left of Figure 6-19. Press OK to display the menu shown on the right of Figure 6-19, highlight the desired setting, and press OK.

Figure 6-18: This icon represents the current white balance setting.

You also can adjust the White Balance setting through the Shooting menu. Just highlight White Balance on the menu, press OK to display a screen listing all the settings, highlight your choice, and press OK.

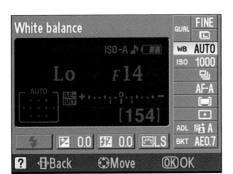

Figure 6-19: You can modify White Balance to suit the ambient lighting.

Going the menu route gives you access to a couple of White Balance options not available through the Quick Settings screen. For example, if you choose the Fluorescent setting, you can select from seven types of bulbs. After selecting Fluorescent, as shown on the left in Figure 6-20, press OK to display the list of bulbs, as shown on the right. Select the option that most closely

matches your bulbs and then press OK. This time, you're taken to a screen where you can fine-tune the setting even more. I explain the fine-tuning steps in the next section. If you don't want to make any further adjustment, just press OK to exit the fine-tuning screen and return to the Shooting menu.

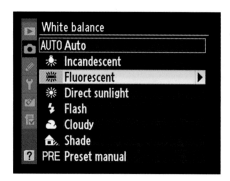 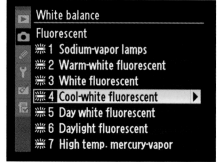

Figure 6-20: If you adjust the White Balance setting through the Shooting menu, you can select a specific type of fluorescent bulb.

 After you select a fluorescent bulb type, that option is always used when you change white balance through the Shooting Information display (as outlined previously) and choose the Fluorescent white balance setting. Again, you can change the bulb type only through the Shooting menu.

Selecting the PRE option on the menu (left screen in Figure 6-20) enables you to create and store a precise, customized white balance setting, as explained in the upcoming "Creating white balance presets" section. This setting is the fastest way to achieve accurate colors when your scene is lit by multiple light sources that have differing color temperatures.

 Your selected white balance setting remains in force for the P, S, A, and M exposure modes until you change it. So you may want to get in the habit of resetting the option to the Auto setting after you finish shooting whatever subject it was that caused you to switch to manual white balance mode.

Fine-tuning white balance settings

You can fine-tune any white balance setting (Direct Sunlight, Cloudy, and so on) except a custom preset that you create through the PRE option. For the greatest amount of control, make the adjustment as spelled out in these steps:

1. **Display the Shooting menu, highlight White Balance, and press OK.**

2. **Highlight the white balance setting you want to adjust, as shown on the left in Figure 6-21, and press OK.**

Now you're taken to a screen where you can do your fine-tuning, as shown on the right in Figure 6-21.

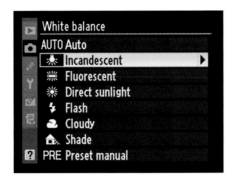 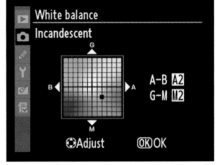

Figure 6-21: You can fine-tune the white balance settings via the Shooting menu.

If you select Fluorescent, you first go to a screen where you select a specific type of bulb, as covered in the preceding section. After you highlight your choice, press OK to get to the fine-tuning screen.

3. **Fine-tune the setting by using the Multi Selector to move the white balance shift marker in the color grid.**

The grid is set up around two color pairs: Green and Magenta, represented by G and M; and Blue and Amber, represented by B and A. By pressing the Multi Selector, you can move the adjustment marker around the grid.

As you move the marker, the A–B and G–M boxes on the right side of the screen show you the current amount of color shift. A value of 0 indicates the default amount of color compensation applied by the selected white balance setting. In Figure 6-21, for example, I moved the marker two levels toward amber and two levels toward magenta to specify that I wanted colors to be a tad warmer.

If you're familiar with traditional colored lens filters, you may know that the density of a filter, which determines the degree of color correction it provides, is measured in *mireds* (pronounced *my-redds*). The white balance grid is designed around this system: Moving the marker one level is the equivalent of adding a filter with a density of 5 mireds.

4. **Press OK to complete the adjustment.**

After you adjust a white balance setting, an asterisk appears next to that setting in the White Balance menu and the Shooting Information display.

By using a feature called *white balance bracketing,* you can automatically record one picture with no shift, one with an amber shift, and one with a blue shift. See the later section "Bracketing white balance" for details.

Creating white balance presets

If none of the standard white balance settings do the trick and you don't want to fool with fine-tuning them, take advantage of the PRE (Preset Manual) feature. This option enables you to do two things:

- ✔ Base white balance on a direct measurement of the actual lighting conditions.
- ✔ Match white balance to an existing photo.

The next two sections provide you with the step-by-step instructions.

Setting white balance with direct measurement

To use this technique, you need a piece of card stock that's either neutral gray or absolute white — not eggshell white, sand white, or any other close-but-not-perfect white. (You can buy reference cards made just for this purpose in many camera stores for under $20.)

Position the reference card so that it receives the same lighting you'll use for your photo. Then take these steps:

1. **Set the camera to the P, S, A, or M exposure mode.**

 If the exposure meter reports that your image will be under- or overexposed at the current exposure settings, make the necessary adjustments now. (Chapter 5 tells you how.) Otherwise, the camera won't be able to create your custom white balance preset.

2. **Frame your shot so that the reference card completely fills the viewfinder.**

3. **From the Shooting menu, select White Balance, press OK, and select the PRE (Preset Manual) white balance setting, as shown on the left in Figure 6-22.**

4. **Press the Multi Selector right, select Measure, as shown on the right in the figure, and press OK.**

 A warning appears, asking you if you want to overwrite existing data.

5. **Select Yes and press OK.**

 You see another message, this time telling you to take your picture. You've got about six seconds to do so. (The letters PRE flash in the viewfinder and Shooting Information display to let you know the camera's ready to record your white balance reference image.)

Figure 6-22: Select these options to set white balance by measuring a white or gray card.

If the camera is successful at recording the white balance data, the letters *Gd* flash in the viewfinder and the message "Data Acquired" appears in the Shooting Information display. If the camera couldn't set the custom white balance, you instead see the message *No Gd* in the viewfinder, and a message in the Shooting Information display urges you to try again. Try adjusting your lighting before doing so.

After you complete the process, the camera automatically sets the White Balance option to PRE so you can begin using your preset. You see the letters PRE in the White Balance area of the Shooting Information display, as shown in Figure 6-23.

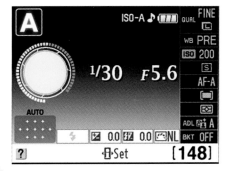

 Any time you want to select and use the preset, switch to the PRE white balance setting. Your custom setting is stored in the camera until you override it with a new preset.

Figure 6-23: Select the PRE (Preset Manual) option to use your custom white balance setting.

Matching white balance to an existing photo

Suppose that you're the marketing manager for a small business, and one of your jobs is to shoot portraits of the company big-wigs for the annual report. You build a small studio just for that purpose, complete with a couple of photography lights and a nice, conservative beige backdrop.

Of course, the big-wigs can't all come to get their pictures taken in the same month, let alone on the same day. But you have to make sure that the colors in that beige backdrop remain consistent for each shot, no matter how much time passes between photo sessions. This scenario is one possible use for an advanced white balance feature that enables you to base white balance on an existing photo.

Basing white balance on an existing photo works well only in strictly controlled lighting situations, where the color temperature of your lights is consistent from day to day. Otherwise, the white balance setting that produces color accuracy when you shoot Big Boss Number One may add an ugly color cast to the one you snap of Big Boss Number Two.

To give this option a try, follow these steps:

1. **Copy the picture that you want to use as the reference photo to your camera memory card, if it isn't already stored there.**

 You can copy the picture to the card using a card reader and whatever method you usually use to transfer files from one drive to another. Copy the file to the folder named 100D5000 (default folder name), inside the main folder, named DCIM by default. (See Chapter 8 for help with working with files and folders.)

2. **Open the Shooting menu, highlight White Balance, and press OK.**

3. **Select PRE (Preset Manual) and press the Multi Selector right.**

 The submenu shown on the left in Figure 6-24 appears.

Figure 6-24: You can create a white balance preset based on an existing photo.

4. **Highlight Use Photo and press OK.**

 The options shown on the right in Figure 6-24 appear.

5. **Select the photo you want to use as your reference image.**

 If the photo appears on the screen already, highlight This Image and press OK.

 Alternatively, highlight Select Image and then press the Multi Selector right to access screens that let you navigate to the photo you want to use as a basis for white balance. Press OK to return to the screen shown on the right in Figure 6-24.

6. Press OK to set the preset white balance based on the selected photo.

Whenever you want to base white balance on your selected photo, just set the White Balance setting to the PRE option.

Bracketing white balance

Chapter 5 introduces you to your camera's automatic bracketing feature, which enables you to easily record the same image at several different exposure settings. In addition to being able to bracket autoexposure and Active D-Lighting settings, you can use the feature to bracket white balance.

Note a couple of things about this feature:

- **You can bracket JPEG shots only.** You can't use white balance bracketing if you set the camera's Image Quality setting to either RAW (NEF) or RAW+Fine. And frankly, there isn't any need to do so because you can precisely tune colors of RAW files when you process them in your RAW converter. Chapter 8 has details on RAW processing.

- **You can apply white balance bracketing only along the blue-to-amber axis of the fine-tuning color grid.** You can't shift colors along the green-to-magenta axis, as you can when tweaking a specific white balance setting. (For a reminder of this feature, refer to the earlier section "Fine-tuning white balance settings.")

- **For each bracketed series, you get one "neutral" shot, one shifted toward amber, and one shifted toward blue.** By "neutral," I mean that the image is recorded at the current White Balance setting, without any bracketing adjustment.

- **You can choose from increments of 1 (WB1), 2 (WB2), and 3 (WB3).** A higher number produces a greater color shift.

I used white balance bracketing to record the three candle photos in Figure 6-25, setting the bracketing to shift colors the maximum three steps. As you can see, even at that maximum setting, the color differences between the shots are subtle. In this photo, I find the differences most noticeable in the color of the backdrop.

To bracket white balance, follow these steps:

1. Set your camera to the P, S, A, or M exposure mode.

White balance options are available only in these modes.

2. Set the Image Quality setting to one of the JPEG options (Fine, Normal, or Basic).

You can adjust the setting through the Quick Settings screen or Shooting menu. (See Chapter 3 for a full explanation of the JPEG options.)

Neutral Amber +3 Blue +3

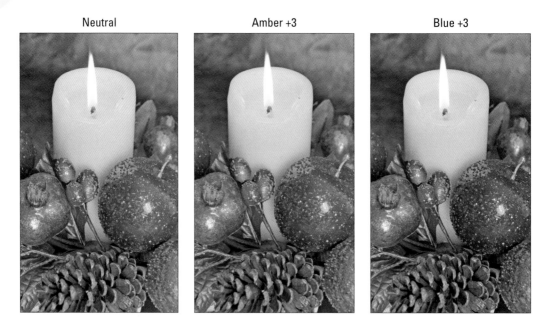

Figure 6-25: I used white balance bracketing to record three variations on the subject.

3. **Display the Custom Setting menu, select the Bracketing/Flash submenu, and press OK.**

4. **Select Auto Bracketing Set, as shown on the left in Figure 6-26, and press OK.**

You see the screen shown on the right in the figure.

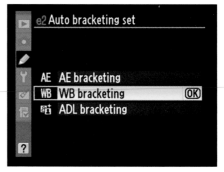

Figure 6-26: Your first step is to set the Auto Bracketing Set option to WB Bracketing.

5. **Select WB Bracketing and press OK.**

 The bracketing feature is now set up to adjust white balance between your bracketed shots. (Exposure and Active D-Lighting are not bracketed.)

6. **Use the Quick Settings screen to set the amount of color shift you want for your bracketed images.**

 After displaying the Shooting Information screen, press the Information Edit button to get to Quick Settings mode. Then use the Multi Selector to highlight the BKT option, as shown on the left in Figure 6-27.

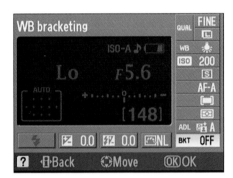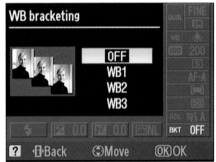

Figure 6-27: Select the amount of color shift through the Quick Settings screen.

7. **Press OK to display the WB Bracketing menu shown on the right in Figure 6-27.**

8. **Highlight the desired increment.**

 Again, WB1 is the smallest increment between color temperatures, and WB3 has the greatest increment between color temperatures.

9. **Press the shutter button once to record your first bracketed series.**

 Each press of the shutter button records the image three times, once at a neutral white balance, once with an amber bias, and once with a blue bias. If you inspect the photo metadata, the white balance values for the bracketed shots will show A (1, 2, or 3) or B (1, 2, or 3).

Your bracketing option remains in effect even after you shut the camera off. When you're finished taking the pictures that need bracketing, remember to disable bracketing. Just revisit the Quick Settings screen and then set the BKT option to Off, as shown on the right in Figure 6-27.

Choosing a Color Space: sRGB vs. Adobe RGB

By default, your camera captures images using the *sRGB color mode,* which simply refers to an industry-standard spectrum of colors. (The *s* is for *standard,* and the RGB is for red-green-blue, which are the primary colors in the digital color world.) The sRGB color mode was created to help ensure color consistency as an image moves from camera (or scanner) to monitor and printer; the idea was to create a spectrum of colors that all of these devices can reproduce.

However, the sRGB color spectrum leaves out some colors that *can* be reproduced in print and onscreen, at least by some devices. So as an alternative, your camera also enables you to shoot in the Adobe RGB color mode, which includes a larger spectrum (or *gamut*) of colors. Figure 6-28 offers an illustration of the two spectrums.

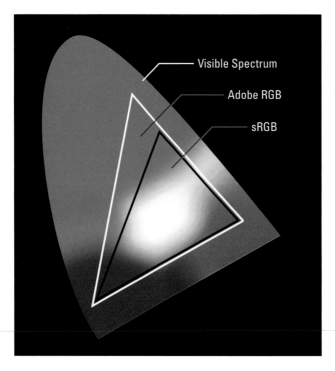

Figure 6-28: Adobe RGB includes some colors not found in the sRGB spectrum.

Some colors in the Adobe RGB spectrum cannot be reproduced in print. (The printer just substitutes the closest printable color, if necessary.) Still, I usually shoot in Adobe RGB mode because I see no reason to limit myself to a smaller spectrum from the get-go.

However, just because I use Adobe RGB doesn't mean that it's right for you. First, if you plan to print and share your photos without making any adjustments in your photo editor, you're usually better off sticking with sRGB, because most printers and Web browsers are designed around that color space. Second, know that in order to retain all your original Adobe RGB colors when you work with your photos, your editing software must support that color space — not all programs do. You also must be willing to study the whole topic of digital color a little bit because you need to use some specific settings to avoid really mucking up the color works.

If you want to go with Adobe RGB instead of sRGB, visit the Shooting menu and highlight the Color Space option, as shown on the left in Figure 6-29. Press OK to display the screen shown on the right in the figure. Select Adobe RGB and press OK again.

Figure 6-29: Choose Adobe RGB for a broader color spectrum.

You can tell whether you captured an image in the Adobe RGB format by looking at its filename: Adobe RGB images start with an underscore, as in _DSC0627.jpg. For pictures captured in the sRGB color space, the underscore appears in the middle of the filename, as in DSC_0627.jpg. See Chapter 4 for more tips on decoding picture filenames.

Taking a Quick Look at Picture Controls

A feature that Nikon calls *Picture Controls* offers one more way to tweak image sharpening, color, and contrast when you shoot in the P, S, A, and M exposure modes and choose one of the JPEG options for the Image Quality setting. (Chapter 3 explains the Image Quality setting.)

Sharpening, in case you're new to the digital meaning of the term, refers to a software process that adjusts contrast in a way that creates the illusion of slightly sharper focus. I emphasize, "slightly sharper focus." Sharpening produces a subtle *tweak,* and it's not a fix for poor focus.

You can select a Picture Control from the Shooting menu, as shown in Figure 6-30, or through the Quick Settings display, as shown in Figure 6-31. See Chapter 1 if you need help navigating menus or the Quick Settings display.

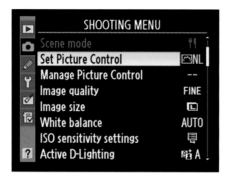
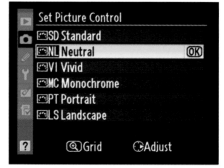

Figure 6-30: Picture Controls apply preset adjustments to color, sharpening, and other photo characteristics to images you shoot in the JPEG file format.

Figure 6-31: You can access the Picture Control options through the Quick Settings display, too.

Whichever route you go, you can choose from six Picture Controls, which produce the following results:

- **Standard:** The default setting for the P, S, A, and M exposure modes, this option captures the image normally — that is, using the characteristics that Nikon offers up as suitable for the majority of subjects. You also are assigned this mode if you shoot in the Auto, No Flash, Sports, Child, and Close Up exposure modes.

- **Neutral:** At this setting, the camera doesn't enhance color, contrast, and sharpening as much as in the other modes. The setting is designed for people who want to precisely manipulate these picture characteristics in a photo editor. By not overworking colors, sharpening, and so on when producing your original file, the camera delivers an original that gives you more latitude in the digital darkroom.

- **Vivid:** In this mode, the camera amps up color saturation, contrast, and sharpening.

- **Monochrome:** This setting produces black-and-white photos. Only in the digital world, they're called *grayscale images* because a true black-and-white image contains only black and white, with no shades of gray.

 I'm not keen on creating grayscale images this way. I prefer to shoot in full color and then do my own grayscale conversion in my photo editor. That technique just gives you more control over the look of your black-and-white photos. Assuming that you work with a decent photo editor, you can control what original tones are emphasized in your grayscale version, for example. Additionally, keep in mind that you can always convert a color image to grayscale, but you can't go the other direction. You can create a black-and-white copy of your color image right in the camera, in fact; Chapter 10 shows you how.

- **Portrait:** This mode tweaks colors and sharpening in a way that is designed to produce nice skin texture and pleasing skin tones. (If you shoot in the Portrait or Night Portrait automatic exposure modes, the camera selects this Picture Control for you.)

- **Landscape:** This mode emphasizes blues and greens. As you might expect, it's the mode used by the Landscape Digital Vari-Program mode.

The extent to which Picture Controls affect your image depends on the subject as well as the exposure settings you choose and the lighting conditions. But Figure 6-32 gives you a general idea of what to expect. As you can see, the differences between the various Picture Controls are pretty subtle, with the exception of the Monochrome option, of course.

Standard Neutral Vivid

Monochrome Portrait Landscape

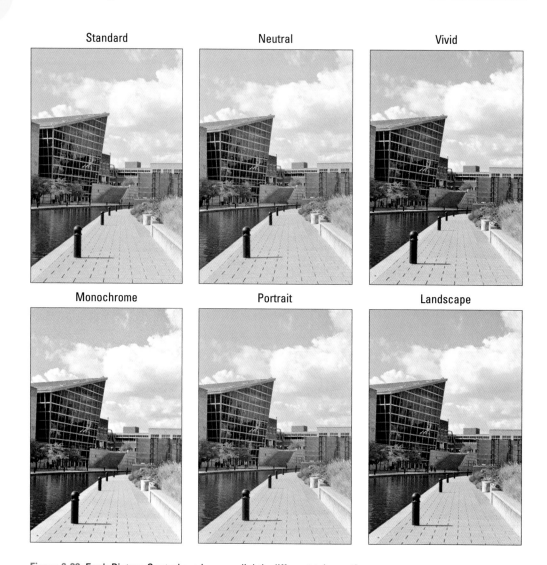

Figure 6-32: Each Picture Control produces a slightly different take on the scene.

Personally, I think that the Standard Picture Control is just ducky, and I rarely use the others. And frankly, I suggest that you do the same. First off, you've got way more important camera settings to worry about — aperture, shutter speed, autofocus, and all the rest. Why add one more setting to your list, especially when the impact of changing it is minimal?

Second, if you really want to mess with the characteristics that the Picture Control options affect, you're much better off shooting in the RAW (NEF) format and then making those adjustments on a picture-by-picture basis in your RAW converter. In Nikon ViewNX, you can even assign any of the existing Picture Controls to your RAW files and then compare how each one affects the image. The camera does tag your RAW file with whatever Picture Control is active at the time you take the shot, but the image adjustments are in no way set in stone, or even in sand — you can tweak your photo at will. (The selected Picture Control does affect the JPEG preview that's used to display the RAW image thumbnails in ViewNX and other browsers.)

For these reasons, I'm opting in this book to present you with just this brief introduction to Picture Controls so that I can go into more detail about functions that I see as more useful (such as the white balance customization options presented earlier). But if you're intrigued, know that you also can create your very own, customized Picture Controls. The camera manual walks you step by step through the process.

Putting It All Together

*E*arlier chapters of this book break down each and every picture-taking feature on your D5000, describing in detail how the various controls affect exposure, picture quality, focus, color, and the like. This chapter pulls all that information together to help you set up your camera for specific types of photography.

The first section offers a quick summary of critical picture-taking settings that should serve you well no matter what your subject. Following that, I offer my advice on which settings to use for portraits, action shots, landscapes, and close-ups. To wrap things up, the end of the chapter includes some miscellaneous tips for dealing with special shooting situations and subjects.

Keep in mind that although I present specific recommendations here, there are no hard and fast rules as to the "right way" to shoot a portrait, a landscape, or whatever. So feel free to wander off on your own, tweaking this exposure setting or adjusting that focus control, to discover your own creative vision. Experimentation is part of the fun of photography, after all — and thanks to your camera monitor and the Delete button, it's an easy, completely free proposition.

Recapping Basic Picture Settings

Your subject, creative goals, and lighting conditions determine which settings you should use for some picture-taking options, such as aperture and shutter speed. I offer my take on those options throughout this chapter. But for many basic options, I recommend the same settings for almost every shooting scenario. Table 7-1 shows you those recommendations and also lists the chapter where you can find details about each setting.

Table 7-1	All-Purpose Picture-Taking Settings	
Option	*Recommended Setting*	*Chapter*
Image Quality	JPEG Fine or NEF (RAW)	3
Image Size	Large or medium	3
White Balance*	Auto	6
ISO Sensitivity	200	5
Autofocus Mode	AF-A (Auto-servo)	6
AF-Area Mode	Action photos; Dynamic area; all others, Single Point	6
Release Mode	Action photos: Continuous; all others: Single	2
Metering*	Matrix	5
Active D-Lighting*	Auto	5

Adjustable only in P, S, A, and M exposure modes.

Setting Up for Specific Scenes

For the most part, the settings detailed in the preceding section fall into the "set 'em and forget 'em" category. That leaves you free to concentrate on a handful of other camera options, such as aperture and shutter speed, that you can manipulate to achieve a specific photographic goal.

The next four sections explain which of these additional options typically produce the best results when you're shooting portraits, action shots, landscapes, and close-ups. I offer a few compositional and creative tips along the way — but again, remember that beauty is in the eye of the beholder, and for every so-called rule, there are plenty of great images that prove the exception.

Shooting still portraits

By *still portrait,* I mean that your subject isn't moving. For subjects who aren't keen on sitting still long enough to have their picture taken — children, pets, and even some teenagers I know — skip ahead to the next section and use the techniques given for action photography instead.

Assuming that you do have a subject willing to pose, the classic portraiture approach is to keep the subject sharply focused while throwing the background into soft focus. This artistic choice emphasizes the subject and helps diminish the impact of any distracting background objects in cases where you can't control the setting. The following steps show you how to achieve this look:

1. **Set the Mode dial to A (aperture-priority autoexposure) and select the lowest f-stop value possible.**

 As Chapter 5 explains, a low f-stop setting opens the aperture, which not only allows more light to enter the camera but also shortens depth of field, or the range of sharp focus. So dialing in a low f-stop value is the first step in softening your portrait background. (The f-stop range available to you depends on your lens.) Also keep in mind that the farther your subject is from the background, the more blurring you can achieve.

 I recommend aperture-priority mode when depth of field is a primary concern because you can control the f-stop while relying on the camera to select the shutter speed that will properly expose the image. Just rotate the Command dial to select your desired f-stop. (You do need to pay attention to shutter speed also, however, to make sure that it's not so slow that any movement of the subject or camera will blur the image.)

 If you aren't comfortable with this advanced exposure mode, Portrait and Child mode also result in a more open aperture, although the exact f-stop setting is out of your control. You should note, too, that both of those modes make subtle adjustments to color and sharpening that may or may not be what you have in mind. See Chapter 2 for details.

 Whichever mode you choose, you can monitor the current f-stop and shutter speed on the Shooting Information display and in the viewfinder, as shown in Figure 7-1.

2. **To further soften the background, zoom in, get closer, or both.**

 As covered in Chapter 6, zooming in to a longer focal length also reduces depth of field, as does moving physically closer to your subject.

Shutter speed

Aperture

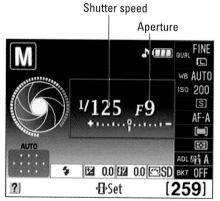

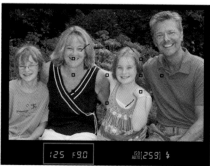

Figure 7-1: You can monitor aperture and shutter speed settings in two places.

A lens with a focal length of 85–120mm is ideal for a classic head and shoulders portrait. But don't fret if you have only the 18-55mm kit lens; just zoom in all the way to the 55mm setting. You should avoid using a much shorter focal length (a wider-angle lens) for portraits. They can cause features to appear distorted — sort of like how people look when you view them through a security peephole in a door.

3. For indoor portraits, shoot flash-free if possible.

Shooting by available light rather than flash produces softer illumination and avoids the problem of red-eye. To get enough light to go flash-free, turn on room lights or, during daylight, pose your subject next to a sunny window, as I did for the image in Figure 7-2.

In the A exposure mode, simply keeping the built-in flash unit closed disables the flash. In Portrait and Child modes, the camera automatically pops up the flash unit in dim lighting. To disable the flash, in those modes, the easiest option is to press the Flash button as you rotate the Command dial to select the Off setting. (You can view the current setting in the Shooting Information display.)

Figure 7-2: For more pleasing indoor portraits, shoot by available light instead of using flash.

If flash is unavoidable, see my list of flash tips at the end of the steps to get better results.

4. **For outdoor portraits, use a flash if possible.**

Even in daylight, a flash adds a beneficial pop of light to subjects' faces, as illustrated in Figure 7-3.

In the A exposure mode, you can just press the Flash button on the side of the camera to enable the flash. For daytime portraits, use the fill flash setting. (That's the regular, basic flash mode.) For nighttime images, try red-eye reduction or slow-sync mode; again, see the flash tips at the end of these steps to use either mode most effectively.

Unfortunately, Portrait and Child mode use Auto flash, and if the ambient light is very bright, the flash may not fire. Switch to an advanced exposure mode (P, S, A, or M) to regain flash control. But do note that whatever exposure mode you use, the top shutter speed available when you use the built-in flash is 1/200 second, so in extremely bright light, you may need to stop down the aperture to avoid overexposing the photo. Doing so, of course, brings the background into sharper focus. So try to move the subject into a shaded area instead.

No flash Fill flash

Figure 7-3: To properly illuminate the face in outdoor portraits, use fill flash.

5. **Press and hold the shutter button halfway to initiate exposure metering and autofocusing.**

 Make sure that an active autofocus point falls over your subject. Chapter 6 explains more about autofocus, but if you have trouble, simply set your lens to manual focus mode and then twist the focusing ring to set focus. See Chapter 1 for help with manual focusing.

6. **Press the shutter button the rest of the way to capture the image.**

Again, these steps just give you a starting point for taking better portraits. A few other tips can also improve your people pics:

- ✔ **Pay attention to the background.** Scan the entire frame looking for intrusive objects that may distract the eye from the subject. If necessary, reposition the subject against a more flattering backdrop. Inside, a softly textured wall works well; outdoors, trees and shrubs can provide nice backdrops as long as they aren't so ornate or colorful that they diminish the subject (for example, a magnolia tree laden with blooms).

- ✔ **Pay attention to white balance if your subject is lit by both flash and ambient light.** If you set the white balance setting to Auto, as I recommend in Table 7-1, enabling flash tells the camera to warm colors to compensate for the cool light of a flash. If your subject is also lit by room lights or sunlight, the result may be colors that are slightly warmer than neutral. This warming effect typically looks nice in portraits, giving the skin a subtle glow. But if you aren't happy with the result or want even more warming, see Chapter 6 to find out how to fine-tune white balance. Again, you can make this adjustment only in P, S, A, or M exposure modes.

- ✔ **When flash is unavoidable, try these tricks to produce better results.** The following techniques can help solve flash-related issues:

 - *Indoors, turn on as many room lights as possible.* With more ambient light, you reduce the flash power that's needed to expose the picture. This step also causes the pupils to constrict, further reducing the chances of red-eye. (Pay heed to my white balance warning, however.) As an added benefit, the smaller pupil allows more of the subject's iris to be visible in the portrait, so you see more eye color.

 - *Try setting the flash to red-eye reduction or slow-sync mode.* If you choose the first option, warn your subject to expect both a preliminary pop of light from the AF-assist lamp, which constricts pupils, and the actual flash. And remember that slow-sync flash uses a slower-than-normal shutter speed, which produces softer lighting and brighter backgrounds than normal flash. (Chapter 5 has an

example.) This mode is available in P and A exposure modes and is also the default setting in Night Portrait mode.

Remember that the slow shutter speed of slow-sync mode means that you should use a tripod and ask your subject to stay very still to avoid blurring.

- *For professional results, use an external flash with a rotating flash head.* Then aim the flash head upward so that the flash light bounces off the ceiling and falls softly down onto the subject. An external flash isn't cheap, but the results make the purchase worthwhile if you shoot lots of portraits. Compare the two portraits in Figure 7-4 for an illustration. In the first example, the built-in flash resulted in strong shadowing behind the subject and harsh, concentrated light. To produce the better result on the right, I used the Nikon Speedlight SB-600 and bounced the light off the ceiling.

- *To reduce shadowing from the flash, move your subject farther from the background.* I took this extra step for the right image in Figure 7-4. The increased distance not only reduced shadowing but also softened the focus of the wall a bit (because of the short depth of field resulting from my f-stop and focal length).

Figure 7-4: To eliminate harsh lighting and strong shadows (left), I used bounce flash and moved the subject farther from the background (right).

A good general rule is to position your subjects far enough from the background that they can't touch it. If that isn't possible, though, try going the other direction: If the person's head is smack up against the background, any shadow will be smaller and less noticeable. For example, you get less shadowing when a subject's head is resting against a sofa cushion than if that person is sitting upright, with the head a foot or so away from the cushion.

✔ **Frame the subject loosely to allow for later cropping to a variety of frame sizes.** Your D5000 produces images that have an aspect ratio of 3:2. That means that your portrait perfectly fits a 4-x-6-inch print size but will require cropping to print at any other proportions, such as 5 x 7 or 8 x 10. Chapter 9 talks more about this issue.

Capturing action

A fast shutter speed is the key to capturing a blur-free shot of any moving subject, whether it's your tennis-playing teen, a spinning Ferris wheel, or, as in the case of Figure 7-5, a flock of ducks in flight.

Doug Sahlin

Figure 7-5: Use a high shutter speed to freeze motion.

Along with the basic capture settings outlined in Table 7-1, try the techniques in the following steps to photograph a subject in motion:

1. **Set the Mode dial to S (shutter-priority autoexposure).**

 In this mode, you control the shutter speed, and the camera takes care of choosing an aperture setting that will produce a good exposure.

 If you aren't ready to step up to this advanced exposure mode, explained in Chapter 5, try using Sports mode, detailed in Chapter 2. But be aware that you have no control over many other aspects of your picture (such as white balance, flash, and so on) in that mode.

2. **Rotate the Command dial to select the shutter speed.**

 (Refer to Figure 7-1 to locate shutter speed in the viewfinder and Shooting Information display.) After you select the shutter speed, the camera selects an aperture (f-stop) to match.

 What shutter speed do you need exactly? Well, it depends on the speed at which your subject is moving, so some experimentation is needed. But generally speaking, 1/500 second should be plenty for all but the fastest subjects (race cars, boats, and so on). For very slow subjects, you can even go as low as 1/250 or 1/125 second.

3. **Raise the ISO setting or add flash to produce a brighter exposure, if needed.**

 In dim lighting, you may not be able to get a good exposure without taking this step; the camera simply may not be able to open the aperture wide enough to accommodate a fast shutter speed. Raising the ISO does increase the possibility of noise, but a noisy shot is better than a blurry shot.

 Adding flash is a bit tricky for action shots, unfortunately. First, the flash needs time to recycle between shots, so try to go without if you want to capture images at a fast pace. Second, the built-in flash has limited range — so don't waste your time if your subject isn't close by. And third, remember that the fastest shutter speed you can use with flash is 1/200 second, which may not be high enough to capture a quickly moving subject without blur.

 If you do decide to use flash, you must bail out of Sports mode; it doesn't permit you to use flash.

4. **For rapid-fire shooting, set the Release mode to the Continuous setting.**

 In this mode, you can capture multiple images with a single press of the shutter button. As long as you hold down the button, the camera continues to record images. Here again, though, you need to go flash-free; you can't use the Continuous capture mode with flash because it isn't compatible with flash photogography.

5. For fastest shooting, switch to manual focusing.

Manual focusing eliminates the time the camera needs to lock focus in autofocus mode. Chapter 1 shows you how to focus manually, if you need help.

If you do use autofocus, try these two autofocus settings for best performance:

- Set the AF-area mode to Dynamic Area.
- Set the Focus mode to AF-C (continuous-servo autofocus).

Chapter 6 details these autofocus options. Note that you can control the Focus mode only in the advanced exposure modes. In the other modes, the camera should automatically switch to continuous-servo autofocus when it senses movement in front of the lens, however.

6. Turn off Image Review.

You turn off Image Review via the Playback menu. Turning the option off can help speed up the time your camera needs to recover between shots.

7. Compose the subject to allow for movement across the frame.

In Figure 7-5, for example, the wide view ensured that the ducks wouldn't fly out of the frame. It's also a good idea to leave more room in front of the subject than behind it. This makes it obvious that your subject is going somewhere.

 Using these techniques should give you a better chance of capturing any fast-moving subject. But action-shooting strategies also are helpful for shooting candid portraits of kids and pets. Even if they aren't currently running, leaping, or otherwise cavorting, snapping a shot before they do move or change positions is often tough. So if an interaction or scene catches your eye, set your camera into action mode and then just fire off a series of shots as fast as you can.

For example, one recent afternoon, I spotted my furball and his equally fluffy new neighbor introducing themselves to each other through the fence that separates their yards. I ran and grabbed my camera, flipped it into shutter-priority mode, and just started shooting. Most of the images were throwaways; you can see some of them in Figure 7-6. But somewhere around the tenth frame, I captured the moment you see in Figure 7-7, which puts a whole new twist on the phrase "gossiping over the backyard fence." Two seconds later, the dogs got bored with each other and scampered away into their respective yards, but thanks to a fast shutter, I got the shot that I wanted.

Figure 7-6: I used speed-shooting techniques to capture this interaction between a pair of pups.

Figure 7-7: Although most of the shots were deletable, this one was a keeper.

Capturing scenic vistas

Providing specific capture settings for landscape photography is tricky because there's no single best approach to capturing a beautiful stretch of countryside, a city skyline, or other vast subject. Take depth of field, for example: One person's idea of a super cityscape might be to keep all buildings in the scene sharply focused. But another photographer might prefer to shoot the same scene so that a foreground building is sharply focused while the others are less so, thus drawing the eye to that first building.

That said, I can offer a few tips to help you photograph a landscape the way *you* see it:

✔ **Shoot in aperture-priority autoexposure mode (A) so that you can control depth of field.** If you want extreme depth of field, so that both near and distant objects are sharply focused, as in Figure 7-8, select a high f-stop value. For short depth of field, use a low value.

You can also use Landscape mode to achieve the first objective. In this mode, the camera automatically selects a high f-stop number, but you have no control over the exact value (or certain other picture-taking settings). And in dim lighting, the camera may be forced to select a low f-stop setting.

Doug Sahlin

Figure 7-8: Use a high f-stop value (or Landscape mode) to keep foreground and background sharply focused.

↙ **If the exposure requires a slow shutter, use a tripod to avoid blurring.**
The downside to a high f-stop is that you need a slower shutter speed
to produce a good exposure. If the shutter speed drops below what
you can comfortably hand-hold, use a tripod to avoid picture-blurring
camera shake. Remember that when you use a tripod, Nikon recom-
mends that you turn Vibration Reduction off.

No tripod handy? Look for any solid surface on which you can steady
the camera. Of course, you can always increase the ISO Sensitivity
setting to allow a faster shutter, too, but that option brings with it the
chances of increased image noise. See Chapter 5 for details.

↙ **For dramatic waterfall shots,
consider using a slow shutter to
create that "misty" look.** The
slow shutter blurs the water,
giving it a soft, romantic appear-
ance, as shown in Figure 7-9.
Again, use a tripod to ensure that
the rest of the scene doesn't also
blur due to camera shake. You
can also use a slow shutter speed
to capture dramatic photographs
of waves coming ashore.

In very bright light, you may over-
expose the image at a very slow
shutter, even if you stop the aper-
ture all the way down and select
the camera's lowest ISO setting.
As a solution, consider investing
in a *neutral density filter* for your
lens. This type of filter works
something like sunglasses for
your camera: It simply reduces
the amount of light that passes
through the lens, without affect-
ing image colors, so that you can
use a slower shutter than would
otherwise be possible.

Figure 7-9: For misty waterfalls, use a slow
shutter speed and a tripod.

↙ **At sunrise or sunset, base exposure on the sky.** The foreground will
be dark, but you can usually brighten it in a photo editor if needed.
If you base exposure on the foreground, on the other hand, the sky will
become so bright that all the color will be washed out — a problem you
usually can't fix after the fact.

Also experiment with different levels of Active-D Lighting adjustment.
Chapter 5 explains this feature, which brightens dark areas in a way that
doesn't blow out highlights, leaving your sky colors intact. You can
adjust the setting only in the P, S, A, and M exposure modes.

✔ **For cool nighttime city pics, experiment with slow shutter.** Assuming that cars or other vehicles are moving through the scene, the result is neon trails of light like those you see in the foreground of the image in Figure 7-10. Shutter speed for this image was about 10 seconds.

Instead of changing the shutter speed manually between each shot, try *bulb* mode. Available only in M (manual) exposure mode, this option records an image for as long as you hold down the shutter button. So just take a series of images, holding the button down for different lengths of time for each shot. In bulb mode, you also can exceed the standard maximum shutter speed of 30 seconds.

✔ **For the best lighting, shoot during the "magic hours."** That's the term photographers use for early morning and late afternoon, when the light cast by the sun is soft and warm, giving everything that beautiful, gently warmed look.

Can't wait for the perfect light? Tweak your camera's white balance setting, using the instructions laid out in Chapter 6, to simulate magic-hour light.

✔ **In tricky light, bracket exposures.** *Bracketing* simply means to take the same picture at several different exposures to increase the odds that at least one of them will capture the scene the way you envision. Bracketing is especially a good idea in difficult lighting situations such as sunrise and sunset.

Doug Sahlin

Figure 7-10: A slow shutter also creates neon light trails in city-street scenes.

In P, S, A, and M modes, you can take advantage of automatic bracketing. See the end of Chapter 5 for details.

Capturing dynamic close-ups

For great close-up shots, try these techniques:

- ✔ **Check your owner's manual to find out the minimum close-focusing distance of your lens.** How "up close and personal" you can get to your subject depends on your lens, not the camera body itself.

- ✔ **Take control over depth of field by setting the camera mode to A (aperture-priority autoexposure) mode.** Whether you want a shallow, medium, or extreme depth of field depends on the point of your photo. In classic nature photography, for example, the artistic tradition is a very shallow depth of field, as shown in Figure 7-11, and requires an open aperture (low f-stop value). But if you want the viewer to be able to clearly see all details throughout the frame — for example, if you're shooting a product shot for your company's sales catalog — you need to go the other direction, stopping down the aperture as far as possible.

Figure 7-11: Shallow depth of field is a classic technique for close-up floral images.

Not ready for the advanced exposure modes yet? Try Close Up mode instead. (It's the one marked with the little flower on your Mode dial.) In this mode, the camera automatically opens the aperture to achieve a short depth of field and bases focus on the center of the frame. As with all the other automatic exposure modes, though, the range of apertures available to the camera depends on the lighting conditions.

✔ **Remember that zooming in and getting close to your subject both decrease depth of field.** So back to that product shot: If you need depth of field beyond what you can achieve with the aperture setting, you may need to back away, zoom out, or both. (You can always crop your image to show just the parts of the subject that you want to feature.)

✔ **When shooting flowers and other nature scenes outdoors, pay attention to shutter speed, too.** Even a slight breeze may cause your subject to move, causing blurring at slow shutter speeds.

✔ **Use flash for better outdoor lighting.** Just as with portraits, a tiny bit of flash typically improves close-ups when the sun is your primary light source. Again, though, keep in mind that the maximum shutter speed possible when you use flash is 1/200 second. So in very bright light, you may need to use a high f-stop setting to avoid overexposing the picture. If you shoot in an advanced exposure mode (P, S, A, or M), you can also adjust the flash output via the Flash Compensation control. Chapter 5 offers details.

✔ **When shooting indoors, try not to use flash as your primary light source.** Because you'll be shooting at close range, the light from your flash may be too harsh even at a low Flash Compensation setting. If flash is inevitable, turn on as many room lights as possible to reduce the flash power that's needed — even a hardware-store shop light can do in a pinch as a lighting source. (Remember that if you have multiple light sources, though, you may need to tweak the white balance setting.)

✔ **To really get close to your subject, invest in a macro lens or a set of diopters.** A true macro lens, which enables you to get really, really close to your subjects, is an expensive proposition; expect to pay around $200 or more. But if you enjoy capturing the tiny details in life, it's worth the investment.

For a less expensive way to go, you can spend about $40 for a set of *diopters,* which are sort of like reading glasses that you screw onto your existing lens. Diopters come in several strengths — +1, +2, + 4, and so on — with a higher number indicating a greater magnifying power. I took this approach to capture the extreme close-up in Figure 7-12, attaching a +2

Figure 7-12: To extend your lens' close-focus ability, you can add magnifying diopters.

diopter to my lens. The downfall of diopters, sadly, is that they typically produce images that are very soft around the edges, a problem that doesn't occur with a good macro lens.

Coping with Special Situations

A few subjects and shooting situations pose some additional challenges not already covered in earlier sections. So to wrap up this chapter, here's a quick list of ideas for tackling a variety of common "tough-shot" photos:

- ✔ **Shooting through glass:** To capture subjects that are behind glass, such as the shark in Figure 7-13, try putting your lens flat against the glass. Before you do, switch to manual focusing; the glass barrier can give the autofocus mechanism fits. Disable your flash to avoid creating any unwanted reflections, too.

- ✔ **Shooting out a car window:** Set the camera to shutter-priority auto-exposure or manual mode and dial in a fast shutter speed to compensate for the movement of the car. Oh, and keep a tight grip on your camera.

- ✔ **Shooting fireworks:** First off, use a tripod; fireworks require a long exposure, and trying to handhold your camera simply isn't going to work. If using a zoom lens, zoom out to the shortest focal length (widest angle). Switch to manual focusing and set focus at infinity (the farthest focus point possible on your lens). Set the exposure mode to manual, choose a relatively high f-stop setting — say, f/16 or so — and start a shutter speed of 1 to 3 seconds. From there, it's simply a matter of experimenting with different shutter speeds.

Be especially gentle when you press the shutter button — with a very slow shutter, you can easily create enough camera movement to blur the image. If you purchased the accessory remote control for your camera, this is a good situation in which to use it. You can also set the self-timer to 2 seconds, which gives the camera time to stabilize after you press the shutter button. (See Chapter 2 for help with the self-timer setting.)

- ✔ **Shooting reflective surfaces:** In outdoor shots taken in bright sun, you can reduce glare from reflective surfaces such as glass and metal by using a *circular polarizing filter,* which you can buy for about $40. A polarizing filter can also help out when you're shooting through glass.

But know that in order for the filter to work, the sun, your subject, and your camera lens must be precisely positioned. Your lens must be at a 90-degree angle from the sun, for example, and the light source must also be reflecting off the surface at a certain angle and direction. In addition, a polarizing filter also intensifies blue skies in some scenarios, which may or may not be to your liking. In other words, a polarizing filter isn't a surefire cure-all.

Doug Sahlin

Figure 7-13: He's watching you . . .

A more reliable option for shooting small reflective objects is to invest in a light cube or light tent such as the ones shown in Figure 7-14, from Cloud Dome (www.clouddome.com) and Lastolite (www.lastolite.com), respectively. You place the reflective object inside the tent or cube and then position your lights around the outside. The cube or tent acts as a light diffuser, reducing reflections. Prices range from about $50 to $200, depending on size and features.

✔ **Shooting in strong backlighting:** When the light behind your subject is very strong, the result is often an underexposed subject. You can try using flash to better expose the subject, assuming that you're shooting in an exposure mode that permits flash. The Active D-Lighting feature, which captures the image in a way that retains better detail in the shadows without blowing out highlights, may also help. (Chapter 5 offers an example.) If you shoot in the advanced exposure modes (P, S, A, or M), you can adjust the amount of the correction.

But for another creative choice, you can purposely underexpose the subject to create a silhouette effect, as shown in Figure 7-15. Set your camera to an advanced exposure mode, disable flash and Active D-Lighting, and then base your exposure on the sky so that the darker areas of the frame remain dark.

Cloud Dome, Inc. *Lastolite Limited*

Figure 7-14: Investing in a light cube or tent makes photographing reflective objects much easier.

Figure 7-15: Experiment with shooting backlit subjects in silhouette.

Part III
Working with Picture Files

The 5th Wave — By Rich Tennant

BUNGCO BUNGEE CORDS

"Come on, Walt-time to freshen the company Web page."

In this part . . .

You've got a memory card full of pictures. Now it's time to download them to your computer so that you can print and share them, as well as enjoy viewing them on something larger than the camera monitor. The first chapter in this part shows you how to get those pictures out of your camera and onto your computer and, just as important, how to safeguard them from future digital destruction. After downloading your files, head for Chapter 9, which offers step-by-step guidance on printing your pictures, sharing them online, and even viewing them on your television.

8

Downloading, Organizing, and Archiving Your Picture Files

- -

In This Chapter

▶ Transferring pictures to your computer

▶ Using Nikon Transfer and ViewNX to download and organize photos

▶ Looking at other photo-management and editing programs

▶ Processing NEF (RAW) files

▶ Keeping your picture files safe from harm

- -

*F*or many novice digital photographers (and even some experienced ones), the task of moving pictures to the computer and then keeping track of all of those image files is one of the more confusing aspects of the art form. And frankly, writing about the downloading and organizing process isn't all that easy, either. (It's a tough job, but somebody's got to do it!) The problem is that providing you with detailed instructions is pretty much impossible because the steps you need to take vary widely depending on what software you have installed on your computer and whether you use the Windows or Macintosh operating system.

To give you as much help as I can, however, this chapter shows you how to transfer and organize pictures using the free Nikon software that came in your camera box. After exploring these discussions, you should be able to adapt the steps to any other photo program you may prefer. This chapter also covers a few other aspects of handling your picture files, including converting pictures taken in the NEF (RAW) format to a standard image format.

One note before you dig in: Most figures in this chapter and elsewhere feature the Windows Vista operating system. If you use some other version of Windows or own a Mac, what you see on your screen may look slightly different but should contain the same basic options unless I specify otherwise.

Sending Pictures to the Computer

You can take two approaches to moving pictures from your camera memory card to your computer:

- ✔ **Connect the camera directly to the computer.** For this option, you need to dig out the USB cable that came in your camera box. Your computer must also have an open USB slot, or *port,* in techie talk. If you're not sure what these gadgets look like, Figure 8-1 gives you a look. The little three-pronged icon, labeled in Figure 8-1, is the universal symbol for USB.

- ✔ **Transfer images using a memory card reader.** Many computers now also have slots that accept common types of memory cards. If so, you can simply pop the card out of your camera and into the card slot instead of hooking the camera up to the computer.

As another option, you can buy stand-alone card readers such as the SanDisk model shown in Figure 8-2. This particular model accepts a variety of memory cards, including the SD card used by your D5000. Check your printer, too; many printers now have card slots that serve the purpose of a card reader.

USB icon

Figure 8-1: You can connect the camera to the computer using the supplied USB cable.

Courtesy SanDisk Corporation

Figure 8-2: A card reader offers a more convenient method of image transfer.

I prefer to use a card reader because when I transfer via the camera, the camera must be turned on during the process, wasting battery power. If you want to transfer directly from the camera, however, the next section explains some important steps you need to take to make that option work. For help using a card reader, skip ahead to "Starting the transfer process" to get an overview of what happens after you insert the card into the reader.

Connecting the camera and computer

You need to follow a specific set of steps when connecting the camera to your computer. Otherwise, you can damage the camera or the memory card.

Also note that in order for your camera to communicate with the computer, Nikon suggests that your computer be running one of the following operating systems:

- Windows Vista 32-bit Home Basic with Service Pack 1, Home Premium, Business, Enterprise, or Ultimate edition
- Windows XP with Service Pack 3, Home or Professional edition
- Mac OS X 10.3.9, 10.4.11, or 10.5.6

If you use another OS (operating system, for the non-geeks in the crowd), check the support pages on the Nikon Web site (www.nikon.com) for the latest news about any updates to system compatibility. You can always simply transfer images with a card reader, too.

With that preamble out of the way, here are the steps to link your computer and camera:

1. **Check the level of the camera battery.**

 If the battery is low, charge it before continuing. Running out of battery power during the transfer process can cause problems, including lost picture data. Alternatively, if you purchased the optional AC adapter, use that to power the camera during picture transfers.

2. **Turn on the computer and give it time to finish its normal startup routine.**

3. **Turn the camera off.**

4. **Insert the smaller of the two plugs on the USB cable into the USB/AV port on the side of the camera.**

 Look under the little rubber door on the left side of the camera, as shown in Figure 8-3, for this port. It's used both for connecting your camera to the computer for USB file transfer and for sending audio and video (A/V) signals to a television, a subject covered in Chapter 9.

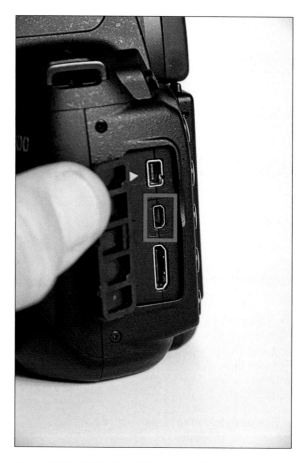

Figure 8-3: The USB slot is hidden under the rubber door on the left side of the camera.

5. Plug the other end of the cable into the computer's USB port.

If possible, plug the cable into a port that's built in to the computer, as opposed to one that's on your keyboard or part of an external USB hub. Those accessory-type connections can sometimes foul up the transfer process.

6. Turn the camera on.

What happens now depends on whether you connected the camera to a Windows-based or Mac computer and what photo software you have

installed on that system. The next section explains the possibilities and how to proceed with the image transfer process.

7. **When the download is complete, turn off the camera and then disconnect it from the computer.**

 I repeat: Turn off the camera before severing its ties with the computer. Otherwise, you can damage the camera.

Starting the transfer process

After you connect the camera to the computer (be sure to carefully follow the steps in the preceding section) or insert a memory card into your card reader, your next step depends, again, on the software installed on your computer and the computer operating system.

Here are the most common possibilities and how to move forward:

Figure 8-4: Windows may display this initial boxful of transfer options.

- **On a Windows-based computer, a Windows message box similar to the one in Figure 8-4 appears.** Again, the figure shows the dialog box as it appears on a computer running Windows Vista. Whatever its design, the dialog box suggests different programs that you can use to download your picture files. Which programs appear depend on what you have installed on your system; if you installed Nikon Transfer, for example, it should appear in the program list, as in the figure. In Windows Vista, just click the transfer program that you want to use. In other versions of Windows, the dialog box may sport an OK button; if so, click that button to proceed.

 If you want to use the same program for all of your transfers, select the Always Do This for This Device check box, as shown in the figure. The next time you connect your camera or insert a memory card, Windows will automatically launch your program of choice instead of displaying the message box.

- **An installed photo program automatically displays a photo-download wizard.** For example, the Nikon Transfer downloader or a downloader associated with Adobe Photoshop Elements, Picasa, or some other photo software may leap to the forefront. On a Mac, the built-in iPhoto

software may display its auto downloader. (Apple's Web site, www. apple.com, offers excellent video tutorials on using iPhoto, by the way.)

Usually, the downloader that appears is associated with the software that you most recently installed. Each new program that you add to your system tries to wrestle control over your image downloads away from the previous program.

Safeguarding your digital photo files

To make sure that your digital photos enjoy a long, healthy life, follow these storage guidelines:

✔ Don't rely on your computer's hard drive for long-term, archival storage. Hard drives occasionally fail, wiping out all files in the process. This warning applies to both internal and external hard drives. At the very least, having a dual-drive backup is in order — you might keep one copy of your photos on your computer's internal drive and another on an external drive. If one breaks, you've still got all your goodies on the other one. Also try to use that second drive only for image storage; assuming that you're not accessing the files every day, this minimizes the run time of the hard drive, which should translate to a longer life span (although it's not guaranteed).

✔ Camera memory cards, flash memory keys, and other portable storage devices, such as one of those wallet-sized media players, are similarly risky. All are easily damaged if dropped or otherwise mishandled. And being of diminutive stature, these portable storage options also are easily lost.

✔ The best way to store important files is to copy them to nonrewritable CDs. (The label should say CD-R, not CD-RW.) Look for quality, brand-name CDs that have a gold coating, which offer a higher level of security than other coatings and boast a longer life than your garden-variety CDs.

✔ Recordable DVDs offer the advantage of holding lots more data than a CD. However, be aware that the DVDs you create on one computer may not be playable on another because multiple recording formats and disc types exist: DVD minus, DVD plus, dual-layer DVD, and so on. If you do opt for DVD, look for the archival, gold-coated variety, just as for CDs.

✔ For a double backup, you may want to check into online storage services, such as Mozy (www.mozy.com) and IDrive (www.idrive.com). You pay a monthly subscription fee to back up your important files to the site's servers.

Note, though, the critical phrase here: *double backup.* Online storage sites have a troubling history of closing down suddenly, taking all their customers' data with them. (One extremely alarming case was the closure of a photography-oriented storage site called Digital Railroad, which gave clients a mere 24-hours' notice before destroying their files.) So anything you store online should be also stored on DVD or CD and kept in your home or office. Also note that photo-sharing sites such as Shutterfly, Kodak Gallery, and the like *aren't* designed to be long-term storage tanks for your images. Usually, you get access to only a small amount of file storage space, and the site may require you to purchase prints or other photo products periodically to maintain your account.

If you don't want a program's auto downloader to launch whenever you insert a memory card or connect your camera, you should be able to turn that feature off. Check the software manual to find out how to disable the auto launch.

✏ **Nothing happens.** Don't panic; assuming that your card reader or camera is properly connected, all is probably well. Someone simply may have disabled all the automatic downloaders on your system. Just launch your photo software and then transfer your pictures using whatever command starts that process. (I show you how to do it with Nikon Transfer later in the chapter; for other programs, consult the software manual.)

As another option, you can use Windows Explorer or the Mac Finder to drag and drop files from your memory card to your computer's hard drive. Whether you connect the card through a card reader or attach the camera directly, the computer sees the card or camera as just another drive on the system. So the process of transferring files is exactly the same as when you move any other file from a CD, DVD, or other storage device onto your hard drive.

In the next sections, I provide details on using Nikon Transfer to download your files and Nikon ViewNX to view and organize your pictures. Remember, if you use some other software, the concepts are the same, but check your program manual to get the small details. In most programs, you also can find lots of information by simply clicking open the Help menu.

Downloading and Organizing Photos with the Nikon Software

Remember unpacking your camera box when you first brought home your D5000? Did you notice a CD-ROM called Nikon Software Suite? If you haven't already done so, dig out that CD and pop it into your computer's CD drive. Then install the following two programs:

✏ **Nikon Transfer:** This program assists you with the process of transferring pictures from your camera or memory card to the computer.

✏ **Nikon ViewNX:** After downloading your files, you can view and organize your picture files using this program. You also can print and e-mail your photos from ViewNX.

Note that this book features Nikon Transfer version 1.4 and Nikon ViewNX version 1.3, which were the most current at the time of publication. If you own an earlier version of these programs, visit the Nikon Web site to install the updates. (To find out what version you have installed, open the program.

Then, in Windows, choose Help⇨About. On a Mac, choose the About command from the Nikon Transfer or Nikon ViewNX menu.)

The next several sections give you the most basic of introductions to using Nikon Transfer and ViewNX. If you want more details, just look in the Help system built in to the programs. (Click the Help menu to access the system.)

Before you move on, though, I want to clear up one common point of confusion: You can use the Nikon software to download and organize your photos and still use any photo editing software you prefer. And to do your editing, you don't need to re-download photos — after you transfer photos to your computer, you can access them from any program, just as you can any file that you put on your system. In fact, for most photo editing programs, you can set things up so that you can select a photo in ViewNX and then open that picture in your chosen photo editor with a click or two. (With some programs, you must first take the step of *importing* the photo files, which enables the program to build thumbnails and, in some cases, working copies of your pictures.) You can find details in the ViewNX Help system (open the program and then choose Help⇨ViewNX Help); look for the section called "Setting Up ViewNX."

Downloading with Nikon Transfer

The following steps explain how to download new pictures to your computer using Nikon Transfer:

1. **Attach your camera or insert a memory card into your card reader, as outlined in the first part of this chapter.**

 Depending on what software you have installed on your system, you may see the initial Nikon Transfer window, as shown in Figure 8-5. Or, in Windows, you may see a dialog box similar to the one shown in Figure 8-4. In that case, click the item that has the Nikon Transfer logo, as shown in Figure 8-4.

 If nothing happens, start Nikon Transfer by using the same process you use to launch any program on your computer. (If some other photo software pops up, close it first.)

2. **Display the Source tab to view thumbnails of your pictures, as shown in the figure.**

 Don't see any tabs? Click the little Options triangle, located near the top-left corner of the window, to display them. Then click the Source tab. The icon representing your camera or memory card should be selected, as shown in the figure. If not, click the icon. The dialog box then displays thumbnails of your images. (If you don't see the thumbnails, click the arrow labeled in Figure 8-5 to expand the dialog box and open the thumbnails area.)

Click to display/hide thumbnails

Click to display/hide options

Select Protected

Figure 8-5: Select the check boxes of the images that you want to download.

3. Select the images that you want to download.

A check mark in the little box under a thumbnail tells the program that you want to download the image. Click the box to toggle the check mark on and off.

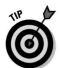

If you used the in-camera functions to protect pictures (see Chapter 4), you can select just those images by clicking the Select Protected icon, labeled in Figure 8-5.

4. Click the Primary Destination tab at the top of the window.

When you click the tab, the top of the transfer window offers options that enable you to specify where and how you want the images to be stored on your computer. Figure 8-6 offers a close-up look.

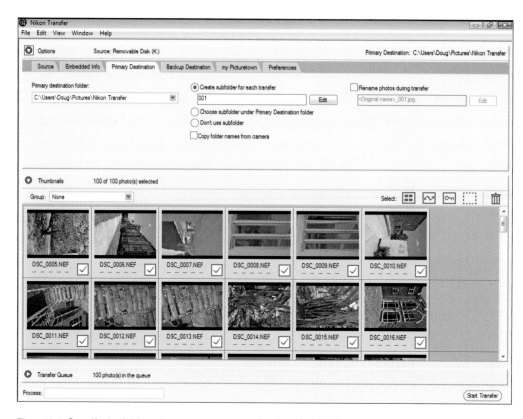

Figure 8-6: Specify the folder where you want to put the downloaded images.

5. **Choose the folder where you want to store the images from the Primary Destination Folder drop-down list.**

If the folder you want to use isn't in the list, choose Browse from the bottom of the list and then track down the folder and select it.

By default, the program puts images in a folder titled Nikon Transfer, which is housed inside a folder named My Pictures in Windows XP and Pictures in Windows Vista and on a Mac. That My Pictures or Pictures folder is housed inside a folder that your system creates automatically for each registered user of the computer.

You don't have to stick with this default location — you can put your pictures anywhere you please. But because most photo programs automatically look for pictures in these standard folders, putting your pictures there just simplifies things a little down the road. *Note:* You can always move your pictures into other folders after you download them if needed, too. The upcoming section "Organizing pictures" explains how to do so in Nikon ViewNX.

6. **Specify whether you want the pictures to be placed inside a new subfolder.**

 If you select the Create Subfolder for Each Transfer option, the program creates a new folder inside the storage folder you selected in Step 5. Then it puts all the pictures from the current download session into that new subfolder. You can either use the numerical subfolder name the program suggests or click the Edit button to set up your own naming system. You might find it helpful to go with a folder name that includes the date and place where the batch of photos was taken, for example. (You can reorganize your pictures into this type of setup after download, however.) If you created custom folders on the camera memory card, an option you can explore in Chapter 11, select the Copy Folder Names from Camera check box to use those folder names instead.

7. **Tell the program whether you want to rename the picture files during the download process.**

 If you do, select the Rename Photos During Transfer check box. Then click the Edit button to display a dialog box where you can set up your new filenaming scheme. Click OK after you do so to close the dialog box.

8. **Click the Preferences tab to set the rest of the transfer options.**

 Now the tab shown in Figure 8-7 takes over the top of the program window. Here you find a number of options that enable you to control how the program operates. Most of the options are self-explanatory, but a couple warrant a few words of advice:

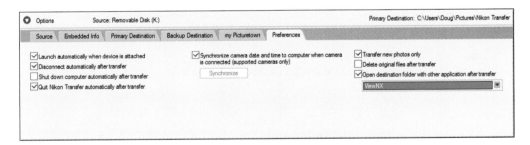

Figure 8-7: Control other aspects of the program's behavior via the Preferences tab.

- *Launch automatically when device is attached.* Deselect this check box if you *don't* want Nikon Transfer to start every time you connect your camera to your computer or insert a memory card into your card reader.

- *Transfer new photos only.* This option, when selected, ensures that you don't waste time downloading images that you've already transferred but are still on the memory card.

- *Delete original files after transfer.* Turn this option off, as shown in Figure 8-7. Otherwise, your pictures are automatically erased from your memory card when the transfer is complete. You should always check to make sure the pictures really made it to the computer before you delete them from your memory card. (See Chapter 4 to find out how to use the Delete function on your camera.)

- *Open destination folder with other application after transfer.* By default, Nikon Transfer shuts itself down when the file download is complete, and Nikon ViewNX then starts automatically so that you can view and organize your images. (That's assuming that you installed ViewNX, of course.) If you want to use a program other than ViewNX for that task, open the drop-down list, click Browse, and select the program from the dialog box that appears. Click OK after doing so. And if you don't want Nikon Transfer to close after downloading, uncheck the Quit Nikon Transfer Automatically After Transfer option.

Your choices remain in force for any subsequent download sessions, so you don't have to revisit this tab unless you want the program to behave differently.

9. **When you're ready to start the download, click the Start Transfer button.**

It's located in the lower-right corner of the program window. After you click the button, the Process bar in the lower-left corner indicates how the transfer is progressing. Again, what happens when the transfer completely depends on the choices you made in Step 8; by default, Nikon Transfer closes, and ViewNX opens, automatically displaying the folder that contains your just-downloaded images.

Browsing images in Nikon ViewNX

Nikon ViewNX is designed to do exactly what its name suggests: enable you to view and organize the pictures that you shoot with your D5000. You also can view other photos — pictures you scanned, received from friends via e-mail, or took with a different camera, for example. The only requirement is that the file format is one that ViewNX can read; for still photos, that means JPEG, TIFF, or NEF, which is the Nikon flavor of Camera Raw. (Chapter 3 explains file formats.) The program also can play the AVI movie files that you create with your D5000. For a complete rundown of supported file formats, check the Appendix section of the built-in program Help system.

Figure 8-8 offers a look at the ViewNX window as it appears by default in Windows Vista. The Mac version is nearly identical, although it features the usual Mac look and feel instead of the Microsoft Windows design.

On either type of system, you can customize a variety of aspects of the window layout by using the options on the View and Window menus.

Folders panel

Zoom slider

Figure 8-8: You can browse and organize your photos using Nikon ViewNX.

To start viewing your pictures, first display the Folders panel along the left side of the program window, as shown in Figure 8-8. (Just click the tab, labeled in the figure.) Now open the folder that holds the photos you want to view. If you came to ViewNX directly after downloading pictures via Nikon Transfer, the folder that holds the new images should already be selected for you. Thumbnails of those images then appear on the right side of the program window. For a movie, you see a thumbnail representing the first shot in the recording.

By opening the View menu, you can choose from the following viewing options:

✓ **Thumbnail View:** This is the default layout. For this view, you can choose from two thumbnail display styles. If you select Thumbnail Grid from the View menu, your screen appears as shown in Figure 8-8. You can adjust the size of the thumbnails by dragging the Zoom slider, labeled in the figure. If you prefer, you can instead select Thumbnail List, in which case you see thumbnails with information such as the filenames, the dates the images were taken, file sizes, and so on. This view is for accountants and other statisticians who also use the Nikon D5000. (Take a peek at Figures 8-11 and 8-12, later in this chapter, for a look at this view.)

✓ **Image Viewer:** Select this option from the View menu to display your files as shown in Figure 8-9. Small thumbnails appear along the top of the pane; the selected thumbnail appears in the larger preview area underneath. Use these maneuvers to inspect your images:

- To select an image or movie file, just click its thumbnail.

- Magnify or reduce the size of photo thumbnails and the preview by using the Zoom sliders labeled in Figure 8-9. For a movie file, the size of the preview automatically changes to fill the preview area as you adjust the thumbnail size.

- Drag in the large preview to scroll the display as needed to view hidden parts of a photo.

- To scroll through your files, click the little arrows under the large preview, labeled Previous and Next in the figure.

Zoom thumbnails

Previous picture — Next picture Zoom image

Figure 8-9: Change to Image Viewer display to see picture and movie files in filmstrip style.

✔ **Full Screen:** Want to see a photo at full-screen size, as shown in Figure 8-10? If you're working in Thumbnail view (with or without all the data displayed), just double-click the picture thumbnail. In Image Viewer view, first click the thumbnail to display it in the large preview. Then double-click the large preview. Or, in either view, click the thumbnail and then press the letter F. For movies, controls for starting the movie playback appear under the preview. (Click the little triangle to begin playback; click the neighboring square to stop it.)

Display Options Zoom slider

Previous/Next buttons

Doug Sahlin

Figure 8-10: Click the arrows to scroll through your photos in Full Screen view.

In Full Screen view, as in the other views, you can magnify still photos by dragging the Zoom slider. To view additional photos at full-screen size, click the Previous and Next arrows under the image display. To

return to the main browser window, just click the window's close button or choose a display option from the Display Options drop-down list, labeled in Figure 8-10.

Viewing picture metadata

When you snap a still photo with your D5000, the camera includes in the picture file some extra data that records all the critical camera settings that were in force. This data, known by nerds as *metadata*, also includes the capture date and time. And, if you take advantage of the Image Comment feature that I cover in Chapter 11, you can even store a brief bit of custom text, such as the shooting location or subject. (Note that the date/time information is included automatically in the metadata; it's unrelated to the Date Imprint function, discussed in Chapter 1. That feature actually places the date and time directly on the image itself rather than hiding it in the metadata.)

Reviewing this data is a great way to better understand what settings work best for different types of pictures, especially when you're just getting up to speed with aperture, shutter speed, white balance, and all the other digital photography basics. To get the full story on how each setting affects your pictures, see Chapters 5 and 6.

To view the metadata in ViewNX, first select an image by clicking its thumbnail in the ViewNX browser window. Then click the Metadata tab on the left side of the window or choose Window⇨Metadata. The metadata information then comes to the forefront, as shown in Figure 8-11.

The metadata is divided into several sections of related capture settings: File Info 1, File Info 2, Camera Info, Exposure, Flash, and so on. To hide or display a section, click the triangle next to it. You may need to use the scroll bar along the right side of the panel to view all the available information. Note that Nikon supplies ViewNX with cameras other than the D5000, and some categories of data apply only to those other models.

The XMP/IPTC Information part of the Metadata panel gives you access to the ViewNX keywords, tags, and rating functions. These functions, along with the program's search feature, provide you with various tools that make locating specific pictures easier, including the option to search for pictures based on the shooting date.

In case you're curious, IPTC refers to text data that press photographers are often required to tag onto their picture files, such as captions and copyright information. XMP refers to a data format developed by Adobe to enable that kind of data to be added to the file. IPTC stands for International Press Telecommunication Council; XMP stands for Extensible Metadata Platform.

Metadata tab

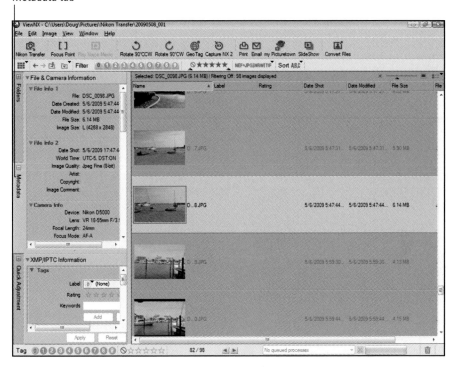

Figure 8-11: Inspecting metadata is a great way to see what settings work best for different subjects and lighting conditions.

Organizing pictures

When you download files from your camera using Nikon Transfer, you can specify where on your computer's hard drive you want to store them. After you get the files on your system, you can further organize them in ViewNX. You can create new folders and subfolders, move images from one folder to another, rename and delete files, and more.

To begin organizing your files, first display the Folders panel by clicking its tab on the left side of the program window. In this panel, you can see and manage the contents of all the drives and folders on your computer. From here, you can set up and rearrange your storage closet as follows:

✔ **Hide/display the contents of a drive or folder.** See a little plus sign (Windows) or right-pointing triangle (Mac) next to a drive or folder? Click it to display the contents of that storage bin. A minus sign

(Windows) or a down-pointing triangle (Mac) means that the drive or folder is open; click that minus sign or triangle to close the drive or folder.

✓ **Create a new folder.** First, click the drive or folder where you want to house the new folder. For example, if you want to create it inside your Pictures or My Pictures folder, click it. Icons representing all the folders and files currently found within that folder then appear in the thumbnail area.

Next, choose File⇨New Folder. An icon representing the new folder should then appear, with the name box activated, as shown in Figure 8-12. Type the folder name and press Enter.

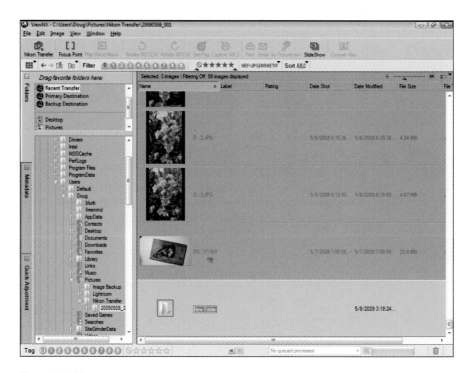

Figure 8-12: You can set up whatever folder structure makes sense to you.

Using your mouse as a shutter button

Nikon offers a piece of specialty software known as Nikon Camera Control Pro 2, which sells for about $180. With this program, you can use your computer to operate your camera.

While your camera is connected to your computer, the software displays a window that contains clickable controls for adjusting all the standard camera settings, from aperture to white balance. When you get those options established, you click another button to record whatever scene is in front of your camera lens.

What's the point? Well, Camera Control Pro is great in scenarios that make having a live photographer close to the subject either difficult or dangerous — for example, trying to get a shot of a chemical reaction in a science lab or capture an image of an animal that's shy around humans. Additionally, the software enables easy time-lapse photography, enabling you to set the camera to take pictures automatically at specified intervals over a period of minutes, hours, or even days. (You don't need the software to use the camera's Interval Timing feature, described in Chapter 2.)

✔ **Move a file from one folder to another.** First, display that file's thumbnail in the browser. Then drag the thumbnail to the destination folder in the Folder pane.

✔ **Delete a file.** In Windows, click the thumbnail and then choose Edit⇨Delete or press the Delete key. On a Mac, choose Edit⇨Move to Trash or press ⌘+Delete. You then see a message asking you to confirm that you really want to trash the file. Click Yes to move forward.

✔ **Protect or unlock photos.** If you used the Protect feature on your camera to "lock" a file, a process you can explore in Chapter 4, you need to remove the protection if you want to edit the image in your photo software. To do so, choose File⇨Protect Files⇨Unprotect.

You also can protect files in ViewNX; just choose Protect from the File⇨ Protect Files submenu. A little key icon then appears on the thumbnail to remind you that the file is now protected from editing or erasing. If you later want to delete the file, you must first unprotect it.

✔ **Select multiple files for moving, deleting, or other actions.** Click the thumbnail of the first image and then Ctrl+click (Windows) or ⌘+click (Mac) the rest. To select all images in the current folder, press Ctrl+A (Windows) or ⌘+A (Mac.)

Processing RAW (NEF) Files

Chapter 3 introduces you to the RAW file format. The advantage of capturing RAW files, which are called NEF files on Nikon cameras, is that you make the decisions about how to translate the original picture data into an actual photograph. You can specify attributes such as color intensity, image sharpening, contrast, and so on — all of which are handled automatically by the camera if you use its other file format, JPEG. You take these steps by using a software tool known as a *RAW converter.*

The bad news: Until you convert your NEF files into a standard file format, you can't share them online or print them from most programs other than Nikon ViewNX. You also can't get prints from most retail outlets or open them in many photo editing programs.

To process your D5000 NEF files, you have a couple of options:

- ✔ **Use the in-camera processing feature.** Through the Retouch menu, you can process your RAW images right in the camera. You can specify only limited image attributes (color, sharpness, and so on), and you can save the processed files only in the JPEG format, but still, having this option is a nice feature. See the next section for details.

- ✔ **Process and convert in ViewNX.** ViewNX also offers a RAW processing feature. Again, the controls for setting picture characteristics are a little limited, but you can save the adjusted files in either the JPEG or TIFF format. The last section of this chapter walks you through this option.

- ✔ **Use Nikon Capture NX 2 or a third-party RAW conversion tool.** For the most control over your RAW images, you need to open up your wallet and invest in a program that offers a truly capable converter. Nikon offers such a program, called Nikon Capture NX 2, which as of this writing sells for about $180. Figure 8-13 gives you a look at the Capture NX 2 RAW converter window.

Another (and less costly option) that I frequently recommend is Adobe Photoshop Elements, which sells for about $90 (www.adobe.com). It includes the Adobe Camera Raw converter, known in the industry as ACR, which is widely considered one of the best available. (*Note:* The converter in Elements doesn't offer all the bells and whistles of the version of ACR provided with Photoshop, however.) In addition, Elements is designed for the novice photo editing enthusiast, so it includes lots of helpful onscreen guides, whereas Capture NX 2 is geared more to the advanced digital photographer.

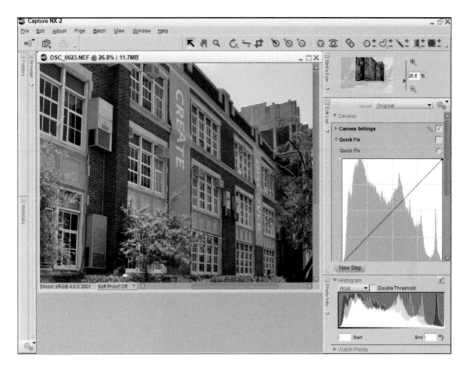

Figure 8-13: Nikon Capture NX 2 is one option for gaining more control over your RAW conversions.

If you do opt for a third-party conversion tool, check the program's Help system for details on how to use the various controls, which vary from program to program. The following general tips apply no matter what converter you use, however:

- ✓ Whenever possible, save your processed files in a nondestructive format such as TIFF. For top quality, don't save originals in the JPEG format, which applies *lossy compression.* You can read about the potential damage to image quality that lossy compression creates in Chapter 3. If you need a JPEG image to share online, Chapter 9 shows you how to create a duplicate of your original, converted image in that format.

- ✓ Some RAW converters give you the option of creating a 16-bit image file. (A *bit* is a unit of computer data; the more bits you have, the more colors your image can contain.) Although you can create 16-bit TIFF files, many photo editing programs either can't open them or limit you to a few editing tools, so I suggest you stick with the standard, 8-bit image option.

Your image will contain more than enough colors, and you'll avoid potential conflicts caused by so-called *high-bit* images.

✔ Resist the temptation to crank up color saturation too much. Doing so can actually destroy image detail. Likewise, be careful about overdoing sharpening, or you can create noticeable image defects.

Processing RAW images in the camera

Scroll past the initial screen of options on the Retouch menu, and you come to a menu item called NEF (RAW) Processing. With this feature, you can process RAW files right in the camera — no computer or other software required.

I want to share two reservations about this option:

✔ First, you can save your processed files only in the JPEG format. As discussed in Chapter 3, that format results in some quality loss because of the file compression that JPEG applies. You can choose the level of JPEG compression you want to apply during RAW processing; you can create a JPEG Fine, Normal, or Basic file. Each of those settings produces the same quality that you get when you shoot new photos in the JPEG format and select Fine, Normal, or Basic from the Image Quality menu.

Chapter 3 details the JPEG options, but, long story short, choose Fine for the best JPEG quality. And if you want to produce the absolute best quality from your RAW images, use a software solution and save your processed file in the TIFF format instead.

✔ You can make adjustments to exposure, color, and a few other options as part of the in-camera RAW conversion process. Evaluating the effects of your adjustments on the camera monitor can be difficult because of the size of the display compared to your computer monitor. So for really tricky images, you may want to forgo in-camera conversion and do the job on your computer, where you can get a better — and bigger — view of things. If you do go the in-camera route, make sure that the monitor brightness is set to its default position so that you aren't misled by the display. (Chapter 1 shows you how to adjust monitor brightness.)

That said, in-camera RAW processing offers a quick and convenient solution when you need JPEG copies of your NEF images for immediate online sharing. (JPEG is the standard format for online use.) Follow these steps to get the job done:

1. **Press the Playback button to switch to playback mode.**

2. Display the picture you want to process in the single-image (full frame) view.

If necessary, you can shift from thumbnails view to single-image view by just pressing the OK button. Chapter 4 has more playback details.

3. Press the OK button.

The Retouch menu then appears atop your photo, as shown in Figure 8-14.

4. Use the Multi Selector to scroll to the NEF (RAW) Processing option, as shown in Figure 8-14.

The option is on the second screen of the Retouch menu.

5. Press OK to display your processing options, as shown in Figure 8-15.

Figure 8-14: In single-image playback mode, press OK to display the Retouch menu over your photo.

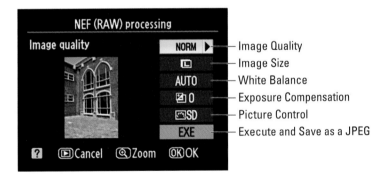

Figure 8-15: Specify the conversion settings here.

This screen is command central for specifying what settings you want the camera to use when creating the JPEG version of your RAW image.

6. Set the conversion options.

Along the right side of the screen, you see a vertical column offering five conversion options, which I labeled in Figure 8-15. To establish the setting for an option, use the Multi Selector to highlight it and then press OK. You then see the available settings for the option. For example, if

you highlight the first option, Image Quality, and press OK, you see the screen shown in Figure 8-16. Use the Multi Selector to highlight the setting you want to use and press OK to return to the main RAW conversion screen.

Rather than detailing all the options here, the following list points you to the chapter where you can explore the settings available for each:

Figure 8-16: Select the setting you want to use and press OK.

- *Image Quality:* See the Chapter 3 section related to the JPEG quality settings for details on this option.

- *Image Size:* The first part of Chapter 3 explains this one.

- *White Balance:* Check out Chapter 6 for details about White Balance options.

- *Exposure Compensation:* With this option, you can adjust image brightness by applying exposure compensation, a feature that I cover in Chapter 5.

- *Picture Control:* This option enables you to adjust color, contrast, and image sharpness. For a review of the available settings, see the last part of Chapter 6.

7. **When you finish setting all the conversion options, highlight EXE on the main conversion screen. (Refer to Figure 8-15.) Then press OK.**

The camera records a JPEG copy of your RAW file and displays the copy in the monitor. To remind you that the image was created with the help of the Retouch menu, the top-left corner of the display sports the little Retouch icon, and the filename of the image begins with CSC rather than the usual DSC, as shown in Figure 8-17. See Chapter 4 for details about file-naming conventions used by the D5000.

Figure 8-17: Filenames of processed RAW images start with CSC.

Processing RAW files in ViewNX

In ViewNX, you can convert your RAW files to either the JPEG format or, for top picture quality, to the TIFF format. (See Chapter 3 if you're unsure about the whole concept of file format and how it relates to picture quality.)

Although the ViewNX converter isn't as full-featured as the ones in Nikon Capture NX 2, Adobe Photoshop Elements, and some other photo editing programs, it does enable you to make some adjustments to your RAW images. Follow these steps to try it out.

1. **Click the thumbnail of the NEF (RAW) image to select it.**

 You may want to set the program to Image Viewer mode, as shown in Figure 8-18, so that you can see a larger preview of your image. Just choose View⇨Image Viewer to switch to this display mode.

2. **Display the Quick Adjustment tab by clicking its tab on the left side of the program window.**

 I labeled the tab in Figure 8-18. The tab provides access to a few controls for fine-tuning your image. You can adjust exposure compensation, white balance, and assign a Picture Control, such as Landscape or Monochrome. Each time you adjust a setting, the preview updates to show you the results.

 A couple of options may require some explanation:

 - *Launch Utility button:* This button, located under the Picture Control option, opens the Picture Control Utility, where you can define your own Picture Controls. I don't get into this advanced function in this book, but if you're curious, open the utility and then click the Help button at the bottom of the window.

 - *Highlight Protection/Shadow Protection/D-Lighting HS:* Try using these options to recover hidden shadow and highlight detail.

 - *Color Booster:* This slider (at the bottom of the panel, not visible in Figure 8-18) enables you to increase saturation. But if you select the People button under the slider, skin tones are left alone. Choose Nature to adjust the saturation of all colors in the photo.

 - *Axial Color Aberration:* Due to an optical phenomenon that's too complex to fully explore here, some lenses can produce a defect known as *axial color aberration* or, in some circles, *color fringing.* This defect results in weird color halos along the edges of an object, typically on the side away from the center of the photo. To check your photo, zoom the display to a magnification of 200 percent or greater — the halos usually aren't visible when the display size is small — and pay special attention to the corners of the photo, where the problem tends to be greatest. If you spot haloing, check the Auto box for the Axial Color Aberration setting and let the program try to apply the proper correction. You then can drag

the slider to tweak the strength of the correction, if needed. (The program may need a few seconds to update the preview after each change, so be patient.)

Convert Files button

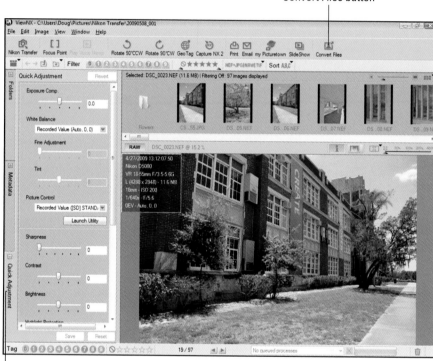

Quick Adjustment tab

Figure 8-18: Display the Quick Adjustment panel to tweak RAW images before conversion.

If you want more details about these or any other of the options, choose Help⇨ViewNX Help to open the Help system, and then display the Help pages related to the Quick Adjustment tab.

3. Click the Save button at the bottom of the Quick Adjustment area.

Or to revert to the original adjustment settings, click Reset.

4. To save the processed file, choose File⇨Convert Files.

Or just click the Convert Files button on the toolbar at the top of the program window. Either way, you see the Convert Files dialog box, shown in Figure 8-19.

5. Select TIFF (8 Bit) from the File Format drop-down list.

Figure 8-19: To retain the best image quality, save processed RAW files in the TIFF format.

You also can opt for TIFF (16 Bit) or JPEG, but I don't recommend it. TIFF (16 Bit) can cause problems when you try to open the file in certain photo editing and organizing programs. And saving in the JPEG format applies *lossy compression,* thereby sacrificing some image quality. If you need a JPEG copy of your processed RAW image for online sharing, you can easily create one from your TIFF version by following the steps laid out in Chapter 9.

6. **Deselect the Use LZW Compression option, as shown in the figure.**

 Although LZW Compression reduces the file size somewhat and does not cause any quality loss, some programs can't open files that were saved with this option enabled. So turn it off.

7. **Deselect the Change the Image Size check box.**

 This step ensures that you retain all the original pixels in your image, which gives you the most flexibility in terms of generating quality prints at large sizes. For details on this issue, check out Chapter 3.

8. **Deselect each of the three Remove check boxes.**

If you select the check boxes, you strip image metadata — the extra text data that's stored by the camera — from the file. Unless you have some specific reason to do so, clear all three check boxes so that you can continue to access the metadata when you view your processed image in programs that know how to display metadata.

The first two check boxes relate to data that you can view on the Metadata tab in ViewNX; earlier sections of this chapter give you the lowdown. The ICC profile item refers to the image *color space,* which is either sRGB or Adobe RGB on your D5000. Chapter 6 explains the difference.

9. **Select a storage location for the processed TIFF file.**

You do this in the Save In area of the dialog box, highlighted in Figure 8-19. Select the top option to save your processed file in the same folder as the original RAW file. Or, to put the file in a different folder, click the Specified Folder button. The name of the currently selected alternative folder appears below the button, as shown in Figure 8-19. You can change the storage destination by clicking the Browse button and then selecting the drive and folder where you want to put the file.

By selecting the Create a New Subfolder for Each File Conversion check box, you can put your TIFF file into a separate folder within the destination folder. If you select the box, click the Naming Options button and then specify how you want to name the subfolder.

10. **Specify whether you want to give the processed TIFF a different filename from the original RAW image.**

To do so, select the Change File Names check box and then click the Naming Options button and enter the name you want to use.

If you don't change the filename, ViewNX gives the file the same name as the original RAW file. But you don't overwrite that RAW file because you are storing the copy in a different file format (TIFF). In Windows, the filename of the processed TIFF image has the three-letter extension TIF.

11. **Click the Convert button.**

A window appears to show you the progress of the conversion process. When the window disappears, your TIFF image appears in the storage location you selected in Step 10.

One neat thing about working with RAW images is that you can easily create as many variations of your photo as you want. For example, you might choose one set of options when processing your RAW file the first time, and then use an entirely different set to create another version of the photo. You could create one image in full color, perhaps, and then open the RAW file again and this time launch the Picture Control Utility and create a sepia version of the image.

Printing and Sharing Your Pictures

*W*hen my first digital photography book was published, way back in the 1990s, consumer digital cameras didn't offer the resolution needed to produce good prints at anything more than postage-stamp size — and even then, the operative word was "good," not "great." And if you did want a print, it was a pretty much a do-it-yourself proposition unless you paid sky-high prices at a professional imaging lab. In those days, retail photo labs didn't offer digital printing, and online printing services hadn't arrived yet, either.

Well, time and technology march on, and, at least in the case of digital photo printing, to a very good outcome. Your D5000 can produce dynamic prints even at large sizes, and getting those prints made is easy and economical, thanks to an abundance of digital printing services now in stores and online.

That said, getting the best output from your camera still requires a little bit of knowledge and prep work on your part. To that end, this chapter tells you exactly how to ensure that your picture files will look as good on paper as they do in your camera monitor.

In addition, this chapter explores ways to share your pictures electronically. First, I show you how to prepare your picture for e-mail — an important step if you don't want to annoy friends and family by cluttering their inboxes with ginormous, too-large-to-view photos. Following that, you can find out how to create digital slide shows and view your pictures and Live View movies on a television.

Printing Possibilities: Retail or Do-It-Yourself?

Normally, I'm a do-it-yourself type of gal. I mow my own lawn, check my own tire pressure, hang my own screen doors. I am woman; hear me roar. Unless, that is, I discover that I can have someone *else* do the job in less time and for less money than I can — which just happens to be the case for digital photo printing. Although I occasionally make my own prints for fine-art images that I plan to sell or exhibit, I have everyday snapshots made at my local retail photo lab.

Unless you're already very comfortable with computers and photo printing, I suggest that you do the same. Compare the cost of retail digital printing with the cost of using a home or office photo printer — remember to factor in the required ink, paper, and your precious time — and you'll no doubt come out ahead if you delegate the job.

You can choose from a variety of retail printing options, as follows:

✔ **Drop-off printing services:** Just as you used to leave a roll of film at the photo lab in your corner drug store or camera store, you can drop off your memory card, order prints, and then pick up your prints in as little as an hour.

✔ **Self-serve print kiosks:** Many photo labs, big-box stores, and other retail outlets also offer self-serve print kiosks. You insert your memory card into the appropriate slot, follow the onscreen directions, and wait for your prints to slide out of the print chute.

✔ **Online with mail-order delivery:** You can upload your photo files to online printing sites and have prints mailed directly to your house. Photo-sharing sites such as Shutterfly, Kodak Gallery, and Snapfish are well-known players in this market. But many national retail chains, such as Ritz Cameras, Wal-Mart, and others also offer this service.

✔ **Online with local pickup:** Here's my favorite option. Many national chains enable you to upload your picture files for easy ordering but pick up your prints at a local store. This service is a great way to share prints with faraway friends and family, by the way. I can upload and order prints from my desk in Indianapolis, for example, and have them printed at a store located a few miles from my parents' home in Texas.

For times when you do want to print your photos on your own printer, you can do so through Nikon ViewNX. However, I find the ViewNX printing options both more complex and more limited than those in other programs, which is why I opted not to cover them in this book. I suggest that you instead print from whatever photo editing program you use or from the software provided by your printer manufacturer.

Preventing Potential Printing Problems

Boy, I love a good alliteration, don't you? Oh, just me, then. Anyway, as I say in the introduction to this chapter, a few issues can cause hiccups in the printing process. So before you print your photos, whether you want to do it on your own printer or send them to a lab, read through the next three sections, which show you how to avoid the most common trouble spots.

Match resolution to print size

Resolution, or the number of pixels in your digital image, plays a huge role in how large you can print your photos and still maintain good picture quality. You can get the complete story on resolution in Chapter 3, but here's a quick recap as it relates to printing:

 ✔ On the D5000, you set picture resolution via the Image Size option, which you can adjust either via the Shooting menu or through the Quick Settings display. (Again, see Chapter 3 for specifics.) You must select this option *before* you capture an image, which means that you need some idea of your ultimate print size before you shoot. And if you crop your image, you eliminate some pixels, so take that factor into account when you do the resolution math.

 ✔ For good print quality, the *minimum* pixel count (in my experience, anyway) is 200 pixels per linear inch, or 200 ppi. That means that if you want a 4-x-6-inch print, you need at least 800 x 1200 pixels.

 ✔ Depending on your printer, you may get even better results at 200+ ppi. Some printers do their best work when fed 300 ppi, and a few (notably, some from Epson) request 360 ppi as the optimum resolution. However, going higher than that typically doesn't produce any better prints.

 Unfortunately, because most printer manuals don't bother to tell you what image resolution produces the best results, finding the right resolution is a matter of experimentation. (Don't confuse the manual's statements related to the printer's *dpi* with *ppi.* DPI refers to how many dots of color the printer can lay down per inch; many printers use multiple dots to reproduce one image pixel.)

 ✔ If you're printing your photos at a retail kiosk or at an online site, the printing software that you use to order your prints should determine the resolution of your file and then guide you as to the suggested print size. But if you're printing on a home printer, you need to be the resolution cop. (Some programs, however, do alert you in the Print dialog box if the resolution is dangerously low.)

So what do you do if you find that you don't have enough pixels for the print size you have in mind? You just have to decide what's more important, print size or print quality.

If your print size does exceed your pixel supply, one of two things must happen:

- The pixel count remains constant, and pixels simply grow in size to fill the requested print size. And if pixels get too large, you get a defect known as *pixelation.* The picture starts to appear jagged, or stairstepped, along curved or digital lines. Or at worst, your eye can actually make out the individual pixels, and your photo begins to look more like a mosaic than, well, a photograph.

- The pixel size remains constant, and the printer software adds pixels to fill in the gaps. You can also add pixels, or *resample the image,* in your photo software. Wherever it's done, resampling doesn't solve the low resolution problem. You're asking the software to make up photo information out of thin air, and the result is usually an image that looks worse than it did before resampling. You don't get pixelation, but details turn muddy, giving the image a blurry, poorly rendered appearance.

Just to hammer home the point and remind you one more time of the impact of resolution picture quality, Figures 9-1 through 9-3 show you the same image as it appears at 300 ppi (the resolution required by the publisher of this book), at 50 ppi, and resampled from 50 ppi to 300 ppi. As you can see, there's just no way around the rule: If you want the best quality prints, you need the right pixel count.

300 ppi

Figure 9-1: A high-quality print depends on a high-resolution original.

50 ppi

Figure 9-2: At 50 ppi, the image has a jagged, pixelated look.

50 ppi resampled to 300 ppi

Figure 9-3: Adding pixels in a photo editor doesn't rescue a low-resolution original.

Allow for different print proportions

Unlike many digital cameras, your D5000 produces photos that have an aspect ratio of 3:2. That is, pictures are 3 units wide by 2 units tall — just like a 35mm film negative — which means that they translate perfectly to the standard 4-x-6-inch print size. (Most digital cameras produce 4:3 images, which must be cropped to fit a 4-x-6-inch piece of paper.)

If you want to print your digital original at other standard sizes — 5 x 7, 8 x 10, 11 x 14, and so on — you need to crop the photo to match those proportions. Alternatively, you can reduce the photo size slightly and leave an empty margin along the edges of the print as needed.

As a point of reference, Figure 9-4 shows you a 3:2 original image. The outlines indicate how much of the original can fit within a 5-x-7-inch frame and an 8-x-10-inch frame.

Your camera's Trim feature, found on the Retouch menu, enables you to crop your photo, but only to five different aspect ratios (3:2, 4:3, 5:4, 1:1, and 16:9). See Chapter 10 for information. For other proportions, most photo editing programs offer very simple cropping tools. You also can usually crop your photo using the software provided at online printing sites and at retail print kiosks. But if you plan to drop off your memory card of original pictures at a lab, be aware that your pictures will be cropped if you select a print size other than 4 x 6.

5 x 7 frame area

8 x 10 frame area

Doug Sahlin

Figure 9-4: Composing your shots with a little head room enables you to crop to different frame sizes.

To allow yourself printing flexibility, leave at least a little margin of background around your subject when you shoot, as shown in Figure 9-4. Then you don't clip off the edges of the subject no matter what print size you choose. (Some people refer to this margin padding as *head room,* especially when describing portrait composition.)

Get print and monitor colors in synch

Your photo colors look perfect on your computer monitor. But when you print the picture, the image is too red, or too green, or has some other nasty

color tint. This problem, which is probably the most prevalent printing issue, can occur because of any or all of the following factors:

✔ **Your monitor needs to be calibrated.** When print colors don't match what you see on your computer monitor, the most likely culprit is actually the monitor, not the printer. If the monitor isn't accurately calibrated, the colors it displays aren't a true reflection of your image colors.

To ensure that your monitor is displaying photos on a neutral canvas, you can start with a software-based calibration utility, which is just a small program that guides you through the process of adjusting your monitor. The program displays various color swatches and other graphics and then asks you to provide feedback about what you see on the screen.

If you use a Mac, the operating system offers a built-in calibration utility, called the Display Calibrator Assistant; Figure 9-5 shows the welcome screen that appears when you run the program. (Access it by opening the System Preferences dialog box, clicking the Displays icon, clicking the Color button, and then clicking the Calibrate button.) You also can find free calibration software for both Mac and Windows systems online; just enter the term *free monitor calibration software* into your favorite search engine.

Figure 9-5: Mac users can take advantage of the operating system's built-in calibration tool.

Software-based calibration isn't ideal, however, because our eyes aren't that reliable in judging color accuracy. For a more accurate calibration, you may want to invest in a device known as a *colorimeter,* which you attach to or hang on your monitor, to accurately measure and calibrate your display. Companies such as Datacolor (www.datacolor.com), Pantone (www.pantone.com), and X-Rite (www.xrite.com) sell this type of product along with other tools for ensuring better color matching.

Whichever route you go, the calibration process produces a monitor *profile,* which is simply a data file that tells your computer how to adjust the display to compensate for any monitor color casts. Your Windows or Mac operating system loads this file automatically when you start your computer. Your only responsibility is to perform the calibration every month or so, because monitor colors drift over time.

✔ **One of your printer cartridges is empty or clogged.** If your prints look great one day but are way off the next, the number-one suspect is an empty ink cartridge or a clogged print nozzle or head. Check your manual to find out how to perform the necessary maintenance to keep the nozzles or print heads in good shape.

If black-and-white prints have a color tint, a logical assumption is that your black ink cartridge is to blame, if your printer has one. But the truth is that a printer that doesn't use multiple black or gray cartridges will always have a slight color tint. Why? Because in order to create gray, the printer instead has to mix yellow, magenta, and cyan in perfectly equal amounts, and that's a difficult feat for the typical inkjet printer to pull off. If your black-and-white prints have a strong color tint, however, it could be that one of your color cartridges is empty, and replacing it may help somewhat. Long story short: Unless you have a printer that's marketed for producing good black-and-white prints, you'll probably save yourself some grief by simply having your black-and-whites printed at a retail lab.

When you buy replacement ink, by the way, keep in mind that third-party brands, while they may save you money, may not deliver the performance you get from the cartridges made by your printer manufacturer. A lot of science goes into getting ink formulas to mesh with the printer's ink-delivery system, and the printer manufacturer obviously knows most about that delivery system.

✔ **You chose the wrong paper setting in your printer software.** When you set up your print job, be sure to select the right setting from the paper-type option — glossy, matte, and so on. This setting affects how the printer lays down ink on the paper.

✔ **Your photo paper is low quality.** Sad but true: The cheap, store-brand photo papers usually don't render colors as well as the higher-priced, name-brand papers. For best results, try papers from your printer manufacturer; again, those papers are engineered to provide top performance with the printer's specific inks and ink-delivery system.

Some paper manufacturers, especially those that sell fine-art papers, offer downloadable *printer profiles,* which are simply little bits of software that tell your printer how to manage color for the paper. Refer to the manufacturer's Web site for information on how to install and use the profiles.

✓ **Your printer and photo software are fighting over color-management duties.** Some photo programs offer features that enable the user to control how colors are handled as an image passes from camera to monitor to printer. Most printer software also offers color-management features. The problem is, if you enable color-management controls both in your photo software and your printer software, you can create conflicts that lead to wacky colors. So check your photo software and printer manuals to find out what color-management options are available to you and how to turn them on and off.

DPOF, PictBridge, and computerless printing

Your D5000 offers two technologies, called DPOF *(dee-poff)* and PictBridge, that enable you to print images directly from your camera or memory card, without using the computer as middle-machine. In order to take advantage of direct printing, your printer must also support one of the two technologies, and you must capture the images in the JPEG file format, which I explain in Chapter 3. (You can also capture the photo in the Raw format and then use your D5000's in-camera conversion tool to make a JPEG copy suitable for direct printing.)

DPOF stands for Digital Print Order Format. With this option, accessed via your camera's Playback menu, you select the pictures on your memory card that you want to print, and you specify how many copies you want of each image. Then, if your photo printer has an SD Card slot and supports DPOF, you just pop the memory card into that slot. The printer reads your "print order" and outputs just the requested copies of your selected images. (You use the printer's own controls to set paper size, print orientation, and other print settings.)

PictBridge works a little differently. If you have a PictBridge-enabled photo printer, you can

connect the camera to the printer using the USB cable supplied with your camera. A PictBridge interface appears on the camera monitor, and you use the camera controls to select the pictures you want to print. With PictBridge, you specify additional print options, such as page size and whether you want to print a border around the photo, from the camera as well.

Both DPOF and PictBridge are especially useful in scenarios where you need fast printing. For example, if you shoot pictures at a party and want to deliver prints to guests before they go home, DPOF offers a quicker option than firing up your computer, downloading pictures, and so on. And if you invest in one of the tiny portable photo printers on the market today, you can easily make prints away from your home or office — you can take both your portable printer and camera along to your regional sales meeting, for example.

For the record, I prefer DPOF to PictBridge because with PictBridge, you have to deal with cabling the printer and camera together. Also, the camera must be turned on for the whole printing process, wasting battery power. But if you're interested in exploring either printing feature, your camera manual provides complete details.

Even if all the aforementioned issues are resolved, however, don't expect perfect color matching between printer and monitor. Printers simply can't reproduce the entire spectrum of colors that a monitor can display. In addition, monitor colors always appear brighter because they are, after all, generated with light.

Finally, be sure to evaluate your print colors and monitor colors in the same ambient light — daylight, office light, whatever — because that light source has its own influence on the colors you see.

Preparing Pictures for E-Mail

How many times have you received an e-mail message that looks like the one in Figure 9-6? Some well-meaning friend or relative has sent you a digital photo that is so large that it's impossible to view the whole thing on your monitor.

Figure 9-6: The attached image has too many pixels to be viewed without scrolling.

The problem is that computer monitors can display only a limited number of pixels. The exact number depends on the monitor's resolution setting and the capabilities of the computer's video card, but suffice it to say that the average photo from one of today's digital cameras has a pixel count in excess of what the monitor can handle. Figure 9-6, for example, shows you how much of a 6-megapixel image is viewable when displayed in a typical e-mail program window.

In general, a good rule is to limit a photo to no more than 640 pixels at its longest dimension. That ensures that people can view your entire picture without scrolling, as in Figure 9-7. This image measures 640 x 428 pixels. As you can see, it's plenty large enough to provide a decent photo-viewing experience. On a small monitor, it may even be *too* large.

Figure 9-7: Keep e-mail pictures to no larger than 640 pixels wide or tall.

This size recommendation means that even if you shoot at your D5000's lowest Image Size setting (2144 x 1424 pixels), you need to dump pixels from your images before sending them to the cyber post office. You have a couple of options for creating an e-mail–sized image:

> Use the Small Picture feature on your camera's Retouch menu. This feature enables you to create your e-mail copy right in the camera.

> Downsample the image in your photo editor. *Downsampling* is geekspeak for dumping pixels. Most photo editors offer a feature that handles this process for you. Use this option if you want to crop or otherwise edit the photo before sharing it.

The next two sections walk you through the steps for both ways of creating your e-mail images. You can use the same steps, by the way, for sizing images for any onscreen use, whether it's for a Web page or multimedia presentation. You may want your copies to be larger or smaller than the recommended e-mail size for those uses, however.

One last point about onscreen images: Remember that pixel count has *absolutely no effect* on the quality of pictures displayed onscreen. Pixel count determines only the size at which your images are displayed.

Creating small copies using the camera

To create small, e-mailable copies of your images without using a computer, use your camera's Small Picture feature. Here's how:

1. **Press the Playback button to set your camera to playback mode.**

2. **Display the picture in single-image view.**

 If the monitor currently displays multiple thumbnails, just press the OK button to switch to single-image view.

3. **Press OK to display the Retouch menu over your image, as shown on the left in Figure 9-8.**

4. **Highlight Small Picture and press OK or press the Multi Selector right.**

Figure 9-8: The Small Picture feature creates a low-resolution, e-mail–friendly copy of a photo.

You see the screen shown on the right in the figure. You can choose from three size options (stated in pixels) for your small copy.

5. Highlight the size you want to use for your copy.

For pictures that you plan to send via e-mail, choose either 640 x 480 or 320 x 240 pixels unless the recipient is connected to the Internet via a very slow, dial-up modem connection. In that case, you may want to go one step down, to 160 x 120 pixels. (The display size of the picture may be quite small at that setting however, depending on the resolution of the monitor on which the picture is viewed.)

If you're a math lover, you may have noticed that all the size options create pictures that have an aspect ratio of 4:3, while your original images have an aspect ratio of 3:2. The camera trims the small-copy image as needed to fit the 4:3 proportions. Unfortunately, you don't have any input over what portion of the image is cropped away.

6. Press OK or press the Multi Selector right.

You see a screen asking you to confirm that you want to create a small copy.

7. Highlight Yes and press OK.

The camera duplicates the selected image and downsamples the copy (eliminates pixels) to achieve the size you specified in Step 5. Your original picture file remains untouched.

If you want to create small copies of several photos on your memory card, you can go another route: Take the camera out of Playback mode and then display the Retouch menu. Select the Small Picture option and press OK. On the next screen, select the Choose Size option and specify the pixel count for your small copies. After doing so, press OK, choose the Select Image option, and press OK again to display thumbnails of all your pictures. Move the yellow highlight box over a thumbnail and press the Zoom Out button to "tag" the photo for copying. (You see a little icon in the top-right corner of the thumbnail; press the button again to remove the tag if you change your mind.) After selecting all your pictures, press OK to display the copy-confirmation screen; highlight Yes and press OK once more to wrap things up.

When you view your small-size copies on the camera monitor, they appear surrounded by a gray border, as shown in Figure 9-9. A tiny Retouch icon appears on the display as well,

Figure 9-9: The gray border indicates a small-size copy.

as labeled in the figure. Note that you can't zoom in to magnify the view of small-size copies as you can your original images.

Pictures that you create using the Small Picture feature are given filenames that start with the letters SSC. The camera automatically assigns a filenumber (the number is different from that of your original file, unfortunately).

Downsizing images in Nikon ViewNX

You can also create a low-resolution, JPEG copy of your image in ViewNX. However, be aware that the program restricts you to a minimum size of 320 pixels along the photo's longest side. If you need a smaller version, use the in-camera Small Picture option to create the copy instead. Or, if you own a photo editing program, investigate its image-resizing capabilities; you likely can create the small copy at any dimensions you like.

Assuming that the 320-pixel restriction isn't a problem, the following steps show you how to create your small-size copy in ViewNX. You can use this process to create a small JPEG copy of both JPEG and NEF (RAW) originals.

1. **Select the image thumbnail in the main ViewNX window.**

 Chapter 8 explains how to view your image thumbnails, if you need help. Just click a thumbnail to select it.

2. **Choose File⇨Convert Files.**

 You see the dialog box shown in Figure 9-10. (As with other figures, this one shows the box as it appears in Windows Vista; it may appear slightly different on a Mac or in other versions of Windows, but the essentials are the same.)

3. **Select JPEG from the File Format drop-down list, as shown in the figure.**

 The other format option, TIFF, is a print format. Web browsers and e-mail programs can't display TIFF images, so be sure to use JPEG.

4. **Select the Change the Image Size check box.**

 Now the Short Edge and Long Edge text boxes become available.

5. **Type the desired pixel count of the longest side of your picture into the Long Edge box.**

 The program automatically adjusts the Short Edge value to keep the resized image proportional. (The image is not cropped to a 4:3 perspective as it is when you use the Small Copy feature on the camera's Retouch menu.)

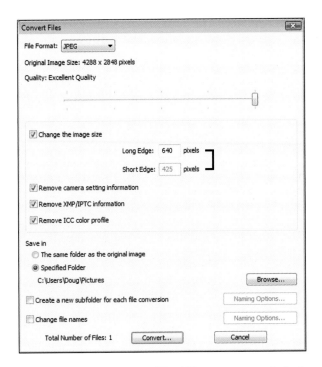

Figure 9-10: You also can use ViewNX to create a small-sized JPEG copy for e-mail sharing.

Again, to ensure that the picture is viewable without scrolling when opened in the recipient's e-mail program, I suggest that you keep the Long Edge value at 640 pixels or less.

6. **Adjust the Compression Ratio slider to set the amount of JPEG file compression.**

As Chapter 3 explains, a greater degree of compression results in a smaller file, which takes less time to download over the Web, but it reduces image quality. Notice that as you move the slider to the right, the resulting quality level appears above the slider. For example, in Figure 9-10, the level is Excellent Quality.

Because the resolution of your image already results in a very small file, you can probably use the highest quality setting without worrying too much about download times. The exception is if you plan to attach multiple pictures to the same e-mail message, in which case you may want to set the slider a notch or two down from the highest quality setting.

7. **Select the next three check boxes (Remove Camera Setting Information, Remove XMP/IPTC Information, and Remove ICC Color Profile), as shown in Figure 9-10.**

 When selected, the three options save the resized picture without the original image metadata, the extra text data that your camera stores with the image. (Chapter 8 explains.) Including this metadata adds to the file size, so for normal e-mail sharing, strip it out. The exception, of course, is when you want the recipient to be able to view the metadata in a photo program that can do so.

8. **Set the file destination.**

 In layman's terms, that just means to tell the program the location of the folder or drive where you want to store your downsized image file. You have two Save In options: Choose the first option to put the file in the same folder as the original, or select Specified Folder to put the file somewhere else. If you choose the first option, you're done. If you choose the second option, the last folder you specified is shown to the left of the Browse button. To choose a different folder, click that Browse button.

 By selecting the Create a New Subfolder for Each File Conversion check box, you can create a new subfolder within your selected storage folder. If you do, the resized file goes into that subfolder, which you can name by clicking the Naming Options button.

9. **(Optional) Specify a filename for the resized copy.**

 If you want to put the small copy in the same folder as the original, the program protects you from overwriting the original by automatically assigning a slightly different name to the copy. By default, the program uses the original filename plus a two-number sequential tag: If the original filename is DSC_0186.jpg, for example, the small-copy filename is DSC_0186_01.jpg. You can change a couple of aspects of this filenaming routine by selecting the Change File Names check box and then clicking the Naming Options button and adjusting the settings in the resulting dialog box. After making your wishes known, click OK to return to the Convert Files dialog box.

 If you *don't* store the copy in the same folder as the original, the program doesn't alter the filename of the copy automatically. That can lead to problems down the road because you will end up with two files, both with the same name but with different pixel counts, on your computer. In this scenario, be sure to input your own filenames for your copies.

10. **Click the Convert button to finish the process.**

ViewNX also offers an e-mail wizard that enables you to resize and send photos by e-mail in one step. If you use this feature, however, you don't create an actual small-size copy of your file; the program simply reduces the size of the file temporarily for e-mail transmission. Also, the wizard works only with certain e-mail programs. On the plus side, the wizard permits you to send a photo at a much smaller size than you can create with the Convert Files feature. For more details, check out the ViewNX Help system.

Online photo sharing: Read the fine print

If you want to share more than a couple of photos, consider posting your images at an online photo-album site instead of attaching them to e-mail messages. Photo-sharing sites such as Shutterfly, Kodak Gallery, and Picasa all enable you to create digital photo albums and then invite friends and family to view your pictures and order prints of their favorites.

At most sites, picture-sharing is free, but your albums and images are deleted if you don't order prints or make some other purchase from the site within a specified amount of time. Additionally, many free sites enable you to upload high-resolution files for printing but then don't let you retrieve those files from the site. (In other words, don't think of album sites as archival storage solutions.) And here's another little bit of fine print to investigate: The membership agreement at some sites states that you agree to let the site use your photos, for free, for any purpose that it sees fit.

Creating a Digital Slide Show

Many photo editing and cataloging programs offer a tool for creating digital slide shows that can be viewed on a computer or, if copied to a DVD, on a DVD player. You can even add music, captions, graphics, special effects, and the like to jazz up your presentations.

But if you want to create a simple slide show — that is, one that simply displays the photo on the camera memory card one by one — you don't need a computer or any photo software. You can create and run the show right on your camera. And by connecting your camera to a television, as outlined in the last section of this chapter, you can present your show to a whole roomful of people.

Follow these steps to create a simple slide show on your computer:

1. **Display the Playback menu and highlight Slide Show, as shown on the left in Figure 9-11.**

2. **Press OK to display the Slide Show screen shown on the right in Figure 9-11.**

3. **Highlight Frame Interval and press the Multi Selector right.**

 On the next screen, you can specify how long you want each image to be displayed. You can set the interval to 2, 3, 5, or 10 seconds.

4. **Highlight the frame interval you want to use and press OK.**

 You're returned to the Slide Show screen.

5. **To start the show, highlight Start and press OK.**

 The camera begins displaying your pictures on the camera monitor.

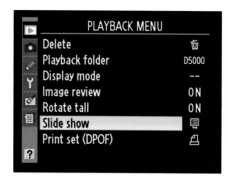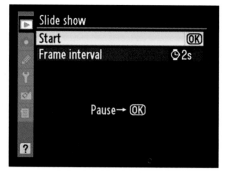

Figure 9-11: Choose Slide Show to set up automatic playback of all pictures on your memory card.

When the show ends, you see a screen offering three options: You can choose to restart the show, adjust the frame interval, or exit to the Playback menu. Highlight your choice and press OK.

During the show, you can control playback as follows:

✔ **Pause the show.** Press OK. Select Restart and press OK to begin displaying pictures again. When you pause the slide show, you also have the option to change the interval — a handy option if the pace is too quick or slow — or exit the show. To change frame interval, highlight the option and press OK. Choose the desired interval from the next screen, and press OK. Highlight Restart and press OK to restart the show with the new interval.

✔ **Exit the show.** You've got three options:

• To return to full-frame, regular playback, press the Playback button.

• To return to the Playback menu, press the Menu button.

• To return to picture-taking mode, press the shutter button halfway.

✔ **Skip to the next/previous image manually.** Press the Multi Selector or rotate the Command dial.

✔ **Change the information displayed with the image.** Press the Multi Selector up or down to cycle through the info-display modes. (See Chapter 4 for details on what information is provided in each mode.)

Turning Still Photos into a Stop-Motion Movie

Chapter 4 explains how to record live-action movies with your D5000. But hidden away on the Retouch menu is another tool for the budding filmmaker. By using the Stop-Motion Movie feature, you can combine a series of still images into brief, animation-style digital videos that can be played on the computer. You also can connect your camera to a TV for playback; see the next section for details.

One popular use of this feature is to animate still objects, similar to what Hollywood types do when producing so-called "claymation" movies. Here's an example: You take 50 shots of a riderless tricycle on your driveway. Before each shot, you rotate the pedals slightly to move the bike forward so that each image captures the bike at a different spot on the driveway. In your finished movie, the individual images are displayed sequentially, at a pace rapid enough to create the illusion that the bike is moving across the driveway by itself, as if it had a ghost rider.

You can also use the Stop-Motion Movie feature to reanimate a subject that was actually moving of its own volition during your shoot. For example, on a recent trip to a local garden, I spotted a butterfly posing on a leaf. As he opened and closed his wings, I clicked off a rapid-fire series of images so that I could capture his wings at different positions. Turned into a stop-motion movie, the images blended together to reproduce the fluttering of the butterfly's wings.

Lest you get the wrong idea here, I should stress that the Stop-Motion Movie feature isn't designed as a substitute for your camera's movie-recording feature. First, the stop-motion movies can be recorded and played at a maximum of 15 frames per second, whereas you get 24 frames per second — the standard for motion-picture films — if you record a regular movie. The difference means that your stop-motion movies appear a little jerky — more like what you see when you fast-forward through a movie on DVD.

Second, the number of images in a stop-motion movie is limited to 100. So if you have 100 frames, played back at 15 frames per second, the maximum length of your stop-motion movie is just shy of 7 seconds. If you want a longer stop-motion movie, you need to create separate movie files and then join them together in a video editing program. If you use the Windows XP or Vista operating system, you can use the free Movie Maker application. If you're on a Mac, you can use iMovie to splice your movie files together.

Despite its limitations, though, the Stop-Motion Movie feature provides an interesting creative project when you're having a boring day. To get started, first record a series of images of a moving subject. The images in the examples here are of an American flag that was rippling in a stiff breeze. After you have your images recorded, take these steps to turn them into a movie:

1. **Open the Retouch menu, highlight Stop-Motion Movie, as shown in Figure 9-12, and press OK.**

 You see the three options shown on the left in Figure 9-13.

2. **Highlight Frame Size and press the Multi Selector right.**

 Now you see the screen shown on the right in Figure 9-13. Here, you set the size of the movie frames, in pixels. The larger the size, the larger you can view the finished movie. But a larger frame size also means a larger data file

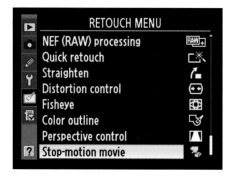

Figure 9-12: The Stop-Motion Movie feature enables you to animate a series of still photos.

needed to store the movie. So for online sharing, consider using one of the two smaller sizes to reduce the time people must spend downloading the file.

 To understand how pixels display onscreen, whether it's a TV or computer monitor, see "Preparing Pictures for E-Mail," earlier in this chapter. Chapter 3 offers some additional tips about pixels.

3. **Select a frame size and press OK.**

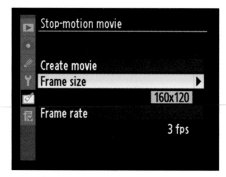
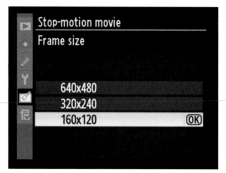

Figure 9-13: The frame dimensions affect the size of the data file needed to store the movie on your memory card.

4. Highlight Frame Rate, as shown on the left in Figure 9-14, and press the Multi Selector right.

You're presented with the screen shown on the right in the figure. Here, you specify the number of frames per second in your movie. The higher the frame rate, the smoother the playback, but the shorter the movie you can create.

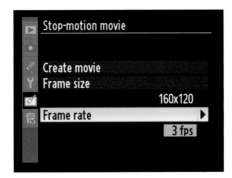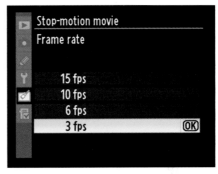

Figure 9-14: For the smoothest playback, choose 15 frames per second (fps).

5. Select a frame rate and press OK.

You're returned to the main Stop-Motion Movie screen.

6. Highlight Create Movie, as shown on the left in Figure 9-15, and press OK.

You see a screen similar to the one on the right in Figure 9-15, with thumbnails of the images on your memory card.

7. Highlight the image that you want to use as the starting shot in the movie.

Notice that one thumbnail is surrounded by a yellow box and is marked with the word Start — in Figure 9-15, it's the middle image. Press the Multi Selector right or left until the image that you want to use to kick off your movie appears under the Start frame.

Figure 9-15: Select the image that you want to use as the starting frame of the movie.

8. Press OK to select the high-lighted image.

The highlight is then replaced with a version that says End instead of Start, as shown in Figure 9-16.

9. Highlight the image that will be the last one in the movie and press OK.

Again, just press the Multi Selector right or left to scroll the images across the screen until the one you want to use appears

Figure 9-16: Select the ending frame of the movie.

under the End frame. Don't worry if there are frames between the Start and End images that you don't want to include in the movie; you can exclude them in the next step.

The little "filmstrip" at the bottom of the screen displays thumbnails of the images you selected as the Start and End pictures, as shown on the left in Figure 9-17.

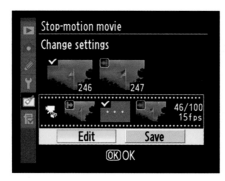
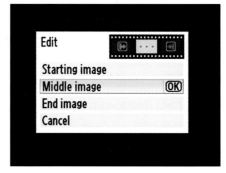

Figure 9-17: Select Edit to exclude frames or change the start or end frame.

10. Edit out any unwanted intermediate frames (optional).

If you don't want to include one or more of the frames that fall between your start and end frames, highlight Edit, as shown on the left in Figure 9-17, and press OK. You then see the screen shown on the right in the figure. Highlight Middle Image and press OK to return to a thumbnail view that displays all the frames between your start and end images, as shown in Figure 9-18.

Images marked with a check mark are tagged to be included in the movie. Press the Multi Selector left or right to highlight a frame and then press up or down to toggle the check mark on or off. Press OK after

you've unchecked all the frames you don't want to include. You see then the screen shown on the left in Figure 9-17.

Should you decide to change the start or end frame, select Starting Image or End Image instead of Middle Image when you see the screen shown on the right in Figure 9-17. Then simply re-choose your start or end frame and press OK.

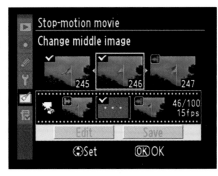

Figure 9-18: Frames with a check mark are included in the movie.

11. **At the bottom of the Change Settings screen (left screen in Figure 9-19), highlight Save and press OK.**

 The camera saves your changes and presents the Create Movie screen, shown on the right in the figure.

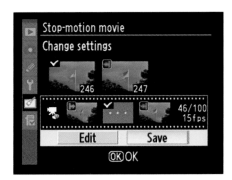

Figure 9-19: Choose Preview to take a look at your movie before you actually save the file.

12. **Highlight Preview and press OK.**

 The camera plays a preview of your movie. If you're not happy with the results, you can take two routes:

 - *Adjust the Frame Rate.* Highlight Frame Rate and press OK to adjust the frame rate that you selected in Steps 4 and 5.

 - *Select different images for the movie.* Highlight Edit and press OK to return to the Edit screen (see the right figure in Figure 9-17) to change the start, end, or intermediate images in the movie. After you do so, press OK to return to the Create Movie screen you see on the right in Figure 9-19.

13. **Highlight Save and press OK.**

The camera takes a few seconds to process and store the movie file, which is recorded in a standard digital movie format known as AVI. Then the first image in the movie appears in full frame on the monitor, as shown in Figure 9-20.

To play the movie, press OK when you see the screen shown in Figure 9-20.

Figure 9-20: Movie files are stored in the AVI digital video format.

During playback, an icon appears that looks like the Multi Selector. Press OK to pause the move, press left to go back, right to go forward, and up to stop playback and display the movie thumbnail.

After you transfer your image files to the computer, you also can view your movie in any program that can handle AVI files.

Viewing Your Photos on a Television

Tired of passing your camera around to show people your pictures or movies on the monitor? Why not display them on a television instead? Your D5000 is equipped with both an HDMI outlet, or port, for connecting the camera to a high-definition TV (or other video device), and an AV (audio/visual) port, for connecting the camera to a regular TV or video device. Both ports are tucked under the little rubber cover on the left-rear side of the camera and highlighted in Figure 9-21. A cable for making a regular video connection is included in the camera box. (It's the cable that has two plugs at one end, one white and one yellow.) For HDMI connections, you need to purchase a cable. You need something called a *Type C mini-pin* cable.

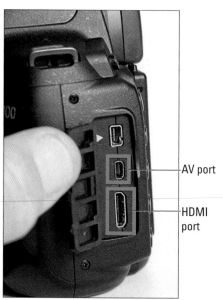

Figure 9-21: You can connect your camera to a television for big-screen playback.

Before connecting your camera, double-check the following menu options, both on the Setup menu and shown in Figure 9-22:

✔ **Video Mode:** You get just two options here: NTSC and PAL. Select the video mode that is used by your part of the world. (In the United States, Canada, and Mexico, NTSC is the standard.)

✔ **HDMI:** Unless you have trouble, stick with the Auto setting; the camera then automatically selects the right format for the HD device you're using. You also can select from four different formats, if you feel comfortable doing so.

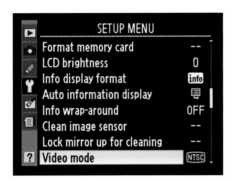

Figure 9-22: The options related to television playback live on the Setup menu.

Whether you go high def or regular def — what the industry now wants us to call *standard definition* — turn the camera off before connecting the devices. For a regular video connection, note that the white plug carries the audio signal, and the yellow one carries the video signal. With HDMI, everything goes through a single connector, and as soon as the two are linked, you can view your photos only on the HDMI screen.

When the two devices are connected, turn the camera and TV or video device on. At this point, you need to consult your TV manual to find out what channel to select for playback of signals from auxiliary input devices like your camera. After you sort that issue out, you can control playback using the same camera controls as you normally do to view pictures and movies on your camera monitor. You can also run slide shows by following the steps outlined in the two preceding sections in this book.

Part IV
The Part of Tens

In this part . . .

*I*n time-honored *For Dummies* tradition, this part of the book contains additional tidbits of information presented in the always popular "Top Ten" list format. Chapter 10 shows you how to do some minor picture touchups, such as cropping and adjusting exposure, by using tools on your camera's Retouch menu. Following that, Chapter 11 introduces you to ten camera functions that I consider specialty tools — bonus options that, while not at the top of the list of the features I suggest you study, are nonetheless interesting to explore when you have a free moment or two.

Ten (Or So) Fun and Practical Retouch Menu Features

In This Chapter

▶ Removing red-eye

▶ Straightening crooked horizon lines

▶ Tweaking exposure and color

▶ Fixing lens distortion

▶ Fixing perspective

▶ Cropping away excess background

*E*very photographer produces a clunker image now and then. When it happens to you, don't be too quick to reach for the Delete button, because many common problems are surprisingly easy to fix. In fact, you often can repair your photos right in the camera, thanks to tools found on the Retouch menu. You can even create some special effects with a couple of the menu options.

This chapter offers step-by-step recipes for using ten of these photo-repair and enhancement features. Additionally, I received special dispensation from the For Dummies folks to start things off with an additional section that summarizes tips that relate to all the Retouch menu options. In the words of Nigel Tufnel from the legendary rock band Spinal Tap, "This one goes to 11!"

Applying the Retouch Menu Filters

When you apply a correction or enhancement from the Retouch menu, the camera creates a copy of your original photo and then makes the changes to the copy only. Your original is preserved untouched.

You can take advantage of most Retouch menu features in two ways:

✏ Display the menu, select the tool you want to use, and press OK. You're then presented with thumbnails of your photos. Use the Multi Selector to move the yellow highlight box over the photo you want to adjust and press OK. You next see options related to the selected tool.

✏ Switch the camera to playback mode, display your photo in single-frame view, and press OK. (Remember, you can shift from thumbnail display to single-frame view simply by pressing the OK button.) The Retouch menu then appears superimposed over your photo. Select the tool you want to use and press OK again to access the tool options. I prefer the second method, so that's how I approach things in this chapter, but it's entirely a personal choice.

The one Retouch menu feature you can't access by using the first technique is the Side-by-Side comparison option. This feature enables you to compare the original image and the retouched version side by side on the monitor. Here's how it works:

1. **Display either the original or edited picture in single-image view, as shown on the left in Figure 10-1.**

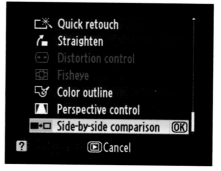

Figure 10-1: In single-image playback mode, press OK to superimpose the Retouch menu over the photo.

See Chapter 4 if you need help with picture playback.

2. **Press OK.**

A variation of the Retouch menu appears superimposed on the image, as shown on the right in Figure 10-1.

3. Highlight Side-by-Side Comparison and press OK.

Now you see the original image in the left half of the frame, with the retouched version on the right, as shown in Figure 10-2. At the top of the screen, you see labels that indicate the Retouch tools you applied to the photo (Fisheye, in the figure).

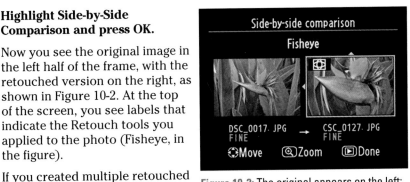

Figure 10-2: The original appears on the left; the retouched version, on the right.

If you created multiple retouched versions of the same original, you can compare all the versions. First, press the Multi Selector right or left to surround the After image with the yellow highlight box. Now press the Multi Selector up and down to scroll through all the retouched versions.

4. To temporarily view the original or retouched image at full-frame view, use the Multi Selector to highlight its thumbnail and then press and hold the Zoom In button.

Release the button to return to side-by-side view.

5. To exit side-by-side view and return to single-image playback, press the playback button or OK.

All retouched copies are saved in the JPEG file format and assigned a filename that begins with one of the following three-letter codes:

- ✔ **SSC:** Used for photos that you crop using the Small Picture function.

- ✔ **CSC:** Indicates that you applied one of the other Retouch menu corrections.

As a reminder, original photos have filenames that begin either with DSC or _DSC. (The underscore at the front of the filename tells you that you recorded the photo using the Adobe RGB color mode, an option you can explore in Chapter 6.)

The specific file numbers of retouched copies don't match those of the original, however, which can be a little confusing. Make note of the filename the retouched version is assigned so that you can easily track it down later. What numbering the camera chooses depends on the numbers of the files already on your memory card.

Removing Red-Eye

From my experience, red-eye is not a major problem with the D5000. Typically, the problem occurs only in very dark lighting, which makes sense: When little ambient light is available, the pupils of the subjects' eyes widen, creating more potential for the flash light to cause red-eye reflection.

If you spot a red-eye problem, however, give the Red-Eye Correction filter a try:

1. **Display your photo in single-image view and press OK.**

 The Retouch menu appears over your photo.

2. **Highlight Red-Eye Correction, as shown on the left in Figure 10-3, and press OK.**

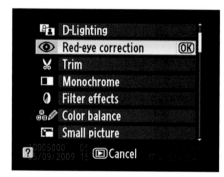 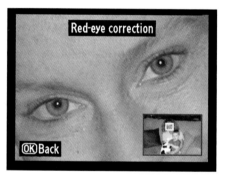

Figure 10-3: An automated red-eye remover is built right into your camera.

If the camera detects red-eye, it applies the removal filter and displays the results in the monitor. If the camera can't find any red-eye, it displays a message telling you so.

Note that the Red-Eye Correction option appears dimmed in the menu for photos taken without flash.

3. **Carefully inspect the repair.**

 Press the Zoom In button to magnify the display so that you can check the camera's work, as shown on the right in Figure 10-3. To scroll the display, press the Multi Selector up, down, right, or left. The yellow box in the tiny navigation window in the lower-right corner of the screen indicates the area of the picture that you're currently viewing.

4. **If you approve of the correction, press OK twice.**

 The first OK returns the display to normal magnification; the second creates the retouched copy.

5. **If you're not happy with the results, press OK to return to normal magnification. Then press the Playback button to cancel the repair.**

If the in-camera red-eye repair fails you, most photo editing programs have red-eye removal tools that should enable you to get the job done. Unfortunately, no red-eye remover works on animal eyes. Red-eye removal tools know how to detect and replace only red-eye pixels, and animal eyes typically turn yellow, white, or green in response to a flash. The easiest solution is to use the paintbrush tool found in most photo editors to paint in the proper eye colors.

Straightening Tilting Horizon Lines

I seem to have a knack for shooting with the camera slightly misaligned with respect to the horizon line, which means that photos like the one on the left in Figure 10-4 often wind up crooked — in this case, everything tilts down toward the right corner of the frame. Perhaps those who say I have a cock-eyed view of life are right? At any rate, my inability to "shoot straight" makes me especially fond of the Straighten tool on the Retouch menu. With this filter, you can rotate tilting horizons back to the proper angle, as shown in the right image in the figure.

Original Straightened

Figure 10-4: You can rotate crooked photos back to a level orientation with the Straighten tool.

In order to achieve this rotation magic, the camera must crop your image and then enlarge the remaining area — that's why the after photo in Figure 10-4 contains slightly less subject matter than the original. (The same cropping occurs if you make this kind of change in a photo editor.) The camera updates the display as you rotate the photo so that you can get an idea of how much of the original scene may be lost.

Here's how to put the tool to work:

1. **Display the photo in single-image playback mode and then press OK to get to the Retouch menu.**

2. **Highlight Straighten, as shown on the left in Figure 10-5, and press OK.**

 Now you see a screen similar to the one on the right in the figure, with a grid superimposed on your photo to serve as an alignment aid.

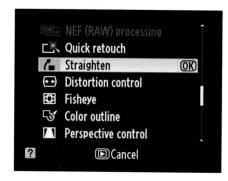 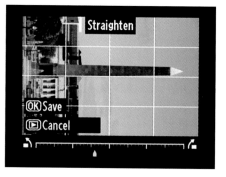

Figure 10-5: Press the Multi Selector right or left to rotate the image in increments of 25 degrees.

3. **To rotate the picture clockwise, press the Multi Selector right.**

 Each press spins the picture by about .25 degrees. You can achieve a maximum rotation of five degrees. The yellow pointer on the little scale under the photo shows you the current amount of rotation.

4. **To rotate in a counter-clockwise direction, press the Multi Selector left.**

5. **When things are no longer off-kilter, press OK to create your retouched copy.**

Shadow Recovery with D-Lighting

In Chapter 5, I introduce you to a feature called Active D-Lighting. If you turn on this option when you shoot a picture, the camera captures the image in a way that brightens the darkest parts of the image, bringing shadow detail into the light, while leaving highlight details intact. It's a great trick for dealing with high-contrast scenes or subjects that are backlit.

You also can apply a similar adjustment after you take a picture by choosing the D-Lighting option on the Retouch menu. I did just that for the photo in Figure 10-6, where strong backlighting left the balloon underexposed in the original image.

Original image D-Lighting, High

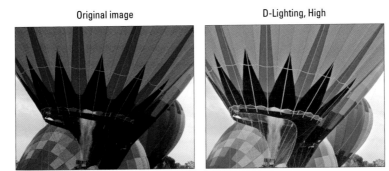

Figure 10-6: An underexposed photo (left) gets help from the D-Lighting filter (right).

Here's how to apply the filter:

1. **Display your photo in single-image mode and then press OK to display the Retouch menu.**

2. **Highlight D-Lighting, as shown on the left in Figure 10-7, and press OK.**

 You see a thumbnail of your original image along with an after thumbnail, as shown in the second image in Figure 10-7.

3. **Select the level of adjustment by pressing the Multi Selector up or down.**

 You get three levels: Low, Normal, and High. I used High for the repair to my balloon image.

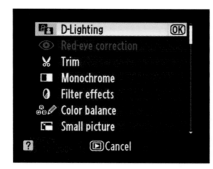 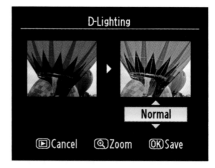

Figure 10-7: Apply the D-Lighting filter via the Retouch menu.

 To get a closer view of the adjusted photo, press and hold the Zoom In button. Release the button to return to the two-thumbnail display.

4. **To go forward with the correction, press OK.**

The camera creates your retouched copy.

 Note that you can't apply D-Lighting to an image if you captured the photo with the Picture Control feature set to Monochrome. (See Chapter 6 for details on Picture Controls.) Nor does D-Lighting work on any pictures to which you've applied the Quick Retouch filter, covered next, or the Monochrome filter, detailed a little later in this chapter.

Boosting Shadows, Contrast, and Saturation Together

The Quick Retouch filter increases contrast and saturation and, if your subject is backlit, also applies a D-Lighting adjustment to restore some shadow detail that otherwise might be lost. In other words, Quick Retouch is sort of like D-Lighting on steroids. Well, kind of, anyway.

Figure 10-8 illustrates the difference between the two filters. The first example shows my original, a close-up shot of a tree bud about to emerge. I applied the D-Lighting filter to the second example, which brightened the darkest areas of the image. In the final example, I applied the Quick Retouch filter. Again, shadows got a slight bump up the brightness scale. But the filter also increased color saturation and adjusted the overall image to expand the

tonal range across the entire brightness spectrum, from very dark to very bright. In this photo, the saturation change is most noticeable in the yellows and reds of the tree bud. (The sky color may initially appear to be less saturated, but in fact, it's just a lighter hue than the original, thanks to the contrast adjustment.)

To try the filter out, display your photo in single-image playback mode and press OK to bring up the Retouch menu. Highlight Quick Retouch, as shown on the left in Figure 10-9, and press OK to display the second screen in the figure.

As with the D-Lighting filter, you can set the level of adjustment to Low, Normal, or High. Just press the Multi Selector up or down to change the setting. (For my example photos, I applied both the D-Lighting and Quick Retouch filters at the Normal level.) Press OK to finalize the job and create your retouched copy.

Note that the same issues related to D-Lighting, spelled out in the preceding section, apply here as well: You can't apply the Quick Retouch filter to monochrome images. Additionally, you can't apply the Quick Retouch filter to a retouched copy that you created by applying the D-Lighting filter, and vice versa. However, you can create two retouched copies of your original image, applying D-Lighting to one and Quick Retouch to the other. You then can use the Side-by-Side Comparison feature to compare the retouched versions to see which one you prefer.

Original

D-Lighting

Quick Retouch

Figure 10-8: Quick Retouch brightens shadows and also increases saturation and contrast, producing a slightly different result than D-Lighting.

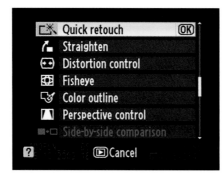
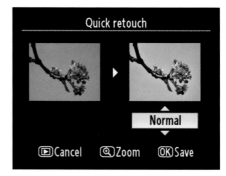

Figure 10-9: Press the Multi Selector up or down to adjust the amount of the correction.

Two Ways to Tweak Color

Chapter 6 explains how to use your camera's White Balance and Picture Control features to manipulate photo colors. But even if you play with those settings all day, you may wind up with colors that you'd like to tweak just a tad.

You can boost color saturation with the Quick Retouch filter, explained in the preceding section. But that tool also adjusts contrast and, depending on the photo, also applies a D-Lighting correction. With the Filter Effects and Color Balance tools, however, you can manipulate color only. The next two sections tell all.

Applying digital lens filters

Shown in Figure 10-10, the Filter Effects option offers five color-manipulation filters that are designed to mimic the results produced by traditional lens filters. (The other two filters on the menu, Cross Screen and Soft Focus, are special-effects filters that you can explore in Chapter 11.) The color-shifting filters work like so:

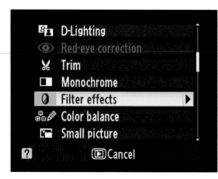
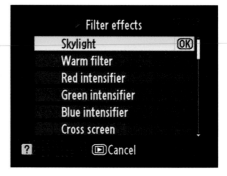

Figure 10-10: You can choose from seven effects that mimic traditional lens filters.

✓ **Skylight filter:** This filter reduces the amount of blue in an image. The result is a very subtle warming effect. That is, colors take on a bit of a reddish cast.

✓ **Warm filter:** This one produces a warming effect that's just a bit stronger than the Skylight filter.

✓ **Color intensifiers:** You can boost the intensity of reds, greens, or blues individually by applying these filters.

As an example, Figure 10-11 shows you an original image and three adjusted versions. As you can see, the Skylight and Warm filters are both very subtle; in this image, the effects are most noticeable in the sky. The fourth example shows a variation created by using the Color Balance filter, explained in the next section, and shifting colors toward the cool (bluish) side of the color spectrum.

Original image

Skylight filter

Warm filter

Color balance, filter shifted to blue

Doug Sahlin

Figure 10-11: Here you see the results of applying two Filter Effects adjustments and a Color Balance shift.

Follow these steps to apply the Filter Effects color tools:

1. **Display your photo in single-frame playback mode and press OK to display the Retouch menu.**

2. **Highlight Filter Effects and press OK.**

 You see the list of available filters. (Refer to Figure 10-10.)

3. **Highlight the filter you want to use and press OK.**

 The camera displays a preview of how your photo will look if you apply the filter.

4. **To apply the Skylight or Warm filter, press OK.**

 Or press the Playback button if you want to cancel the filter application. You can't adjust the intensity of these two filters.

5. **For the color-intensifier filters, press the Multi Selector up or down to specify the amount of color shift. Then press OK.**

Manipulating color balance

The Color Balance tool enables you to adjust colors with more finesse than the Filter Effects options. With this filter, you can shift colors toward any part of the color spectrum. For example, shifting colors toward the cooler — bluer — spectrum produced the fourth example in Figure 10-11.

Take these steps to give it a whirl:

1. **Display your photo in single-image playback mode and press OK.**

 Up pops the Retouch menu.

2. **Highlight Color Balance, as shown on the left in Figure 10-12.**

Figure 10-12: Press the Multi Selector to move the color-shift marker and adjust color balance.

3. **Press OK to display the screen shown on the right in the figure.**

 The important control here is the color grid in the lower-left corner. When the little black box is in the center of the grid, as in the figure, no color-balance adjustment has been applied.

4. **Use the Multi Selector to move the black square in the direction of the color adjustment you want to make.**

 Press up to make the image more green, press right to make it more red, and so on. The histograms on the right side of the display show you the resulting impact on overall image brightness, as well as on the individual red, green, and blue brightness values — a bit of information that's helpful if you're an experienced student in the science of reading histograms. (Chapter 4 gives you an introduction.) If not, just check the image preview to monitor your results.

5. **Press OK to create the color-adjusted copy of your photo.**

Creating Monochrome Photos

With the Monochrome Picture Control feature covered in Chapter 6, you can shoot black-and-white photos. Technically, the camera takes a full-color picture and then strips it of color as it's recording the image to the memory card, but the end result is the same.

As an alternative, you can create a black-and-white copy of an existing color photo by applying the Monochrome option on the Retouch menu. You can also create sepia and *cyanotype* (blue and white) images via the Monochrome option. Figure 10-13 shows you examples of all three effects.

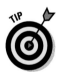

I prefer to convert my color photos to monochrome images in my photo editor; going that route simply offers more control, not to mention the fact that it's easier to preview your results on a large computer monitor than on the camera monitor. Still, I know that not everyone's as much of a photo editing geek as I am, so I present to you here the steps involved in applying the Monochrome effects to a color original in your camera:

1. **Display your photo in single-image view and press OK to bring the Retouch menu to life, as shown on the left in Figure 10-14.**

Figure 10-13: You can create three monochrome effects through the Retouch menu.

2. **Highlight Monochrome and press OK to display the three effect options, as shown on the right in the figure.**

Figure 10-14: Select a filter and press OK to start the process.

3. **Highlight the effect that you want to apply and press OK.**

 You then see a preview of the image with your selected photo filter applied.

4. **To adjust the intensity of the sepia or cyanotype effect, press the Multi Selector up or down.**

 No adjustment is available for the black-and-white filter.

5. **Press OK to create the monochrome copy.**

Removing (Or Creating) Lens Distortion

Certain types of lenses can produce a type of distortion that causes straight lines in a scene to appear curved. Wide-angle lenses, for example, often create *barrel distortion,* in which objects at the center appear to be magnified and pushed forward — as if you wrapped the photo around the outside of a sphere. The effect is perhaps easiest to spot in a rectangular subject like the oil painting in Figure 10-15. Notice that in the original image, on the left, the edges of the painting appear to bow slightly outward. *Pincushion distortion* affects the photo in the opposite way, making center objects appear smaller and farther away, as if you wrapped the photo around the inside of a sphere.

You can minimize the chances of distortion by researching your lens purchases carefully. Photography magazines and online photography sites regularly measure and report distortion performance in their lens reviews.

Slight barrel distortion

After Distortion Correction filter

Figure 10-15: Barrel distortion makes straight lines appear to bow outward.

If you do notice a small amount of distortion, your D5000 offers two potential fixes. First, you can try enabling the Auto Distortion Control option on the Shooting menu. This feature attempts to correct distortion as you take the picture. (Chapter 6 has details.) Or you may prefer to wait until after reviewing your photos and then use the Distortion control on the Retouch menu to try to fix things. I applied the filter to create the second version of the subject in Figure 10-15, for example. Less helpful, in my opinion, is a related filter, the Fisheye filter, that actually creates distortion in an attempt to replicate the look of a photo taken with a fisheye lens.

The extent of the in-camera adjustment you can apply is fairly minimal. Additionally, I find it a little difficult to gauge my results on the camera monitor because you can't display any sort of alignment grid over the image to help you find the right degree of correction. For those reasons, I prefer to do this kind of work in my photo editor. Wherever you make the correction, understand that distortion correction filters crop away part of your existing scene as part of the alteration, just like the Straighten tool, covered earlier in this chapter.

All that said, the first step in applying either filter is to display your photo in single-image playback mode and then press OK to display the Retouch menu. Highlight the filter you want to use (Distortion Control or Fisheye) and press OK again. From that point, the process depends on which of the two filters you're using:

✓ **Distortion Control:** After you press OK to select the Distortion Control filter, you see the screen shown on the left in Figure 10-16. For some lenses, an Auto option is available; as its name implies, this option attempts to automatically apply the right degree of correction. If the Auto option is dimmed or you prefer to do the correction on your own, choose Manual and press OK to display the right screen in the figure. The little scale under the image represents the degree and direction of shift that you're applying. Press the Multi Selector right to reduce barrel distortion; press left to reduce pincushioning. Press OK when you're ready to make your corrected copy of the photo.

Figure 10-16: Use the Distortion Control filter to reduce barrel or pincushion distortion.

> ✔ **Fisheye:** After you highlight the filter name and press OK, you see a screen similar to the right one in Figure 10-16. This time, you see the word Fisheye at the top of the screen, however, and the scale at the bottom of the image indicates the strength of the distortion effect. Press the Multi Selector right or left to adjust the amount. Then press OK to create the fisheye copy.

Correcting Perspective

When you photograph a tall building and tilt the camera to get it all in the frame, an effect called *convergence* or *keystoning* occurs. This effect causes vertical structures to appear to be leaning toward the center of the frame and the entire building seems to be falling away from you, as shown in the left image in Figure 10-17. (If the lens is tilting down, verticals instead appear to lean outward, and the building appears to be falling toward you. Through the Retouch menu's Perspective Control feature, you can right those leaning verticals, as shown in the "after" photo on the right in Figure 10-17.

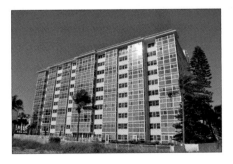
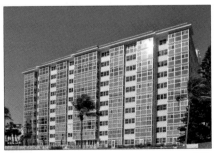

Doug Sahlin

Figure 10-17: The original photo exhibited convergence (left); applying the Perspective Control filter corrected the problem (right).

Note, though, that just like the Straighten tool, described earlier in this chapter, you lose some area around the perimeter of your photo as part of the correction process. So when you're shooting this type of subject, frame loosely — that way, you ensure that you don't sacrifice an important part of the scene due to the correction.

To try out the feature, follow these steps:

1. **Display your photo in single-image view and press OK to bring the Retouch menu to life.**

2. **Highlight Perspective Control, as shown in the left in Figure 10-18, and press OK.**

 After enabling this filter, you see a grid and a horizontal and vertical scale, as shown on the right in Figure 10-18.

3. **Press the Multi Selector left and right to move the out-of-whack object horizontally.**

4. **Press the Multi Selector up and down to rotate the object toward or away from you.**

5. **Use the guides to get the perspective as close to normal as possible and then press OK to make a copy of the original image with your changes.**

Figure 10-18: Press the Multi Selector to adjust the correction type and amount.

Cropping Your Photo

To *crop* a photo simply means to trim away some of its perimeter. Cropping away excess background can often improve an image, as illustrated by

the original bird of paradise flower picture, shown in Figure 10-19, and its cropped cousin, shown in Figure 10-20. When shooting this photo, Doug couldn't get close enough to the flower to fill the frame with it, so he simply cropped it to achieve his desired composition.

With the Trim function on the Retouch menu, you can crop a photo right in the camera. Note a few things about this feature:

✔ You can crop your photo to five different aspect ratios: 3:2, which maintains the original proportions and matches that of a 4 x 6-inch print; 4:3, the proportions of a standard computer monitor or television (that is, not a wide-screen model); 5:4, which gives you the same proportions as an 8 x 10-inch print; 1:1, which results in a square photo; and 16:9, which is the same aspect ratio as images on a wide-screen movie. If your purpose for cropping is to prepare your image for a frame size that doesn't match any of these aspect ratios, crop in your photo software instead.

Doug Sahlin

Figure 10-19: The original contains too much extraneous background.

Figure 10-20: Cropping creates a better composition and eliminates background clutter.

✔ For each aspect ratio, you can choose from six crop sizes. The sizes are stated in pixel terms — for example, if you select the 3:2 aspect ratio, you can crop the photo to measurements of 3424 x 2280 pixels, 2560 x 1704 pixels, 1920 x 1280 pixels, 1280 x 856 pixels, 960 x 640 pixels, and 640 x 424 pixels.

✔ After you apply the Trim function, you can't apply any other fixes from the Retouch menu. So make cropping the last of your retouching steps.

Keeping those caveats in mind, trim your image as follows:

1. **Display your photo in single-image view and press OK to launch the Retouch menu.**

2. **Highlight Trim, as shown on the left in Figure 10-21, and press OK.**

 Now you see a screen similar to the right side of the figure. The yellow highlight box indicates the current cropping frame. Anything outside the frame is set to be trimmed away.

 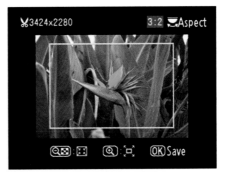

Figure 10-21: You can crop to five different aspect ratios: 3:2, 4:3, 5:4, 1:1, or 16:9.

3. **Rotate the Command dial to change the crop aspect ratio.**

 The selected aspect ratio appears in the upper-right corner of the screen, as shown in Figure 10-21.

4. **Adjust the cropping frame size and placement as needed.**

 The current crop size appears in the upper-left corner of the screen. (Refer to Figure 10-21.) You can adjust the size and placement of the cropping frame like so:

 • *Reduce the size of the cropping frame.* Press and release the Zoom Out button. Each press of the button further reduces the crop size.

 • *Enlarge the cropping frame.* Press the Zoom In button to expand the crop boundary and leave more of your image intact.

 • *Reposition the cropping frame.* Press the Multi Selector up, down, right, and left to shift the frame position.

5. **Press OK to create your cropped copy of the original image.**

Ten Special-Purpose Features to Explore on a Rainy Day

Consider this chapter the literary equivalent of the end of one of those late-night infomercial offers — the part where the host exclaims, "But wait! There's more!"

The ten features covered in these pages fit the category of "interesting bonus." They aren't the sort of features that drive people to choose one camera over another, and they may come in handy only for certain users, on certain occasions. Still, they're included at no extra charge with your camera purchase, so check 'em out when you have a few spare moments. Who knows; you may discover that one of these bonus features is actually a hidden gem that provides just the solution you need for one of your photography problems.

Annotate Your Images

Through the Image Comment feature on the Setup menu, you can add text comments to your picture files. Suppose, for example, that you're traveling on vacation and visiting a different destination every day. You can annotate all the pictures you take on a particular outing with the name of the location or attraction. You can then view the comments either in Nikon ViewNX, which ships free with your camera, or Capture NX 2, which you

must buy separately. The comments also appear in some other photo programs that enable you to view metadata.

Here's how the Image Comment feature works:

1. **Display the Setup menu and highlight Image Comment, as shown on the left in Figure 11-1.**

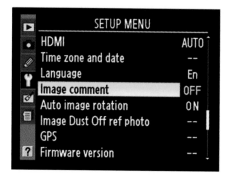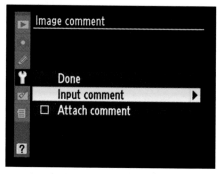

Figure 11-1: You can tag pictures with text comments that you can view in Nikon ViewNX.

2. **Press OK to display the right screen in the figure.**

3. **Highlight Input Comment and press the Multi Selector right.**

 Now you see a keyboard-type screen like the one shown in Figure 11-2.

4. **Use the Multi Selector to highlight the first letter of the text you want to add.**

 Note that if you scroll the display, you can access lowercase letters in addition to the uppercase ones shown on the initial screen.

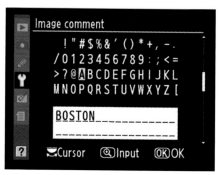

Figure 11-2: Highlight a letter and press the Zoom In button to enter it into the comment box.

5. **Press the Zoom In button to enter that letter into the display box at the bottom of the screen.**

6. **Keep highlighting letters and pressing the Zoom In button to continue entering your comment.**

 Your comment can be up to 36 characters long.

 To move the text cursor, rotate the Command dial in the direction you want to shift the cursor.

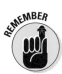

To delete a letter, move the cursor under the offending letter and then press the Delete button.

7. To save the comment, press OK.

You're returned to the Image Comment menu.

8. Highlight Attach Comment and press the Multi Selector right to put a check mark in the box.

The check mark turns the Image Comment feature on.

9. Highlight Done and press OK to wrap things up.

You're returned to the Setup menu. The Image Comment menu item should now be set to On.

The camera applies your comment to all pictures you take after turning on Image Comment. To disable the feature, revisit the Image Comment menu, highlight Attach Comment, and press the Multi Selector right to toggle the check mark off. Select Done and press OK to make your decision official.

To view comments in Nikon ViewNX, display the Metadata tab. (Click the tab on the left side of the program window.) Select an image by clicking its thumbnail. The Image Comment text appears in the File Info 2 section of the tab, as shown in Figure 11-3. (If the panel is closed, click the little triangle next to File Info 2.) See Chapter 8 for more details about using ViewNX.

Figure 11-3: Comments appear with other metadata in Nikon ViewNX.

Creating Your Own Menu

Keeping track of how to access all of the D5000's options can be a challenge, especially when it comes to those that you adjust through menus. To make things a little easier, you can build a custom menu that holds up to 20 of the options you use most frequently. Check it out:

1. **Display the Recent Settings/My Menu menu, as shown on the left in Figure 11-4.**

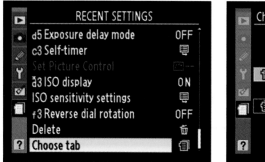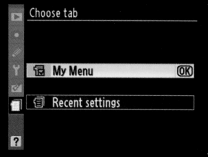

Figure 11-4: You can create a custom menu to hold up to 20 of the settings you access most often.

2. **Scroll to the bottom of the menu, highlight Choose Tab, and press OK.**

 You see the second screen shown in Figure 11-4.

3. **Highlight My Menu and press OK.**

 The main My Menu screen appears, as shown on the left in Figure 11-5.

Figure 11-5: Select Add Items to add options to your custom menu.

4. Highlight Add Items and press OK.

Now you see a list of the five main camera menus, as shown on the right in Figure 11-5.

5. Highlight a menu that contains an option you want to add to your custom menu and then press the Multi Selector right.

You see a list of all available options on that menu, as shown on the left in Figure 11-6. (If you select the Custom Setting menu, you have to first select the submenu that contains the option you want to put on your menu.)

Figure 11-6: Highlight a menu item and press OK to add it to your custom menu.

A few items can't be added to a custom menu. A little box with a slash through it appears next to those items.

6. To add an item to your custom menu, highlight it and press OK.

Now you see the Choose Position screen, as shown on the right side of FIgure 11-6, where you can change the order of your menu items. For now, just press OK to return to the My Menu screen; you can set up the order of your menu items later. (See the list following these steps.) The menu item you just added appears at the top of the My Menu screen.

7. Repeat Steps 4–6 to add more items to your menu.

When you get to Step 5, a check mark appears next to any item that's already on your menu.

After creating your custom menu, you can access it by pressing the Menu button and choosing the Recent Settings/My Menu screen. (If you want to switch to the Recent Settings menu, select Choose Tab to display the right screen shown in Figure 11-4 and then select Recent Settings.)

You can reorder the menu items and remove items as follows:

✔ **Change the order of menu options.** Display your custom menu and highlight Rank Items, as shown on the left in Figure 11-7. You then see a screen that lists all your menu items in their current order. Highlight a menu item, as shown on the right in the figure, press OK, and then use the Multi Selector to move it up or down the list. Press OK to lock in the new position of the menu item. When you're happy with the order of the menu items, press the Multi Selector left to return to the My Menu screen.

✔ **Remove menu items.** Again, head for the My Menu screen. Select Remove Items and press the Multi Selector right. You see a list of all the current menu items, with an empty box next to each item. To remove an item, highlight it and press the Multi Selector right. A check mark then appears in that item's box. After tagging all the items you want to remove, highlight Done and press OK. A confirmation screen appears; press OK to wrap things up.

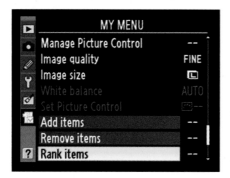 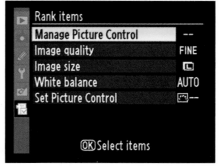

Figure 11-7: Choose Rank Items to change the order of menu items.

Creating Custom Image Folders

By default, your camera initially stores all your images in one folder, which it names 100D5000. Folders have a storage limit of 999 images; when you exceed that number, the camera creates a new folder, assigning a name that indicates the folder number — 101D5000, 102D5000, and so on. You see the full name of the default folders when you view the memory card contents on your computer. While viewing pictures on the camera, you see only a single folder, named D5000, that holds all your pictures, even after you exceed 999 photos and the camera creates a second folder for you.

If you choose, however, you can create your own, custom-named folders. For example, perhaps you sometimes use your camera for business and sometimes for personal use. To keep your images separate, you can set up one folder named DULL and one named FUN — or perhaps something less incriminating, such as WORK and HOME.

Whatever your folder-naming idea, you create custom folders like so:

1. **Display the Shooting menu and highlight Active Folder, as shown on the left in Figure 11-8.**

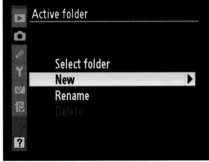

Figure 11-8: You can create custom folders to organize your images right on the camera.

2. **Press OK to display the screen shown on the right in Figure 11-8.**

3. **Highlight New and press the Multi Selector right.**

 You see a keyboard-style screen similar to the one used to create image comments, as described at the start of the chapter. The folder-naming version appears on the left in Figure 11-9.

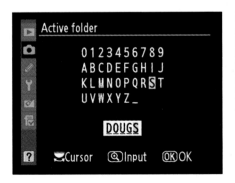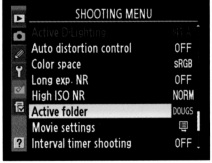

Figure 11-9: Folder names can contain up to five characters.

4. Enter a folder name up to five characters long.

Use these techniques:

- To enter a letter, highlight it by using the Multi Selector. Then press the Zoom In button.

- To move the text cursor, rotate the Command dial in the direction you want to move the cursor.

- To delete a letter, place the cursor under it and press the Delete button.

5. After creating your folder name, press OK to complete the process and return to the Shooting menu.

The folder you just created is automatically selected as the active folder, as shown on the right in Figure 11-9.

If you take advantage of this option, remember to specify where you want your pictures stored each time you shoot: Select Active Folder from the Shooting menu and press OK to display the screen shown on the left in Figure 11-10. Highlight Select Folder and press the Multi Selector right to display a list of all your folders, as shown on the right. Highlight the folder that you want to use and press OK. Your choice also affects which images you can view in Playback mode; see Chapter 4 to find out how to select the folder you want to view.

Figure 11-10: Remember to specify where you want to store new images.

If necessary, you can rename a custom folder by using the Rename option on the Active Folder screen. (Refer to the left screen in Figure 11-10.) The Delete option on the same screen enables you to get rid of all empty folders on the memory card.

Customizing External Controls

When your camera ships from the Nikon factory, the buttons and Command dial are set up to work as described throughout this book. You can, however, assign different functions to two buttons, the AE-L/AF-L button and the Function button, as described in the next two sections. (Look in the section about the AE-L/AF-L button for information about making a related adjustment to the shutter button; see Chapter 1 for a few additional customization options.)

Assigning a duty to the Function button

Tucked away on the left-front side of the camera, just under the Flash button, the Function (Fn) button is set by default to activate Self-Timer Shooting for your next picture. But if you don't use that function often, you may want to assign some other purpose to the button.

You establish the button's behavior via the Assign Fn Button option, found on the Controls submenu of the Custom Setting menu and shown on the left in Figure 11-11. After highlighting the option, press OK to display the screen shown on the right in the figure. Here's a quick description of the possible settings.

Figure 11-11: You can assign any number of jobs to the Function button.

- ✔ **Self-Timer:** The default option actives Self-Timer shooting with the current specified time delay. The Self-Timer mode applies only to your next shot, however.

- ✔ **Release Mode:** If you select this option, pressing the Fn button while turning the Command dial lets you choose the desired Release mode.

✔ **Image Quality/Size:** If you select this option, pressing the Fn button while turning the Command dial lets you choose the desired image quality and size.

✔ **ISO Sensitivity:** If you select this option, pressing the Fn button while turning the Command dial lets you choose the desired ISO setting.

✔ **White Balance:** If you select this option, pressing the Fn button while turning the Command dial lets you choose the desired white balance setting in P, S, A, and M modes.

✔ **Active-D Lighting:** If you select this option, pressing the Fn button while turning the Command dial lets you choose the desired Active-D Lighting setting. As with White Balance, this control is available only in the P, S, A, and M modes.

✔ **+ NEF (RAW):** This setting relates to the Image Quality option, introduced in Chapter 3. If you set that option to JPEG Basic, Fine, or Normal and then press the Fn button, the camera records two copies of the next picture you shoot: a JPEG version plus a second image in the NEF format. After the capture is complete, the Image Quality option is reset automatically to capture only the JPEG version.

✔ **Auto Bracketing:** If you select this option, pressing the Fn button while turning the Command dial lets you select a bracketing increment for AEB (automatic exposure bracketing) or white balance bracketing. For ADL (Active D-Lighting) bracketing, you can use the button and Command dial to turn bracketing on and off. Bracketing, explained at the end of Chapter 5, is possible only in the P, S, A, or M exposure modes.

After selecting the function you want to assign, press OK to lock in your choice.

Changing the function of the AE-L/AF-L button

Set just to the right of the viewfinder, the AE-L/AF-L button enables you to lock focus and exposure settings when you shoot in autoexposure and autofocus modes, as explored in Chapters 5 and 6.

Normally, autofocus and autoexposure are locked when you press the button, and they remain locked as long as you keep your finger on the button. But you can change the button's behavior. To access the available options, open the Custom Setting menu, navigate to the Controls submenu, press OK, and then highlight Assign AE-L/AF-L Button, as shown on the left in Figure 11-12. Press OK to display the options shown on the right in the figure.

Figure 11-12: You can set the AE-L/AF-L button to lock autoexposure only if you prefer.

The options produce these results:

- **AE/AF Lock:** This is the default setting. Focus and exposure remain locked as long as you press the button.

- **AE Lock Only:** Autoexposure is locked as long as you press the button; autofocus isn't affected. (You can still lock focus by pressing the shutter button halfway.)

- **AF Lock Only:** Focus remains locked as long as you press the button. Exposure isn't affected.

- **AE Lock (Hold):** This one locks exposure only with a single press of the button. The exposure lock remains in force until you press the button again or the exposure meters turn off.

- **AF-ON:** Pressing the button activates the camera's autofocus mechanism. If you choose this option, you can't lock autofocus by pressing the shutter button halfway.

After highlighting the option you want to use, press OK.

The information that I give in this book with regard to using autofocus and autoexposure assumes that you stick with the default setting. So if you change the button's function, remember to amend my instructions accordingly.

On a related note, my instructions also assume that the Shutter Release Button AE-L option, found on the Timers/AE Lock submenu of the Custom Setting menu, is set to its default, which is Off. At that setting, pressing the

shutter button halfway locks focus but not exposure. If you turn the feature on, your half-press of the shutter button locks both focus and exposure.

Adding a Starburst Effect

Want to give your photo a little extra sparkle? Experiment with your D5000's Cross Screen filter. This filter adds a starburst-like effect to the brightest areas of your image, as illustrated in Figure 11-13.

Figure 11-13: The Cross Screen filter adds a starburst effect.

Traditional photographers create this effect by placing a special filter over the camera lens; the filter is sometimes known as a Star filter instead of a Cross Screen filter. With your D5000, you can apply a digital version of the filter via the Retouch menu, as follows:

1. **Display your photo in single-image playback mode and press OK to call up the Retouch menu.**

2. **Highlight Filter Effects and press OK.**

3. **Highlight Cross Screen and press OK, as shown in Figure 11-14.**

The preview shows you the results of the Cross Screen filter at the current filter settings, as shown in Figure 11-15.

4. **Adjust the filter settings as needed.**

You can adjust the number of points on the star, the strength of the effect, the length of the star's rays, and the angle of the

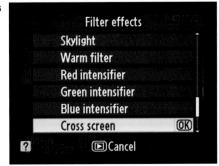

Figure 11-14: Select a filter effect.

effect. Just use the Multi Selector to highlight an option and then press the Multi Selector right to display the available settings. Highlight your choice and press OK. I labeled the four options in Figure 11-15.

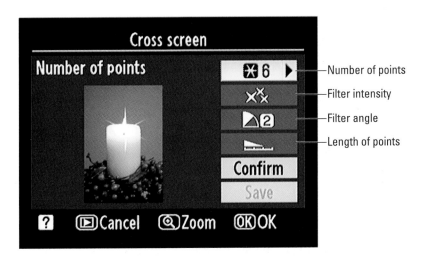

Figure 11-15: You can play with four filter settings to tweak the effect.

To update the preview, highlight Confirm and press OK.

You can also press and hold the Zoom In button to temporarily view your image in full-screen view. Release the button to return to the normal preview.

5. **Highlight Save and press OK to create your star-crossed image.**

Keep in mind that the number of starbursts the filter applies depends on your image. You can't change that number; the camera automatically adds the twinkle effect wherever it finds very bright objects. If you want to control the exact placement of the starbursts, you may want to forgo the in-camera filter and find out whether your photo software offers a more flexible star-filter effect. (You can also create the effect manually by painting the cross strokes onto the image in your photo editor.)

Creating a Color Outline

If you're like me, when you put a paintbrush to canvas, it's like mixing oil with water. It ain't pretty. But you can take one of your photo masterpieces and use it as the basis for a work of art by creating a color outline, as shown in Figure 11-16. Then you can grab your crayons, colored pencils, or whatever else may be lurking in your failed art-experiment drawer and draw between the lines. This is also a fun project to do with kids — you can, in essence, create a custom coloring-book page.

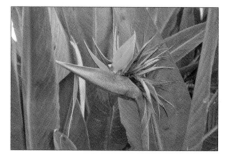 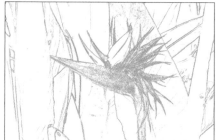

Figure 11-16: You can turn a photo into the basis for a color outline.

Try it out:

1. **Display your photo in single-image playback mode and press OK to display the Retouch menu over the image.**

2. **Highlight Color Outline as shown on the left of Figure 11-17 and press OK.**

 A preview of your art masterpiece appears onscreen, as shown on the right of Figure 11-17.

3. **Press OK.**

 The camera software creates a copy of your image with the effect applied.

Figure 11-17: Turn your photos into coloring pages for the kids.

Using the Soft Filter

Some photographers spend a lot of money for soft-focus filters. You'll be glad to know you can mimic the effect, without spending a dime, by using the Soft filter on the Retouch menu. This filter is well suited for portraits, but some people also use the filter to give a landscape a soft, dreamy look. Here's how to apply the filter:

1. **Display your photo in single-image playback mode and press OK to call up the Retouch menu.**

2. **Highlight Filter Effects, press OK, and then highlight Soft as shown on the left side of Figure 11-18.**

3. **Press OK.**

 The right side of Figure 11-18 shows the controls you use to apply the Soft filter.

Figure 11-18: You can create soft-focus effects to give your photo a dreamy look.

4. Press the Multi Selector up or down or rotate the Command dial to determine how soft you want the image.

Your choices are Low (kinda soft), Normal (soft with some details), and High (pass the rose-colored glasses). While you're pondering your decision, you can press the Zoom In button to get a better look.

5. Press OK to apply the filter.

Figure 11-19 shows the Bird of Paradise photo from Figure 11-16 after applying the Soften filter at the Normal setting.

Figure 11-19: This photo shows the result of using the Normal setting on the original from Figure 11-16.

Combining Two Photos with Image Overlay

Are you into double exposures? Well, you can't officially do a double exposure with the D5000, but the Image Overlay feature found on the Retouch menu enables you to merge two photographs into one. I used this option to combine a photo of a werewolf friend, shown on the top left in Figure 11-20, with a nighttime garden scene, shown on the top right. The result is the ghostly image shown beneath the two originals. Oooh, scary!

Figure 11-20: Image Overlay merges two RAW (NEF) photos into one.

On the surface, this option sounds kind of cool. The problem is that you can't control the opacity or positioning of the individual images in the combined photo. For example, you might assume that you could use this feature to create one of those old-fashioned "two views" portrait composites, with one area of the picture showing a frontal view of the subject and another showing a profile shot. But this really works well only if the background in both images is a solid color (black seems to be best) and you compose your photos so that the subjects don't overlap in the combined photo. Otherwise, you get the ghostly portrait effect like what you see in my example.

Additionally, the Image Overlay feature works only with pictures that you shoot in the Camera RAW (NEF) format. For details on RAW, see Chapter 3. The resulting image is also created in the RAW format, which means that you have to use a RAW processor to convert it into an actual image file before you can print or share it. Chapter 8 has details on that issue.

To be honest, I don't use Image Overlay for the purpose of serious photo compositing, however. I prefer to do this kind of work in my photo editing software, where I have more control over the blend. In addition, previewing the results of the overlay settings you use is difficult, given the size of the camera monitor.

That said, it's a fun project to try, so give it a go when you have a spare minute. Take these steps:

1. **Display the Retouch menu, highlight Image Overlay, and press OK.**

 You see the screen shown on the left in Figure 11-21, with the preview area for Image 1 highlighted. (The yellow border indicates the active preview area.)

 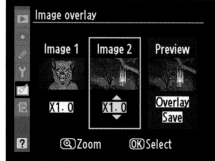

Figure 11-21: Preview the overlay image by pressing the Zoom button.

2. **Press OK to display thumbnails of your images.**

3. **Select the first of the two images that you want to combine.**

 A yellow border surrounds the currently selected thumbnail. Press the Multi Selector right and left to scroll the display until the border appears around your chosen image. Then press OK.

 The Image Overlay screen now displays your first image as Image 1.

4. **Repeat Steps 2 and 3 to select the second image.**

 Now you see both images in the Image Overlay screen, with the combined result appearing in the Preview area, as shown on the right in Figure 11-21.

5. **Press the Multi Selector right to move the yellow selection box over the Preview thumbnail.**

6. **In the Preview thumbnail area, highlight Overlay and press OK to get a full-frame view of the merged image.**

 If you aren't happy with the result, press the Zoom Out button to exit the preview. Then adjust the gain setting underneath the image thumbnails to manipulate the combined image. Press the Multi Selector right

or left to highlight Image 1 or Image 2 and then press up or down to adjust the gain for that image. To see the results of your adjustment in full-frame view, just highlight Overlay and press OK again. Press the Zoom Out button to exit the full-frame preview.

7. **To save the merged image, highlight Save (in the Preview thumbnail area) and press OK.**

 Again, the combined image is created in the Camera RAW (NEF) format.

Controlling Flash Output Manually

By default, your camera automatically adjusts the output of its built-in flash based on the ambient light so that you wind up with a proper exposure. But if you're experienced in the way of the flash, you do have the option of manually setting the flash output when you shoot in the P, S, A, and M exposure modes. To do so, take these steps:

1. **From the Custom Setting Menu, Highlight Bracketing/Flash and press OK.**

 The Bracketing/Flash options are displayed.

2. **Highlight Flash Cntrl for Built-In Flash (shown on the left in Figure 11-22) and press OK.**

 The menu shown on the right of Figure 11-22 appears.

 The TTL setting is the default flash setting, in which the camera sets the proper flash power for you. *TTL* stands for *through the lens*.

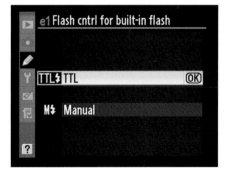

Figure 11-22: You can control the Flash output manually.

3. **Highlight Manual and press OK.**

 Now the menu shown in Figure 11-23 appears.

4. **Highlight the desired flash output and press OK.**

 Your options are from 1/32 power to Full power. The next time you use the built-in flash, it emits a burst of light at the power you specify.

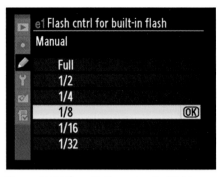

Figure 11-23: Specify the amount of light you want the flash to emit.

Adjusting flash power this way is a little cumbersome and, again, requires some lighting expertise to use properly. So remember that you can also keep the flash in auto mode (TTL mode) and then use the Flash Compensation control to bump the flash power up or down a few notches from what the camera's metering system thinks is appropriate. Of course, if you want to get really tricky, you can employ Flash Compensation even with manual flash control. See Chapter 5 for details on Flash Compensation.

Index